GRAPHIC DESI6N BASICS

GRAPHIC DESI6N BASICS

AMY E. ARNTSON
Professor Emerita
University of Wisconsin–Whitewater

AUSTRALIA | BRAZIL | JAPAN | KOREA | MEXICO | SINGAPORE | SPAIN | UNITED KINGDOM | UNITED STATES

Graphic Design Basics, Sixth Edition
Amy Arntson

Publisher: Clark Baxter
Development Editor: Kimberly Apfelbaum
Editorial Assistant: Ashley Bargende
Senior Media Editor: Wendy Constantine
Executive Marketing Manager: Diane
 Wenckebach
Marketing Coordinator: Loreen Pelletier
Senior Marketing Communications Manager:
 Heather Baxley
Senior Content Project Manager: Lianne Ames
Senior Art Director: Cate Barr
Print Buyer: Julio Esperas
Rights Acquisition Specialist, Image: Mandy
 Groszko
Production Service: Lachina Publishing Services
Text Designer: Lisa Kuhn
Cover Designer: Lisa Kuhn
Compositor: Lachina Publishing Services

For product information and technology assistance, contact us at
Cengage Learning Customer & Sales Support, 1-800-354-9706

For permission to use material from this text or product,
submit all requests online at **www.cengage.com/permissions.**
Further permissions questions can be emailed to
permissionrequest@cengage.com.

Library of Congress Control Number: 2010929199

ISBN-13: 978-0-495-91207-1

ISBN-10: 0-495-91207-7

Wadsworth
20 Davis Drive
Belmont, CA 94002
USA

Cengage Learning is a leading provider of customized learning solutions with office locations around the globe, including Singapore, the United Kingdom, Australia, Mexico, Brazil and Japan. Locate your local office at **international.cengage.com/region**

Cengage Learning products are represented in Canada by Nelson Education, Ltd.

For your course and learning solutions, visit
www.cengage.com

Purchase any of our products at your local college store
or at our preferred online store **www.cengagebrain.com.**

Printed in China
2 3 4 5 14 13 12 11

TO THOSE SPECIAL STUDENTS,
FRIENDS, AND TEACHERS WHO
MAKE LEARNING A JOYFUL
PROCESS.

BRIEF CONTENTS

1 APPLYING THE ART OF DESIGN 2

2 GRAPHIC DESIGN HISTORY 18

3 PERCEPTION 40

4 TOWARD A DYNAMIC BALANCE 58

5 GOOD GESTALT 72

6 USING VISUAL LANGUAGE 88

7 LAYOUT DYNAMICS 110

8 THE DYNAMICS OF COLOR 130

9 ILLUSTRATION AND PHOTOGRAPHY IN DESIGN 150

10 WHAT IS ADVERTISING DESIGN? 174

11 PRODUCTION FOR PRINT AND ONLINE GRAPHICS 186

CONTENTS

→

Preface	*xxi*

APPLYING THE ART OF DESIGN — 2
 TERMINOLOGY — 3

KEY POINTS — 3

PRINCIPLES AND PRACTICES — 3

WHAT IS GRAPHIC DESIGN? — 4
 VALUES — 5
 DESIGN FIELDS — 7

THE DESIGN PROCESS — 9
 RESEARCH — 9
 THUMBNAILS — 10
 ROUGHS — 11
 COMPREHENSIVES — 13
 PRESENTATION — 14
 READY FOR PRESS — 14

CAREERS — 14
 DESIGN STUDIOS — 14
 IN-HOUSE DESIGN — 14
 PRINTING COMPANIES — 16
 ADVERTISING AGENCIES — 16
 FREELANCE — 16

DIGITAL FOCUS: CAREERS — 16
 NEW MEDIA — 16

THE CHALLENGE — 16

EXERCISE — 17

GRAPHIC DESIGN HISTORY 18
TERMINOLOGY 19

KEY POINTS 19

THE BEGINNING 19

THE TURN OF THE CENTURY 22

MODERNISM 24

ABSTRACT MOVEMENTS 27

FIGURATIVE MOVEMENTS 30

AMERICAN DESIGN 31
POSTMODERNISM 35
FORM AND SUBSTANCE 35

DIGITAL FOCUS: POSTMODERN MEDIUM 36

NEW TECHNOLOGIES 36
THE DEVELOPMENT OF COMPUTER GRAPHICS 36
INTERACTIVITY 37

THE FUTURE 36

PROJECT 36

GOALS AND OBJECTIVES 39

CRITIQUE 39

PERCEPTION 40
TERMINOLOGY 41

KEY POINTS 41

SEEING AND BELIEVING 41
SEARCH FOR SIMPLICITY 41
INTERPRETATIONS 42

FIGURE/GROUND 42
CATEGORIES 44
STABLE FIGURE/GROUND 44
REVERSIBLE FIGURE/GROUND 44

AMBIGUOUS FIGURE/GROUND 44
CONDITIONS 46
LETTERFORMS 48

SHAPE **49**
SHAPE VERSUS VOLUME 49
GROUPING SHAPES 49
THE FORM OF SHAPES 50
LETTERFORM SHAPES 51

DIGITAL FOCUS: VECTOR AND RASTER GRAPHICS **52**
TERMINOLOGY 52

EXERCISES **55**

PROJECT **55**

GOALS AND OBJECTIVES **56**

CRITIQUE **56**

TOWARD A DYNAMIC BALANCE **58**
TERMINOLOGY 59

KEY POINTS **59**

VISUAL AND INTELLECTUAL UNITY **59**
DESIGN AS ABSTRACTION 60
WORKING TOGETHER 60

VISUAL DYNAMICS **61**
TOP TO BOTTOM 62
VERTICAL AND HORIZONTAL 63
LEFT TO RIGHT 63
OVERALL 64

BALANCE **64**
SYMMETRY 65
ASYMMETRY 65
BALANCE THROUGH CONTRAST 66

DIGITAL FOCUS: MANIPULATING LETTERFORMS **70**

EXERCISES **71**

PROJECT 1: WORD ILLUSTRATION **71**

PROJECT 2: ELEPHONTS **71**

GOALS AND OBJECTIVES **71**

CRITIQUE **71**

GOOD GESTALT **72**

 TERMINOLOGY 73

KEY POINTS **73**

THE WHOLE AND THE PARTS **73**

WHOLE **73**

GALLERY PROFILE: JOHN HEARTFIELD (1891–1968) **74**

GESTALT PRINCIPLES **74**

 SIMILARITY 76
 PROXIMITY 76
 CONTINUATION 77
 CLOSURE 78
 FIGURE/GROUND 79

TRADEMARKS **81**

 FUNCTIONS 81
 MAKING "MARKS" 82
 SYMBOLS 82
 LOGOS 83

DIGITAL FOCUS: LAYERS **85**

EXERCISE **86**

PROJECT **86**

GOALS AND OBJECTIVES **87**

CRITIQUE **87**

5

USING VISUAL LANGUAGE **88**
TERMINOLOGY 89

KEY POINTS **89**

THE DEVELOPMENT OF WRITTEN COMMUNICATION **89**
ALPHABETS 89

TYPE CATEGORIES **91**
HISTORIC TYPE FAMILIES 93

TYPE FAMILIES **97**
SELECTION 98
SIZE 98
LINE LENGTH 98
STYLE 98
LEADING 100
SPACING 102

GALLERY PROFILE: PAULA SCHER (B. 1948) **103**
FORMAT 103
STYLE AND CONTENT 104
SOME PROBLEMS 106

DIGITAL FOCUS: MORE ABOUT TYPE **106**

A DESIGN SUMMARY **106**

EXECUTION **107**
SPECIFYING AND CORRECTING COPY 107

EXERCISE **108**

PROJECTS **108**

GOALS AND OBJECTIVES **109**

CRITIQUE **109**

LAYOUT DYNAMICS 110
TERMINOLOGY 111

KEY POINTS 111

THE BALANCING ACT 111

SIZE AND PROPORTION 112

VISUAL RHYTHM 115

GRID LAYOUT 119
KEEPING THE BEAT 119
PLAYING THE THEME 119
GRIDS IN HISTORY 119
CHOOSING A GRID 121
CONSTRUCTING THE GRID 121

PATH LAYOUT 121
FOCAL POINT 122

PHOTOGRAPHY IN A LAYOUT 122
CROPPING 122
RESIZING 123
SELECTING 123

DIGITAL FOCUS: RESIZING 124
MULTIPANEL DESIGN 124
LAYOUT STYLES 126

GALLERY PROFILE: APRIL GREIMAN (B. 1948) 127

CONCLUSION 127

EXERCISES 128

PROJECT 128

GOALS AND OBJECTIVES 129

CRITIQUE 129

THE DYNAMICS OF COLOR 130
TERMINOLOGY 131

KEY POINTS 131

DESIGNING WITH COLOR **131**
THE COLOR WHEEL 132
PROPERTIES OF COLOR 133
COLOR SCHEMES 134

THE RELATIVITY OF COLOR **135**

GALLERY PROFILE: JOSEF ALBERS (1888–1976) **137**

THE PSYCHOLOGY OF COLOR **137**
ASSOCIATIONS 137
SELECTING COLOR 139

VISUAL PERCEPTION **139**

UNDERSTANDING ELECTRONIC COLOR **141**
COLOR MODELS 141
ANOTHER COLOR WHEEL 143
COLOR GAMUTS 143

COLOR IN PRINTING **144**
TINT SCREENS 144
SPOT COLOR OR PROCESS COLOR? 146
PROCESS COLOR SEPARATIONS 146
CUTTING COSTS 147
HALFTONES, DUOTONES, AND TRITONES 147

PROCESS COLOR SEPARATION SUMMARY **148**

EXERCISES **148**

PROJECT **149**

GOALS AND OBJECTIVES **149**

CRITIQUE **149**

ILLUSTRATION AND PHOTOGRAPHY IN DESIGN **150**
TERMINOLOGY 151

KEY POINTS **151**

THE DESIGNER-ILLUSTRATOR **151**

WHY ILLUSTRATION? **152**

ADVERTISING AND EDITORIAL ILLUSTRATION **154**

RECORDING AND BOOK ILLUSTRATION 154
MAGAZINE AND NEWSPAPER ILLUSTRATION 156
FASHION ILLUSTRATION 157
ILLUSTRATION FOR IN-HOUSE PROJECTS 157
GREETING CARD AND RETAIL ILLUSTRATION 158
MEDICAL AND TECHNICAL ILLUSTRATION 158
ANIMATION AND MOTION GRAPHICS 158

STYLE AND MEDIUM **158**

GETTING IDEAS **159**

DIGITAL FOCUS: GRADIENTS **160**

REFERENCE MATERIALS **163**

CONTEMPORARY VISION **163**

THE IMPACT OF PHOTOGRAPHY **164**

THE DESIGNER-PHOTOGRAPHER **165**

SPECIALTIES **166**

PHOTOJOURNALISM 166

DIGITAL FOCUS: PHOTOGRAPHY **167**

PRODUCT PHOTOGRAPHY 167
CORPORATE PHOTOGRAPHY 168
PHOTO ILLUSTRATION 168

GALLERY PROFILE: DIANE FENSTER (B. 1947) **170**

FINDING PHOTOGRAPHS AND PHOTOGRAPHERS **170**

PROJECT **171**

GOALS AND OBJECTIVES **171**

CRITIQUE **171**

WHAT IS ADVERTISING DESIGN? **172**

TERMINOLOGY 173

KEY POINTS **173**

THE PURPOSE OF ADVERTISING **173**

TYPES OF ADVERTISING **175**
 TELEVISION 175

GALLERY PROFILE: PAUL RAND (1914–1996) **176**
 NEWSPAPERS 176
 DIRECT MAIL 177
 OTHER FORMS OF ADVERTISING 179

DIGITAL FOCUS: ONLINE DESIGN **182**
 PERSONAL PROMOTION 182

CORPORATE IDENTITY **182**

WORKING WITH OTHERS **184**

EXERCISES **184**

PROJECT **184**

GOALS AND OBJECTIVES **185**

CRITIQUE **185**

**PRODUCTION FOR PRINT
AND ONLINE GRAPHICS** **186**
 TERMINOLOGY 187

KEY POINTS **187**

PART I: A DESIGNER'S TOOL **187**

HISTORY OF COMPUTER GRAPHICS **187**

DIGITAL FOCUS: DESKTOP REVOLUTION **188**
 THE MOVING DOT 188
 REALISM IN COMPUTER GRAPHICS 188
 ANIMATION 188
 PAINTING AND DRAWING 189
 LAYERED COMMUNICATION 191

ANALOG AND DIGITAL DATA **192**
 ANALOG TO DIGITAL CONVERSIONS 193
 THE SCREEN IMAGE 193
 OBJECT-ORIENTED AND BITMAPPED GRAPHICS 194
 HARDWARE AND SOFTWARE 194

MEMORY 195
RAM AND ROM 195
STORAGE DEVICES 196

INPUT/OUTPUT DEVICES 196
DATA IN 196
DATA OUT 196
FINE ART 196

PART II: PRODUCTION FOR PRINT 198
THE PROCESS 198
AN HISTORIC PROCESS 198
TERMINOLOGY 199
QUALITY ISSUES 200

DIGITAL PREPRESS 200
THE RIP 200
FONTS 201
DIGITAL IMAGE 202
LPI AND DPI 202
FILE LINKS 202
FILE FORMATS FOR PRINT 202
COMPRESSION 203
PREPARING ELECTRONIC FILES FOR A SERVICE BUREAU 203

PART III: PRODUCTION FOR THE WEB 203
INTERNET ORIGINS 203

THE GLOBAL VILLAGE 203

GALLERY PROFILE: MARSHALL McLUHAN (1911–1980) 204

SIMILARITIES AND DIFFERENCES 204
COMMON METHODOLOGY 205
DESIGN SIMILARITIES 205

DIGITAL FOCUS: NEW TECHNOLOGY AND NEW VISIONS 206
PRODUCTION SIMILARITIES 206
DESIGN DIFFERENCES 206
PRODUCTION DIFFERENCES 206

WHAT ARE THE RULES? 206

NAMING YOUR FILES 206
FILE FORMATS 207
RESOLUTION 207
FILE SIZE 207
MONITOR SIZE 208
COLOR 208

WEB COMPONENTS 208

PAGES AND SITES 208
LINKS 209
TABLES AND FRAMES 209
ANIMATION AND SOUND 210
WEB SOFTWARE 210
WEB PUBLISHING 210

SUMMARY 210

PROJECTS 211

CRITIQUE 211

IN CONCLUSION 211

Glossary *213*

Bibliography *223*

Index *227*

PREFACE

Graphic Design Basics introduces students to an exciting and demanding field. Design is linked tightly to society as it both reflects and helps to shape the world around us. Designers are part of this dynamic, important process. To enter this field requires discipline-specific information, hands-on practice, and an understanding of time-honored principles. The sixth edition of this text continues to weave a concern for design principles with specialized information about contemporary applications in the field of graphic design. It continues to showcase inspiring, contemporary work in the field.

Following in the tradition of the previous editions of *Graphic Design Basics*, the sixth edition offers students a comprehensive introduction to the field of graphic design that stresses theory and creative development. This edition includes additional beautiful, full-color visuals that reflect many stylistic directions. The designs and illustrations are chosen from some of the best work in historical and contemporary design. Although graphic styles are constantly evolving, the structural underpinnings of good design remain constant. The application of these basic principles leads to successful design solutions.

The tools of the graphic design field are changing quickly, offering opportunities for new complexities of creation and delivery of content. The sixth edition of *Graphic Design Basics* provides a guide to generating successful files for electronic prepress. It also interweaves samples of successful Web design throughout the chapters. "Digital Focus" boxes highlight the importance of the computer in graphic design. The added "Gallery Profiles" introduce the reader to biographies of leaders in the field of graphic design.

The pedagogical features in *Graphic Design Basics* are useful for both students and instructors. Each chapter of the sixth edition begins with "Terminology" and "Key Points" to prepare students to get the most out of the material. The Terminology and Glossary introduce and explain theoretical and technical terms, while the Bibliography opens the door to further discoveries and is helpfully arranged by chapter. The accompanying Web site is a vital part of the text and includes links for additional exploration.

Graphic Design Basics introduces both the form and the function of graphic design. It works well for courses in the field of design, as well as related courses dealing with visual communication and advertising. Updated projects and exercises challenge students to internalize the lessons in the text and to learn by doing. Goals and objectives for exercises as well as suggestions for critique help students get the most out of these exercises. Written and oral presentations are emphasized.

Major changes to the body of the text include the increased presence of Web design and new images of the best contemporary designs as well as the addition to Digital Focus boxes and Gallery Profiles. And importantly, the accompanying Web site explores and expands each chapter's content.

Chapters 1 and 2 present an introduction to the design process and to the field of design history. Chapters 3, 4, and 5 discuss the vital principles of visual perception, dynamic balance, and gestalt and how they relate to graphic design.

Chapters 6 and 7 focus on principles and practices of text and layout design in both print and Web applications. Traditional and electronic color are discussed in Chapter 8 along with information about the application of color theory on and off the computer. Illustration and photography are presented in Chapter 9, with new samples of a wide variety of digital and analog artwork. Chapter 10 gives an enlarged overview of the goals, media, and methods of advertising design.

Chapter 11 discusses the process of getting a design successfully into print, with an updated step-by-step guide for electronic prepress. The second part of Chapter 11 gives an overview of preparing files for the Web and compares the similarities and differences between print and Web design.

Thank you to the following reviewers for their help in preparing this edition.

Florence A. Bommarito, SLCC at FV
Randy Clark, South Dakota State University
Mary W. Hart, Middlesex Community College
Ryan Russell, Penn State University
Jennifer Schuster, Anne Arundel Community College
Adrienne R. Schwarte, Maryville College
Kevin Smith, Radford University

Thank you especially to the staff at Wadsworth and at Lachina Publishing Services for their excellent work. They are both professional and personable. I hope to work with the same team on the next edition.

ABOUT THE AUTHOR

Amy E. Arntson is a Professor Emerita at the University of Wisconsin–Whitewater, where she taught art, design, and computer graphics for over twenty years. Her artwork is exhibited nationally and internationally. She has given presentations on the nature of design and perception in Europe, Scandinavia, Central and South America, China, and the United States. Currently a full-time artist, Professor Arntson is also the author of *Digital Design Basics*.

GRAPHIC DESI6N BASICS

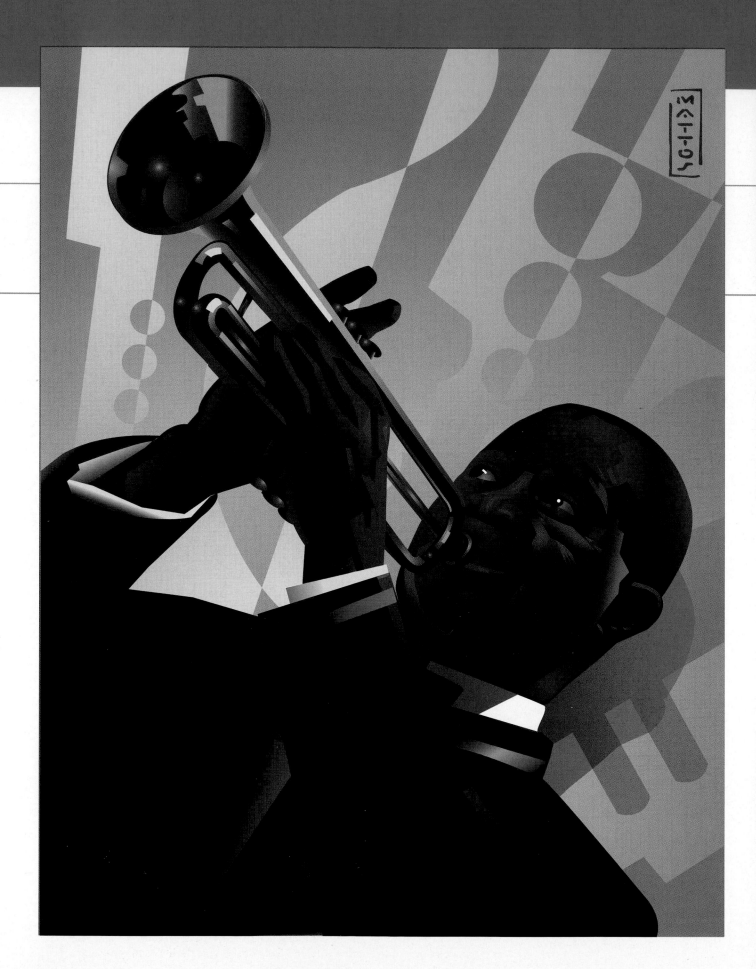

APPLYING THE ART OF DESIGN

TERMINOLOGY
(See glossary for definitions.)

Age of Information
Industrial Age
industrial design
environmental design
graphic design
Web and multimedia design
research
thumbnails
roughs
comprehensives
design studio
in-house design

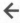

1–1 John Mattos. *Portrait for the* Baltimore Sun. *This digital illustration created in Adobe Illustrator uses a dynamic series of diagonal lines to express the energy of the musical sound. Visit the artist's Web site at www.johnmattos.com.* Courtesy of the artist.

KEY POINTS

This chapter defines the field of graphic design and describes its processes. It describes and illustrates the stages in the development of a finished design. Finally, it introduces potential career choices to demonstrate the wide parameters of this challenging field of study.

PRINCIPLES AND PRACTICES

This book is about applying the *principles* of visual perception to the *practice* of visual communication. The premise is that a course of study in graphic design should begin by applying the principles and theory of basic design. Interwoven with information about how we perceive and shape a two-dimensional surface will be its application to graphic design problems. As you learn specific graphic design terminology and techniques in this text, you will also discover how closely this ties in with the basic theory of 2-D design introduced in previous classes.

Students often believe that a class in graphic design or computer graphics is about the hardware and software. That's only a partial truth. The computer is a powerful, complex, exciting tool to be mastered, but the end product is no better than the concept that defines it. The computer is a tool and a partner that aids in the development of an original concept. The artist and designer are responsible for the research, concepts, and visual development necessary to realizing the final design.

Graphic design is sometimes defined as *problem solving*. Problems in graphic design almost always relate to visual communication. There are specific methods of creating a design that communicates visually and conceptually. This text discusses them in simple and straightforward language and contains many fine illustrations throughout, from various periods of art and design history. Discover how applying basic design theory and principles can enhance communication. Explore the nature of visual perception, the role of visual illusion, and the relationship between visual and verbal communication, as well as the full range of basic design skills.

The study of shapes on a flat ground yields a great deal of information about how we see, understand, and interact with the image on the page. This information can be applied to solve a wide range of graphic design problems.

A designer is not in search of one solution, but several. There is no one correct answer in graphic design, but a rich set of possibilities. This book presents principles such as gestalt unit forming, balance, emphasis, and eye direction as tools, not as rules. Use them to increase your options and widen your vision. These methods may become intuitive after a while, but in the beginning, practice studying and consciously applying them. Later, you will learn to interpolate and experiment, combining formal study with a more personal, intuitive approach. The poster by John Mattos (www.johnmattos.com) shown in **Figure 1–1** incorporates several design principles to deliver a dynamic sense of excitement. This portrait was created for the *Baltimore Sun* newspaper in the Illustrator program.

WHAT IS GRAPHIC DESIGN?

Graphic design is traditionally defined as problem solving on a flat, two-dimensional surface. Package design, Web design, and multimedia expand the field into 3-D and time-based 4-D applications. New-media designers sometimes refer to themselves as *information architects*, referring to the importance of organizational hierarchy. *The organization of information is a vital part of all graphic design.*

The designer conceives, plans, and executes designs that communicate a specific message to a specific audience within given limitations—financial, physical, or psychological. A poster design, for example, may be restricted to two colors for financial reasons. It may be physically restricted in size by the press it will be run on or because of the mailing method. It may

be restricted by the standard viewing distance for a poster in a hall or store window, by the size of a Web surfer's screen, or by the age and interests of the group for whom it is intended. Nevertheless, the designer must say something specific to a given audience about a given product or piece of information. Communication within specific parameters is the vital element in graphic design.

It is this element of communication that makes graphic design such an interesting and ever-evolving contemporary field. Designers must present current information to modern taste with up-to-date tools, staying informed about trends, issues, inventions, and developments. The Web site design by Planet Propaganda in **Figure 1–2** is an excellent and lively but at the same time disciplined example (www.planetpropaganda.com).

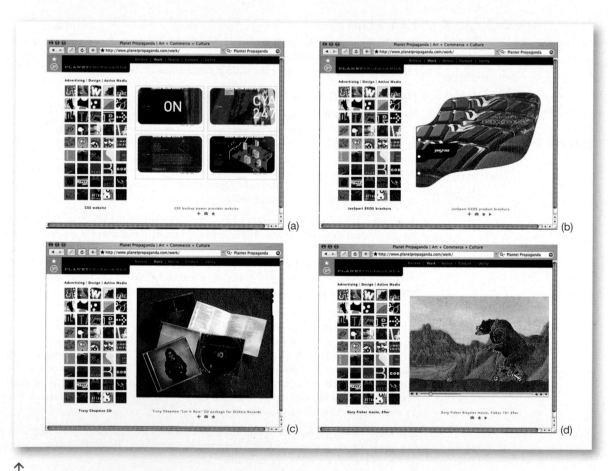

↑
1–2 *This Web site for the Planet Propaganda design firm uses repetition and variation to present and unite their varied creations. Visit the studio's Web site at www.planetpropaganda.com/work/.* Courtesy of the studio.

Design education is a lifetime activity. Constant change requires constant renewal. Graphic design is not a career for a slow-paced, nostalgic person. To keep up with this fast-changing field, you must approach the basic principles, new technologies, and practices with a flexible and curious mindset.

Values

Our current Western society is based on processing information more than producing goods. We are in the *Age of Information*, no longer the *Industrial Age*. The Industrial Age was characterized by a population evenly divided between agricultural and manufacturing industries. The development of large-scale energy production and metallurgy are examples of technological innovations vital to the Industrial Age.

The Age of Information is a term applied to the period when movement of information became faster than physical movement, during the late 20th century. The product itself, the information disseminated, the point of view illustrated, and the mode of communication used all contribute to shaping the world in this Age of Information.

Ask early in your career how you feel about goals and values. As a designer you will make career decisions that shape your life and contribute to shaping the character of our society. **Figure 1–3** is an example of design work that expresses a personal vision for peace created by illustrator Ronald J. Cala II.

A successful designer vividly described one of his early career decisions. His first job out of college was as a junior designer at a small advertising firm, where he was put to work designing a hot dog package. After preparing several roughs, he presented them to the client, only to be sent back to the drawing board. Rejected time after time, the designer grew more familiar with hot dogs than he ever wanted to become. He persevered, learned the basics, and now has his own firm specializing in educational and service-oriented accounts. This allows him more creative freedom and work that is consistent with his personal values.

→
1–3 *This poster created by* **Ronald J. Cala II** *for Calagraphic Design in Pennsylvania is part of a campaign for peace. The negative space creating the dove graphically expresses the idea that peace can be achieved only if we work together.* Courtesy of the artist.

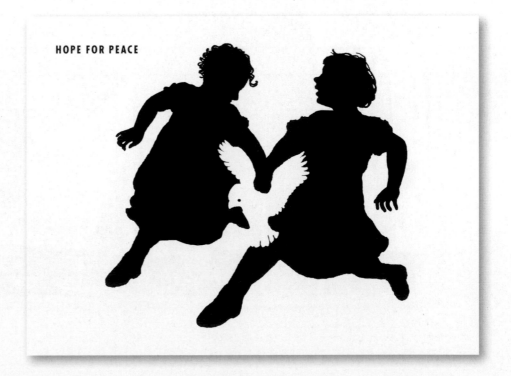

HOPE FOR PEACE

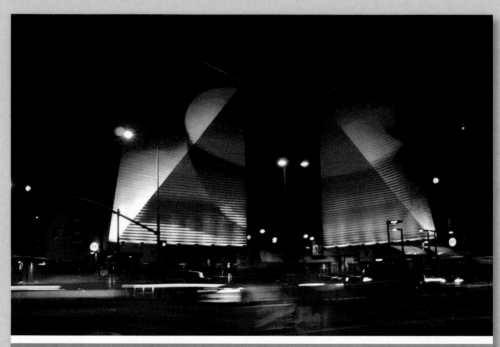

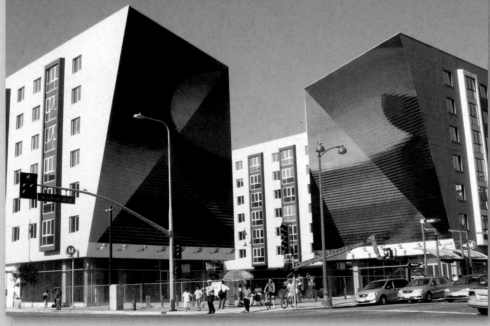

CHAPTER 1 Applying the Art of Design

April Greiman, a well known contemporary artist and designer, created this mural (**Figure 1–4**), titled "Big Bowl of Rice Finished." A video still of this 8200-square-foot public art commission was captured and translated into oil paint. Rice is a symbol of abundance. This is an example of creative freedom that is expressed through an integration of media on a large scale.

Most beginning design jobs do not usually offer many opportunities for the exercise of creative freedom. For the most part, we are designers working in a consumer society. Designers are integrally involved in the production and marketing of consumer goods and disseminating information. However, we must consider our potential impact on society. The major artistic movements of the 20th century each had a theory of society that provided a structure and direction for their artwork. The futurists, constructivists, dadaists, and surrealists actively helped define and reflect their society and their role in relationship to it. As designers, we have a vital role that needs to be continually examined as it shifts and changes.

Creating a design that is appropriate for a given product and its audience may not always give you an opportunity to exercise your own sense of aesthetics. Laying out a motorcycle products catalog may not provide much of an opportunity to experiment with visual effects. But the application of sound design principles always applies. This in itself can be very rewarding. In addition to directing the visual to a particular audience, the designer must also consider the individual client's preferences. There are many different kinds of jobs in this field, and a beginning designer is wise to plan on staying at an entry position only until skills and experience permit advancement.

Each of us must satisfy our own values in our career path, as well as learn to satisfy the requirements of the workplace. Try asking yourself these questions: Are there products or points of view you do (or do not) want to promote? How important is sala ry? What will make this career successful for you? What kind of lifestyle do you want for yourself? How hard are you willing to work? Where do you want to be in 10 years? How can you plan to achieve your goals?

Design Fields

The field of applied design includes industrial design, environmental design, graphic design, and Web and multimedia design. *Industrial design* is the design and development of three-dimensional functional objects. **Figure 1–5** shows a strikingly elegant teapot by Marianne Brandt, considered an important landmark in the history of functional design. Ms. Brandt (1893–1983) is best known as a Bauhaus designer and metalworker, although she also worked in a variety of other media. She is regarded as one of the leaders of the Bauhaus style. Brandt's designs for household objects such as teapots, lamps, and ashtrays are considered the origins of modern industrial design.

Machines, tools, kitchen implements, and other products are among the objects shaped by the industrial designer. Package design for these objects is often placed in the category of graphic design because it

←
1–4 April Greiman. Wilshire Vermont Mural. Courtesy of the artist.

→
1–5 Marianne Brandt. *This teapot beautifully integrates positive and negative shapes into this utilitarian object.* Brandt, Marianne (1893–1983) Teapot, 1924. Nickel silver and ebony. height, 7" (width), 9". Manufacturer: Bauhaus Metal Workshops, Weimar, Germany. Phyllis B. Lambert Fund. (186.1958.1a-c) Location: The Museum of Modern Art, New York, NY, U.S.A. Photo Credit: Digital Image © The Museum of Modern Art/ Licensed by SCALA / Art Resource, NY / © 2010 Artists Rights Society (ARS), New York / VG Bild-Kunst, Bonn

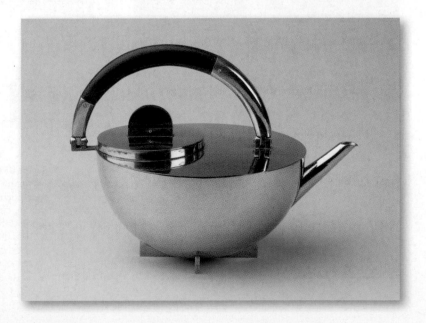

must be designed and printed flat before assembling. The industrial designer attempts to simplify the use and manufacture of objects as well as increase their safety and efficiency.

Environmental design is a large general category that includes the design of buildings, landscapes, and interiors. Again, the designer attempts to fashion designs that are safe, efficient, and aesthetic. Environmental design develops physical environments. It focuses on engaging people as they move through space. Deborah Sussman has long been a leader in the field of environmental graphic design. **Figure 1–6** shows her dynamic integration of typography and environment. She has worked at the interface of graphic and environment design for more than 30 years. Her credits include the 1984 Olympics in Los Angeles, Seattle's opera house, and Disney World. She creates permanent and temporary installations for architectural and public spaces.

Graphic design is the design of things people see and read. The field is constantly expanding. Posters, books, signs, billboards, advertisements, commercials, brochures, package design, Web sites, and motion graphics are what graphic designers create. They attempt to maximize both communication and aesthetic quality.

Web and multimedia design are the design of interactive, often motion-based graphics. Graphic designers are often expected to have skills in both print and Web design. Multimedia design is information in more than one form. It may include the use of text, audio, graphics, animations, and full-motion video. **Figure 1–7** shows a still from Planet Propaganda's TV ad sampler for the Wisconsin Film Festival. View the full multimedia creation on this book's accompanying Web site.

Buildings, environments, products, Web sites, and written communications affect us whether they have been carefully and deliberately designed or not. A printed piece always communicates more than words alone, because it uses a visual language. It may, however, communicate exactly the opposite of the intended message. It can damage the image of a company or cause. Learning to apply the *theory* of design and information processing to the *practice* of graphic design helps achieve the intended communication. *There is an intricate relationship between form and function.* That is the underlying premise of this text. All information is structured to help with this goal.

Designers must interface with fields other than their own. They need to address the basic marketing con-

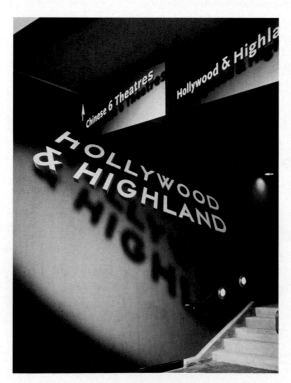

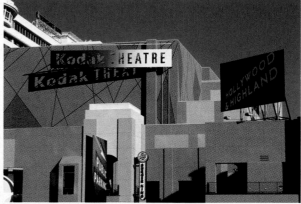

← ↑
1-6 a, b Sussman/Prejza & Company created this dynamic 3-D signage for the Hollywood & Highland development, which houses the Kodak Theatre (home of the Academy Awards), cinemas, shopping, entertainment, and overnight accomodations. The designs for project identity, signs and graphics use the interplay of shadows and light to evoke Hollywood glamour. Deborah Sussman is recognized as a pioneer of environmental graphic design. Visit their Web site for more details. Courtesy of the studio.

1–7 *This animated Wisconsin Film Festival TV ad sampler is created by the design firm* **Planet Propaganda**
Courtesy of the studio.

cerns of the client; the concerns of colleagues such as illustrators, photographers and Web designers; and the requirements of the printing and online distribution processes.

Some graphic designers do a whole range of work—typography, illustration, photography, corporate identity, logo design, and advertising. Others specialize in only one of these areas. Whatever area of design or illustration you pursue, it is always best to follow the design process.

THE DESIGN PROCESS

Research

The first step in preparing a design solution is *research*, or determining the parameters of the problem. Who is the audience? What constraints are there in format, budget, and time? What is the goal of the project?

The next step is to gather and study all the related materials. Presenting this design to a client (or an instructor) will be easier if it is backed with solid research and justified from a perspective the client will understand. Designers may work in a large firm or agency where most of the research and information gathering is done by marketing professionals. Visual research, however, is the designer's area. It's important to know what has been done before and what is being created locally and nationally for this type of design situation. Develop a feeling for contemporary work by studying design annuals, periodicals, and Web sites.

Designers also keep an electronic and/or print file of anything that is interesting or well done. A personal file of such samples can be useful to look through for ideas to build on. Subscribe to graphic design magazines and plan to save all the back issues. The Internet is also an excellent source of good design. For example, the AIGA Web site shows thousands of award winning designs. Never simply lift another designer's solution; that is unethical. Looking at how someone else solved a particular problem, however, is part of your education. Designers are expected to build on the work of others. We do not create in a vacuum, but are influenced and inspired by the thousands of samples of good and bad design we are exposed to every day.

Your challenge as a beginning designer is to expand your visual vocabulary. Use that vocabulary to build new designs. This is similar to an author using a word vocabulary developed over time. An author does not have to create a new alphabet or a new language in order to create an original piece of literature. He or she needs to combine these elements in an original fashion.

As part of the research stage, search for a creative approach to your design problem in as many ways as possible. Build your visual and conceptual vocabulary. Try looking up a dictionary definition of your topic. Look in an encyclopedia for additional background. Search the Internet for information on the topic. Use a thesaurus. Make a word-association list of everything you can think of that is associated with your topic. Save personally significant visuals and collectibles. *Approach a design as both prose and poetry*. Be both logical and intuitive.

Thumbnails

A designer needs to explore many alternative solutions. *Thumbnails* are the second step in the design process. They are idea sketches that provide visual evidence of the thinking, searching, and sorting process that leads to final solutions.

Exercising the mind with thumbnail sketches is like exercising any muscle. The more it is exercised, the more powerful it gets. The more you work to develop ideas through small, preliminary sketches (pencil or computer), the richer will be the range of solutions available to choose from for the final design. Never shortcut this stage, because it determines the strength of the final solution. For a student, the thumbnails are more important than the final project, because they demonstrate thinking, experimentation, and growth. Keep these thumbnails. The ideas in them may be of use to you in other projects, and prospective employers may wish to see evidence of the flexibility and tenacity of your thinking.

Figure 1–8 shows a series of thumbnails created by designer Candy Thieme for her client. She used Adobe Illustrator to generate very polished "thumbs." PmFAQtory's goal is to provide prospective clients across the United States with project management–related consulting services and products. The shield device reflects a strong defense in battle. The triangle reflects scope, time, and cost. See this book's accompanying Web site for more information on this design process.

Thumbnails are usually small because they are meant to be fast and not detailed. They are drawn in *proportion* to the dimensions of the finished piece. Fill a sheet of paper with ideas. Never reject an idea; just sketch it and go on. Work through the idea with your pencil or mouse from every perspective you can imagine. Then try taking one good idea and doing several variations on it. If you're using a pencil, tracing paper or lightweight bond is excellent for this purpose. You may also want to cut and paste and recombine existing images

↑
1–8 *Freelance designer* **Candy Thieme** *created this series of thumbnail proposals for her client's logo. The final choice is shown in a business card prepared for press output in Adobe Illustrator. A description of the process can be found at this text's Web site.* Courtesy of the artist.

for new effects. It may be faster to work at a size determined by existing elements. In that case, the thumbnails may become larger or smaller. The principle of "sketching through" ideas holds true no matter what the size or format of your preliminary investigation. Be as neat and precise as is necessary to show the relationship between elements and their general shapes. The stages of thumbnails, roughs, comps, and camera-ready art often blend together when executed on a computer. The danger with this blending is that although software may help provide quick, workable solutions, it can be tempting to shortcut the planning stages. Thumbnails are often successfully done by hand. They are vital to good design and in whatever size or stage of polish they must exhibit flexible, tenacious visual thinking. **Figure 1–9** shows how the pen-and-ink thumbnails for the cover design of the fifth edition of this text investigated a variety of approaches.

Roughs

Once the range of ideas has been fully explored, select the best thumbnails for refinement into more polished half or full size designs called *roughs*. Talk this choice over with other designers and with the instructor. Later, as a professional designer, you will present the thumbnails to an art director or the *roughs* to a client for review. Or you may be the art director who is reviewing someone else's design. Often, considerable redefining and rethinking occur at these stages. The thumbnail process may begin all over again. Be prepared to be flexible in this field.

When using computer, you may want to do a full-size rough. The purpose is to test whether the original idea works on a larger scale. Take this opportunity to work out small problem areas that you could not deal with or foresee at the thumbnail stage. The typestyle,

→

1–9 *Initial pen-and-ink thumbnails by the author investigated various ideas for the cover of* GDB *5*. A. E. Arntson.

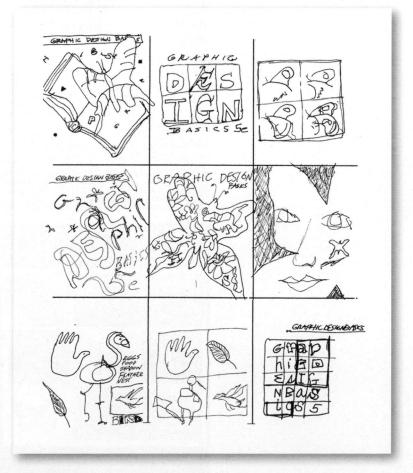

the other shapes, the relationship of these elements to the edge of the format, and the color and value distribution can all be refined at this stage. **Figure 1–10** shows three of the rough designs presented for the cover of the previous edition of this text. Consider which you prefer, and what new design you would propose.

Comprehensives

The *comprehensive*, or *comp*, is the fourth step in the design process. It is the piece of art presented to the client for final approval. Although based on the rough, it is much more precisely executed. Once again, it is important to consult with art directors, editors, or the instructor before choosing the rough idea to refine for a final solution.

The client can judge the design solution from the comp because it looks much like the finished printed piece. There is no need to explain "what would go there" or how "this would be smoother." A comp is usually computer generated, with all components assembled and exactly positioned. It can include such diverse elements as photographs, computer-generated type, electronic illustrations, and a scanned pen-and-ink rendering.

In most projects from this text, the comp will be the final step. These comps will form the basis of a student portfolio that is built upon throughout a course of study. In the workplace, the final stage is the printed project.

Comps take different forms depending on the media for which they are intended. Television and film ideas are presented as storyboards, with key scenes drawn in simplified and stylized fashion, or as abbreviated animation saved on CD. The three-dimensional comp for a package design may be presented in multiples in order to demonstrate the stacking display possibilities of the package. **Figure 1–11** shows the potential complexity of a CD package. A multipage publication such as an annual report or a newsletter is usually represented by the cover and certain key pages in the layout design. A Web site proposal, on the other hand, is presented to the client with a flow chart and key pages completed.

Roughs and comps can be sent to a client for approval via CD, e-mail, or fax. This streamlines the process and makes the designer and client's diverse locales a less important consideration.

1–10 *Computer-generated rough designs were created by the author based on the initial pen-and-ink sketches for the cover of the previous edition*. A. E. Arntson. Letterforms in version 3 designed by Seth Vandeleest.

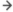

1–11 Planet Propaganda *created this Grammy-nominated CD package for jazz musician Ben Sidran's* Concert for Garcia Lorca. Courtesy of the studio.

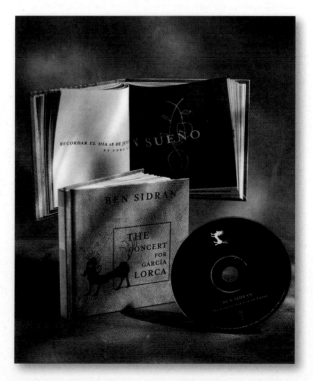

Presentation

Practice promoting your concept verbally before presenting the visual solution. Refer to the client's perspective and goals. Discuss the design enthusiastically in terms the client or art director can understand. Be prepared, however, to listen and to compromise. If revisions are called for, note them carefully. In this text, students are often asked to write a brief presentation to accompany the visual solution. Class critiques provide an opportunity to practice verbal presentation and listening skills.

Ready for Press

Once accepted, the job is now ready for production, as discussed in Chapter 11. The comprehensive shown to the client may look exactly like the finished piece, but it often cannot be used to produce the final printed product. Everything must be sent to the printer ready for press. In a two- or three-color design, printer's inks must be indicated. Paper selection is an important part of the process.

The file must be cleanly prepared, with all links and fonts included. Electronic files that print well inside a classroom may not "RIP" on an imagesetter at the printing company. Figure 1–8 shows a final print-ready version of a file prepared in Adobe Illustrator. Many designers are responsible for selecting and communicating with a printer. Often the work must be bid on by two or three printers, giving each an opportunity to estimate costs. Finding a good printer and establishing an easy working relationship are important. A good printer can be an excellent reference for answering tricky production questions and suggesting alternate solutions to an expensive design.

The first chapters in this text focus on building concepts and understanding design structure, whereas later chapters discuss the reproduction process. Build a strong design before focusing on how to reproduce it. Begin the first project with a respect for precision, accuracy, and cleanliness. *There should be no compromise with perfection in this line of work.*

CAREERS

The design field encompasses many working environments. What suits one person may feel like a limitation or undue pressure to another. It is wise to have an idea of what the opportunities are before beginning a job search. The following categories give an idea of the array of design positions available.

Design Studios

Clients with various needs and backgrounds may seek the assistance of a design studio. The studio will have designers, production artists, account service representatives, and often illustrators and photographers on staff or on call. Design studios hire freelance creative help when their regular staff is too busy or lacks specific skills to handle a project. Designers working in a studio generally have other artists around to discuss and share ideas. The number of working hours spent on each assignment is logged and the time billed to a client's account or to the studio itself. A high value is placed on an ability to work quickly and with a clear understanding of the client's needs and preferences. Clients consist primarily of various advertising agencies and large and small companies or institutions. The graphic design work prepared for these clients includes brochures, mailers, illustration and photography, catalogs, display materials, Web sites, and promotional videos. Studios vary in size and in their client roster. Small studios with only a couple of designers who have good skills and equipment can provide full-service design. Such a small studio can provide a rich opportunity for design variety. Larger studios can provide room for advancement and a stimulating creative environment with other designers. **Figure 1-12** shows an illustration by Matt Zumbo, who has his own design studio.

In-House Design

Many institutions employ their own in-house design staff. These in-house designers serve the particular needs of a wide variety of institutions, including hospitals, banks, newspapers, insurance companies, publishers, museums, colleges and universities, and large and small manufacturing concerns. In-house design organizations vary greatly according to the type of product or service their institution provides. **Figure 1–13** is a personal statement by university designer McRay Magleby. For many years, Magleby was creative director at Brigham Young University, where he and his staff produced publications, books, and posters. Recently, he worked for the University of Utah, while also creating independent design projects. *How* magazine named him as one of the "Twelve Most Influential Designers Today."

In-house designers work on projects that relate to the parent institution's activities. Individual designers may keep track of their hours if the design department bills its time to other departments. But many in-house design operations offer services free to the other departments within the company. Individual designers may work closely with the client or receive

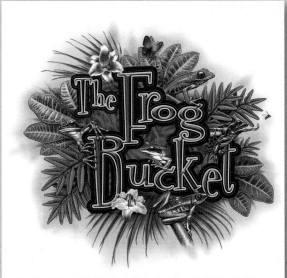

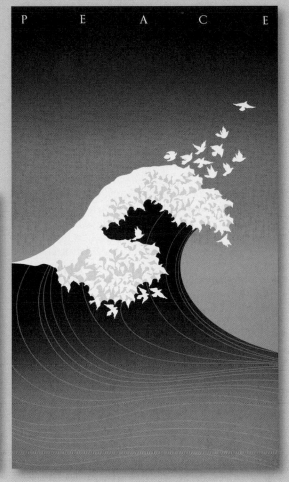

↑
1–12 Freelance illustrator **Matt Zumbo** *created this illustrated logo for The Frog Bucket. His projects range from national to regional to local clients.* Courtesy of the artist.

↑
1–13 McRay Magleby *created this* Wave of Peace *poster. The choice of color and creation of shapes reinforce the concept. Research the Web for more information on this significant designer, who is a professor of graphic design at the University of Utah and formerly the creative director for BYU. McRay manages his own studio, Magleby and Company.* Courtesy of the artist.

all information and instructions funneled through an art director.

An in-house design organization may lack the challenge of interpreting and representing various clients that a design studio provides. However, an advantage to working in an in-house operation is the opportunity to get to know one company in depth by developing a relationship with it and its various departments. Often the deadline pressure is less and the job security better than in a studio. The growth of computer software has caused a boom in in-house design as more and more companies find it possible to meet many of their publication needs in-house.

Printing Companies

Many positions for designers exist at local printing companies. These companies sometimes have their own in-house design departments or hire interns to do prepress work. A printing company can be an excellent place to gain valuable experience in the technical aspects of reproduction.

Advertising Agencies

Ideas and sales are the cornerstones of the advertising agency. It is dominated by people who deal in words. Account executives bring in the jobs and develop the advertising concepts with the creative director. The creative director, designer, and copywriter execute the concepts, although the number of people involved and the exact tasks vary from agency to agency. Projects cover all forms of print and multimedia advertising, including film and video work, TV, packaging, display, print ads, billboards, and Internet applications. A good creative director is versatile. He or she is skilled at conceptualizing and presenting ideas verbally and visually as well as directing others and organizing assignments. More money is spent on advertising than on any other area of graphic design, which is reflected in the salary a designer can expect to earn in this field.

Freelance

Working as a freelance artist allows a maximum amount of freedom, but it calls for certain business-related skills. Personal promotion, networking, and a constant vigilance to find new customers will help establish a freelance career. Good organizational skills in billing and record keeping, excellent design and illustration ability, and hard work keep a freelance business going. Computers make it possible to live outside a metropolitan area and still maintain client contact once it is established. One of the drawbacks to a freelance career is the lack of health insurance and retirement benefits. It can also be comparatively lonely though creatively fulfilling work. Figure 1-12 was created by Matt Zumbo, who has his own illustration business. Visit his web site to see the full range of artwork created for a wide variety of clients.

New Media

Web site creation calls for design skills in page layout, logo design, scripting, illustration, typography, and animation. Many companies now use the Internet to communicate with prospective clients, and designers play an important part in facilitating this informational and persuasive communication. Motion graphics and multimedia design are exciting and rewarding careers.

THE CHALLENGE

The challenge of being a graphic designer involves working through the restrictions and demands of the design process. It involves visualizing the completed job, although the actual finished product will not be done by hand. It may be completed on a press with printer's paper and inks, with elements that may have been photographed or drawn by other artists, and with copy written by others. Or it may be shown on a Web site or via another electronic mode of presentation. It involves meeting *personal* design standards as well as the needs of the client and the audience. It calls for organization and self-discipline to meet the constant deadline pressure. In the classroom, students generally get one project at a time and a generous length of time to complete it. The emphasis in school is on learning. On the job, designers work on several projects at once and must uphold design standards while concentrating on time and money issues. Designers must constantly update their education and stay current with new technologies. Technology makes major changes in the design field every year, and greater changes are always on the way.

The final design challenge is to take a responsible stance in the world. Traditionally, it has been the fine artist who has set new visual trends and opened fresh creative ways to see ourselves. The designer now also plays this role. **Figure 1–14** by illustrator and artist Diane Fenster (www.dianefenster.com) asks us to "Look, Listen, Think, Feel."

DIGITAL FOCUS
Careers

Graphic designers work at an array of jobs, using a variety of software to prepare their files. Opinions differ on how best to prepare a student for this field. Some academic programs separate their software instruction from their classes in graphic design concepts but teach them concurrently. Other programs begin the first classes with non-digital techniques, intending to build strong design skills through concentrating on principles before spending time on software rendering skills. Some programs integrate the two from the beginning in all classes, believing they are best and most efficiently learned together. Whichever approach a program takes, *a designer needs a command of both graphic design principles and concepts and the related digital techniques.*

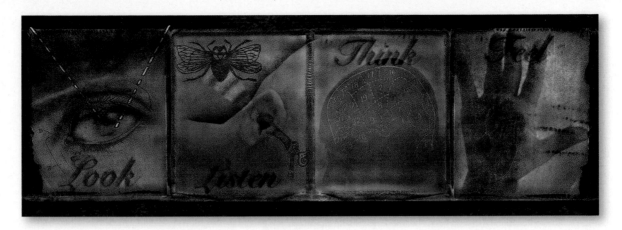

↑
1–14 Diane Fenster, LookListen. *Fenster was the first artist to be inducted into the Adobe Photoshop Hall of Fame, in September 2001.* Courtesy of the artist.

One of the issues facing contemporary design is the impact of our printed product on the environment. Recycled paper products are part of an attempt to lessen the negative impact of printed materials on the environment. Online graphics are also helping. The aesthetic qualities of design affect our lives in many ways, but the total effect of a design solution has numerous varied and important impacts on our lives. As designers, we are continually in the process of redefining our field. We need to examine how our culture and other cultures function, and how our perceptions and our values shape, and are shaped by, the world around us.

EXERCISE

As a class, research the types of employment opportunities in your geographic area. Find samples of a design firm, an in-house facility, and an advertising agency. Arrange a field trip.

If a field trip is not an option, do the research on the Internet, investigating the designers in your area or those presented in this chapter. Prepare a brief report, sharing the verbal and visual information with classmates.

Visit the accompanying Web site for research links and step by step interviews with the artist.

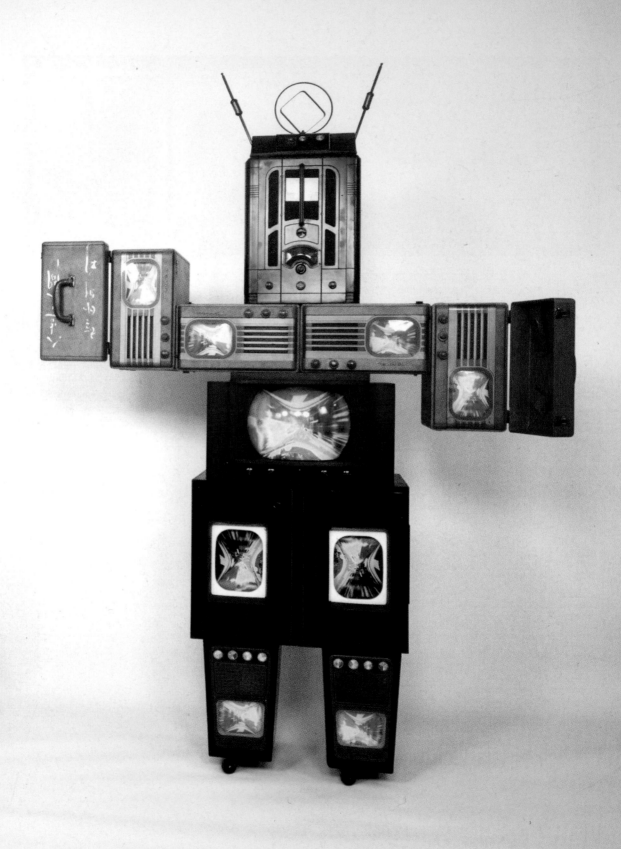

2 GRAPHIC DESIGN HISTORY

TERMINOLOGY
(See glossary for definitions.)

Industrial Revolution
art nouveau
arts and crafts movement
cubism
expressionism
fauvism
gestalt
futurism
Plakatstil
Dada
concrete poetry
photomontage
suprematism
constructivism
de Stijl
Bauhaus
new typography
Swiss Design
International Typographic Style
art deco
surrealism
modernism
postmodernism
computer graphics
interactivity

KEY POINTS

For a graphic designer, the movement of cultural ideas is as important to understand as changes in visual style. In fact, they are closely related. *Design is affected by areas as diverse as concepts in fine art, science, psychology, and the development of new technologies.* Most of these combined interests are shown in the whimsical contemporary creation in **Figure 2–1** by Nam June Paik. The study of design history can provide inspiration and insight into the future of design. This chapter's brief overview shows how design developed both as an art form and as a reflection of society. Hopefully, it will set the stage for further study. The history of art and design can provide a great deal of inspiration to contemporary designers.

THE BEGINNING

The birth of graphic design can be traced back 30,000 years to cave painting or about 550 years to Gutenberg's invention of the printing press and its use of movable type (**Figure 2–2**). Whatever we choose to call the origins, the explosive development during the last decade of the 19th century is a good place to begin this chapter.

The *Industrial Revolution* brought about new attitudes and inventions, both of which contributed to the sudden growth of graphic design. It was a period of rapid industrial growth, when machines and large-scale production replaced hand tools.

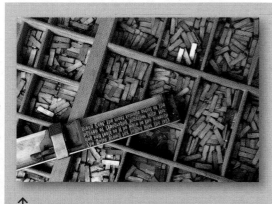

↑
2–2 *Movable type similar to that used by Gutenberg.* Photo courtesy of Wikipedia.

It began in the mid- to late 1700s in England and spread to other countries in the 1800s. This period lasted in the United States and Europe through most of the 1800s, as nations shifted from an agricultural to a manufacturing base. A spirit of innovation and progress gave rise to a new interest in providing information to an entire culture rather than only to an affluent elite. The growth of population centers, industry, and a money-based economy all increased the need for the dissemination of information. Advertising

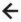 **2–1 Nam June Paik.** Family of Robot: Grandfather. *1986. Single-channel video sculpture with vintage television and radio casings and monitors.* Carl Solway Gallery, Cincinnati, OH, photo by Cal Kowal

flourished during this exciting time, and great strides were made in printing. The first photographic metal engraving was invented in 1824; the first halftone screen was made in 1852. A halftone screen is a pattern of dots of different sizes used to simulate and print a continuous-tone image in color or black and white. Color process work was first successfully printed in 1893. The first automated steam press for lithography was designed around 1868, and the first offset press in 1906.

Advancement in stone lithography color prints in the 1880s encouraged artists to work directly on the stone for multiple reproductions of large-scale posters. They were freed from the stiff, geometric confines of the letterpress. Stone lithography involves drawing the image on a stone by using a greasy black lithographic pencil. Plates are made for each color. The resulting burst of sensual and decorative images in the advertising posters of the time is classified as *art nouveau*. The movement began in France, and the artists most closely associated with its development are the Frenchmen Jules Chéret (**Figure 2–3**) and Henri de Toulouse-Lautrec and the Czech Alphonse Mucha (Figure 9-24).

Toulouse-Lautrec was primarily a painter and print-maker who produced only about 32 posters as well as music and book jacket designs. Mucha is best known for the furniture, carpets, jewelry, and posters he designed for the famous actress Sarah Bernhardt. Jules Chéret is now called the father of the modern poster. He produced more than a thousand posters, some of them close to 7 feet tall. This size was achieved by joining sections mounted on walls. Posters brought art out of the galleries and into the streets and homes of the working class. Art nouveau became an international style that spanned the period from 1890 to 1910. Its organic, decorative quality stressed the invention of original forms that were often inspired by nature. These forms and shapes were applied not only to graphic design but also to product design and crafts. Its influence has lasted much longer than the official dates for the period.

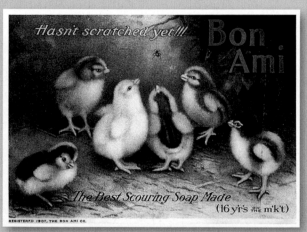
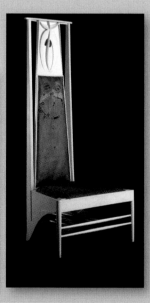

↑
2–3 *Poster advertising the Palais de Glace on the Champs Elysees.* Poster advertising the Palais de Glace on the Champs Elysees. (colour litho), Chéret, Jules (1836–1932) / Private Collection / The Bridgeman Art Library International

↑
2–4 *Trade card. Nineteenth century.* Wisconsin Historical Society Iconographic Collection

↑
2–5 C. R. Mackintosh. *Chair designed for the Rose Boudoir, Scottish Section, International Exhibition of Modern Decorative Art, Turin, 1902.* Photo © Hunterian Museum and Art Gallery, University of Glasgow, Mackintosh Collections

All of the functional arts grew during this time. In the United States, Louis Tiffany created stained glass windows, lamps, and glassware. **Figure 2–4** shows early advertising design in the United States flourishing in the form of trade cards. These are small cards that businesses would give to potential clients. They are an early form of our business cards.

Scottish architect, designer, and watercolorist Charles Rennie Mackintosh; his wife, Margaret MacDonald; and her sister, Frances MacDonald, developed furniture and cutlery designs as well as interior and graphic designs that celebrated the organic forms of nature (**Figure 2–5**).

An English artist whose work is an important example of art nouveau style is Aubrey Beardsley. A curving, sensual line and a compelling tension between the figure and background (**Figure 2–6**) characterize his illustrations for Oscar Wilde's *Salome* and other books. A prolific artist with an enduring reputation, Beardsley died at age 26.

Among the many North American art nouveau artists is Maxfield Parrish, an illustrator for *Harper's* and *Life* magazines as well as many other clients (**Figure 2–7**). Parrish worked as an illustrator for the first three decades of the 20th century, creating book, magazine, and advertising illustrations inspired by art nouveau. **Figure 2–8** is by the highly prolific German designer Ludwig Holwein, who also produced artwork for three decades, primarily creating advertising posters.

The legacy of art nouveau is not only its stylistic surface treatments but also its concern with the interrelationship of materials, processes, and philosophy. Not all reactions to the Industrial Revolution embraced progress. William Morris founded the Kelmscott Press in 1890 against what he regarded as the mass-produced, inferior, inhuman product of the machine. Styles of past eras were being copied in art schools and factories with an emphasis on quantity over quality. He and the writer-philosopher John Ruskin wished to renew an

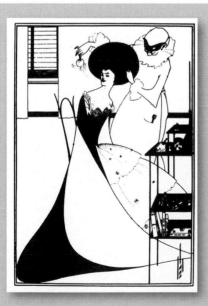

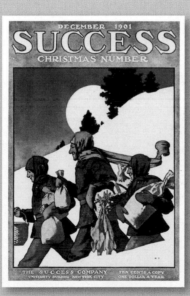

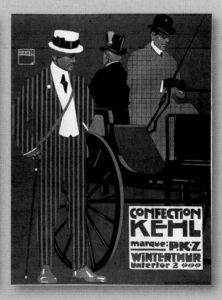

2–6 Aubrey Beardsley. *Pen-and-ink drawing for an illustration in* Salome. *1894. 813.16 x 65.16" (22 x 17 cm).* © Copyright the Trustees of The British Museum

2–7 Maxfield Parrish. *Cover illustration for* Success *magazine. December 1901.* Engel Poster Collection, Rare Book and Manuscript Library, Columbia University

2–8 Ludwig Holwein. Hohlwein, Ludwig (1874–1949) Confection Kehl, Marque: PKZ, Winterthur Unterior 2 (1908). Lithograph, printed in colour, 48 1/2 x 36 1/8". Gift of Peter Müller-Munk. (140.1968). The Museum of Modern Art, New York, NY, U.S.A. Photo Credit: Digital Image © The Museum of Modern Art/ Licensed by SCALA / Art Resource, NY / © 2010 Artists Rights Society (ARS), New York / VG Bild-Kunst, Bonn

appreciation for handcrafted, unique, labor-intensive products. Morris worked in many different media, including fabric, rugs, wallpaper, furniture, and typography. Thanks to Morris, the common person's home and furnishings became worthy of an artist's design. His highly stylized hand-printed books and hand-woven tapestries are wonderful examples of English art nouveau (**Figure 2–9**). Morris was a key figure in the English *arts and crafts movement*. This movement originated in England around the middle of the 19th century, and its influence spread to continental Europe and the United States. It rejected the heavy ornamentation of the Victorian style in favor of good craftsmanship and clean design. An intensely romantic idealist, Morris was deeply concerned with the ethics of art. He equated bad design with a faulty ethical system. He is credited, along with the Bauhaus, with bringing about a renewal of the standards of craftsmanship. His work was an inspiration to European modernists who, in turn, greatly influenced American art of the 20th century.

THE TURN OF THE CENTURY

The turn of the 20th century brought fundamental changes in our understanding of the world. In 1905 Albert Einstein made public his theory of relativity and altered our ideas of space and time. We began to consider them interrelated variables instead of isolated absolutes. After Sigmund Freud published *The Interpretation of Dreams* in 1909, dreams were no longer considered simply fantastic, clearly divided from reality. Sexuality also was no longer safely reserved for the bedroom but appeared in various symbols in everyday life. The accepted boundaries of reality began to shift.

The philosophy of existentialism further undermined faith in absolutes by suggesting that there is no single correct answer or moral action. Instead we are individually responsible for shaping meaning. This philosophy argues that humans define themselves by the choices and actions they freely and consciously make. Subjectivity rules over absolutes.

Meanwhile, travel and the growth of a communications network made it possible for us to hear of cultures with different lifestyles, beliefs, and perceptions. This communications explosion and the related technology continue to be one of the most important influences on society today. As designers we play an important part in its development. *Art and design both reflect society and help shape it.*

In the beginning of the 20th century, cubism emphasized the flat surface of the canvas. The relationship between the figures and the picture plane itself was ambiguous. Cubism influenced many movements, including futurism. (See Figure 2-12.) As cubism

←

2–9 William Morris. *Tapestry "Angeli Laudantes." 1894. H 240.7 cm x W 204.5 cm. This wool and silk tapestry was made from figures taken from Sir Edward Burne-Jones's cartoon for a stained glass window.* Victoria & Albert Museum, London / Art Resource, NY

developed, shapes became increasingly abstracted, showing objects from multiple points of view, with transparent overlapping. Such shapes denied an absolute, inviolate place in space for any single object. In these respects, cubism influenced the subsequent development of 20th-century design. Nature was no longer the only form of reality to depict. The human mind itself played a part in structuring reality, and subjectivity ruled over absolutes. The cubist practice of integrating letterforms into paintings influenced the typography of subsequent art and design movements.

In Germany, Friedrich Nietzsche and the nihilist rebellion contributed to *expressionism*, which appeared around 1905. The nihilists championed the independence of the individual, questioning the validity of all forms of preconceived ideas and social norms. The expressionist movement aspired to show subjective emotions and responses rather than objective reality. The idea that art is primarily self-expression led to a dramatic nonnaturalistic art, typified by Oskar Kokoschka and Ernst Kirchner (**Figure 2–10**).

In Paris in 1905 the first exhibition of a group of artists who would be called *les fauves* ("the wild beasts")

was held. Led by Henri Matisse and similar in look to expressionism, with its open disregard of the forms of nature, *fauvism* favored wildly expressive, subjective, and nonlocal colors. Fauvism ended around 1908; expressionism ended around 1920. Neo-expressionism, influenced by the expressionists and the fauves, shows up today in contemporary illustration. The concept of local color versus arbitrary color enriches artwork today.

In 1890 the German psychologist Christian von Ehrenfels published an essay called "On Gestalt Qualities." In it he proposed that the *gestalt* (total entity) is larger than the sum of its parts. Ehrenfels suggested that the parts interact to form a new whole. Our perception of an object is influenced by the arrangement of objects around it. This work pointed the way to another new idea. Reality could be seen as dependent on context rather than as absolute. This is an important part of our contemporary understanding of design and visual perception.

In 1910 at the Frankfurt Institute of Psychology, Max Wertheimer, an admirer of Ehrenfels, began research on apparent movement, which is the basis for the

→
2–10 Ernst Kirchner. *Cover for catalog of K. G. Brucke exhibition. 1905–1907. 32.7 x 31.9" (83 x 81 cm).* Collection Kaiser Wilhelm Museum. Copyright 2010 Ernst Ludwig Kirchner Archiv Galerie Henze & Ketterer

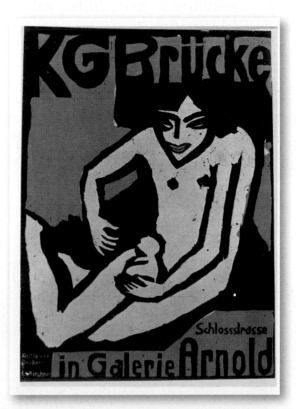

motion picture. He asked why we perceive some images as belonging together and others as not. He arrived at the gestalt principle of unit forming, which describes how we organize and interpret patterns from our environment. Simply put, things that are similar will be perceptually grouped together. (For a more detailed description of unit-forming factors, see Chapter 5.) Wolfgang Köhler and Kurt Koffka carried on Wertheimer's investigations, and later Rudolf Arnheim applied these principles to art and visual perception throughout much of the 20th century.

Germany also gave birth to Peter Behrens, a pictorial and graphic artist who moved into architecture. He was an artist of the Deutsche Werkbund, founded in 1907. Inspired by William Morris and the English arts and crafts movement, the Werkbund artists believed in examining the moral questions inherent in art and in preventing commercial and industrial abuse. Behrens received the first corporate identity job in the history of design. AEG, a large German corporation, asked him to design everything including its architecture and its advertising and products (**Figure 2–11**). Behrens taught Walter Gropius, who would later become famous as a leader of the Bauhaus, which we will discuss soon. See the accompanying Web site for links to investigate these ideas that surfaced in the early 20th century.

MODERNISM

The development of the European modernist era spanned roughly from 1908 to 1933, from the early days of cubism until Hitler's rise. Modernism encompassed fine art, graphic design, and architecture through various movements, including cubism, futurism, Plakatstil, suprematism, Dada, de Stijl, the Bauhaus, and constructivism. Many artists and designers fit into multiple categories.

The years before World War I brought new movements that continued to expand our notion of reality. *Futurism* showed time itself on canvas by capturing motion through multiple images. The movement was established around 1909 by the Italian poet Emilio Marinetti and developed by artists such as Giacomo Balla, Gino Severini, and artist-designer E. McKnight Kauffer, who spent much of his career as an illustrator. The futurist artists were so named for their optimistic belief that the machines of the Industrial Age would lead to a better future. Ironically and sadly, many artists of the movement were killed in World War I. **Figure 2–12** is a futurist painting of men and machines during the war. The combination of war, art, death, and a belief in machines is poignantly displayed in this painting. Futurism's influence, however, continued beyond that period. Motion pictures were popular by 1910, and they widened our visual reality, creating images that moved through time, as the futurists hoped their paintings would do. The futurists, originating in Italy in the early 20th century have ties to cubism.

Plakatstil, a flat-color pictorial design style that maintained a balance between 2-D design structure and imagery, emerged in Germany early in the 20th century. Lucian Bernhard created a compelling series of advertising posters using imagery made from flat colors with an emphasis on shape, combined with the product name (**Figure 2–13**).

Around this same time, another movement surfaced that would also influence graphic design. *Dada* was founded

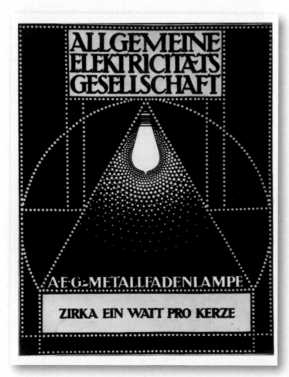

←
2–11 Peter Behrens. *Poster for AEG lightbulbs. 1901.*

→↗
2–12 Gino Severini. Severini, Gino (1883–1966) Armored Train in Action, 1915. Oil on canvas, 45 5/8 x 34 7/8". Gift of Richard S. Zeisler. (287.198 / Digital Image © The Museum of Modern Art/ Licensed by SCALA / Art Resource, NY / © 2010 Artists Rights Society (ARS), New York / ADAGP, Paris

→↘
2–13 Lucian Bernhard (Emil Kahn). Osram AZO. *c. 1910. Lithograph, printed in color, 175.8 x 373.8" (44.7 x 95.9 cm). The Museum of Modern Art, New York.* Bernhard, Lucian (1883–1972) Osram Azo, c. 1910. Lithograph, 27⅝ x 37⅜". Purchase Fund. (467.1987). Digital Image © The Museum of Modern Art/Licensed by SCALA / Art Resource, NY / © 2010 Artists Rights Society (ARS), New York / VG Bild-Kunst, Bonn

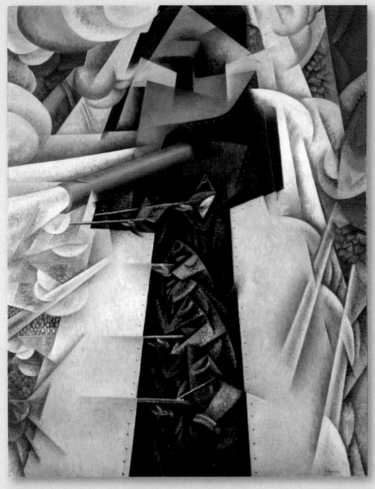

in 1916 by a group of poets, chief of whom was the Romanian-born Tristan Tzara. Its name, like the movement itself, had no meaning, according to the Dadaists.

> Colonial syllogism
> No one can escape from destiny
> No one can escape from DADA
> Only DADA can enable you to escape from destiny.
> You owe me: 943.50 francs.
> No more drunkards!
> No more aeroplanes!
> No more vigor!
> No more urinary passages!
> No more enigmas!

The Dadaists were extremely important in 20th-century art and philosophy because they questioned meaning itself with an assault on all accepted values and conventional behavior. Marcel Duchamp exhibited such things as bicycle wheels, urinals, and bottle racks, challenging the criteria by which we define something as art. He stated, "I was interested in ideas—not merely in visual products. I wanted to put painting again at the service of the mind." The Dada poet Guillaume Apollinaire created a series of "Calligrammes" around 1918 that seemed to break every known rule of typography. His *concrete poetry* was poetry in which both typography and layout add to the overall meaning. The written word exists as *visual* marks of white on black or as patterns of *sound*.

One of the many Dada publications, *Der Dada*, introduced *photomontage*, which was characterized by an intentional disorder. Letters of all types and sizes, various languages, and dictionary illustrations mingled (**Figure 2–14**). Figurative photographic images were treated with the same freedom from conventions. With "rayographs" or photograms and techniques such as solarization, Man Ray made an important contribution to graphic design in the form of photomontage.

Hannah Höch (**Figure 2–15**) and John Heartfield (Figure 5–4) were also important photomontage artists, creating

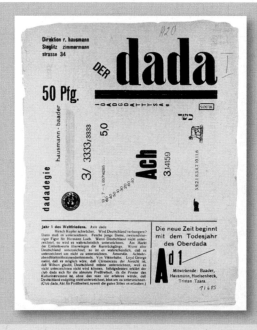

 2–14 Der Dada *cover. 1920.* Collection, The Art Institute of Chicago. Mary Reynolds Collection.

↑ **2–15 Hannah Höch**. Höch, Hannah (1889–1978) Cut with the Dada Kitchen Knife through the Last Weimar Beer-Belly Cultural Epoch in Germany. 1919. Collage, 114 x 90 cm. NG 57/61. Bildarchiv Preussischer Kulturbesitz / Art Resource, NY / © 2010 Artists Rights Society (ARS), New York / VG Bild-Kunst, Bonn

rich, unexpected visual effects. Both Höch and Heartfield made anti-Hitler images that spoke with images about political realities. Kurt Schwitters, another Dada artist, combined cubism with Dada for a series of collages that remain a rich visual resource for artists today.

ABSTRACT MOVEMENTS

The first totally abstract poster is attributed to Henry van de Velde in 1897 (**Figure 2–16**). A Belgian art nouveau artist, he moved to Germany in 1906 to teach and became interested in architecture and a more structural approach to art. He was an architect, designer, educator, and painter, and his ideas contributed to the later development of the Bauhaus movement. Van de Velde's work is regarded as a precursor to 20th-century abstract painting. His only poster was for Tropon, a concentrated food product. In his writing he called for a new art that would integrate the best of the decorative and the applied arts of the past.

The first abstract painting is attributed to Wassily Kandinsky. He and others were working in an abstract fashion by 1911. Such paintings, in Kandinsky's words, issued from "inner necessity." For Kandinsky a painting was above all "spiritual," an attempt to render insights and awareness transcending obviously descriptive realism. Author of *On the Spiritual in Art*, he joined the Weimar Bauhaus around 1920.

Constructivism began as a Soviet youth movement. The Russian Revolution of 1917 involved many Russian artists, who combined political propaganda and commercial advertising in support of the new state enterprises and revolutionary change. Civic-minded artists designed posters and packaging intended to attract buyers to state products. Advertising became a means for artists, poets, and others to advance the goals of Soviet society. Kasimir Malevich, Aleksandr Rodchenko, and others were abstract painters whose goal to directly reach viewers' consciousness adapted readily to advertising propaganda for the good of Soviet society. The state enterprises flourished with the support of painters turned graphic designers (**Figure 2–17**). Rodchenko worked in a variety of

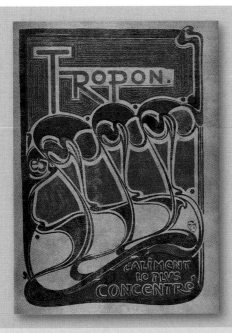

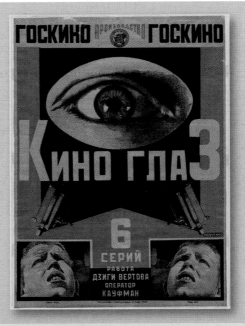

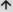
2–16 Henry van de Velde. Tropon, 1898 (litho), Velde, Henry van de (1863-1957) / Calmann & King, London, UK / The Bridgeman Art Library

2–17 Aleksandr Rodchenko. Kino Glaz (Film Eye). *1924. Lithograph, printed in color, 361.2 x 271.2" (92.5 x 70 cm).* Digital Image © The Museum of Modern Art/Licensed by SCALA / Art Resource, NY / Art © Estate of Alexander Rodchenko/RAO, Moscow/VAGA, New York

media, including filmmaking and set and costume design for film and theater. He designed posters for several films by using photo collage.

El Lissitzky was a Russian constructivist and designer who devoted a great deal of effort to propaganda work (**Figure 2–18**). He also developed the rules of typography and design that laid the groundwork for the development of grid systems. Designing a book of Vladimir Mayakovsky's poetry, he wrote, *"My pages relate to poetry in a way similar to a piano accompanying a violin. As thought and sound form a united imagination for the poet, namely poetry, so I have wanted to create a unity equivalent to poetry and typographical elements."* Lissitzky experimented with the photogram and foresaw the importance photography would come to have in graphic design. This innovative thinking and design work spread its vision to other countries. In Germany, Lissitzky and the Bauhaus influenced advertising and packaging design. The contemporary designer Paula Scher uses the strong constructivist approach of Lissitzky's

layouts to create a modern design that deliberately mirrors this movement (**Figure 2–19**).

Closely related to constructivism, *de Stijl* developed in Holland, where artists fled to avoid direct involvement in World War I. It flourished during the 1920s in Europe and strongly influenced the later Bauhaus work. De Stijl was anti-emotion and based on a utopian concept of style. At first glance, it may look similar to the Bauhaus movement described later, but de Stijl was more concerned with formal aesthetic problems than with function. The most widely known painters of the period are Piet Mondrian and Theo van Doesburg (**Figure 2–20**). Their style is the epitome of de Stijl, with straight black lines set at right angles to one another and a careful asymmetrical balancing of primary colors.

The School of Applied Arts and Crafts, founded by Henry van de Velde in 1906, closed at the outbreak of World War I and reopened as the *Bauhaus* at Weimar, Germany, in 1919. Walter Gropius, who worked with Peter Behrens (Figure 2–11) at the Deutsche

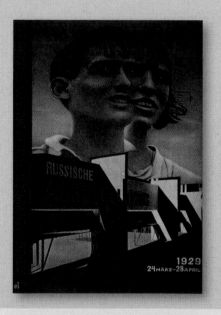

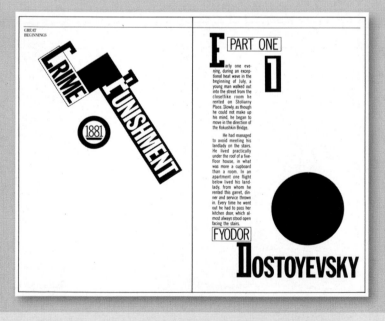

↑
2–18 El Lissitzky. Lissitzky, El (Eleazar) (1890-1941) USSR Russische Ausstellung. 1929. Gravure, 49 x 35¼". Jan Tschichold Collection, Gift of Philip Johnson. (376.1950). Digital Image © The Museum of Modern Art/Licensed by SCALA / Art Resource, NY / © 2010 Artists Rights Society (ARS), New York / VG Bild-Kunst, Bonn

↑
2–19 Paula Scher. *Two-page layout from* Great Beginnings. *1980.* Courtesy of the artist.

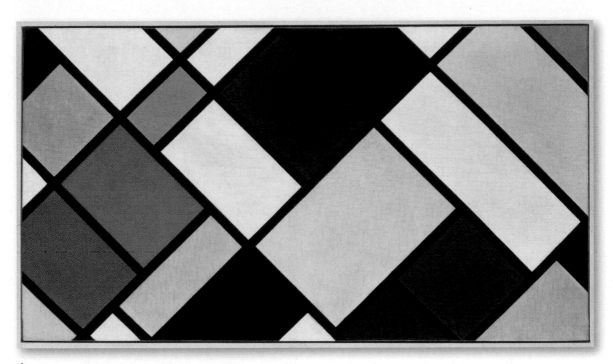

↑
2–20 Theo van Doesburg. Kontra-Komposition mit Dis-
sonanzen XVI. *1925*. Contra-Composition of Dissonances, XVI,
1925, Doesburg, Theo van (1883-1931) / Haags Gemeentemu-
seum, The Hague, Netherlands / The Bridgeman Art Library

Werkbund, became the Bauhaus director. In 1922 the constructivist El Lissitzky met with Theo van Doesburg and László Moholy-Nagy in a congress of constructivists and Dadaists in Germany. Their exchange of ideas formed a core for the Bauhaus after 1923. This German design school shaped 20th-century graphic design, product design, furniture, and architecture.

Expressionism, Dada, constructivism, and de Stijl influenced the Bauhaus in its early years. By the late 1920s, the Bauhaus was emphasizing functional graphic design. The Bauhaus trained artists in all areas. It attempted to bridge the gap between pure and applied art, to place equal importance on all areas of arts and crafts. It stressed clean, functional forms. Its weavers, metalsmiths, and carpenters did not attempt to produce works of art, but rather good and useful designs in which form was tied to function. The industrial designer was born from this movement. Bauhaus publications featured asymmetry, a rectangular grid structure, and sans serif type.

The contributions by artists of the Bauhaus have been vastly important and continue to exert a strong influence in contemporary design. Bauhaus artists who were influential in the development of graphic design include Josef Albers, who is known for his research into color and structural relationships (Figures 8–12). His wife, Anni Albers, was a gifted fiber artist. László Moholy-Nagy developed photography as illustration. He saw the camera as a design tool that could be integrated with typography to create a new and better communication.

Bauhaus artist Herbert Bayer created several typeface designs, including Universal. In keeping with the Bauhaus philosophy, he believed in removing personal values from the printed page, leaving it purely logical and functional in design. Bayer typically avoided using capital letters in printed material and used extreme contrast of weight and size to establish a visual hierarchy. After the Nazis forced the closing of the Bauhaus in 1933, many of its artists immigrated to the United States, where they contributed to the growth of American architecture and graphic design.

New typography is a term that came to identify the new, Bauhaus-inspired approaches to graphic design. Its chief German proponent, Jan Tschichold, designed typefaces that emphasized clarity. Considered one of the most influential typographers of the 20th century, he used white space to create visual intervals in an asymmetrical layout, while an underlying horizontal and vertical structure unified the page.

The Swiss also continued to develop the ideas of the Bauhaus in typography and layout design from the 1950s onward. Work from this period came to be known as *Swiss Design* or the *International Typographic Style*. Major practitioners included Josef Müller-Brockmann (Figure 4–3), Emil Ruder (Figure 7–5), and Armin Hofmann. Their emphasis on visual unity and formal grid elements contributed greatly toward shaping the design field. Personal expression was seen as less important than order and clarity. The predominant graphic design style in the world by the 1970s, it featured a strong reliance on typographic elements, usually sans serif typefaces in a flush left and ragged right format.

FIGURATIVE MOVEMENTS

Art deco appeared as a definite style in Paris around 1925. It was especially influenced by art nouveau and also by African sculpture and cubism. Although it developed at the same time as the Bauhaus, art deco emphasized the figurative image with decorative appeal. It was applied to architecture, clothing, graphic design, advertising, packaging, crafts, and furniture. Artists associated with this movement included the Russian Erté and the Frenchman Georges Lepape, who contributed to *Vogue* magazine. Perhaps the best known and most respected art deco artist, who continues to have a strong influence today, is A. M. Cassandre, a Ukrainian-French artist. His posters and advertisements show the influence of cubism, but the forms retain a recognizable physical identity balanced with an intricate gestalt unity (**Figure 2–21**). It is a very recognizable style. For a time, art deco was out of favor in the eyes of architects and designers because it did not follow the Bauhaus tenets of functional, nonornamental design, but today many influences coexist. Surrealism also surfaced in the 1920s. Now the style is often incorporated into the eclectic mix of contemporary design.

Owing a philosophical debt to Dada for its questioning attitude, *surrealism* was joined by several Dada artists. This literary and artistic movement was based on revealing the unconscious mind in dream images,

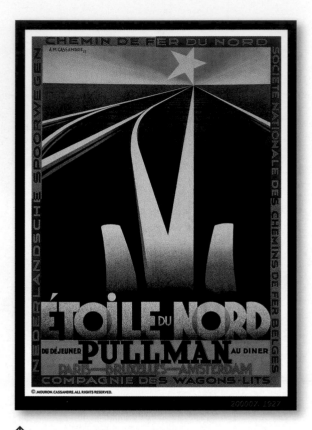

↑
2–21 A. M. Cassandre. © MOURON. CASSANDRE. Lic 2010-29-06-05 www.cassandre-france.com

the irrational, and the fantastic by juxtaposing incongruous subject matter. The writer André Breton was influential in starting this movement, which then found visual expression. The surrealists drew inspiration from Freud's *Interpretation of Dreams*. Like the author James Joyce, who used stream-of-consciousness techniques rather than rational, linear development of characters, surrealists sought to reveal the subconscious.

Surrealism exerted a strong influence on illustration and advertising. René Magritte (**Figure 2–22**) is much imitated today, and in fact he created quite a lot of advertising illustration, working for a time in an agency he created with his brother. Other surrealists, such as Max Ernst and Man Ray, show the influence

↑
2–23 *Contemporary illustrator* **Matt Zumbo** *created this
advertising image inspired by the art of Georges Seurat.
(See Figure 8-14)*

of Dada in their unorthodox and compelling arrangement of elements. Surrealism's search for unconscious motivation and innovative combinations continues to interest today's designer/advertiser. In the 1930s many surrealist artists put found objects in strange combinations that evoked poetic and unconscious associations. **Figure 2–23** by illustrator Matt Zumbo shows the contemporary illustrator's interest in art history. Georges Seurat was a French Post-Impressionist painter. *A Sunday Afternoon on the Island of La Grande Jatte* (1884–1886) is his most famous painting, which this work is based upon.

AMERICAN DESIGN

European *modernism* (whose movements we've just read about) greatly influenced design in the United States. Modernists believed that each new generation must build on past styles in new ways or break with the past in order to make the next major historical contribution. Many samples of modernist American graphics are shown throughout this text. Modern art is associated with innovation and progress. Other new

art forms began to attract the attention of curators and critics in the 1970s, and the demise of modernism is often dated to that decade, although some argue that it continues as a highly functional movement today, especially in the design field.

László Moholy-Nagy came to Chicago in 1937 to direct the New Bauhaus. It closed after one year, and Moholy-Nagy operated his own Institute of Design from 1938 to 1946. This school offered the first complete modern design curriculum in America. The Illinois Institute of Technology is a descendant of the New Bauhaus.

Lester Beall, an American-born Chicago artist, embraced modern design and European influences from cubism, constructivism, and Dada. Working in New York in the 1940s, he combined drawing, symbols, photography, and mixed typefaces into a coherent, eclectic design. Many young American designers of the time drew inspiration from European modern art and design, including Paul Rand. Rand realized that his role as a designer involved reinventing the problem

presented by the client (**Figures 2-24**, 3-22, 10-4, 10-7, and 10-12). He focused on restating the problem, and he drew inspiration from painters such as Klee and Miró. His books on design and his life's work are extremely important contributions to the field.

Through the 1930s and early 1940s, Cipe Pineles learned editorial art direction from one of the masters of the era, Dr. M. F. Agha, at Condé Nast publications. She became (at *Glamour* magazine) the first autonomous female art director of a mass-market American publication. She was the first art director to hire fine artists to illustrate mass-market publications. After achieving national prominence as art director for *Glamour*, British *Vogue*, and *Seventeen*, Pineles became the first female member of the New York Art Directors Club. She was one of the few female designers to gain recognition during this period. Cipe Pineles's career spanned almost 60 years, up to her death in 1991. Designers from this period synthesized the influences of the European avant-garde and design movements to create new designs for magazines, posters, advertisements, and corporate communications. **Figure 2–25** shows Cipe Pineles at work.

By the 1950s, marketing research was an important influence on business decisions. Advertising designers dealt with the proliferation of national television and radio networks, the emergence of large chain stores, and the importance of public perception and corporate identity. The International Design Conference in Aspen was founded in 1951 to assess and discuss the role of design in the commercial environment. The Aspen Design Summit continues to meet, coordinated by the American Institute of Graphic Arts (AIGA) and the International Design Conference in Aspen (IDCA). Design students are encouraged to participate.

The 1950s saw the emergence of design curricula in universities and art schools and the articulation of an important concept. Leo Lionni—then art director for *Fortune* magazine, as well as an author, an illustrator, and a fine artist—stated that "Whatever [the designer's]

activities, they involve, to some, and various, extent, the shaping, interpretation and transmission of values." This issue of values and the role of design in society is an important topic.

Push Pin Studios was founded in 1955 in opposition to the spirit of Swiss Design. The founders were Seymour Chwast, Reynold Ruffins, Ed Sorel, and Milton Glaser. Glaser stated, "We frequently find corruption more interesting than purity" (see Figures 4–7 and 4–9). This studio revived art nouveau, art deco, and narrative illustration, turning to visual history for inspiration. This attitude, with its historical references, heralded postmodernism. The studio's founders continue to contribute to the shape and direction of design in the 21st century.

During the mid-20th century the media theorist Marshall McLuhan noted the influence of television on communication and wrote about the potential for a global village united by a shared vision. McLuhan saw print media as an isolationist influence, giving rise to categorization, linear sequencing, and dogmatism. Television, according to McLuhan, has the potential to reunite society into a new global village. It certainly exerts a major influence on advertising and communication and, thus, on society. McLuhan's writings remain thought-provoking today as media continue to evolve, influence, and restructure our society. See his Gallery Profile in Chapter 11.

Magazine design was a creative area in the 1960s. In 1964 Ruth Ansel and Bea Feitler took charge of *Harper's Bazaar* as co–art directors. Drawing inspiration from pop art and underground images, *Harper's Bazaar* represented the glamour and glitter of the 1960s.

Herb Lubalin, a major figure in the field, was art director for the countercultural magazines *Avant Garde*, *Fact*, and *Eros* (**Figures 2–26**, 5–13, 5–17, and 5–29). Alternative publications with political and cultural commentary flourished during the 1960s but were often short lived because of various lawsuits.

→↑
2–24 Paul Rand. IBM. *1982. Offset lithograph, printed in color, 36 x 24" (91.4 x 61 cm).* The Museum of Modern Art/ Licensed by SCALA / Art Resource, NY

→→
2–25 Cipe Pineles *at Condé Nast, late 1930s or early 1940s.* Copyright AIGA.

→↓
2–26 Herb Lubalin. *Logo for* Eros *magazine. A magazine with a graphically beautiful approach to love and sex; only four issues were published.* Courtesy of the Herb Lubalin Study Center of Design and Typography at the Cooper Union

STREAMS OF MODERNISM

September 25, 2009, through January 3, 2010

←↑
2–27 April Greiman. *Art director–designer*. Design Quarterly #133. Does It Make Sense? *Publication insert, Walker Art Center, 1986. MIT Press Publisher*. Courtesy of the artist.

←↙
2–28 Katherine McCoy. *Streams of Modernism Exhibition Brochure Cover. Date: 2009. Client: Kirkland Museum of Fine & Decorative Art, Denver, Colorado*

←↘
2–29 Tadanori Yokoo. Japanese Society for the Rights of Authors, Composers, and Publishers. *1988. Silkscreen, printed in color, 40½ x 28⅝" (102.8 x 72.5 cm)*. The Museum of Modern Art, New York. Gift of the artist. Photograph 2001, the Museum of Modern Art, New York / Art Resource, NY

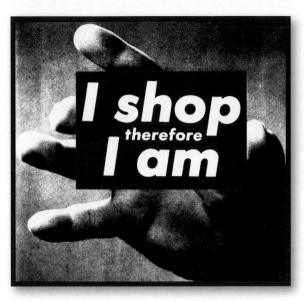

↑
2–30 Barbara Kruger. BARBARA KRUGER "Untitled" (I shop therefore I am). 111" by 113" (282 cm by 287 cm) photographic silkscreen/vinyl 1987 COPYRIGHT: BARBARA KRUGER. COURTESY: MARY BOONE GALLERY, NEW YORK. (MBG#4057)

Postmodernism

In the 1970s the term *postmodernism* was first applied to architecture. A questioning of rational Swiss Design led to New Wave, postmodern graphic design. This period is said to question the modernist concept of constant innovation and progress. Contradictory and coexistent trends from a variety of historical periods provide rich concepts for study in postmodernism. April Greiman's early work is an example of New Wave design, mixing formal experiments with popular and personal imagery (**Figure 2–27**). The remainder of the 20th century saw history as a shopping mall of styles. Art deco and art nouveau were among the styles that were revived and revised, as decorative and figurative work regained respect.

Women had an important impact on design from this time forward. Designer and educator Katherine McCoy joined in questioning the modernist ideal of a permanent, universally valid aesthetic. She encouraged the production of visually rich and complex designs, believing that there is more to design than the clear, impartial transmission of information. McCoy believes designers interpret and communicate cultural values through the forms they create. (See **Figure 2–28**.)

Technology became an increasingly important issue during the postmodern period. Muriel Cooper and others at the Massachusetts Institute of Technology

(MIT) developed the Visible Language Workshop—a multidisciplinary, multimedia program that brings together artists, designers, computer scientists, sociologists, and others to study communication in the electronic age. Electronic media have been used to explore and invent eclectic, personal art and design work. **Figure 2–29** is a fine example of the visual complexity of Japanese postmodernism. This design combines visual motifs from a variety of cultures and periods, including Édouard Manet's painting *The Fifer* and Michelangelo's Medici tombs.

Form and Substance

During the 1980s the question of style over substance became an important issue. Theorists such as Stuart Ewen questioned the role and impact of advertising design on society. He wrote (and continues to write) books on advertising and morality. Fine artist Barbara Kruger worked for a time as a layout artist and used that skill to develop an "advertising campaign" that is anti-advertising. Her mock ads and billboards used typographical devices and images to expose the persuasion-consumption cycle of commercial advertising (**Figure 2–30**).

DIGITAL FOCUS
Postmoderrn Medium

The computer made possible the visual and conceptual layering that is the hallmark of postmodernism in graphic design. By the late 1980s, type could be overlapped to create a rich visual texture and be intertwined with the photographic image. Thanks to the computer, by the last decade of the 20th century typography could be used to explore multiple meanings rather than strictly to clarify a fixed message. The Internet is a very postmodern medium, with its interactive, nonlinear flow. The impact of ever-developing computer technology influences our style and our content. Ideas change technology, and technology influences ideas.

An interest in the intellectual and historical foundations of design led to the 1983 publication of Philip Meggs's *History of Graphic Design*. This comprehensive and thoughtful text provides a foundation for many contemporary design history classes.

NEW TECHNOLOGIES

New technologies always influence the course of graphic design. We can trace our history and development from medieval manuscripts to Gutenberg's printing press to hot type to cold type to computer-generated type and images. Later chapters discuss the stages in this development in greater detail. In the opening years of the 21st century, the use of electronic technology has revolutionized design and communications. Style and content are affected by the technology used in their creation. This chapter's brief history of design has shown the relationship between design and technology, citing the invention of the printing press and of stone lithography as examples of earlier technologies that affected design and societal patterns of communication. The mid-20th century's emphasis on clarity and structural integrity has been replaced by an interest in rich textural layers of information, as graphics are now generated with software programs that encourage stylistic complexity.

The Development of Computer Graphics

Computer graphics, the use of computers to draw images, dates back to 1953, when a simple visual display of a bouncing ball was used to calculate and show military targets. Funding for the development of computers and computer graphics in the United States originally came from the Defense Department. In 1962 at MIT, Ivan Sutherland created the first interactive computer graphics display. A light pen touched to the video screen could draw a line stretched from the previous point. Although its early development was tied to defense and aerospace, computer graphics now has a wide variety of applications, such as engineering, medicine, geology, graphic design, animation, the film industry, and the Internet. Professor Charles Csuri was a pioneer in early computer graphics and animation. In 1967 he produced more than 14,000 still frames, which exploded a line drawing of a bird and reconstructed it. The Museum of Modern Art purchased the film for its permanent collection as representative of the first computer-animated artworks. Read more about the history of computer graphics in Chapter 11.

Interactivity

Text, photography, animation, illustration, sound, and video can now be combined and linked by using a variety of desktop programs. Unlike books, film, or video that present linear information, the new electronic media can be truly interactive and present nonlinear, animated browsing opportunities.

The Internet offers not only *interactivity* but also freedom from the physical constraints of traditional media. CD-ROM storage and DVDs offer interactivity, but only the Internet travels through time and space with few physical barriers. This medium is transforming the nature of communication as well as physical and political boundaries. Web sites carry an enormous amount of information as shown in **Figure 2-31**.

THE FUTURE

During the 20th century we have progressed along a visual escalation from photography to film to video to computers to the Internet. Computer graphics has come a long way since the original moving-ball display in the 1950s. The digital desktop has come a long way since the Macintosh was introduced in the mid-1980s. The Internet has become a vehicle for marketing products and disseminating information of all kinds. Web site production is an important market for graphic designers as the complexity of these sites

2–31 April Greiman's *promotional site for her Miracle Manor Retreat can be accessed at http://miraclemanor .com. Four pages are shown here.*

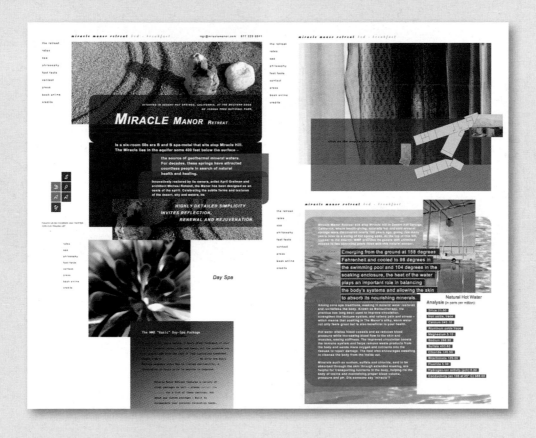

↑
2–32 *Graphic Havoc avisualagency, studio. Video projection for a concert tour by Wamdue Project.* Graphic Havoc avisualagency. ©

rapidly increases. Our ability to communicate with interactive visuals and to create presentation video and 3-D animation is also a developing market for graphic designers (**Figure 2–32**).

Virtual reality is another developing technology. It extends the senses, allowing a person to move through and interact with a computer-simulated environment by wearing special glasses and clothing or other sensors. These monitor physical movements and gestures in the alternate, virtual world. Psychologist R. L. Gregory stated in his book *Eye and Brain*, "The seeing of objects involves many sources of information beyond those meeting the eye when we look at an object. It involves knowledge of objects from previous experience and not only sight but touch, taste, smell, hearing, and perhaps also temperature or pain." What will the impact of virtual reality be on design and communication?

In the early years of the 21st century, it is interesting to remember the important developments at the turn of the last century. The future will be exciting and challenging for designers intent on maintaining an emphasis on issues of values and content while learning and using a proliferation of new media.

PROJECT

In consultation with your instructor, research a contemporary designer mentioned in this chapter. Prepare a paper and classroom presentation based on your research. Describe the designer's work, philosophy, and background. Gather and present visual materials on computer, and consider bringing library books to pass around. Schedule this presentation to the class. The accompanying Web site can be helpful as an Internet data source.

GOALS AND OBJECTIVES

By researching design history and its individuals and movements, you will learn about and gain appreciation for the artist or period you choose. You will also gain skills in research, which are a vital part of this field. The goal is to enrich the knowledge of everyone in the class with each presentation.

CRITIQUE

Did you support your talk with images?

Did you cover the artist's biography as well as discuss his or her style?

Did you explain why you are drawn to this artist or period?

Ask for comments and questions from the audience. The more discussion you get, the better your presentation is likely to be.

Visit the accompanying Web site for research links and software downloads.

PERCEPTION

→

TERMINOLOGY

(See glossary for definitions.)

gestalt
visual perception
semiotics
icon
symbol
index
figure/ground
stable
reversible
ambiguous
shape
typography
volume
realism
stylization
abstraction
nonobjective
counter
serif
sans serif
ascender
descender
type size
x-height
typeface
font
baseline
stress

KEY POINTS

A successful visual whole, or *gestalt*, is achieved by the careful combination of parts. A graphic designer works with shapes in both word and image, so this chapter stresses creating and perceiving shapes in typography and imagery. Figure/ground is also discussed, because it is a vital part of understanding and working with shape. If we are aware of how the eye and brain organize marks on a surface to give them meaning, we will be much more successful in creating designs that do what we intend. **Figure 3-1** is an example of figure/ground relationships in crochet work.

SEEING AND BELIEVING

Graphic designers do more than decorate a surface. They work with the fundamental principles of *visual perception*. When we look at a printed page, whether it is covered with type, illustrations, or a photograph, there is more than meets the eye. The brain is sifting and cataloging the visuals. We carry a load of experiences, innate responses, and physiological considerations that interact with the designs we see, whether they are in print, Web, or other venues. Designs that effectively use that process of visual perception have the creative strength of sight itself on their side.

As soon as the first mark is made on a blank sheet of paper, it is interpreted by the eye. We cannot see only a flat mark on a flat piece of paper. Our past experience, our expectations, and the structure of the brain itself filter the information. The visual illusions created through this process are a real part of perception. *Realism in art and design is not an absolute but a convention that our culture and personal background create from visual data.*

Search for Simplicity

Gestalt psychologists investigated the way humans process information from a two-dimensional surface. There is an interplay of tensions between shapes on a flat surface because the appearance of any one element or shape depends on its surroundings. Any mark drawn on paper stimulates an active, interpretive response from eye and brain. We finish uncompleted shapes, group similar shapes, and see foreground and background on a flat surface. The experiments of Gestalt psychologists led them to describe a basic law of visual perception: Any stimulus pattern tends to be seen as a structure as simple as conditions permit. This law is similar to the principle of parsimony known to scientists, which states that when several hypotheses fit the facts, the simplest one

3–1 *Figure/ground relationships have been an important element of design in many different cultures over the centuries.*

should be accepted. The eye and brain choose an interpretation.

In science, elegance and success result from explaining a phenomenon with the minimum number of steps. A similar elegance can be achieved on the printed page. A great deal may be happening on a page although few marks exist. In fact, adding more marks without understanding their effect can often make less happen. That is poor design.

In this and following chapters, we discuss the manner in which Gestalt psychologists believe our brain interprets and groups the images on a flat surface. Gestalt theory is generally recognized as a useful tool for designing visual images so they will be comprehended as we intend. No single theory, however, explains all there is to visual perception. Much has yet to be discovered.

Interpretations

The lines in **Figure 3–2** demonstrate our busy interaction with simple marks drawn on a page. The resulting interpretations are influenced by the culture in which we live. We accept the black mark in Figure 3–2a as nearer than the field it occupies, although they both exist on the same physical plane on the surface of the page. Adding a second mark of a larger size (Figure 3–2b) requires another interpretation involving depth. The larger mark can seem closer in space than the smaller one. A line placed vertically that divides the space (Figure 3–2c) enhances the two-dimensional quality. Use an angled line (Figure 3–2d), and a sense of space begins to develop. Add another angled line (Figure 3–2e), and suddenly the eye may see the perspective of a road or railroad tracks running at an angle into the distance. The addition of changes in size and value enrich our possible interpretations.

Visual perception, and thus communication, is always colored by interpretation. Context, personal experi-

ence, and culturally inculcated systems of signs and symbols play a strong role in perception. Later chapters discuss this phenomenon from varying perspectives. *Semiotics* is the study of influences on our perception. It goes beyond linguistics to incorporate the visual language of sign and symbol (**Figure 3–3**). The field of semiotics often breaks down visuals into the categories of icon, symbol, and index. An *icon* looks like the thing it represents. A road sign with an image of a deer is an icon. A road sign with a circle and slash, meaning "forbidden," is an example of a *symbol*, which has a culturally accepted meaning. Words are also considered symbols of the thing they reference. An *index* is a visual we have learned to associate with a particular meaning. For example, a thermometer is an index of temperature. A footprint can indicate a deer. A nest can suggest a bird. The study of semiotics crosses between the field of linguistics and the field of visual language. Working to apply the concepts of icon, symbol, and index to thumbnail designs can enrich the range and depth of your solutions.

FIGURE/GROUND

If we are aware of how the eye and brain organize marks on a flat surface to give them meaning, we will be much more successful in creating designs that do what we intend. The most fundamental organizational principle of sight for an artist working on a flat, two-dimensional surface is *figure/ground*. It is sometimes called *positive/negative space*. An ability to see and structure both figure and ground is crucial to the designer. You must learn to create and evaluate effective figure/ground relationships. Whenever we look at a mark on a page, we see it as an object distinct from its background. This distinction is the fundamental first step in perception. A thing (figure) is visible only to the extent that it is seen as separate from its background (ground). This theory applies to every area of perception. A tree, for example, can be seen only in relation

3–2a 3–2b 3–2c 3–2d 3–2e

↑

3–3 *How many different ways can you express the idea of "bird"? This is a good mental exercise to stretch your conceptual muscles.*

↑ ↗

3–4 David McLimans. *Freelance illustrator, Madison, WI. An intricate play of figure/ground and repetition of shape makes up this beautifully designed illustration.*
Courtesy of the artist. Collection of the author.

↑ ↘

3–5 *Bugs! logo created for a campaign for the Minnesota Zoo by Rapp Collins Communications. Designer* **Bruce Edwards** *has won numerous national awards for this design, including awards from Print, Communication Arts, and Adobe Design.*

to the space around it, the "not-treeness." We can look at the shapes and lines of a photograph and recognize a picture because of figure/ground grouping. **Figure 3–4** shows a contemporary illustration with a dynamic figure/ground relationship that encourages varied readings. Is the white figure in profile, or do the white and black combine into a single figure? This design is

both abstract and figurative. The repeated oval shapes in mouth and notes make a symbolic visual tie between mouth and music.

Figure 3–5 makes playful and effective use of reversible figure/ground grouping. We can recognize and read the words because we organize the letters into a white

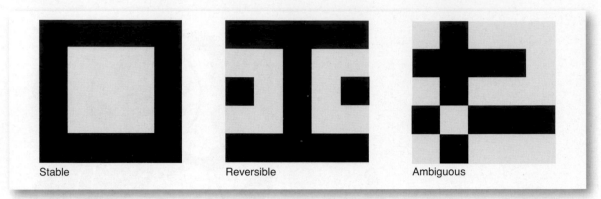

Stable Reversible Ambiguous

↑
3–6 *Stable, reversible, and ambiguous types of figure/ ground are shown here.*

figure lying against a black ground. We can change our focus from the insects to the white space and back again. At its best, design becomes inseparable from communication. Form becomes content.

Categories

Every figure appears to lie at some location in front of the ground. A successful design depends on handling both areas. Many beginning artists concentrate only on the mark they make and are not aware of the white space surrounding it. It is vital to remember that the space, or ground, is as integral a part of the page as the figure placed on it. The three main categories in figure/ ground shaping are *stable*, *reversible*, and *ambiguous*. Some designs incorporate more than one kind of figure/ground relationship (**Figure 3–6**).

Stable Figure/Ground

Each two-dimensional mark or shape is perceived in an unchanging, stable relationship of object against background. The illustrator Aubrey Beardsley played deliberately with the tension of a stable figure/ground relationship on the verge of breaking down (see Figure 2–6). The poster shown in **Figure 3–7** by Emile Preetorius also has a great deal of compelling figure/ground tension as the shadows carve out white space. Logo designs make creative use of a variety of figure/ground relationships, as discussed in Chapter 5. **Figure 3–8** is a logo created by a young designer for his student portfolio that makes good use of figure/ground relationships. As this student did, consider building a portfolio by donating your design skills to a local not-for-profit organization.

Reversible Figure/Ground

Figure and ground can be focused on equally when positive and negative elements attract our attention equally. What was initially background becomes foreground. Because we cannot simultaneously perceive both images as figure, we keep switching between them. This is perhaps the most enjoyable type of figure/ ground to explore. There are many examples in this chapter to enjoy and examine, including Figure 3-29b.

Ambiguous Figure/Ground

In some puzzle pictures, one figure may turn out to be made up of another figure, or of several different figures (**Figure 3–9**). The designs in the exercise at the end of this chapter are good examples of a whole design that is made up of many individual, repeated

→↑
3–7 Emile Preetorius. Licht und Schatten (Light and Shadow). *1910. Lithograph, printed in color, 11¾ x 8¾" (29.8 x 22.2 cm). The Museum of Modern Art, New York. Gift of The Lauder Foundation, Leonard and Evelyn Lauder Fund.* Photograph copyright 1998, The Museum of Modern Art, New York / Art Resource, New York.

→→
3–8 *Humane Society logo designed by* **Andy Hoffman** *for his student portfolio.* Courtesy of the artist.

→↓
3–9 *Japanese symbolic picture. Nineteenth century. An example of ambiguous figure/ground.*

↑
3–10a
3–10b

shapes. In Figure 5–1, the animals created to make playful alphabet letters also form an ambiguous figure/ground. The gestalt notion that the whole is more than the mere sum of its parts is clearly illustrated by these examples.

Conditions

Once mastered, figure/ground grouping is an invaluable tool in all areas of graphic design, including logo design, layout, screen graphics, and illustration. It is richly complex and deserves study. Here are some conditions under which one area appears as figure and another as ground. Use these principles when completing the first exercise at the end of this chapter.

↑
3–11a 3–11c
3–11b 3–11d

■ The enclosed or surrounded area tends to be seen as figure; the surrounding, unbounded area as ground (**Figure 3–10a**).

■ Visual texture makes for figure perception. The eye will be drawn to a textured area before it is drawn to a nontextured area (**Figure 3–10b**).

■ Convex shapes are more easily seen as figure than concave (**Figure 3–11a**).

■ Simplicity (especially symmetry) predisposes an area to be seen as figure (**Figure 3–11b**).

■ Familiarity causes a shape to pull out from its surroundings. As we focus on it, it becomes figure while the surroundings become ground (**Figure 3–11c**).

■ The lower half of a horizontally divided area reads as the solid figure to which gravity anchors us (**Figure 3–11d**).

■ Black tends to be viewed as the predominant figure more readily than does white.

Several conditions affect figure/ground perception in the time honored diagram in **Figure 3–12** and the artwork in **Figure 3–13**. Can you identify them?

←
3–12 *This diagram of Rubin's vase is commonly used to show a reversible figure/ground relationship.*

3–13a *Illustrator* **David McLimans** *created this number 9 to resemble a Mediterranean Monk Seal as part of his* Gone Fishing *children's book.*

3–13b and c *Designer* **Tim Girvin** *created an entire playfully shaped alphabet that was used on book jackets, an annual report, and a promotional A–Z poster. Visit his site at www.girvin .com.*

Letterforms

How does this figure/ground phenomenon affect letterforms, the basic ingredient of the printed page? Stop now and study Exercise 1 at the end of this chapter. As you do the exercise, you will realize that figure/ground affects letterforms the same as any mark or image on the page. Using type effectively depends on seeing both the shapes of the letters and the shapes between, within, and around them. Pay close attention to the shape of the ground areas shown at the bottom, called counters (**Figure 3–14**). This has direct application in logo and layout design (Chapters 5 and 7).

Because we tend to read for verbal information and not for visual information, nondesigners are rarely aware of the appearance of type itself. They read it but do not "see" it. To work effectively with typography, one must recognize it as design.

For the first several chapters, we will be concerned with type as a pure design element while learning to identify it and learn its language. To begin with, only display, or headline-size, letterforms are used. Look closely at the letter *a* shown in five typestyles in Figure 3–24 and study all the parts of their structure, paying close attention to the different counter shapes. Renaissance artist Albrecht Dürer constructed his own typestyle. His structural diagrams demonstrate the careful shaping and measurements necessary when hand-constructing letterforms (**Figure 3–15**). Computer software has simplified the creation of new typestyles, but a discerning eye is still the most important ingredient—that and a love and respect for type design.

↑
3–14 *The shape of letterform counters can be seen easily when figure/ground is reversed.*

↑
3–15 Albrecht Durer. *From* On the Just Shaping of Letters. *1525.*

SHAPE

Design is the arrangement of shapes. They underlie every drawing, painting, photograph, and graphic design. It is easy to become enamored with the subject matter of a design and forget about basic shapes. A designer must develop the ability to see and think in terms of shapes even though those shapes look like dots or apples or oranges or letterforms (**Figure 3–16**). Shape occurs in both figure and ground, in both type and image, and in both abstraction and realism.

Shape versus Volume

A *shape* is an area created by an enclosing boundary that defines the outer edges. The boundary can be a line, a color, or a value change. Shape describes a two-dimensional artwork; *volume* describes a three-dimensional work, such as a ceramic pot, a sculpture, or a piece of furniture. A rectangle and a circle are 2-D shapes, whereas a box and a sphere are 3-D volumes (**Figure 3–17**). Just as a 2-D surface can give the illusion of volume, as shown in the "box" camera, a 3-D sculpture can use 2-D shapes to enrich its surface design. **Figure 3–18** shows a richly textured theme of repeated rectangles in the surface treatment and basic structure of a contemporary teapot design.

Grouping Shapes

Every shape is affected by surrounding shapes. The normal sense of sight grasps shape immediately by identifying an overall pattern. Grouping letters into words makes it possible to recall the letters more accurately than when they are presented alone. If it is possible to also group marks into a recognizable or

↑
3–16 *Look for similarity of shape in type and image.*

↑ ↗
3–17 *This rectangle can be made to resemble a camera, but it is still made up of only two-dimensional shapes.*

↑ ↘
3–18 Linda Threadgill. 2000. Teapot, *sterling silver*. Photo credit: James Threadgill. Courtesy of the artist.

repeating shape, the eye will do so, because it is the simplest way to perceive and remember the marks. The letters in *word* are easier to remember than *o*, *d*, *w*, and *r*. A well-designed logo or illustration or Web page with repeating shapes also makes the design easier to recognize and remember.

For the graphic designer, the shape of a circle may represent the letterform *O*, a diagram of a courtyard, a drawing of a wheel, or a photograph of a French horn. **Figure 3–19** shows how beautiful a circular shape can be. These objects are not linked by subject matter to any common theme. They are linked by shape. Repetition of basic shape can bring unity to a group of seemingly disparate objects. The designer works with so many different objects that to be blind to their shapes would result in utter chaos on the page. *Repeating similar shapes in different objects is an excellent way to bring visual unity to a design.*

The Form of Shapes

An artist may choose to represent an object or a person realistically, by an image similar to an unaltered photograph. Actually, reality is a little more difficult to define than that, and philosophers have been working on it for centuries. We know that visual reality is created in part by the viewer's interaction with what meets the eye. In later chapters we'll discuss other factors that contribute to our visual perception.

An artist/designer may also represent an object in a purposeful distortion or *stylization* that can emphasize an emotional quality, as in **Figure 3–20**, a beautiful example of shape finding from 18th-century Japan. This woodcut illustration, which emphasizes shapes, looks as if it could be created in a contemporary vector graphics computer program with a lot of points on a curve. The history of art and design offers many such inspirations for computer solutions.

↑
3–19 *Beautiful shapes can be found in many objects. The circle is integral to the structure of this French horn.*

↑
3–20 Utagawa Kunimasa. *Japanese, 1773–1810. Bust Portrayal of Nakamura Nakazo II as Matsuomaru, 1796. Color woodcut (right panel of a triptych), 15⅛ x 10¼" (38.5 x 26 cm). Achenbach Foundation for Graphic Arts purchase, 1970.* Fine Arts Museums of San Francisco, Museum Purchase, Achenbach Foundation for Graphic Arts Endowment Fund, 1970.25.52.

→
3–21 Ikko Tanaka. Nihon Buyo. *1981. Offset lithograph. 40½ x 28¾" (102.2 x 73 cm).* The Museum of Modern Art, New York. Gift of the College of Fine Arts, UCLA. Photograph copyright 2001 The Museum of Modern Art, New York / Art Resource, New York.

Abstraction is another approach to illustration and design. It implies a simplification of existing shapes. Details are ignored, but the subject is often still recognizable. Often the pure design shapes of the subject are emphasized, as in **Figure 3–21**, a Japanese portrait created in the late 20th century that uses squares. How many can you find?

Purely *nonobjective* shapes are abstractions that have no recognizable realistic shapes. The constructivists worked with nonobjective shapes to give structure and character to their designs. Nonobjective shapes are the basis of the invisible, underlying grid structure of layout design.

Letterform Shapes

The ability to see and use shapes is especially important with letterforms. True, they are symbols of something, but first and foremost they are pure shape, a fundamental design element. Successful layout and logo design depend on creating unity through the play of similarity and variety of letterform shapes.

DIGITAL FOCUS
Vector and Raster Graphics

There are two kinds of image files in computer graphics: vector graphics and raster graphics. Vector graphics are like a cross-stitch embroidery pattern in which the yarn stays as separate interwoven strands. Raster graphics, on the other hand, are like a woven fabric in which the color pattern is dyed into the cloth. The vector "strands" can be separated and moved independently, but raster "fabric" cannot.

Vector graphics involve creating shapes that are clean edged and defined as geometric objects. Each vector object, whether a shape or a drawn line, can be easily selected and edited, repositioned, and transformed. Vector graphics are resolution independent, which means that they retain crisp edges when enlarged. This is a powerful concept. However large or small you transform a vector file, it remains perfectly sharp. Typography, logo design, and some forms of illustration are created in vector programs such as Illustrator, and in page layout programs such as InDesign. Raster programs such as Photoshop are excellent for image manipulation and can best be used for typography that will not need to be resized.

↑
3–22 Paul Rand. *Trademark, the American Broadcasting Corporation, 1962*. Courtesy of Mrs. Marion Rand.

The distinction is often made between geometric shapes and curvilinear, organic shapes. **Figure 3–22** shows the logo for ABC designed by Paul Rand, who skillfully repeated basic geometric shapes.

Typestyles often have different expressive qualities depending on their shapes. Those with hard, straight edges and angular corners have a colder, more reserved feeling than typestyles with graceful curves, which have a relaxed, sensual feeling. To become sensitive to the shapes in a letterform, look carefully at its anatomy (**Figure 3–23**). Then learn how these vary between typestyles. Chapter 6 discusses the history and classification of typestyles. Right now, however, concentrate on making comparisons between a few classics (**Figure 3–24**).

Terminology
The following list of terms and definitions will help you know what to look for when comparing shapes in letterforms. Again, reference Figure 3–23.

COUNTER
Counters are the white shapes inside a letter. Duplicating a letterform accurately calls for close attention to both the white and the black shapes (the ground and the figure). When drawing a letterform or designing with one, think of yourself as creating the white shapes.

SERIF
A *serif* is a short line that projects off the main stroke of a letter at the bottom or the top. Letters without serifs are called *sans serif*.

→ ↑
3–23 *Parts of a letterform.*
→ →
3–24 *These five varied but highly legible typestyles are, from top to bottom, Garamond, Baskerville, Bodoni, Helvetica, and Lubalin Graph.*

abcdefghijklmn

abcdefghijklmnop

abcdefghijklmnopq

abcdefghijklmnop

abcdeefghijkl

ASCENDER

An *ascender* is the part of a lowercase letter that rises above the body of the letter. The letter *e* has no ascender, but the letter *t* does. See **Figure 3–25a**.

DESCENDER

A *descender* is the part of a lowercase letter that falls below the body of the letter. The letters *a*, *b*, *c*, *d*, and *e* have no descenders, but the letter *g* does.

TYPE SIZE

Type size is measured by points For example, 72-point type is 1 inch high, as measured from the top of the ascender to the bottom of the descender. See Figure 3–25a.

X-HEIGHT

The *x-height* is the height of the body of a lowercase letter such as *x* or *a*. It does not include the ascender or descender. The x-height varies in typefaces even though the point size is identical. This variation is why different typestyles of the same point size may appear larger or smaller. Thus 10-point Garamond has a small x-height and long ascenders and descenders; 10-point Univers has a larger x-height and smaller ascenders and descenders. See **Figure 3–25b.**

The Swiss designer Adrian Frutiger developed Univers in 1954. It was the first typestyle available in many font style variations with a consistent x-height throughout.

TYPEFACE

A *typeface* is a style of lettering. Most typefaces vary a great deal, as you can see when you develop an eye for the differences. Each family of typefaces may contain variations such as italic and bold in addition to regular, or roman.

FONT

A *font* is a specific size and variation on a typeface. (For example, Baskerville Bold is a different font from Baskerville Italic, and 12-point Baskerville Italic is a different font from 24-point Baskerville Italic.) Currently, however, the terms *font* and *typeface* are often used interchangeably.

BASELINE

The line that typography sits on is called a *baseline*.

STRESS

Stress is the distribution of weight through the thinnest part of a letterform. It can be seen easily by drawing a line through the thinnest part of an *o* and observing the slant of the line (**Figure 3–26**).

Using this terminology, choose three typestyles to analyze and ask yourself the following questions:

How much variation is there between thick and thin strokes?

Which style has a short x-height? Which style has a tall x-height?

Which has the longest ascenders and descenders?

What are the differences in the serifs? Which type has the most vertical stress?

What are the similarities among letters that belong to one style?

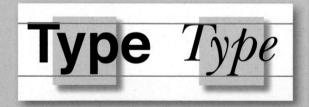

↑
3–25a *Ascenders and descenders determine type size. These are both 72 pt.*

↑
3–25b *The Univers typestyle has a consistent x-height in all its family of font variations.*

↑
3–26 *Stress varies greatly between typestyles.*

EXERCISES

These exercises are carefully crafted to allow the student to express the basic content of this chapter by creating designs that emphasize figure ground and shape relationships.

These exercises can also be used to gradually introduce skills in vector graphics, such as reversals, cut and paste, rotation, and grid placement. Noncomputer classes can do well learning these concepts with pencil, pen, and graph paper.

1. *Place a letterform inside a rectangular format, using a Helvetica typestyle. Place the letter and its values so the letter (uppercase or lowercase) becomes ground instead of figure. Familiarity with the shape can make this exercise difficult* (**Figure 3–27**).

↑
3–27 *Reverse, crop, and place the letter* H *to make it read as background.*

2. *Group several copies of an arrow to form an interesting symmetrical pattern. Emphasize the creation of shapes in figure and in ground* (**Figures 3–28a, b**).

↑
3–28a Eric Wuebben **3–28b** Melissa **Wirth**

3. *Choose one of the typestyles shown in this chapter. Repeat a letterform in a symmetrical pattern, as shown in* **Figure 3–29**. *What do you see as figure? Why? Can you change the figure into ground? Critique these exercises before or along with the final project.*

↑
3–29 Lindsay Riesop's *symmetrical letterform design.*

PROJECT
Figure/Ground and Letterforms

Applying figure/ground to letterform shapes is the best way to really see typography. Choose two letterforms from the type styles shown in this chapter. If they are your initials, you may choose to use your design for a business card and letterhead later. Create a design that uses one letter as the figure and another as the ground. This relationship can be stable, reversible, or ambiguous. Remember the importance of thumbnails, exploring a minimum of 15 possibilities.

Fit your design within an 8 x 10" (20 x 25-cm) format. Keep your letters "true to form" and "letter perfect." Do not stretch, warp, or skew the original shapes; resizing is fine. Use solid black or white shapes. You can (1) extend the edge of a shape, (2) overlap a form, or (3) hide an edge by placing a black letter against a black background or white against white. Bring out the beauty, variety, and personality of those shapes. **Figures 3–30 a, b, c** *are student designs based on this project.* **Figure 3–31** *shows a page of thumbnails based on this assignment.*

↑
3–30a Christy Niewolny **3–30b Erin Bartelson** **3–30c Eric Wuebben**

←
3–31 Eric Wuebben's
thumbnail explorations.

GOALS AND OBJECTIVES

Learn to see the shapes in typography and begin to recognize fonts.

Use thumbnails to explore and evaluate alternative solutions.

Experiment with creating figure/ground relationships.

Learn to manipulate tools and software.

CRITIQUE

Begin by looking as a class at the results of the exercises. What forms of figure/ground do you see? Which are the most successful and interesting examples of reversible and of ambiguous figure/ground? Identify the typestyle used in your two favorites. How does the anatomy of this typestyle contribute to the look of the final piece? Where do you see repetition of shape? Which is the best example of gestalt, where the whole is more than the sum of the parts? Spend some time looking,

learning, and talking about these exercises, with everyone participating. You won't agree about everything. That can make for a good discussion. The instructor will make comments, identifying which designs he or she thinks are most successful and explaining why.

When finished with the final project, you are ready for the next part of the critique. Present your solution to the class orally, along with your thumbnails. Tell which typestyle you've chosen and why. Explain why you chose this design from your thumbnails. Discuss your use of symmetry or asymmetry and repetition of shape. What is the figure/ground relationship in your design? How do you think the design might be improved? Ask the class for comments on how to improve it. Hopefully, the instructor will let you make changes based on the class critique. That way, critical comments can be used constructively. Again, ask the instructor to make some final comments about what works and why. Consider voting on the best three solutions.

Visit the accompanying Web site for research links and project examples. Studio techniques show beginning vector layers, reversals, rotations, cut, and paste.

4 TOWARD A DYNAMIC BALANCE

→

TERMINOLOGY
(See glossary for definitions.)

intellectual unity
visual unity
kinesthetic projection
symmetry
asymmetry
radial symmetry
visual weight
visual direction
visual texture

KEY POINTS

The elements on a page are a combination of type and image, of photography and illustration. Understanding how to make these diverse elements work together calls for a knowledge of the visual language of balance (**Figure 4–1**). This chapter examines how type and image are placed in a composition intentionally to direct the eye and achieve visual unity. The final assignments are type based, to emphasize that placement and command of the visual language of typography is crucial in page layout.

VISUAL AND INTELLECTUAL UNITY

Two kinds of unified communication occur in graphic design. *Intellectual unity* is idea generated and word dominated. The mind, not the eye, makes the grouping. *Visual unity*, in contrast, is created by placement of design elements perceptible to the eye. In the most successful designs, these reinforce one another.

The poster in **Figure 4–2** by the famous early 20th-century designer A. M. Cassandre is unified both intellectually and visually. It is a poster for an optician, so it is intellectually unified by the slogan, the emphasis on the eyeglasses, and the bright, clear area of vision through which the eyes peer at us. It is visually unified through a complex series of events as the small type frames the subject's eyes and leads our eyes down and into the *O* of *Leroy*. The size of this small type echoes the size of the serifs on the larger name. The verticality of the typography in *Leroy* is echoed by the bright rectangle surrounding the face.

4–2 A. M. Cassandre.
Poster for an optician.
© MOURON. CASSANDRE.
Lic 2010-04-08-01 www
.cassandre-france.com

Imagine that a designer and a writer are hanging a gallery show of a photojournalist's work. The designer is hanging photographs together that have similar value and shapes. The writer is following behind, rehanging the photos together according to subject matter: a picture of a burning building next to one of firefighters. One is *thinking* of subject matter (intellectual unity); the other is *looking* at design (visual unity).

4–1 Herbert Bayer. *Cover for* Bauhaus Magazine. *1928.*
A beautiful example of how type and image can be placed to direct the eye and achieve visual unity. Cover for Bauhaus Magazine. 1928 VG Bild-Kunst, Bonn. © 2010 Artists Rights Society (ARS), New York / VG Bild-Kunst, Bonn

As a design student, you are learning to see the visual unity in a composition and to create with an eye for it. Few people have this skill. Study the form of your design. Once you have mastered the visual "language," you will be able to use it to strengthen both visual and intellectual communication. Both are important and should work together.

Design as Abstraction

Abstract art drew attention to pure visual design. It was "about" color, value, shape, texture, and direction, although often incorporating recognizable imagery. In a purely nonobjective painting by Theo van Doesburg (Figure 2-20) we are intrigued by the breakup of space and the distribution of value and color. There is no "picture" to distract us from the visual information. The de Stijl movement had a tremendous influence on graphic design as layout artists began arranging their shapes and blocks of type into asymmetrically balanced compositions.

A good graphic artist must be a good abstract artist, using both pictorial and nonobjective elements.

Figure 4–3 shows an International Typographic Style layout by Swiss designer Josef Müller-Brockmann that demonstrates a strong eye for pure design shapes reminiscent of de Stijl's surface divisions and strong horizontal/vertical orientation. **Figure 4–4** by contemporary Louisville designer Julius Friedman shows a de Stijl influence on letterhead design.

Graphic design is essentially an abstract art that combines a greatly varied array of elements into a formal 2-D structure. A work should be balanced and visually compelling in its own right as well as supportive of an idea. *Design is a visual language.* The 20th-century movements in art and design contributed greatly to our current understanding of that language. The fields of Gestalt psychology and semiotics have also helped us understand how meaning is formed from visual data.

Working Together

In a design firm, the visual design of a project is given full consideration. In an ad agency, however, copywriters often dominate. Many other places that employ designers also have word people in key positions.

↑
4–3 Josef Müller-Brockmann. *Poster for Kunstgewerbemuseum, Zurich. 1960.* J. Müller-Brockmann. Poster for Kunstgewerbemuseum, Zurich. 1960. © 2010 Artists Rights Society (ARS), New York / ProLitteris, Zürich

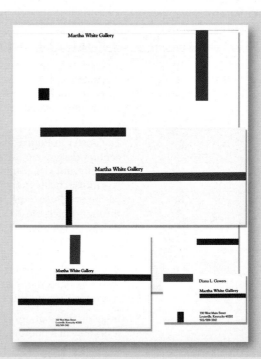

↑
4–4 Julius Friedman. *Art director, designer. Images design firm. Louisville, KY.* Courtesy of the artist.

These people tend to be sensitive primarily to words and ideas (intellectual unity). They are not trained in visual communication. For this angle they rely on you. Together you can ensure, as the Bauhaus would say, that the *form* of a design matches its *function*.

Constructivist El Lissitzky said, *"The words on the printed page are meant to be looked at, not listened to."* How do we *look* at designs, and how do we *create* visually unified ones? The answer has a great deal to do with balance.

VISUAL DYNAMICS

A ladder leaning precariously against a wall will make us tense with a sense of impending collapse. A diver poised at the top of the high dive fills us with suspense. We are not passive viewers. We project our experience into all that we see, including the printed page. How do we project our physical experience into that flat, rectangular surface? *Kinesthetic projection* (sensory experience stimulated by bodily movements and tensions) is operating, whether we deal with pictures of people or the abstract shapes of type design. **Figure 4–5** by Don Egensteiner demonstrates the attraction of gravity on type. Western culture reads a page from top to bottom, a movement that matches our experience with gravity. It is harder for us to read a design of words or images that asks the eye to go from bottom to top.

We project emotional as well as physical experience onto the page. An illustration of a man stabbed causes discomfort due to such projection. Visual form stirs up memories and expectations. That is why visual perception is so dynamic.

Loose strokes that allow the process of construction to show through also arouse this dynamic tension. The visible brushstroke or "mark of the maker" pulls viewers into the process of creation. Many interesting and appealing printed pieces are created by allowing the tension of the creative process to show through, as in a delightful visual pun on the St. Louis arch shown in **Figure 4–6**.

As you saw in Chapter 3, any mark made on a sheet of paper upsets the surface and organizes the space

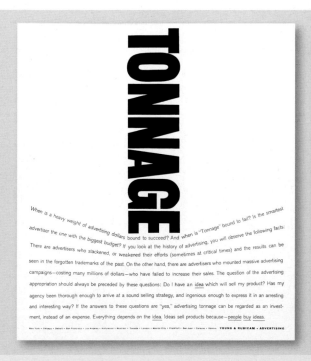

↑
4–5 Don Egensteiner. *(Young & Rubicam, Inc.) Ad in* Fortune *magazine. 1960.* Courtesy of the artist.

↑
4–6 *Self-Promotional Ad. Bartels and Company, St. Louis, MO.* Courtesy of the studio.

around the mark. *This dynamic tension is not contained in the paper itself, or in the graphite, ink, or computers we use. It is created by our interaction with the image.*

Top to Bottom

We are uncomfortable with shapes clustered at the top of a page, with open space beneath them. We have observed in the world around us that many more things are at rest on the ground than in the sky. If they are not "standing" on anything, we feel suspense as we wait for them to fall. We experience a design as top-heavy much more quickly than as bottom-heavy.

Milton Glaser, a contemporary designer and illustrator helped found Push Pin Studios in 1954 and has been a major force in graphic design since then (see Chapter 2). He deliberately plays with this top-to-bottom tension in his double portrait of dancer Nijinsky (**Figure 4–7**). All that anchors the dancing, gravity-defying feet are the line of the baseboard under the left foot and the vertical line at the corner.

Type designers have long believed in the importance of putting extra weight at the bottom of a letterform to make it look firm and stable. The *8* and *3* in **Figure 4–8** look top-heavy when viewed upside down. Book designers customarily leave more space at the bottom than at the top of a page. They understand that a sense of balance cannot be achieved by simply placing identical margins at the top and bottom of a composition. This is the same principle used when matting artwork. The bottom measurement is slightly greater than the top, allowing for an optical center that is slightly different from the mathematical center.

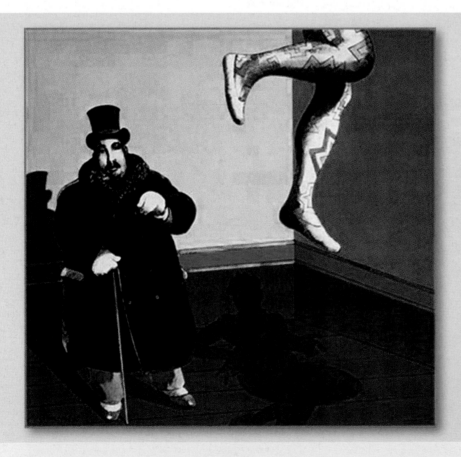

↑
4–7 Milton Glaser. Portrait of Nijinsky & Diaghilev *designed and illustrated for* Audience *magazine.* Courtesy of the artist.

↑
4–8 *Type turned upside down looks top-heavy.*

Vertical and Horizontal

We find horizontal and vertical lines stable, probably because they remind us of our vertical bodies on the horizontal earth. Milton Glaser again deliberately violates this sense of stability in **Figure 4–9**. As he comments, "The diagonal of this figure gives the illustration its surreal perversity."

We find diagonal lines dynamic because they seem in a state of flux, poised for movement toward the more stable horizontal or vertical. The de Stijl artist Theo van Doesburg deviated from Mondrian's horizontal and vertical compositions, stating that the modern human spirit felt a need to express a sharp contrast to the right

angles found in architecture and landscape. An oblique angle is one of the quickest, most effective means of showing tension.

This tension can be created by placing a single shape at an oblique angle or by placing the entire composition at an angle. This kind of design solution can surprise and interest the viewer.

Left to Right

Western cultures read from the left side of the page to the right, and this experience influences the way we look for balance between the sides of a design. The left side is more important, as our attention goes there first. Pictorial movement from the left toward

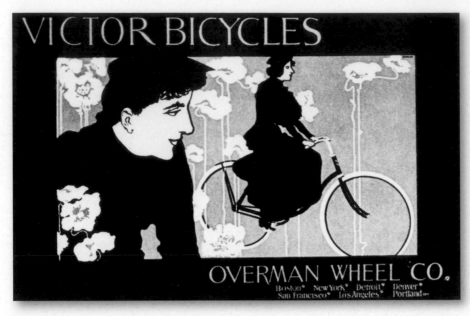

4–10 Will Bradley. *Poster for Victor Bicycles. 1899.* Courtesy of the UW-Whitewater Slide Library.

the right seems to require less effort than movement in the opposite direction. See **Figure 4–10**. An animal speeding from right to left, for example, seems to be overcoming more resistance than one shown moving from left to right. You can explore this left-to-right balance by holding your designs up to a mirror. They may now appear unbalanced.

Overall

Every two-dimensional shape, line, figure/ground relationship, value, and color possesses visual dynamics. We have seen the dynamic value of a kinesthetic reaction, or empathy with the image. There is more to the dynamic of perception, however. We have all seen images of a supposedly moving figure that appears in awkward, static immobility. The objects of dancer or automobile can lead us to expect movement, but only skillful control of visual language can evoke it. Successful communication requires balance, the directing and conducting of visual tensions.

BALANCE

Every healthy person has a sense of balance. It allows us to remain upright and walk, run, or ride a bicycle. Our eyes are pleased with a balanced composition, just as we are pleased with our ability to ride a bicycle and not wobble. Figure 4–10 creates a focus on the bicycle product, as the large figure on the left directs our gaze at the riding woman. The interwoven dark values help unite the composition, and the placement of the typography again draws our gaze across the bicycle. All of this

is a visual balancing act. Lack of balance in a design will irritate viewers and impair the communication. In isomorphic terms, we identify our physical structure with the physical layout/structure of the page and can feel in danger of "falling off the bicycle." How do we create a unified, "rideable," and well-balanced design?

When the dynamic tension between elements is balanced, we are most likely to communicate our intended message. Otherwise, the eye is confused. It shifts from element to element, wanting to move things so they sit right on the page, as we want to straighten a picture hanging crooked on a wall. The viewer so bothered will pay less attention to the quality or content of the picture.

Balance is achieved by two forces of equal strength that pull in opposite directions, or by multiple forces pulling in different directions whose strengths offset one another. Think of visual balance as a multiple rope pull where, for the moment, all teams are exerting the same strength on the rope. It is not a state of rest, but a state of equal tension.

If artists always employed the simplest and quietest form of balance, their art would seem dull. Too much predictability and unity disturbs us just as too much chaos does. We are animals of change and tension. We strive for growth and life. A simple decrease in visual tension resulting in a quiet balance will not satisfy us for long. An interplay between tension-heightening and tension-reducing visual devices seems to satisfy us and match our kinesthetic and emotional experience. *We yearn for diversity as well as unity.*

Symmetry

The two basic types of balance are *symmetry* and *asymmetry*. In symmetrical balance, identical shapes are repeated from left to right in mirrored positions on either side of a central vertical axis. **Figure 4–11** is a symmetrical stained-glass window design by architect Frank Lloyd Wright. **Figure 4–12** is a symmetrical logo design by contemporary designer Margo Chase. Some symmetrical designs also repeat from top to bottom, often in a pattern of *radial symmetry* (in which the elements radiate from a central point). Symmetrical balance dominated Western painting and architecture until the Renaissance. It dominated graphic design throughout the first centuries of the printing trade, when type was carefully set in centered, formally ordered pages. The traditional book form is a classic example of symmetry (**Figure 4–13**). **Figure 4–14** shows the most classical form of symmetry of all, the human body, in this digital photo-based painting by illustrator Matt Zumbo.

Symmetrical design, with its sense of order, is useful whenever stability and a sense of tradition are important. It uses contrasts of value, texture, and shape to relieve boredom and introduce variety. There are various ways to achieve symmetry. The most common has a similarity of form on either side of a central dividing line. Symmetrical balance can happen even when images are not precisely identical on either side of this axis. Some differences may occur in shape, color, or value. The important consideration is whether the overall balance of shape, value, and color remains primarily symmetrical. That symmetry may be vertical, horizontal, radial, or overall.

Asymmetry

Asymmetrical design evokes a greater sense of movement and change, of possible instability and relative weights. It is like taking your bicycle through an obstacle course. It is a contemporary balance that reflects the changing times. Symmetrical design has a logical certainty that is lacking in asymmetrical design. In symmetrical design, a 2-in. (5-cm) square in the upper left dictates another such square in the upper right. In asymmetrical design, that square could be balanced by a vast number of shapes, values, colors, or textures. The effects can be difficult, challenging, and visually exciting.

Asymmetrical designs are balanced through contrast to achieve equal visual weight among elements. To be effective, contrast must be definitive. Shapes that are

↑ ↖
4–11 Frank Lloyd Wright. *Tree of Life Window, 1904.* Fine Arts Museums of San Francisco, Gift of Mrs. Darwin D. Martin, 1982.70 / © 2010 Frank Lloyd Wright Foundation, Scottsdale, AZ/ Artists Rights Society (ARS), NY

↑
4–12 Margo Chase. *Logo design for John Fogerty's* Eye of the Zombie *album cover.* Courtesy of the artist.

↑
4–13 Scott Walker *and* **Tim Girvin.** *Page design for* Fine Print. *1979.*

almost but not definitely different are irritating to the eye. **Figure 4–15** is an asymmetrical design that uses several forms of contrast in both figures and letterforms to achieve a balanced, intriguing design.

Balance through Contrast

Symmetry achieves balance through likeness; asymmetry achieves balance through contrast. The easiest way to achieve visual unity would be to make one shape into an overall symmetrical pattern on the page. A full book page with nothing on it but a solid block of type is visually unified, no matter what the words say. It is also visually dull. In the case of novels, this visual dullness is deliberate. The reader is directed to the content of the words without distraction. In most

publications and advertising design, however, this unity must be tempered with contrast if it is to attract and hold the viewer. The designer is usually working with many different elements. Most successful designs rely on a carefully juggled balance of similarities and contrasts.

There are two considerations in setting up balance through contrast: weight and direction. *Visual weight* is the strength or dominance of the visual object. *Visual direction* is the way the eye is drawn between elements over the flat surface. Balance is determined by the natural weight of an element and by the directional forces in the composition. Weight and direction are influenced by several forces that are listed next.

↑
4–14 *Illustrator* **Matt Zumbo** *created this lovely example of symmetry titled* Liset Tattoo.

↑
4–15 Michael David Brown. Death in the Afternoon from Creativity Illustrated. *1983. An example of asymmetrical balance.*

LOCATION

The center of a composition will support more weight than the edges. Although a shape is most stable when in the center, it is also visually "light." Small shapes at the edges of a composition can balance large ones in the middle (**Figure 4–16a**).

SPATIAL DEPTH

Vistas that lead the eye into the page have great visual strength. We project ourselves into the spatial illusion, so it seems to have greater presence of size (**Figure 4–16b**).

SIZE

Visual weight also depends on size (**Figure 4–16c**)—the larger the heavier. Size is the most basic and often

used form of contrast in graphic design. The contrast between large and small should be sharp and definite without overpowering the smaller elements so they cannot contribute their share. Most successful designs benefit greatly from size contrast in type or in image. In layout design, the contrast is often between large and small photographs and between headline and text type, as in the 1931 poster design by Max Bill shown in **Figure 4–17**.

An interesting sort of size contrast is contrast in expected size. The expectedly large element is played small and vice versa, resulting in a visual double take, as in the 1935 poster depicting skiing and ski goggles shown in **Figure 4–18**.

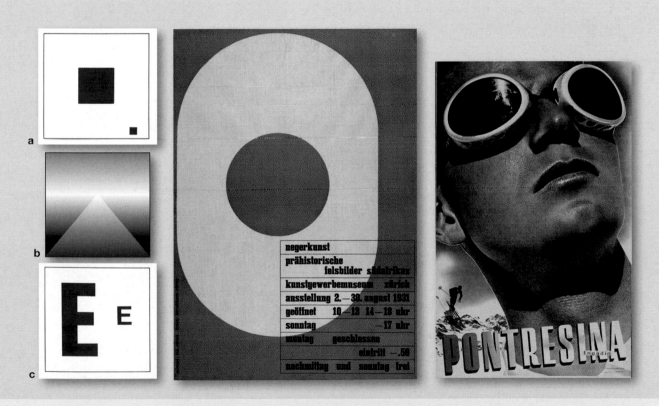

↑
4–16a-c
Balance through placement. Balance through the illusion of spatial depth. Balance through size contrast.

↑
4–17 Max Bill. Negerkunst, Prähistorische Felsbilder Südafrikas (Negro Art, Prehistoric Rock Paintings of South Africa). 1931. Linoleum cut and letterpress, printed in color. The Museum of Modern Art, New York. Gift of the designer. Photograph copyright The Museum of Modern Art, New York / © 2010 Artists Rights Society (ARS), New York / ProLitteris, Zürich

↑
4–18 Herbert Matter. Pontresina Engadin. 1935. Gravure printed in color, 41 x 25⅛" (104.1 x 63.8 cm). The Museum of Modern Art, New York. Gift of the designer. Photograph © 1998 The Museum of Modern Art, New York/Art Resource, NY.

↑
4–19a, b, c, d
↑ ↗
4–20 Herb Lubalin. *1965*. Courtesy of the Herb Lubalin Study Center of Design and Typography at the Cooper Union

↑ ↘
4–21 Alexey Brodovitch. *Pages from* Portfolio. *1951. The art director of* Harper's Bazaar *for 25 years. Brodovitch created only three issues of this magazine from 1950 to 1951. Considered a high point of American graphic design, they profiled leading designers of the time.*

TEXTURE

A small, highly textured area will contrast with and balance a larger area of simple texture (**Figure 4–19a**). This rule refers to *visual texture*, not tactile texture. Contrast of texture is especially useful with text type (type smaller than 14 point, used to set the body of copy).

ISOLATION

A shape that appears isolated from its surroundings will draw attention to itself more quickly, and have greater visual weight, than one surrounded by other shapes (**Figure 4–19b**).

SUBJECT MATTER

The natural interest of subject matter will draw the viewer's eye and increase visual weight. It can also create directional movement as we move our eyes between lovers or follow the eye direction of a figure. Our eyes are drawn to the realistic representation of something that interests us (**Figure 4–19c**). The design in **Figure 4–20** is by Herb Lubalin, an important American designer

from the last half of the 20th century. The subject is playfully suggested with placement.

VALUE

Areas of high contrast have strong visual weight. A small area of deep black will contrast with and balance a larger area of gray when both are placed against a white background (**Figure 4–19d**). The creation of light and dark areas in a drawing, a painting, a photograph, or an illustration produces a dramatic play of values that delights the eye. Alexey Brodovitch designed these pages for a visual arts magazine in the 1950s (**Figure 4–21**). The high contrast of texture and size, and the cropping of images, create an extremely well-balanced and dynamic layout.

Typography also uses value contrast. The contrast of a black, heavy type against a light one helps relieve boredom and makes the page more readable. Contrasts between headings and body text and the white areas of paper can create three distinct weights: the black bar of the heading is played against the gray, textured rectangle of the body text, both of which contrast with the white areas of the background page. Designers

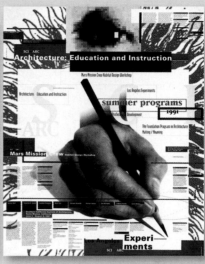

↑
4–22a–c

↑
4–23 Margo Chase. *Margo Chase Design, Los Angeles. Logo design for Virgin Records.* Courtesy of the artist.

↑
4–24 April Greiman. *Summer Programs: poster for Southern California Institute of Architecture. 1991.* Courtesy of the artist.

sometimes alternate boldface and regular-weight type for a visual pattern.

SHAPE

The shape of objects generates a directional pull along the main structural lines. Complicated contours also have a greater visual weight than simple ones. Therefore a small complex shape will contrast with and balance a larger simple shape (**Figure 4–22a**). One block of type may be set in a long, thin ragged rectangle while another is set in a large, square block form. Contrast in shape also works with single letterforms. You may play the round openness of an *O* against the pointed complexities of a *W*, or the shape of an uppercase *A* against a lowercase *c* (**Figure 4–22b**).

STRUCTURE

In type design, structure refers to the contrasting characteristics of type families. It is a kind of contrast of shape. Compare the *G* in Baskerville with the *G* in Helvetica (**Figure 4–22c**). They are the same basic shape, but their differences are important in typography. Their structures—thick/thin, serif/sans serif—are different.

The logo design in **Figure 4–23** plays with both contrast and similarity, as well as delivering a clever visual pun equating the *V* with facial structure.

COLOR

The brighter and more intense the color, the heavier it will be visually. A large gray-blue shape will be balanced by a small bright red shape. A small bright intense green will contrast with and balance a large toned-down, low-intensity green. In graphic design, you won't always work with full color. Each additional color costs money, so it must be used wisely. A second color can be used to enliven a magazine from cover to cover or only on those pages that are cut from the same printed signature. Remember, in one-color design, that color need not be black. It can be a rich gray, a deep green, or any color you can envision working with your combination of type and image. **Figure 4–24**, by renown designer April Greiman, shows a creative use of a limited color palette as well as a creative integration of type and image.

DIGITAL FOCUS
Manipulating Letterforms

Vector programs like Adobe Illustrator allow you to type in a letterform and transform it by typestyle and placement, as well as by using the commands for rotate, reflect, scale, and shear. You must enter each letter individually, or use the cut and paste functions to manipulate an individual letterform. These functions were used in **Figure 4–25**. **Figure 4–26** also makes use of the pen tool to add and subtract vector points, and the scissors tool is used to eliminate points. Converting type to outline is a good way to gain control of vector points, but the type tools will no longer work on the letterforms. These assignments give students an opportunity to gradually increase their software skills as well as explore creative solutions that will be of use in later chapters. The Web site accompanying this text has more information.

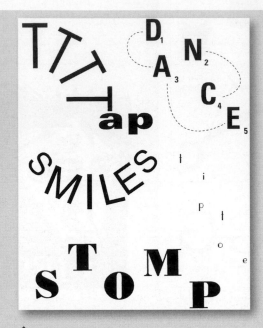

↑
4–25 Becky Kliese. *Word illustration, "Movement," created in response to project 1.*

↓
4–26 *Solutions by*
a. **Michelle Storrm.**
b. **Miguel Villarreal.**
c. **Melissa Wirth.**
d. **Jeremy Weber.**

EXERCISES

1. Prepare a classroom presentation based on a written critique of a poster, an advertisement, or an illustration. Describe how the design achieves or fails to achieve visual and intellectual unity.

2. Select letterforms or simple shapes to demonstrate the following principles. (It can be fun to use a font like Dingbats for clip art shapes.)
 a. A single shape can balance several shapes.
 b. A large shape can be balanced by a group of smaller shapes.
 c. Shapes can be balanced by negative space.
 d. A dark shape can be balanced by a larger, lighter shape.
 e. A large flat shape can be balanced by a smaller textured shape.

PROJECT 1: WORD ILLUSTRATION

This project asks you to concentrate on placement, contrast, and kinesthetic projection to create a balanced and interesting design. Figure 4–25 shows student designs based on this project.

Choose a word to illustrate. Practice on those listed here, then choose your own words. A dictionary and thesaurus (online or in print) can be useful tools. Base these thumbnails and your project on existing typestyles. Search for an appropriate one for each solution. Do not use pictures or distort your letterforms into pictures to tell your story. Let the letterforms communicate their message visually through size, color, value, shape, structure, texture, placement, and kinesthetic projection. Tell visually what the word says intellectually. Be able to describe the tensions and balancing forces.

Execute your design so it fits within an 8½ x 11" (21.5 x 28-cm) format. Use black and incorporate one shade of gray or color, if it will strengthen your design. If you use a computer-generated solution, stay within the same design limitations of size and color. Do not use software to lure you to distort the basic shape of the letterform. Enjoy it for its clarity and beauty of design, retaining its integrity.

Practice Words

Rain	Tight	Crowded	Black and Blue
Reflection	Happy	Divide	Alone
Dance	Repeat	Movement	(Your choice)

PROJECT 2: ELEPHONTS

Create an animal out of typographic forms. Choose a typestyle and stay with its family of fonts, resizing and rotating as desired. Choose the typography carefully, looking for both shapes and the feeling the typestyle communicates. Feel free to reverse values, overlap, and cut and paste to create your animal, but again, avoid stretching and distorting the proportions of the type for this assignment. Place your animal somewhere within the rectangle of an 8½ x 11" (21.5 x 28-cm) page, in either a vertical or a horizontal format. Be sensitive to the edges of the overall composition and the open spaces. Figure 4–26 shows several playful and creative student solutions that make use of software functions that include type/create outline, cut/paste, object/group/ungroup, resize and rotate, and delete vector points. Visit Chapter 4 on the accompanying Web site for more information.

GOALS AND OBJECTIVES

Practice creating a visually balanced design.

Explore the personalities of varying typestyles.

Increase your control of media, tools, and software, as well as your respect for precision.

CRITIQUE
Project 1

Which solution seems most successful? Make your choice and talk to the class about the characteristics of the typestyle and how it contributes to the solution. What is happening with symmetrical and asymmetrical balance? How does kinesthesia contribute to this design?

Project 2

How do the parts contribute to the whole? Identify the letterforms in your favorite design. Ask the class and the instructor how your design could be improved. Make any necessary changes for the final portfolio piece.

Visit the accompanying Web site for research links and project examples. Studio techniques show beginning vector scissors, joining, and more.

GOOD GESTALT

→

TERMINOLOGY
(See glossary for definitions.)

gestalt
similarity
proximity
continuation
closure
figure/ground
trademark
symbol
pictogram
semiotics
icon
index
logo
combination mark

KEY POINTS

This chapter introduces the fundamental concepts of visual gestalt that underlie all design structure. Gestalt theory is explained and examined by showing its practical application to symbol and logo design. The function of symbol and logo design in the graphic design field is discussed in terms of the relationship between form and content. All gestalt principles introduced here can be applied in future chapter assignments in layout, illustration, Web design, and more.

THE WHOLE AND THE PARTS

The Gestalt school of psychology, which began in Germany around 1912, investigated how we see and organize visual information into a meaningful whole (**Figure 5–1**). The conviction developed that the whole is more than the sum of its parts. This whole cannot be perceived by a simple addition of isolated parts. Each part is influenced by those around it.

WHOLE

As you read these words, you perceive the whole word, not the individual letterforms that make it up. You can still pause and examine each letter individually, but the word is more than the sum of its separate letterforms (**Figure 5–2**).

Similarly, when you sew a shirt, you begin with pieces of fabric cut into parts. When the parts have been assembled, a new thing has been created. The collar, the facing, and the sleeve still exist, but they have a new "whole" identity called a shirt.

↑
5–2 *The whole is more than the sum of the separate letterforms in this diagram, where individual letters in a word are rearranged.*

 ← **5–1** *Caldecott Honor–winning illustrator* **David McLimans** *created these fanciful numbers as part of his book* Gone Fishing: Ocean Life by the Numbers. *Printed by Walker & Company in 2008. McLimans uses fins, flippers, and tentacles to create numerical masterpieces and showcase ocean facts. Together the letterforms and the animal forms create a new whole, a gestalt.*

↑
5–3 Giuseppe Arcimboldo. *Sixteenth-century painting in which the separate parts combine to form a new whole.*

Giuseppe Arcimboldo, a painter from the 16th century, demonstrated the principle clearly in the portrait in **Figure 5–3**. A close examination reveals the separate parts that make up this head.

The early Gestalt psychologists and many other researchers into visual perception have discovered that the eye seeks a unified whole, or *gestalt*. Knowing how the eye seeks a gestalt can help you analyze and create successful designs. By knowing what connections the eye will draw for itself, you eliminate clutter and produce a clearly articulated design.

GESTALT PRINCIPLES

A designer works not simply with lines on paper, but with perceptual structure. Learn these gestalt perceptual principles and you can take advantage of the way object, eye, and graphic creation interweave. A beautiful example can be found in the editorial illustration by John Heartfield (1891–1968) shown in **Figure 5–4**. Heartfield was a follower of the Berlin Dada movement, and he often used photomontage to create strong statements. Figure 5–4 makes a powerful comment through its use of similarity. The figure on the top is a medieval depiction of a man being "broken on the wheel." In this form of torture, the victim would be tied to a wagon wheel and struck with a blunt weapon to break the bones. The figure on the bottom is a photo collage by Heartfield that shows a man symbolically caught and

→
5–4 John Heartfield. "As in the Middle Ages . . . so in the Third Reich" *photomontage. 1934. This powerful comment on Hitler's regime makes beautiful and effective use of the gestalt principle of similarity that evokes a gestalt conceptual closure.* "As in the Middle Ages...so in the Third Recih." Photoimage by John Heartfield, 1934. © 2010 Artists Rights Society (ARS), New York / VG Bild-Kunst, Bonn

↑↖
5–5 *The use of similarity also draws attention to differences.*

↑↙
5–6 Saul Bass. *Trademark for Alcoa.* Courtesy, Aluminum Company of America.

↑↗
5–7 *Proximity grouping is grouping by similarity in spatial location.*

↑↘
5–8 A3 Design *created this logo for Valley Winery. Similarity, continuation, and reversible figure/ground all unite this strong design.* Courtesy of A3-Design

tortured in the swastika symbol for Hitler's regime. The similar shape and placement make the artist's point that "As in the Middle Ages . . . so in the Third Reich."

Similarity

When we see things that are similar, we naturally group them. Grouping by *similarity* occurs when we see similar shape, size, color, spatial location (proximity), angle, or value. All things are similar in some respects and different in others. In a group of similar shapes and angles, we notice a dissimilar shape or angle. In the diagram in **Figure 5–5** the gray square draws attention because it is different from the squares surrounding it. The three letters *i* in *similarity* are shown to be similar by treating them in a similar fashion to each other but differently from the other letterforms.

Grouping by similarity is true for realistic subject matter as well as nonfigurative design forms. The symbol and logotype created for Alcoa by Saul Bass (1920–1996), a renowned American designer, relies on similarity of shape. Count the triangles in **Figure 5–6**.

Proximity

Grouping by similarity in spatial location is called *proximity*, or nearness. The closer two visual elements

↑

5-9 *Nationally renown designer and educator* **Michael Vanderbyl** *created this logo for a wine distributor in Toronto. It incorporates several gestalt principles.*

↑ → ↖

5–10 **Stefan Kantscheff,** *Bulgarian designer, created this beautiful example of rhythm and repetition in symbol design.* Courtesy of the artist.

↑ ↗

5–11 *Continuation occurs when the eye is carried smoothly along a suggested line or curve.*

↑ ↘

5–12 **George Jadowski,** *designer,* **Danny C. Jones,** *art director. Symbol for the U.S. Energy Extension Service. This symbol illustrates energy with its use of continuation.*

are, the more likely we will see them as a group. In **Figure 5–7** the four squares on top seem to form a group whereas the eight squares on the bottom appear to belong to a different group. **Figure 5–8** uses a close and careful placement of all the elements to create a winery logo. Similarity is important, but so is the close proximity and careful placement of the elements. **Figures 5–9** and **5–10** place shapes in close proximity that never touch but form a dynamic whole through proximity and more gestalt unit-forming principles listed next. The proximity of lines or edges makes it easier for the eye to group them to form a figure. When you finish the chapter, come back to these marks and analyze the combination of unit-forming principles at work.

Continuation

The viewer's eye will follow along a line or curve. *Continuation* occurs when the eye is carried smoothly into a line or curve that links adjoining objects. The diagram in **Figure 5–11** shows how the eye will follow the interruption of the black outline, seeing a continued, implied shape (in this case an *X*). This principle is used extensively in layout design to unite various elements, often by placing them along invisible grid lines.

Shapes that are not interrupted but form a harmonious relationship with adjoining shapes please the eye. The symbol of the U.S. Energy Extension Service (**Figure 5–12**) uses continuation to emphasize the moving,

dynamic nature of energy. In this example the ends of the *e* line up with the ends of the arrowhead, forming a continued line that harmoniously unites the shapes. The *Family Circle* logo by Herb Lubalin and Alan Peckolick (**Figure 5–13**) creates continuation by lining up the verticals of the two *i* letterforms and also lining up the *l* and *r* forms. The eye draws a line down those vertical shapes that makes a new whole out of two different words. American graphic designer and photographer Herb Lubalin (1918–1981) was the editorial design director for several distinguished publications. His work is shown several times throughout this text.

Closure

Familiar shapes are more readily seen as complete than incomplete. When the eye completes (closes) a line or curve in order to form a familiar shape, *closure* has occurred. The diagram in **Figure 5–14** shows white circles appearing as the eye and brain close the open areas into a familiar circular shape. **Figure 5–15** is a symbol created by the 1 plus 1 Design firm. Do you see the white plus sign created by the figure/ground relationship? This is a visual closure as our eyes finish the form. Part of the closure in this example includes a sudden conceptual connection and understanding of the name of the firm. This sort of connection is especially useful in trademark design. Closure is sometimes accompanied by an "Oh, now I see!" reaction. An elegant editorial statement is made in **Figure 5–16** in this opera symbol when we recognize the link between a musical note and a heart.

↑ ↑
5–13 Herb Lubalin *(art director)* and **Alan Peckolick** *(designer). Family Circle. 1967. This magazine logo makes quiet but elegant use of placement and continuation.* Courtesy of the Herb Lubalin Study Center of Design and Typography at the Cooper Union

↑ ↙
5–14 *The eye and brain close the white areas into circles. This demonstrates a highly active partnership between eye and brain and graphic image that is at the heart of visual gestalt.*

↑ ↘
5–15 Pat Hughes *and* **Steve Quinn.** *This elegantly constructed symbol for 1 + 1 Design uses a rich combination of similarity, reversible figure/ground, and closure.*

↑
5–16 Stefan Kantscheff. *Symbol for the Staatliches Operettentheater in Sofia, Bulgaria.*

Figure 5–17 by Herb Lubalin calls for active conceptual participation by the viewer to achieve an intellectual closure with the O shape and a womb. The playful shape in **Figure 5–18** for an eyewear company on closer inspection forms spectacles. Another "Oh"! A wide variety of applications for this logo are shown on the accompanying Web site. ◻

Figure/Ground

The fundamental law of perception that makes it possible to discern objects is the *figure/ground* relationship. The eye and mind separate an object (figure) from its surroundings (ground). As you read this page, your eyes are separating out words (figure) from ground (paper). Often the relationship between figure and ground is dynamic and ambiguous, offering more than one solution to the searching eye, as we discussed in Chapter 3. The diagram in **Figure 5–19** lets us see black bars on a white central background or see white squares on a black ground. Gestalt relationships in graphic design are always intended to help structure an appropriate communication. The most structurally beautiful design is not successful if it fails to present the subject appropriately. **Figure 5–20** presents a fairly abstract symbolic notion of the delivery and exchange of information. It creates a lively figure/ground relationship with the white squares in the background. Similarity in the linear treatment and repeated arrow shapes unite the overall symbol. Finally, the two directional arrows suggest the notion of interactivity.

↑↖

5–17 Herb Lubalin. *1965. This creation by an important 20th-century designer relies on an anthropomorphic identification with the shape of letterforms to bring closure.* Courtesy of the Herb Lubalin Study Center of Design and Typography at the Cooper Union

↑↙

5–18 *The wide ranging Memphis Design Firm* **Tactical Magic** *created this design for The Eyewear Gallery. Samples of this design are shown on the accompanying Web site, applied to billboard, Web and signage applications.* ◻ Online Project Gallery

↑↗

5–19 *The perception of figure/ground underlies much of symbol and logo construction.*

↑↘

5–20 A. E. Arntson. *1985. This symbol for Interactive Financial Learning Systems uses a variety of gestalt principles to illustrate the nature of the company. This design was created when computers in graphic design were very young, using black ruling tape and a great deal of care.*

Sometimes referred to as a positive/negative space relationship, the figure/ground principle is crucial to shaping a strong design (see Chapter 4). You must be aware of creating shapes in the "left over" ground every time you create a figure. M. C. Escher (1898–1972) created the wonderful example of a reversible figure/ground relationship shown in **Figure 5–21**. There is no dominant foreground. As soon as our eyes fasten on an image, the surrounding background lays claim to our attention, reversing the figure. Escher, born in the Netherlands, is one of the world's best-known graphic artists, creating hundreds of lithographs, wood engravings, and woodcuts.

There are a variety of figure/ground relationships to investigate. **Figure 5–22** uses a reversible figure/ground relationship similar to the yin-yang symbol. **Figure 5–23** uses a reversible relationship, where it is possible to focus on either the plus or the h forms.

TRADEMARKS

The interplay of gestalt principles occurs in all areas of art and design but is clearest in the creation of logo and symbol trademarks. Here form and function are closely related. We have examined the gestalt formal structure of trademarks. Next we consider the function of these marks. The final project in this chapter will ask you to relate these two considerations.

Functions

Symbols and trademarks have served many functions in history. The early Christians relied on the symbol of the fish to identify themselves to one another secretly. In the Dark Ages, family trademarks were used. No nobleman in the same region could wear the same coat of arms as another. **Figure 5–24** shows a typical coat of arms. These "arms" came to mark the owner's possessions. Peasants used simpler housemarks, which were especially useful because few people could read. Also, each medieval artisan inscribed a personal mark on his or her products and hung out a sign showing his or her calling. During the Renaissance, the three golden balls of the Medici family symbolized money lending. The Medici mark can still be seen today, co-opted by modern pawnbrokers. More recently, in the western United States each cattle rancher uses a unique brand or mark to identify the ranch that owns individual cattle (**Figure 5–25**).

←
5–21 M. C. Escher. Sun and Moon. *1948 woodcut. 25.1 x 27 cm.* M.C. Escher's "Sun and Moon" © 2010 The M.C. Escher Company-Holland. All rights reserved. www.mcescher.com

→ ↖
5–22 Maggie Macnab *created this logo design for Maddoux-Wey Arabians, an Arabian horse breeding farm. Macnab is author of* Decoding Design: Understanding and Using Symbols in Visual Communication. *See the accompanying Web site for her clearly articulated explanation of the form and content behind the development of this symbol.*

→ ↗
5–23 Maggie Macnab, *a national award winning designer, created this logo design for Health Plus, New Mexico's first HMO. Macnab established her own design firm in 1981, and writes on critical thinking in design and teaches at the U of NM.*

→ ↙
5–24 *A medieval coat of arms is an early example of a trademark.*

→ ↘
5–25 *Cattle brands are also examples of trademarks.*

Today trademarks are widely used by corporations. A *trademark* is any unique name or symbol used to identify a product and to distinguish it from others. These unique marks can be registered and protected by law. Their primary use is to increase brand recognition and advertise products and services. The use of trademarks, or logos, flourishes as individuals identify themselves on letterheads, résumés, and home pages. Consumers come to rely on the quality associated with a trademark (think of Coca-Cola) and are willing to try new products identified with that recognized trademark.

Making "Marks"

Unlike other forms of advertising, the modern trademark is often a long-term design. It may appear on letterhead, company trucks, packaging, employee uniforms, newsletters, and so on. Designers can spend months developing and testing one trademark. Only a strong design with a simple, unified gestalt will stand the test of repeated exposure.

Keep several points in mind when developing a mark:

■ You are not just "making your mark on the world;" you are making a mark to symbolize your client and your client's product. It must reflect the nature and quality of that product to an audience. Research the company, product, and audience. As designer Paul Rand said, "A trademark is created by a designer, but *made* by a corporation. A trademark is a picture, an image . . . of a corporation."

■ The mark is often reproduced in many different sizes, from the company vehicle to a business card. Your design must remain legible and strong in all circumstances.

■ Because this mark may be reproduced in newspaper advertising or with severely limited in-house duplicating facilities, it must reproduce well in one color.

■ Many trademarks are seen in adverse viewing conditions, such as short exposure, poor lighting, competitive surroundings, and lack of viewer interest. Under such conditions, simplicity is a virtue. A simple, interesting shape with a good gestalt is easier to remember than a more complex design.

Some designers refer to all trademarks as logos, whereas others have a complex system of subtle categories. The two most common categories of trademarks, however, are symbols and logos.

Symbols

Merriam-Webster's Eleventh Collegiate Dictionary says a *symbol* is "something that stands for or suggests something else by reason of relationship, association, convention, or accidental resemblance; especially: a visible sign of something invisible. . . . an arbitrary or conventional sign used in writing or printing relating to a particular field to represent operations, quantities, elements, relations, or qualities." Historically important symbols include national flags, the cross, and the swastika (**Figure 5–26**).

↑
5–26 *The flag, cross, and swastika are examples of historically important visual symbols.*

5–27 Michael Vanderbyl. *This symbol proposed but not adopted for the California Conservation Corps is an excellent integration of form and content.* Courtesy of the artist.

5–28 Roger Cook *and* **Don Shanosky.** *(Cook and Shanosky Associates). Department of Transportation pictograms prepared by the American Institute of Graphic Arts (AIGA).*

The symbol is a type of trademark used to represent a company or product. It can be abstract or representational, but it does not usually include letterforms. It represents invisible qualities of a product, such as reliability, durability, strength, or warmth.

A symbol has several advantages, including the following:

1. Original construction
2. Simple gestalt, resulting in quick recognition
3. A strong association that "colors" the symbol's interpretation

Figure 5–27, a symbol proposed for the California Conservation Corps by the critically acclaimed designer Michael Vanderbyl, demonstrates all three qualities. It is an original mark, unlike any other, and it makes excellent use of the figure/ground relationship. We cannot see the baby without the presence of the parent. The whole that is formed by these strong, seemingly simple shapes can be quickly recognized. The associations that this symbol stimulates are positive and nurturing. Form and content reinforce one another in this fine design.

A *pictogram* is a symbol used to cross language barriers for international signage. It is found in bilingual cities, such as Montreal, for traffic signs. It is also found in

airports and on safety instructions inside airplanes. It is representational rather than abstract, as shown in **Figure 5–28**.

Symbols can also be examined in the light of *semiotics*, which shows how an image takes on a culturally accepted meaning that goes beyond its merely recognizable shape. As mentioned in Chapter 3, the study of images in semiotics involves the categories of icon, symbol, and index.. An *icon* is a sign that looks like what it represents. Realistic drawings and photographs are examples. Symbols, like the images shown in Figure 5–26, have culturally determined significance. For example, the eagle and the Statue of Liberty are symbols for the United States. The theory of semiotics goes on to define an *index* as a sign that bears a direct relationship to the object it represents without simply showing that object. For example, the shadow of a building indicates its presence; a feather can indicate the presence of a bird. Symbols, icons, and indexes are all good conceptual approaches in the development of a trademark symbol and often are combined in a single mark.

Logos

The second category of trademark is called a logo or logotype. The *logo* is a unique type or lettering that spells out the name of a company or product. It may be

CHAPTER 5 Good Gestalt

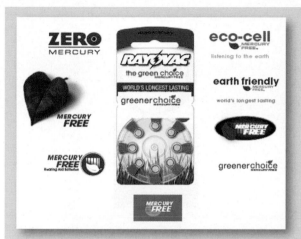

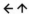
5–32 Chris Eichman, *working with* **Bennett Syverson,** *created many thumbnail concepts for Rayovac's new hearing aid battery with a zero-mercury formula. The strongest logos were tested with focus groups and sent back to the drawing board. After several revisions based on input from various stakeholders, the final design is currently on packaging being sold across the United States.*

Digital Focus
Layers
Most logo designs are created using vector graphics. Because vectors can be enlarged or reduced with no loss of detail or resolution, they are the logical choice for logos that will appear on trucks, letterhead, signage, and other applications. Raster graphics can form the underlying basis for scanned imagery that is imported into a vector program and traced over in successive layers. The raster scan is then deleted, and the file flattened before sending to print. It is always wise to save a file with all the original layers in case you need to revise them.

Class Discussion
Choose a logo design from this chapter, or bring in an example to discuss. Analyze the gestalt unit-forming principles at work. If you prefer, bring in an example that needs improvement. **Figure 5-32** shows an example of a professional design that went through a development process.

hand lettered, but it is usually constructed out of variations on an existing typeface. Historically, it developed after the symbol, because it requires a literate audience.

When you create a logo, choose type that suits the nature of your client and audience. **Figure 5–29** was created for *Reader's Digest* by one of the most respected logo designers, Herb Lubalin. The clean, bold typestyle makes it easy to see the play on similar shapes that creates the "family connection" hidden in the word. **Figure 5–30** was created for the Ditto Corporation, a duplication products manufacturer. Compare this typestyle with the one before. Although both are sans serif, each is distinctively suited to its use.

The advantages of a logotype include (1) original construction and (2) easy identification with the company or product because the name is included.

A *combination mark* is a symbol and logo used together. These marks can be more difficult to construct with a good gestalt because of their complexity. They are often used, however, because they combine the advantages of symbol and logo. This design for the Word Wildlife Fund incorporates the initials for World Rescue Team with endangered animal outlines. (**Figure 5–31**).

In all these marks, gestalt principles help create a unified and striking design. With good gestalt, form and function interweave in a powerful whole.

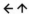
5–29 Herb Lubalin. *Trademark created for* Reader's Digest. *Assigned to* Military Family Communication, *publisher of* Families *magazine.* Courtesy of the Herb Lubalin Study Center of Design and Typography at the Cooper Union

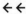
5–30 *Logotype for Ditto Corporation. The Ditto trademark is a federally registered trademark of Starkey Chemical Process Co. of LaGrange, IL.*

5–31 *This combination mark for the World Wildlife Fund was created by Eyebeam Creative, based in Washington, DC.*

EXERCISE

This exercise emphasizes the dynamic importance of simple shapes while requiring precision using vectors.

This assignment is best accomplished by using a vector graphics program with the grid turned on, using guides and rulers. If necessary, all assignments in this text can also be done with graph paper using ink or collage **(Figure 5–33).**

1. *Select a circle ½" (4 cm) in diameter (or slightly more), and practice overlapping two circles to create new and varied shapes. Then try three circles. Do not use line or gray tones—only shape and black-and-white values. Reverse one out of another for more interesting effects.*

2. *Place a circle in various positions within a square. Again, do not use line. Use black-and-white shapes. Experiment with size and border-variations.*

3. *Set up a series of vertical lines so the white lines gradually diminish while the black lines expand. Start by making a series of vertical lines ¼" (5 mm) apart. Each line can then be incrementally thickened.*

4. *Create a break or anomaly in a series of vertical lines.*

5. *Examine the illustrations in this chapter and identify the unifying gestalt features in each mark, to enrich the development of your own logo.*

6. *Use one or more of these exercises to develop an appropriate symbol for a company of your choice.*

PROJECT

Combination Mark

Design a combination mark for the company mentioned here or one selected by you or provided by your instructor. Do personal or Internet research to learn about the character and purpose of this company. Combine logotype and symbol into one image, carefully placed together. Experiment with many visual options in your thumbnail sketches, however you choose to execute them. Practice incorporating each of the gestalt principles discussed in this chapter into your thumbnail investigations.

↑
5–33 Eric Wuebben. *Line variations using an anomaly, or change, in an expected pattern.*

Begin with an existing typestyle and make careful alterations. Spend time looking through type choices. Experiment with fonts, finding which are appropriate for the company you have selected. List the name of the font next to your initial sketches.

After consulting with the instructor, select two thumbnails to create as full-size roughs for final review. Fine-tune and execute the strongest within an 8 x 10" (19 x 25-cm) format. Using only one color, execute the design in ink or vector graphics.

Keep your design visually strong and uncluttered. Be prepared to discuss the gestalt principles

involved during the critique. Use at least two of them in your final trademark. As you create your design, consider the audience your trademark will be reaching. What will appeal to them? Consider the company. What will be an accurate and positive image? Be prepared to discuss the function of your mark and why the design suits it. The final should be shown in black and white, as well as any color application you feel enhances the design.

Narnia Zoo

The Narnia Zoo is a large, well-funded zoo. It hosts everything from aardvarks to zebras and

↑
5–34 Russ Jacobs. *Continuation unites type and image in this combination mark for a special exhibition at the zoo. Notice how the abstract tiger stripes connect the lines of the type on top and bottom.*

emphasizes preservation of endangered species and habitats. It is planning a special exhibition for which you will create a name and design a combination mark (see **Figure 5–34**).

GOALS AND OBJECTIVES

Learn to apply gestalt principles to logo design that reflects the client's needs.

Communicate the nature of an institution with a design that appeals to the public. Apply gestalt principles to develop a trademark that appropriately represents a company or product.

Research for inspirational solutions in periodicals, at the library, in original photos, or on the Internet. Collect or create images for symbol reference.

CRITIQUE

How does your design use the gestalt principles of similarity, proximity, continuation, closure, and figure/ground? What is the nature of the institution? How does your design capture the nature of the institution or product? What typeface have you chosen, and why is it appropriate?

How does your design embody the qualities of a successful trademark as discussed in this chapter?

How can your design be improved?

What is the most successful example of each gestalt principle in the various class solutions? This is an excellent way to invite class discussion.

Visit the accompanying Web site for research links and project examples. Studio techniques show controlling line and fill, and more in vector graphics.

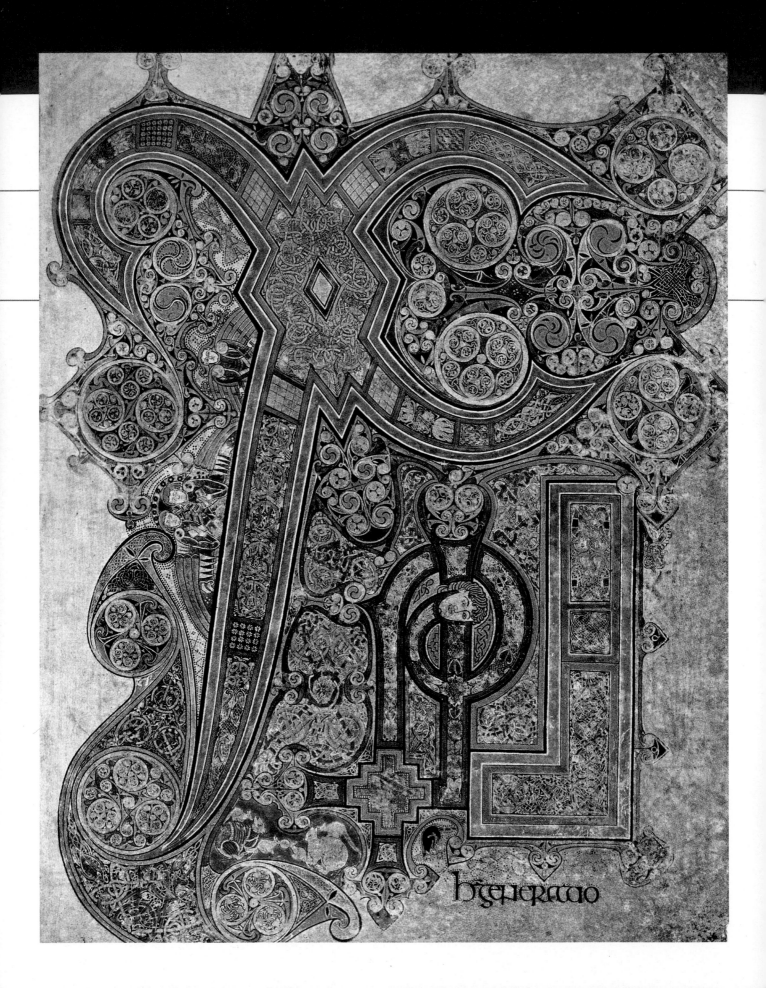

USING VISUAL LANGUAGE

TERMINOLOGY
(See glossary for definitions.)

type categories
old style
roman
italics
transitional
modern
sans serif
Egyptian
bracketing
type family
font
hot type
text type
point
pica
line length
leading
letterspacing
word spacing
justified
flush left
flush right
widow
orphan

KEY POINTS

Innovations in technology have greatly affected the development of our visual record of the spoken language. Historically, the tools used to create letterforms have largely determined the shape of those letterforms. This chapter briefly introduces the historical development of typestyles, explaining the relationship between style and technology starting with the Book of Kells (**Figure 6–1**) and ending with 21st-century type design. It describes the role of text type in page layout, including size, line length, style, leading, spacing, and format.

THE DEVELOPMENT OF WRITTEN COMMUNICATION

Since a person first made a mark in the sand for another to find, we have been communicating with a visual language. The earliest forms of visual communication were pictorial drawings of everyday objects, such as weapons and animals. As the need to communicate grew, these pictures were combined to convey thoughts and ideas that eventually led to the creation of letterforms.

With visual language, an individual's mark could be seen and understood after the maker had moved on or even died. Civilization developed along with our visual record of the spoken language. So did the importance of the individual and his or her written "voice."

Alphabets

The earliest known alphabet emerged in Egypt some 4,000 years ago. Its inventors adopted pictorial characters from Egyptian writing to represent sounds in a different language. That language was spoken by a western Asian people then living in Egypt. For the most part, characters in Egyptian writing represented entire words or other meaningful units of language. In contrast, each character in the first alphabet represented a single sound within a word. The development of the alphabet revolutionized communication. To master Egyptian writing required memorizing hundreds of characters; to master the alphabet, one needed to learn fewer than 30.

By 1000 B.C. the Phoenicians were using the alphabet. A nation of traders, they needed an efficient, condensed writing system to record business transactions. As time passed, the Phoenician letterforms grew more abstract and linear. The Greeks adopted the

6–1 *This page from the Book of Kells is perhaps the best known of all the pages of Kells. Full of images of people and animals incorporated with letterforms and words, this illuminated manuscript is bound into four volumes of elaborate illustrations and calligraphy on vellum. Such manuscripts were produced from the 7th to the 9th century, with the Book of Kells created during the latter part of that time period. It is housed at Trinity College, Dublin, University of Dublin.* The Granger Collection, New York

1. Phoenician alphabet

2. Greek alphabet

3. Roman alphabet

↑

6–2 *The Phoenician, Greek, and Roman alphabets.*

alphabet from the Phoenicians a few centuries later. Unlike the Phoenicians, however, the Greeks developed letters to represent vowels as well as consonants. By 700 B.C. the Greek alphabet had spread to the Italian peninsula, where the Romans eventually learned it, further modifying it to suit the sounds of Latin. Gradually the Roman alphabet evolved into a form almost identical to that used in most western European alphabets today (**Figure 6–2**).

As designers working with the letters of the alphabet, we have thousands of years of history behind us. The shape of letters has been largely determined by the tools used to create them. The Phoenicians, Greeks, and Romans applied ink to reed brushes or pens for writing on papyrus. This method created letters with a pattern of thick and thin strokes and frequently rounded forms. The Greeks and Romans also used a sharp, pointed stylus to write on a wax-coated tablet, resulting in strokes of even thickness. Important inscriptions were carved into stone with a chisel. In early stone inscriptions, letters tended to have simpler straighter lines, perhaps because curves were more difficult to carve. Eventually, however, the Roman alphabet, even as cut into stone, came to have a greater variety of straight and curved forms than its predecessors. Also, this alphabet came to have a finishing line, or serif, at the top and/or foot of vertical elements. A by-product of the way the letters were carved, serifs gave the Roman alphabet an unprecedented sense of overall harmony. But these letterforms were difficult to write and took up a lot of space on increasingly expensive papyrus. So a simpler, more condensed, more easily written script

developed. Eventually the classic capital letters came to be used with smaller letters, setting a precedent for our upper- and lowercase style. Handwritten papyrus scrolls kept the alphabet alive during the early Middle Ages.

Our most common typefaces are imitations of early handwriting or modifications of early typefaces modeled after the lettering in manuscript books. The invention of the first printing press with a system of movable type was around 1440, when Johannes Gutenberg assembled a mechanical press using metal type molds to create inked text blocks pressed onto paper.

INFLUENCE OF TECHNOLOGY

Innovation in printing technology during the Industrial Revolution (18th–19th century) contributed to the development of new typestyles. Advances in mechanical design and cast-iron parts were applied to the printing press in the early 1800s, allowing for a much larger printed sheet. The London *Times* was the first publisher to replace the hand press with a steam-powered printing press, which could make more than a thousand impressions an hour. Another important innovation of the 1800s was the invention of the Linotype machine in 1886 by Ottmar Mergenthaler. It replaced hand typesetting with a keyboard-operated machine that generated lines of type cast in melted lead. These lines of type were locked into slim wooden cases before printing. The demand for increased advertising and other forms of print media led to the development of a variety of type designs.

The invention of phototypography in the 1960s heralded the Age of Information, as it became increasingly

↑
6–3 *This cover design effectively integrates the sans serif typestyle with similar lines in the accompanying illustration.*

↑
6–4 *Garamond Book, a revised oldstyle typeface.*

easy and important to disseminate information by word and image. Computers now make it possible to quickly develop seemingly infinite variations on existing typestyles quickly. Specialized software makes the creation of new styles simpler and more accessible than ever before, and digital presses continue to speed print production. *Whatever technology used, in whatever century, the eye and mind of the designer remains a vital factor.* **Figure 6–3** integrates type and image by matching quality of line and color.

TYPE CATEGORIES

Like the alphabet itself, typographic design has undergone a long development. A brief look at its history will help you assemble and recognize types with similar attributes, or *type categories*. History provides a key to proper use.

The type category we refer to as *old style*, with gently blended serifs leading into thick and thin strokes, was created around 1470 by Nicolas Jenson, a French printer working out of Venice. French typographer Claude Garamond based a typestyle now known as Garamond on Jenson's design. This classic remains

in use today, and a version of it is shown in **Figure 6–4**. Around 1530 Garamond established the first type foundry—a business set up specifically to market typefaces to printers. The many fonts Garamond created were extremely precise and legible, setting a standard for typographic beauty that is still recognized today. During the early 1700s William Caslon designed a typeface based on Garamond's classic typestyles that was so widely adopted it became the standard for British newspapers.

A modern revival of 15th-century Italian types occurred in Europe and the United States around 1890. Englishman William Morris produced a type called Golden that recalled the spirit of the 15th century. Golden was based on type designs by Nicolas Jenson in the 1470s. Morris set up a hand press in a rented cottage, establishing Kelmscott Press, which was committed to meticulous hand printing, handmade paper, and hand-cut woodblocks. The press celebrated the book as an art form. From 1891 until 1898, Kelmscott Press produced 53 different titles and more than 18,000 volumes. Golden, Troy, and a smaller version of Troy, called Chaucer, were all

abcdefghijklmnop
qrstuvwxyzAB
CDEFGHIJKLM
NOPQRSTUV
WXYZ$1234567
890(.,""'-;:!)?&

6–6 *Baskerville, a transitional typeface.*

Morris's typeface creations based on Jenson and Gothic styles (see **Figure 6–5**).

Most *roman* types today (a regular or normal version of a typestyle) have variations available called *italics*. Italics are slanted letterforms that relate to the original typestyle but do not duplicate it. Around the turn of the 16th century, Venetian printer Aldus Manutius (credited with being the first publisher) and his type designer, Francesco Griffo, developed italics as a way of fitting more letters on a line to save space. For about 40 years, italic was simply another style of type, until an italic was consciously developed from an upright roman mold. Today most roman types have matching italics as well as several other variations, such as bold and condensed.

Roman faces with strong contrast between thick and thin strokes and with thin serifs were developed in the 18th century. These faces are generally classified as *transitional*. Because they were designed specifically for the printing industry, they printed more clearly and

precisely than their predecessors. A widespread interest in copperplate engraving at the time encouraged the development of types that incorporated a very fine line. Baskerville is a serif typeface designed in 1757 by the Englishman John Baskerville. Planning to increase legibility, he increased the contrast between thick and thin strokes, with sharper and more tapered serifs and graceful curves. The result was a lovely, refined design, considered a transitional typeface (**Figure 6–6**).

The typefaces Didot and Bodoni imitated the engraver's tool with precise hairline strokes. The term *modern* is used to describe these 18th-century typestyles. The Italian type designer and printer Giambattista Bodoni was influenced by Didot and Caslon. His entire Bodoni type family ushered in the modern era of hairline serifs and strong contrast between thick and thin strokes.

The 19th century saw the development of many new typefaces with a wide variety of looks. Among these faces were *sans serifs* and the *Egyptians*. William Morris's

→
6–7 Paula Scher. *This layout design for* The Magic Mountain *is part of the Great Beginnings series.* Courtesy of the artist.

revival of the old, classic typefaces occurred during this time.

Since the early 19th century, serif and sans serif types have alternated in popularity. Great interest surrounded sans serif during much of the 20th century. Bauhaus designers in Germany during the 1920s began designing sans serif faces such as Futura. In the 1950s, Univers and Helvetica became the dominant typefaces used by design professionals. The sans serif dominance lasted throughout the 1960s and 1970s. Newer versions of Helvetica show more consistency among font variations. Large x-height and beautiful positive and negative shapes accompany a clean precision and understated elegance of line. The horizontals are cut along a common line.

Figure 6–7 is a layout by contemporary designer Paula Scher that uses sans serif type to evoke an earlier era. Designed in 1984 for the Koppel & Scher firm, this small book featured the first two paragraphs of several famous novels. Each spread was designed in the period style popular when the novel was written. Today's designers are able to choose from a rich array of old and new typestyles. In fact, such an extensive array of fonts is available on every computer that selecting one can be quite difficult. A basic familiarity with typography will help you develop a discerning eye.

Historic Type Families

OLD STYLE

Characteristics of old style faces include thick- and thin-stroke serifs that seem to merge into the main strokes. This feature is called *bracketing*. Garamond and Caslon are examples. Created in the early 1600s, Garamond (Figure 6–4) was the first typeface designed to appear uniformly printed rather than hand lettered. It remained the principal typeface for more than 200 years, with many derivatives.

TRANSITIONAL

This category of type combines features of both old style and modern, emphasizing thicks and thins and gracefully bracketed serifs as in Baskerville. It is lighter than old style and has a more precise, controlled character. It is less mechanical and upright than the modern faces.

Baskerville has straighter and more mechanical lines than the old style typefaces, with flatter serifs that come to a fine tip. Increased contrast between the thick and thin strokes of the letterforms, as well as rounded brackets, give it more delicacy than old style faces such as Caslon.

John Baskerville made several technical innovations that affected the appearance of his type. He passed

Baskerville

Since the first person made a mark in the sand for another to find, we have been communicating with a visual language. The earliest forms of visual communication were pictorial drawings of everyday objects such as weapons and animals. As the desire to communicate grew, these pictures were combined to convey

8/11

Since the first person made a mark in the sand for another to find, we have been communicating with a visual language. The earliest forms of visual communication were pictorial drawings of everyday objects such as weapons and animals. As the desire to communicate

9/10

Since the first person made a mark in the sand for another to find, we have been communicating with a visual language. The earliest forms of visual communication were pictorial drawings of everyday objects such as weapons and animals. As the desire to communicate

9/11

Garamond Book

Since the first person made a mark in the sand for another to find, we have been communicating with a visual language. The earliest forms of visual communication were pictorial drawings of everyday objects such as weapons and animals. As the desire to communicate grew, these pictures were combined to convey

8/11

Since the first person made a mark in the sand for another to find, we have been communicating with a visual language. The earliest forms of visual communication were pictorial drawings of everyday objects such as weapons and animals. As the desire to communicate grew, these

9/10

Since the first person made a mark in the sand for another to find, we have been communicating with a visual language. The earliest forms of visual communication were pictorial drawings of everyday objects such as weapons and animals. As the desire to communicate grew, these

9/11

abcdefghijklmnopq
rstuvwxyzABCDEFG
HIJKLMNOPQRST
UVWXYZ$12345678
90(.,""''-;:!)?&

printed sheets through heated copper cylinders to smooth out the rough texture of the paper then in use. This smooth surface made it possible to reproduce delicate serifs clearly. **Figure 6–8** shows text-size Garamond and Baskerville fonts in different leading (space between lines). When working with typography, the three factors—typestyle, point size, and leading—are interrelated.

MODERN

The modern styles evolved from transitional types. They show still greater contrast between thicks and thins. Modern typefaces are characterized by hairline-thin serifs that join the body with a stiff unbracketed corner. There is strong vertical stress to the letters.

Bodoni (**Figure 6–9**) fits this category. It was created in the late 1700s by Italian printer Giambattista Bodoni. Bodoni was influenced by the work of Baskerville and François-Ambroise Didot, a Frenchman who also gave Europe a fully developed type measurement system.

EGYPTIAN

The first slab serif typestyle was introduced around 1815. The category was dubbed "Egyptian" because Egyptian artifacts and Egyptian travel were in vogue. Napoleon's conquest of Egypt aroused great enthusiasm for that country. During this period, type design became less predictable and more eclectic. Type characteristics were mixed and recombined, producing many variations. The heavy square serifs in this category often match the strokes in thickness. There is less difference between thicks and thins than in the modern and transitional periods. Clarendon and Century are examples of this group.

The popularity of square slab serif type decreased greatly in the early 20th century but then revived somewhat in its latter decades. Lubalin Graph (**Figure 6–10**), designed in 1974 by Herb Lubalin and drawn by Tony DiSpigna and Joe Sundwall, has the characteristics of Egyptian typestyles.

SANS SERIF

William Caslon created the original sans serif in the early 1800s. The 1920s saw the development of sans serif type families including Gill Sans, created by Eric Gill, as well as Herbert Bayer's Universal. In the 1950s, designers of the International Typographic Style examined available typefaces and found them lacking. Weight changes were not subtle enough, and the various weights and widths in a type family often lacked coherency. This disorder was natural, because fonts within a family were often designed by different people. Then a young Swiss type designer named Adrian Frutiger developed a sans serif face called Univers. He created a completely consistent family of types in all possible weights and widths.

Several classic sans serif typefaces were designed at the German Bauhaus (see Chapter 2). Influenced by the Bauhaus, the Swiss firm Haas worked with the German

←↑
6–8 *Point size and leading affect one another.*

←↓
6–9 *Bodoni, a modern typeface.*

→
6–10 *Lubalin Graph, an Egyptian slabserif typeface.*

abcdefghijkl
mnopqrstuvwx
yzABCDEFGHI
JKLMNOPQRST
UVWXYZ$123
4567890(.,'"-;:!)?&

ABCDEFGHIJKL
MNOPQRSTUV
WXYZ&abcdefg
hijklmnopqrstuvw
xyz1234567890
$.,"-:;!?

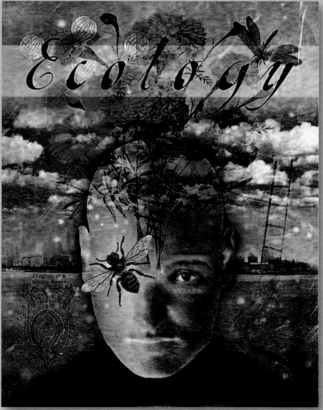

← ↑
6–11 *Helvetica, a sans serif typeface.*

← ↙
6–12 El Lissitzky. El Lissitzky, Russian, 1890-1941, Plastic Figures of the Electro-mechanical Show: Victory Over the Sun, 1923, Color lithograph on wove paper, 532 x 450 mm, Restricted gift of Mr. and Mrs. Gaylor Donnelley, Print and Drawing Club Fund, and the William McCallin McKee Fund, 1966.175b Reproduction, The Art Institute of Chicago / © 2010 Artist Rights Society (ARS), New York / VG Bild-Kunst, Bonn

← ↘
6–13 Diane Fenster. *Book cover for* Ecology. *This appropriate use of an unusual typestyle fits well with the illustration.* Courtesy of the artist.

Stempel foundry in 1957 to produce Helvetica (**Figure 6–11**). It is still considered by many designers to be the perfect type—versatile, legible, and appropriate in a wide variety of applications. **Figure 6–12** is a design from 1923 using a grid layout and sans serif type by El Lissitzky. (Note its similarity to Figure 6–7.) A leading Russian constructivist, Lissitzky believed in the power of graphic design to influence social order. He helped export constructivist theory and style to the rest of Europe through his printed work and lectures.

MISCELLANEOUS FACES

Many fonts do not seem to belong to any category. They are often experimental, ornamental styles of limited application, sometimes created by hand. These eccentric types are rarely suitable for text type, but they do find appropriate usage in display headings, such as the book cover in **Figure 6–13** by Diane Fenster, where type and image are delicately integrated.

It is possible to use specialized ornate styles in display headlines and not hamper readability too greatly. In large amounts of body copy, however, every subtle variation has a cumulative effect that can seriously hinder readability. A classic all-purpose typestyle will remain legible and unobtrusive as body type. Selecting an appropriate text type calls for a sensitive, educated eye.

TYPE FAMILIES

The five categories of typestyles we have discussed are filled with typefaces, such as Bodoni and Baskerville. Each typeface is composed of a type family that comes in a variety of weights and sizes. A *type family* is all the variations of a particular typeface. Helvetica, for example, is available in a series of variations described as light condensed, medium condensed, bold condensed, ultra light, ultra light condensed, ultra light italic, light, medium, regular, medium light, bold, bold italic, and bold extended. **Figure 6–14** displays the Helvetica family.

A specific variation in a specific size is called a *font*. For example, 18-point Helvetica italic is a font. A great variety of shapes exist in a single font. These various shapes can be successfully combined into a unified design because of their similarities in width, brackets, serifs, and x-height. A well-designed combination of type fonts is an excellent example of the interplay of repetition and variety that makes for good design.

Computerized layout gives the designer the ability to make a wide variety of changes in these carefully designed fonts. Vector programs allow type to be mirrored, scaled with varying horizontal and vertical values, and otherwise manipulated for effect. The precomputer *hot type* technology was based on actual physical pieces of metal shaped into letterforms. These could not be stretched or set to overlap unless the sheet was printed twice and the font recast. Now that nearly everything is possible, an enthusiasm for exploration needs to be tempered by respect for the subtle and complex beauty of a font.

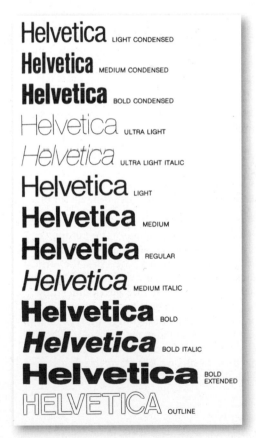

↑
6–14 *The Helvetica family.*

Selection

How do you select which style of type to use? What factors are involved in designing with text type? Selecting the type for a given layout means making decisions in six interrelated areas: type size, line length, typestyle, leading, spacing, and format.

Designers sometimes set their own type as they develop a layout design. But whether you set the type yourself or design it for someone else who prepares it, the six characteristics mentioned earlier need to be specified. It is important to develop a fine critical eye for type quality, watching for problems such as uneven letterspacing and low resolution. Inking problems can be caused by a reversal of a serif typestyle. (**Figure 6–15**).

Size

Text type is any type that is less than 14 points in size. A *point* is a unit of measurement based on the *pica*. There are 12 points in a pica and approximately 6 picas in an inch, so there are 72 points in an inch. The point system of measurement was introduced in the 18th century, because the small sizes of text type called for a measuring system with extremely fine increments (**Figure 6–16**). Type size is measured in points until it reaches about 2 inches (5 cm) high. It is available from 5 points to 72 points on desktop computer menus, or larger sizes can be specified.

The easiest way to measure type without a computer is by comparing it with a type specimen book and matching the size visually (**Figure 6–17**). It can also be measured with a point-and-pica ruler. Remember to measure from top of ascender to bottom of descender. When choosing a type size, keep the audience in mind. Type smaller than 10 points is often difficult for older people to read.

Type size can be difficult to judge on the computer monitor, because the screen image may not be the same size as your final printed page. Also, the vertical, backlit quality of a monitor is a different medium from the printed page, and we interact with it differently. Beginning designers tend to choose sizes that are too large when they first start designing with type on the computer. It is easier to judge the effect of typography accurately in a printed proof than onscreen. However, if the final format will be a Web page, its effectiveness should be judged on the screen rather than in printed form.

Line Length

Line length also is measured by the pica system. It is the length in picas of a line of text type. The dimensions of the page itself, however, are usually expressed in inches (or centimeters). For example, 8-point type may be set in a 22-pica line length on an 8 1/2 x 11" (22 x 28-cm) page format. Or it may simply flow to fill a predetermined column layout in your layout program.

The length of a line is closely related to the size of type. A small point size such as 6 point or 8 point on a line 44 picas long is difficult to read. The type seems to jump around along the midsection of the line, and the eye must search for the beginning of each new line. This trouble is worse when there is insufficient space between lines. Usually you want the reader's eyes to move smoothly, never being forced to slow down or lose their place. The standard line length and point size ratio for optimal legibility is a line 50 to 70 characters long. To remember this ratio, keep in mind that *for optimum readability, line length in picas should be approximately double the point size.* An 8-point type sits well on a 16-pica line. However, variations on this theme can be used purposely to slow the reader down.

Style

When you choose text type, legibility is a prime consideration. Although there are many elegant and accessible styles, stay away from styles with an excess of ornamentation.

Next, seek a type appropriate to the audience, the publication, and your own sense of aesthetics. Sans serif has a modern feel and is highly legible in the limited amounts of copy used in most annual reports, newsletters, and so on. The serif types are generally more traditional and classical in feeling. They are easier to read in large amounts. Many of the newer styles strive to combine the virtues of serif and sans serif type.

Trends arise in type just as in music, clothes, and lifestyles. Notice how they change from year to year. Use the fashionable typestyles only when they seem both appropriate and aesthetically pleasing.

The printing process can help determine typestyle selection. Delicate hairline serifs are not appropriate when a heavy ink coverage is required, because the ink will block up the serifs and result in a blotchy look. Heavily textured paper will also make a delicate serif unadvisable. The texture of the paper will cause the finely inked serifs to break up.

Beginning designers often combine several typestyles in a typographical layout. They choose each for its own beauty and interest but forget the effect

This is an example of a reversed 9 point serif font. Often such delicate lines will be overwhelmed by a reversal.

POINT SIZE CHART

1 1 1 1 1 1 1 1 1 1 1 1

6 8 10 12 14 18 24 30 36 48 60 72

6–15 *A reversed font can decrease legibility.*

6–16 *This pica rule gives measurements in points, picas, and inches.*

6–17 *Type is measured in points until it reaches about 2" (5 cm) high.*

of the whole design. Diverse styles usually refuse to combine into an organized whole and have an undisciplined and chaotic look. Many experienced designers prefer to work within one type family, drawing on its bold, italic, and roman faces (see Figure 6–14). They achieve a look of variety without risking going outside one family. This course is certainly the safest for a new designer.

Exciting layouts, however, often do mix distinctively different typefaces. Mixing takes sensitivity to how the styles affect one another and contribute to the whole. A good rule of thumb when choosing to mix type families is to make certain they are very different. The composition will work if there is either deliberate similarity or definite variety. It can confuse and displease

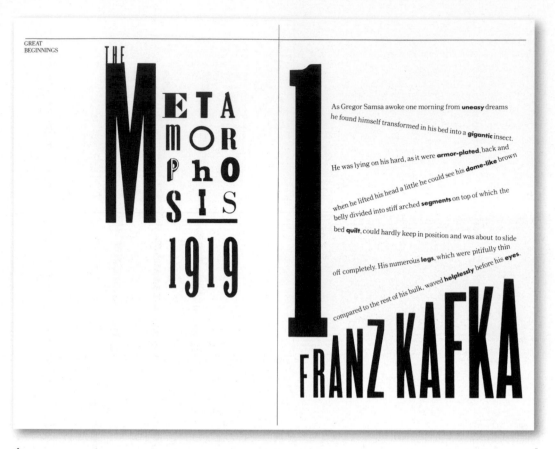

THE METAMORPHOSIS 1919

1

As Gregor Samsa awoke one morning from **uneasy** dreams he found himself transformed in his bed into a **gigantic** insect. He was lying on his hard, as it were **armor-plated**, back and when he lifted his head a little he could see his **dome-like** brown belly divided into stiff arched **segments** on top of which the bed **quilt**, could hardly keep in position and was about to slide off completely. His numerous **legs**, which were pitifully thin compared to the rest of his bulk, waved **helplessly** before his **eyes**.

FRANZ KAFKA

↑

6–18 Paula Scher. *Layout design for* The Metamorphosis *in a brochure for the Great Beginnings series*. Courtesy of the artist.

the eye if the distinctions are muddy. **Figure 6–18** is a design by well-known designer Paula Scher that uses a variety of typographic treatments to present the 1919 book *Metamorphosis* by Franz Kafka. Contemporary designers in print and online graphics have many more choices of typefaces, and opportunities to work with design effects, than ever before. Take a look at **Figure 6-19** on this book's accompanying Web site. 🖱

Leading

Leading (pronounced like the metal lead) describes the vertical spacing between lines of type. The historical origin of the term goes back to hot-metal typesetting, when a thin strip of lead was inserted as a spacer between lines of metal type. This type and leading were locked together

into a galley, inked, and printed. Leading strongly affects the look and readability of the layout. Type is considered to be set solid when no space is inserted between the descender of the top line and the ascender of the bottom line. A 10-point type set on a 10-point leading is an example of solid leading. Herb Lubalin's design for *Avant Garde* magazine in 1967 uses very tight leading (see Figure 7–12). How much leading should you use? Several factors affect that decision, including type size, line length, typestyle, and available space.

TYPE SIZE

Leading should be proportionate to the size of the type. Although there is no one correct leading for a certain type size, we often find 10-point type set on 12-point

6-19 *The AIGA Design Archives is one of the richest online resources available to those who study, practice, and appreciate excellent design. The site will lead the viewer to many creative type solutions. Second Story, inc, a design firm located in Portland, OR created this presentation. Visit their Web site and the AIGA site for inspiration.*

leading. This means an extra 2 points of space have been inserted between the lines of type. A larger or smaller type size may require less leading. A 14-point type may need only 14- or 15-point leading, for instance. It is rare to find minus leading, or a 10-point type set on 9-point leading. Current typesetting technology makes it possible to set one line of type on top of another and to weave entire paragraphs over each other for visual texture. The important criteria always are as follows: Is it appropriate? Does the form follow and enhance the communication function?

LINE LENGTH

Line length is an important factor in determining leading. The longer the line, the more leading is appropriate. With longer line lengths, the eye tends to wander. If there is insufficient space between lines, you will find yourself reading the line above or beneath and having difficulty finding the beginning of each line.

TYPESTYLE

Three aspects of the typestyle also affect leading: x-height, vertical stress, and serif versus sans serif. The x-height, as you know, refers to the size of the body of the letter, without its ascender or descender. The x-height of Helvetica is much greater than the x-height of an older type such as Baskerville. Consequently Helvetica probably requires more leading because it does not have lots of extra white space

packed around its body. It has relatively short ascenders and descenders, so the lines of type appear closer together (**Figure 6–20a**).

The vertical stress of a typestyle also affects leading, because the stronger the vertical emphasis, the more the eye is drawn up and down instead of along the line of type. Hence the greater the vertical stress, the more leading is required. A typestyle such as Baskerville has a stronger vertical stress than Garamond and therefore requires more leading.

A serif helps draw the eye along in a horizontal direction, so serif type is generally considered easier to read than sans serif type. Sans serif type usually requires more leading than serif styles to keep the eye moving smoothly along.

Spacing

Letterspacing is the amount of space between letters of a word (**Figure 6–20b**). A good figure/ground relationship between letterforms is as important with text type as with display type. If the letters are spaced too far apart, the eye must jump between letters, and reading becomes strained.

Whether designing with text type or display type, keep an eye out for the creation of equal volumes of white space between individual letterforms. Kerning is a term that describes the specific adjustment of space between individual letterforms. *IO*, for example, will require spacing different from *MN* (**Figure 6–21**).

The amount of space between words is called *word spacing*. If word spacing is too great, it is difficult for

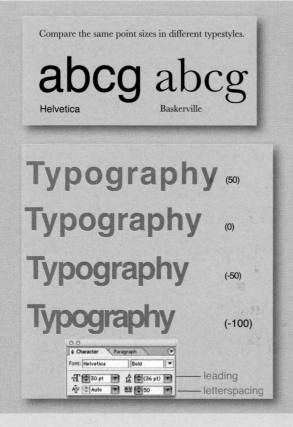

In justified type the lines are all the same length, so that the left and right edges of the column of type are straight. This format is used in newspaper layout and text and trade books. It is useful when speed reading is the primary consideration.

 6–20a *Identical point sizes can have very different x-heights.*

 6–21 *Spacing between individual letterforms must vary to please the eye. This is called kerning.*

6–20b *Letterspacing can vary from very loose to very tight. It is easily adjusted in many software programs. This is called tracking.*

 6–22 *Justifying copy in a short line will cause white holes to appear and can hamper readability.*

GALLERY PROFILE
Paula Scher (b 1948)

Paula Scher (b. 1948) has been at the leading edge of graphic design for nearly 40 years. Scher earned her BFA at the Tyler School of Art in Philadelphia and began her career in the 1970s as an art director for Atlantic and CBS Records. In 1984 she cofounded the Koppel & Scher design firm. In 1991 she joined Pentagram as a partner. Her teaching career includes more than two decades at the School of Visual Arts in NYC, along with positions at Cooper Union, Tyler School of Art, and Yale University. Her award-winning work has been exhibited all over the world and is included in the permanent collections of MOMA, the Cooper-Hewitt National Design Museum, and many more.

Scher has developed identity and branding systems, promotional materials, environmental graphics, and packaging and publication designs for a broad range of clients. Several spreads from her *Great Beginnings* brochure are included in these chapters.

The flush right format is unusal, and somewhat difficult to read. It has a ragged left edge and is used for design effect in special situations.

The flush left format has a straight left edge and a ragged right. This format is commonly used in annual reports, brochures, and identification lines under artwork. One of the benefits of this format, compared with justified copy is that it is possible to avoid hyphenated words.

Centered copy is often found in headlines or invitations, but rarely in standard copy. It is a slow-reading, classical format that encourages the reader to pause after each line.

Asymmetrically arranged type can enhance the message of a poem. It was used early in the 20th century by the poet Apollinaire.

6–23 *Variations in format include justified, flush left, flush right, centered, and asymmetrical.*

the eye to move quickly along the line of type. There is a tendency to pause between individual words. The reader should be unaware of the space between words and aware instead of their content.

Word spacing usually is not a problem with text type, unless the type is being set in a justified format (flush left and flush right edges). To make the lines come out even, the computer will insert extra space between words. If a line is long, with many words, this addition is not noticeable. However, if the line is short, large white holes seem to appear in the copy (**Figure 6–22**). Look at your local newspaper, and squint. Often rivers of white will appear in the columns of text type as a result of a poor combination of justified type on a too-short line length.

Format

Format design refers to the arrangement of lines of type on the page (**Figure 6–23**). There are two basic categories: justified and unjustified. In *justified* type, all the lines are the same length, so that the left and right edges of the column of type are straight. This format is commonly used in newspaper layout and in text and trade books. It is appropriate when speed and ease of reading are the primary considerations. Justified copy is considered by many to be slightly easier to read than unjustified copy. The straight, squared-off columns of type give an orderly, classical feeling to the page.

Unjustified copy can be arranged in a variety of ways: flush left, flush right, centered, and asymmetrically. The New Typography proponents of the 1920s believed ragged right type was more readable than justified type. Unequal line length was also an important part of the International Typographic Style.

FLUSH LEFT

The *flush left* format calls for a straight left edge and a ragged right edge. Typewritten copy is usually flush left. This format is commonly used in annual reports, brochures, identification lines under photographs, and whenever you want a slightly less formal look than can be achieved with justified type. One of the benefits of this format is that it is possible to avoid hyphenated words. Page layout software programs usually allow the user to set parameters for hyphenation. A designer can specify how many hyphenated line endings can happen in succession and just how ragged the right or left edge can become.

6–24 *An asymmetrical typographic illustration by* **Donna McWilliams** *for her student portfolio. Based on Galatians 5:22–23.*

→

6–25 *Visitors can peer into the colorful past of Portland Oregon's Armory building, introduced by the period-inspired typography. Second Story, inc created this move-able peep-show in 2006. The cabinet borrows elements of the Armory's facade while the interior shows viewers mechanically inspired animation.*

FLUSH RIGHT

The flush right format is unusual and difficult to read. It has a ragged left edge and is used for design effect in special situations. It is difficult for the eye to search out the beginning of each new line without a common starting point.

CENTERED

Centered copy is often found in headlines or invitations but rarely in standard copy. It is a slow-reading, classical format that encourages the reader to pause after each line. It is important to make logical breaks at the end of each line. This format has a pronounced irregular shape and packs a lot of space around itself. The white space and irregular outline can draw the eye strongly. Consider the content of your material, how rapidly it should be read, and the overall look of the page before deciding on a centered format.

ASYMMETRICAL

Asymmetrically arranged type can put across the point of a poem or an important statement. Asymmetry is also used in display type to achieve better balance among letterforms. Contour type is a form of asymmetry that fits the shape of an illustration, following its contour. Type that is set around the squared edge of a photo is called a runaround. Occasionally type will be set in the shape of a contour itself.

The ancient Egyptians and Greeks originally experimented with this format. It was used early in the 20th century by the poet Apollinaire and more recently by contemporary designers. **Figure 6–24** is an asymmetrical typographic illustration.

Style and Content

Typography sets a visual tone depending on the variables we have just examined. The style, the leading, and the format all contribute to a nonverbal communication that has a great deal to say. This visual communication, or visual language, affects the image of the client. It is a function of the choices the designer has made—partly as a personal preference, partly in response to the client's needs, and partly in response to contemporary design trends. The type design shown in **Figure 6-25** presents old style typography placed on a very modern interactive exhibition.

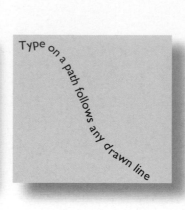

6–26 *Type inside a shaped area, type on a path, and vertical area type are shown here.*

Specific typestyles and layout designs are associated with historical periods. Typestyles can evoke the mood of an era just through careful type selection and usage. The 20th century in the United States saw many styles come into vogue and then fade out. Typestyles reflect their era's philosophical and technological status.

Wood display type was widely used in the 1800s. By the latter part of the century, these wooden typestyles became elaborate, beautifully decorative designs. Typestyles and trends continued to change, reflecting the sensibilities and technology of the time. The Broadway typestyle was popular in the 1930s; the sans serif styles of Helvetica and Univers were widely used in the 1950s and 1960s. Today's styles show an appreciation for classic style as well as an eclectic willingness to experiment with unusual graphic effects, as digital typesetting encourages stylistic innovation.

With the advent of digital typography, special effects with type and layout design have become easier to achieve than ever before. Experimentation is good, especially when tempered by a firm knowledge of traditional typographic design principles. **Figure 6–26** shows some examples of digital options for type placement. The vertical treatment is not generally recommended.

Some Problems

Once the format for the layout is selected and the type is set, some awkward accidents may occur. If you are aware of these potential problems, you can avoid them.

Widows and *orphans* are romantic names designating short, isolated paragraph-ending lines. A widow is a short line that appears at the top of a printed column and is most distressing when it appears at the top of a new page. An orphan is a short line that appears at

DIGITAL FOCUS
More about Type

Computer programs that work with vector graphics typography can generate a wide variety of typographic effects. Type can be keystroked directly (or placed from word-processing programs) into Illustrator, Freehand, or InDesign and others, with a wide variety of effects to choose from. The same block of type can be placed with a variety of sizes, fonts, spacing, and formats using these programs. With all these choices available, it is more important than ever to develop a good eye for type use. In your program of choice, experiment with type on a path, type inside an area, and varying formats, and become familiar with an array of fonts and spacing options. Keep an eye out for elegance, understatement, clarity, and beauty. But an element of "fun" can also be a great addition.

the bottom of a column or page, or a single word or word part that appears on a line by itself at the end of a paragraph.

Hyphenation can also become a problem, especially if the line length is short and the format is justified. Too many hyphenated words will interfere with readability. Hyphens should always fall between syllables, and they should not chop a word into unrecognizable segments.

A DESIGN SUMMARY

Designing well with typography is a delicate thing. It relies on so many interrelated variables that it cannot be reduced to a simple formula. Here, however, are a few general guidelines:

- When choosing typestyles, remember that it is wise to either stay within the same type family or mix very different fonts. For example, two similar serif fonts will be more difficult to use together than a serif and a sans serif. Staying within a family is safe. It gives a wide but unified choice.

- The design principles of proximity, similarity grouping, and focal point are all important to consider in layout design. Variations in point size and font style function as a code to guide the reader. The heading and subheading formats in a text, for example, should be carefully chosen to visually group information and highlight topics. Each heading should be placed closer to the information it introduces than to the unrelated paragraph above it.

- Decide what kind of speed you want from your reader. A justified format is the quickest read; ragged right takes a little more intimate involvement on the part of the reader. A centered format is a slow read, presenting itself line by line rather than as a grouped paragraph. Mixing these formats can give the reader visual clues about the content. The running text in a chapter may be justified, for example, while the photo captions are all ragged right.

- Every element that goes onto a page is important. Every element contributes to the whole, so take nothing for granted.

EXECUTION
Specifying and Correcting Copy

When you specify or "spec" copy, you provide all the information necessary to set the final type for layout: typestyle, point size, leading, format, line length, sometimes letterspacing, and special instructions. Almost always some corrections are needed in typeset copy, due to last-minute revisions or errors caught late. Proofreading is an easier job now, with the spell-check feature available on type-based programs. Use it always. However, do not rely on it to always be correct. Take a look. Did you mean lie or lien? They both pass a spell check.

You can use proofreader's marks to request error corrections from a design point of view, such as damaged copy, poor breaks in words, or incorrect fonts. These time-honored proofreader's marks for communicating with a typesetter are shown in **Figure 6–27**.

Delete Close up

Insert here Elevate a word

Move to left Move to right

Lower a letter Insert an Em space

Insert 2 Em spaces Broken type, please reset

New paragraph No new paragraph

Open up a space Close up a space

Restore to original Wrong font

Transpose Set in caps and lower case

Set in all caps Set in small caps

Set in boldface Set in roman

Set in italics Change to lower case

Insert period

6–27 *Proofreader's marks.*

EXERCISE

Study various magazines, newspapers, and other publications for samples of different typographic treatments. Which are successful, and which are flawed? Choose two of the less effective samples for analysis. Determine their line length, leading, point size, and typestyle, making recommendations for improvement. Prepare these for a class discussion.

PROJECTS

Typographical Illustration of a Poem

Select a poem or a portion of an interesting and emotive piece of prose (song lyrics are OK) that is no longer than 20 lines. Set it twice. The first time, follow the standard guidelines for typography to enhance readability, paying close attention to leading, line length, spacing (kerning and tracking), and format. Select one type family, limit the fonts, and restrict the point-size variation. Look at Josef Müller-Brockmann for inspiration.

*The second time you set the copy, break as many rules as you wish while creating an effect appropriate to the piece and your feelings about it. Experiment with complexity and diversity. Use a vector graphics program for this project. If your class is using Photoshop, feel free to incorporate imagery that echoes your type treatments (**Figure 6–28**).*

↑
6–28 *Spread from BYU Magazine. Design studio: BYU Publications & Graphics, Provo, Utah. Art Director:* **Bruce Patrick**. *Designer/Illustrator:* **Emily Johnson**. **John Rees photographer**/ johnrees@qwest .net. *Courtesy of the artist.*

Book Cover Design

Book covers are like small posters. They attract readers with their strong visuals. Create two covers for books that are part of a reissued series by a 20th-century author. The covers for this series should be visually united to indicate that the books are part of a series. Consider similar color, layout, graphic technique, and so on. Be sure the covers are also varied enough to hold interest. Use a primarily typographic treatment. Paula Scher's designs for the Great Beginnings series shown in this chapter may provide good inspiration for this project. **Figure 6–29** *is a professional cover design that effectively uses an integration of type and image.*

↑
6–29 *This textbook cover skillfully places a dramatic photo behind a large, lower case, sans serif type. The column of type on the right is aligned with the right side of the "m".*

Design the entire cover for this assignment, including front, spine, and back. Include appropriate information. Include space for the flaps and print the finished pieces, folding them around an actual book for final presentation. Consider incorporating an image. The research part of this assignment is important. Be familiar with the author's writing so that your design reflects the content and tone of the writing. Spend time at a local bookstore, or online (but a bookstore smells better) looking at the competition's cover designs and searching for designs that are primarily typographic. Look at a series, and consider how the cover designs are united. **Figure 6–30** *shows a solution to a similar problem.*

GOALS AND OBJECTIVES

Practice integrating text and display type while carefully orchestrating eye direction.

Explore creating various typographic treatments.

Learn to apply gestalt unit-forming principles to layout design.

CRITIQUE

Answer the following questions for your own design and for another from the class. What typestyles were used in the solution to this design problem? Are they appropriate to the subject matter? Why? Consider all the characteristics of the chosen fonts. Ask yourself questions such as the following: Can the choice of point size be improved? Do you see any widows or orphans? How can they be avoided in this design? How do the type and/or image contribute to establishing a mood appropriate to the book's content?

↑

6–30 Tiffany Dorner *created this cover design for her student portfolio by using Photoshop and Illustrator. Her personal logo is included on the spine.*

Visit the accompanying Web site for research links. Studio techniques show beginning raster graphics including scanning.

Louisville Ballet

TERMINOLOGY
(See glossary for definitions.)

layout design
symmetrical layout
asymmetrical layout
proportion
golden section
visual rhythm
alternating rhythm
progressive rhythm
grid layout
visual weight
visual design theme
editorial content theme
path layout
focal point
cropping
resizing
resolution
interpolation

KEY POINTS

Page layout, whether in print or Web format, calls for a skillful balancing of diverse visual elements throughout the design (**Figure 7–1**). Multiple pages, and sometimes multiple documents, must be integrated with one another through the repetition and variation of visual (and related conceptual) themes. This chapter discusses how to use grid and path layouts to achieve a dynamic, unified design between pages. Everything you have studied in previous chapters about visual gestalt is relevant here.

THE BALANCING ACT

Layout design is a balancing act in two senses. First, it relates the diverse elements on a printed page in a way that communicates and has aesthetic appeal. Ideally, the form enhances the communication, no matter what style is being used. **Figure 7–2** uses type placement to illustrate the fear of flying and all it symbolizes. Every element on the page affects how the other elements are perceived. Layout is not simply the addition of photographs, text type, display type, or artwork. It is a carefully balanced integration of elements.

→

7–2 Terry Koppel. *(Koppel & Scher, New York.) Layout for* Fear of Flying *in brochure for Great Beginnings series*. Courtesy of the artist.

← **7–1 Julius Friedman**, *designer;* **John Lair**, *photographer. Poster for the Louisville Ballet.*

The layout artist must select an appropriate typeface from the vast array available. The format, size, and value contrast of the typographical elements should be closely related to accompanying photographs and illustrations. Layout may be the most difficult balancing act a designer is ever called on to perform.

A good relationship between figure and ground is essential. The careful shaping of the white ground of the page gives cohesion and unity to the figures or elements placed on it. No leftover space should be unshaped (undesigned) because open white space functions as an active, participating part of the whole design. Pages can be designed with a *symmetrical layout* or an *asymmetrical layout*. Figure 7–2 uses asymmetry on the left page and symmetry on the right page to achieve its overall design. In either case, sensitivity to figure/ground grouping and white space enhances the readability and beauty of the page.

A careful balancing of contrast can give the page dynamic, unpredictable energy that will draw the reader's eyes. Chapter 4 discusses contrasts in size, shape, value, and texture, showing how a combination of similarity and contrast creates a balanced and successful layout. Chapter 6 discusses the use of typography

and design elements in a single-page layout. This chapter discusses the balancing of multiple pages that is relevant in both print and Web design.

SIZE AND PROPORTION

This difficult balancing act calls for sensitivity to *proportion*—the organization of several things into a relationship of size, quantity, or degree. Artists have understood the importance of size relationships for centuries. The Parthenon expressed the Greeks' sense of proportion. It was based on a mathematical principle that came to be known as the *golden section*. The 15th-century painter and printmaker Albrecht Dürer used the golden section to analyze and construct his alphabet (**Figure 7–3**). The 20th-century architect Le Corbusier applied the proportions of the golden mean, or section, to architectural design. It is based on a rectangle that can be subdivided into a square. The square can be divided into two rectangles with the same proportions as the original. Each resulting small rectangle can be subdivided to produce the same results. **Figure 7–4** shows a diagram of those proportions. Ultimately, however, any mathematical system is only a tool to aid the designer's intuitive feeling for proportion and a sense of balance and energy in contrast. When the

↑
7–3 Albrecht Durer. *Fifteenth-century type designs based on the golden section.*

↑
7–4 *The golden section is believed to generate harmonious proportions.*

↑

7–5 Emil Ruder. *Page areas in harmonious proportion.*
Diagrams courtesy of Arthur Niggli Ltd., Niederteufen, Switzerland.

contrast between elements is too great, harmony and balance are lost.

The division of a page into areas in harmony with one another is at the heart of all layout design. **Figure 7–5** shows how Emil Ruder, an influential 20th-century Swiss designer of the International Typographic Style, worked at bringing a page and its elements into harmony. He felt that the relationships between type sizes, between printed and unprinted areas, between type and image, and between various values of gray must all be harmoniously proportionate.

When we refer to size, we usually use words like *big* or *small*. These terms are meaningless, however, unless we have two objects to compare. A 36-point word in a page with a lot of text type will seem large. On a spread with a 72-point headline, it will seem relatively small. An element large or bold in proportion to other elements on the page makes an obvious visual impact and a potentially strong focal point. Do not be afraid to use a very large element, as in Figure 7–2, where the letter *T* makes a bold graphic statement. Several magazines use a larger format than is standard. This is another example of size contrast. Next to other magazines on the news racks, they have the impact of a comparatively large and impressive display.

Another way of determining size is to have a standard expected size in mind. If we refer to a large house cat, "large" may mean more than 12 inches (30 cm) high. If we refer to a large horse, we have a different size in mind. Deliberately violating this expectation can create a dynamic, unusual effect. Mixing standard relative

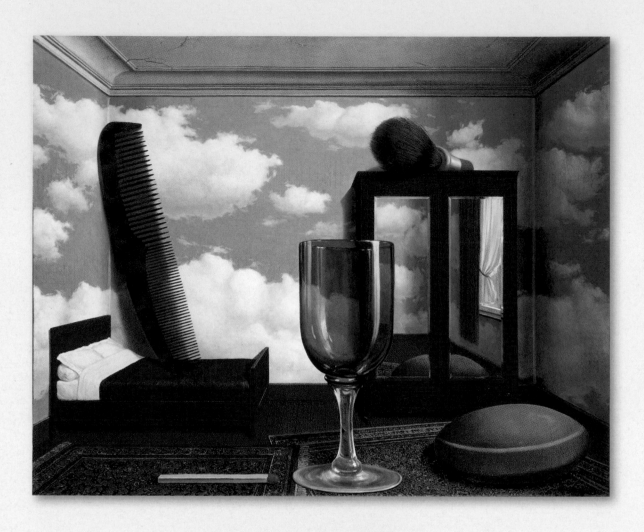

CHAPTER 7 Layout Dynamics

sizes creates strong tension and compelling interest, as shown in the surrealist Rene Magritte's painting in **Figure 7–6**.

Another approach to confusing our sense of size and scale is showing objects larger than life. On the printed page, viewers have come to expect things to be shown smaller than they really are. We have no problem accepting a photograph in which the Empire State Building appears 3" (8 cm) high, but magnify a relatively tiny object, and we get a visual jolt that makes us pay attention. Imagine a photograph of a common housefly 20 times its actual size. **Figure 7–7** shows a creative play on portfolio size by designer and educator Karen Roehr. This tiny portfolio, when mailed to a potential client, draws attention because it is so much smaller than expected.

VISUAL RHYTHM

Another important consideration in layout design is *visual rhythm*. Life itself is based on rhythm. There is a rhythm to the passing days and seasons. The tempo of our days may be fast or slow. The growth and gradual decline of all natural life forms has a rhythm. Cities have particular pulsing rhythms. Different periods in our history have seemed to move to various beats. Our current age has an eclectic/quickened tempo compared with a hundred years ago.

Visual rhythm is based on repetition of shapes, values, colors, and textures. Recurrence of shapes and the spacing between them set up a pattern or rhythm. It can be lively and lyrical or solemn and dignified. Rhythm is crucial in many visual artists' work, including the London subway illustration in **Figure 7–8**, in which repeated shapes in water, woods, and sky vibrate with energy. The bird and boat reinforce each other, carrying our eyes in a race toward the lower right of the composition, while the rounded triangles of sailboats (in primary colors) set up a counterpoint to the primary rhythm.

←↑
7–6 René Magritte. Magritte, René (1898–1967) Les Valeurs personnelles, 1952. Oil on canvas. Location: Private Collection. Banque d'Images, ADAGP / Art Resource, NY / © 2010 C. Herscovici, London / Artists Rights Society (ARS), New York

←↓
7–7 Karen Roehr. *"Good Things Come in Small Packages," a direct-mail self-promotional design. The accompanying note suggests that the recipient call to see the "bigger book" of this contemporary freelance designer.*

→
7–8 Regent's Park *by* **Frank Ormrod**, *created in 1937 for the London Underground. 40 x 25". This illustration for the London subway system uses rhythm and repetition of line and shape to unify its design.* London Transport Museum.

REGENT'S PARK

There are many ways to use rhythm in typography. Within a single word, a rhythmic pattern of ascenders and descenders and curves and straights is created. The rhythm may be symmetrical or asymmetrical. Letter and word spacing can set up a typographical movement of varying tempos, as can changes in value and size (**Figure 7–9**). The total layout of the page is another opportunity to form a rhythmic pattern. The lines of type can form a rhythm of silent pauses, of leaps, of slow ascents and descents. An endless variety of rhythms can be created this way.

The spacing and size of photographs can intermingle with typography. An *alternating rhythm* may reserve every right page for a full-page photograph while the left page is textured with smaller units of text and other elements (**Figures 7–10a, b**).

Another form of rhythm is *progressive rhythm*. The repeated element changes in a regular fashion, as in **Figure 7–11**, in which the typography beautifully echoes the image. Text type may be used in changing values from regular to bold to extra bold and back again. An illustration may be repeated on successive

→

7–11 Dugald Stermer *created this powerful hand drawn integration of typography and image.*

↑↑
7–9 *Letterspacing, size, font, and placement affect tempo.*

↑
7–10a, b *Layouts for self-promotional brochure by 12Twelve Design, a division of Terry Printing.* **Mary Hakala**, *art director;* **Dennis Dooley**, *photographer.* Courtesy of the artist.

a

b

pages, each time with more of the image displayed. Change in a regular manner is at the heart of a progressive rhythm.

GRID LAYOUT

A sense of pacing and rhythm can be set up throughout an entire publication with the aid of a grid. A *grid layout* is an invisible structure that underlies the page and functions as a guide for the placement of layout elements.

When and why is it appropriate to use a grid? Large publications usually require one to keep order. Grids may also be used in single-page designs, such as advertisements and posters, as in **Figure 7–12**, created by the 20th-century American designer Herb Lubalin. Grids are used to bring continuity to single pages or multiple pieces of a design series. A grid is most useful when it brings an organized unity not only to a single page but also to facing pages, an entire publication, or a series of publications.

Layout design that uses a grid is as flexible and creative as its designer is. The grid has been accused of bringing a boring conformity to page design. Grids, however, can help generate distinctive, dynamic images. They allow for experimentation with all the forms of contrast. A grid functions like a musical instrument. A piano, for instance, has a limited number of keys of fixed tone and position. It is possible, however, to play many different musical compositions through placement, rhythm, and emphasis. **Figure 7–13a** by Herb Lubalin brings many different elements into harmony by using a grid.

← ↑
7–12 Herb Lubalin. *Advertisement for the magazine* Avant Garde's *antiwar poster competition, 1967. An underlying grid and play on size contrast give a tight structure to this design.* Courtesy of the Herb Lubalin Study Center of Design and Typography at the Cooper Union

← ↙
7–13a Herb Lubalin. *Cover for* U&lc *magazine. 1974. An underlying grid gives a clear structure to the many diverse elements in this layout design.* Courtesy of the Herb Lubalin Study Center of Design and Typography at the Cooper Union

← ↘
7–13b Chris Eichman *designed this Web site for the author featuring her paintings. The pages are integrated by a common color and grid scheme.*

Keeping the Beat

A musical composition has timing or a beat that pulses beneath all the long and short notes. In a visual composition, a grid often keeps this beat. Just as a four-beats-to-the-measure musical score would not be cut off at 3.5 beats, a grid layout that has four sections across will not end at 3.5. Whether the fourth unit is filled with an element or left as a white ground, it gets its full count and full *visual weight*. Within these four musical counts may be a mixture of quarter notes, half notes, and whole notes. The four-unit grid may hold one large four-unit element, two half-unit elements, or four quarter-unit elements. The beauty in any composition, whether visual or auditory, comes once the structure is set up and the variations in pacing, timing, and emphasis begin.

Playing the Theme

An underlying musical theme, as in Beethoven's Sixth Symphony (the *Pastoral*), appears over and over in different guises, tying the symphony together into a whole. An underlying visual theme accomplishes the same for a visual composition. A layout for a publication unfolds through time, just as a musical concert does. Each page must be turned before the next is revealed. It cannot be seen and grasped at one viewing, like a painting, an advertisement, or a poster. Unifying it requires a theme. Often this theme includes both a purely *visual design theme* and an *editorial content theme*.

The editorial theme could be the repetition of quotations on a particular topic. It could be a contrast of "then and now," a set of interviews—anything that seems to tell an interesting story related to a common topic. Advertising campaigns are usually based on an editorial theme. Specialty publications such as annual reports, which revolve around one company, may also use an editorial approach. The artist Web sites shown on page 118 have a natural cohesion of theme that is enhanced by the consistent layout structure (**Figure 7–13b**).

A visual theme almost always accompanies the editorial theme. It may be the repeated use of a single thematic photograph on several pages throughout the publication. It may be a particular repeated arrangement of typography—or of the grid itself. Several images in this chapter show two-page print spreads that make sensitive use of an underlying structure to bring unity to the pages.

Grids in History

The grid is by no means a new invention. It has been used for centuries by various cultures to design

↑↑
7–14 *An ornamental grid design.*

↑
7–15 Julius Friedman *and* **Walter McCord**, *designers;* **Craig Guyon**, *photographer. Quilts: Handmade Color.*

ornamental screens and textiles (**Figure 7–14**). It has formed the basis for quilt design, architecture, and navigation. Eastern cultures, Native Americans, Africans, Western designers, and a host of others have used it. The squared grid, in which each of the four sides of a unit is equal to the others, is the simplest variation, but it is capable of yielding sophisticated results, whether used in quilts or layout design (**Figure 7–15**).

Renaissance artists developed a method of examining a subject through a network of strings and then drawing on paper similarly divided into sections. In the 20th century, the grid became interesting to artists as a shape in itself. Frequently drawings, illustrations, and paintings allow the grid structure to show through, just as Bauhaus architects insisted that the structure of their buildings show through.

Today many layouts that have a strong grid structure trace their origins to the de Stijl movement. By 1918 both van Doesburg and Mondrian were using dark lines to divide their canvases into asymmetrical patterns (Figure 2–20).

A more recent figure associated with the grid layout is Swiss designer Josef Müller-Brockmann. He had tremendous influence on the structure and definition of graphic design. He stated that *"The tauter the composition of elements in the space available, the more effectively can the thematic idea be formulated."* Copy, photographs, drawings, and trade names are all subservient to the underlying grid structure in this modernist approach, which continues to have a strong influence on contemporary design (Figure 4–3).

Grid design is incorporated into our current technology. Dedicated page layout programs like InDesign and Illustrator do an excellent job of accommodating a grid-based layout. They allow the designer to construct a grid or use a prepackaged one and specify type to fill the columns.

Choosing a Grid

Grids differ from one another as much as the minds that create them. They vary from the familiar three-column format to overlapping squares to a variety of contemporary creations.

The first consideration when choosing a grid is the elements it will contain. Consider the copy. How long is it, how long are the individual segments, and how many inserts and subheads does it contain? If the copy is composed of many independent paragraphs, the underlying grid should break the page area up into small units. If the copy is a textbook of long unbroken chapters with few visuals, however, a complex grid is wasted; most of its divisions will seldom be used.

Now consider the art. A publication that uses many photographs and illustrations will call for a grid different from that of a publication that is copy heavy. Whenever many elements need to be incorporated into a layout, a more complex grid, broken down into many small units, is the most useful. It will give more possibilities for placing and sizing images.

You can create your own grid that corresponds to the number of elements and the size of your page. The tinier the grid units, the more choices you will need to make about placement. The more placement options there are, the greater the chance that the underlying unity will be lost. In other words, sometimes a simple grid is the best choice.

Both the vertical and the horizontal divisions in a grid are important. The vertical dividers determine the line length of the copy. Both the vertical and horizontal lines determine the size of photographs or artwork. Remember to relate line length and type size to make it easy for the eye to read and keep its place. Forcing large type into small grid units makes for slow, difficult reading.

Constructing the Grid

The vertical divisions of the grid are usually expressed in picas or in inches, as is the line length of copy measured for typesetting. The horizontal divisions are most frequently measured in points, as is leading. A 10-point type, for example, with 2 points of leading between lines would be set on 12-point leading. This type could be specified at a 21-pica or 3½-inch line length. The column width would correspond. The structure is usually sounder if the elements themselves align with the grid edges and only suggest the presence of the grid. With precise alignment, our eyes will draw an invisible line of continuation between elements that forms a much stronger bond than a physical inked line, as shown in **Figure 7–16**.

Grid structure and the path layout discussed next are both used to bring balance and harmony to page design. Both depend on the eye and mind detecting such unit-forming factors as repetition and continuation, tempered with a deliberate contrast or variation for effect.

PATH LAYOUT

The *path layout* assumes no underlying, unifying grid structure. Rather, the designer begins with a blank sheet of paper and attempts to visualize the elements on it in various arrangements. This complex approach can yield tremendously varied results. The unity comes from a direct reliance on unit-forming factors. This reliance is sometimes unconscious, but beginning designers should learn and practice it on a conscious level. It can lead to excellent results.

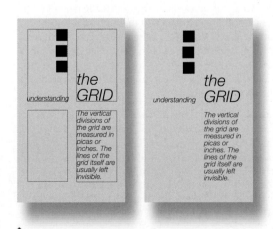

7–16 *The invisible line of continuation between elements on a grid helps create a unified composition.*

The word *path* describes this less structured, more spontaneous approach because the designer is attempting to set up a path for the eye. The goal is to guide the eye skillfully through the various elements. To do so, there must usually be a clear entry point, or focal point, and a clear path to the next element and the next. A simple symmetrical and centered path layout is used effectively in Figure 7–1.

Focal Point

The *focal point*, or the point of entry into a design, is the first area that attracts attention and encourages the viewer to look further. If at first glance, our eyes are drawn equally to several different areas, visual chaos results and interest is lost. Focal points can be set up in many different ways, but they all have to do with creating difference or variety. Whatever disrupts an overall visual field will draw the eye. The focal point should not be so overwhelming that the eye misses the rest of the composition.

These differences could become the focal point:

- A heavy black value set down in a field of gray and white.

- A small isolated element set next to several larger elements near one another.

- An irregular, organically shaped element set next to geometric ones.

- A textured element set next to solid areas. Text type can often function in this manner.

- An image or word that is emotionally loaded.

PHOTOGRAPHY IN A LAYOUT

An important element in layout design is the photograph. An art director or designer must learn what makes a good photograph and how to use it to best advantage. Copywriters, photographers, and designers depend on one another's skills. Poor page design can make a beautiful photograph lose all its impact and appeal. Conversely, a poor photograph can be strengthened by a good design.

Dynamic photos, strong in design and human interest, can be made to look lifeless with certain design mistakes. One problem can be the paper choice. If it is too absorbent for the reproduction method, it will ink poorly, so the value contrast in the reproduced photos will be muddy. Another common mistake is lack of size contrast. When photos of similar sizes compete for attention, the eye will be drawn to none. Other

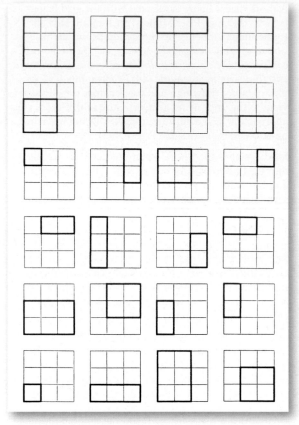

↑

7–17 Emil Ruder. *Photo placements on a grid*. Design courtesy Arthur Niggli Ltd.

elements on the page may also point away or detract from the photographic image.

Figure 7–17 by Emil Ruder shows different ways of placing a photograph on a grid layout. Practice some variations yourself, attempting to establish a visual pacing. A similar grid and photographs for placement can be found on this text's accompanying Web site. You can practice cropping and resizing these photographs in Photoshop. 🖱

Cropping

Sometimes photographs can be improved by the designer's careful cropping. *Cropping* is eliminating part of the vertical or horizontal dimension of

↑

7–18 Dan Bittman, *designer;* **Corson Hirschfeld**, *photographer; and* **the Hennegan Company**, *lithography. Poster for the Cincinnati Ballet Company.*

a photograph to focus attention on the remaining portion. Cropping is also used to fit a photograph into an available space by altering its proportions. When cropping to fit a space, use discretion, because cropping can destroy the mood and design of the image.

Sometimes a photograph, like an overwritten paragraph, can be improved by deleting excess information. The format is fixed in a camera, but the action being photographed may be taking place within a compact square area or a long, thin vertical. Trimming away the meaningless part of the image on the sides will improve the impact. It can also enhance a feeling of rhythm, as shown in **Figure 7-18.**

Cropping a photograph can make it dramatic. If you wish to emphasize the height of a tall building, for example, cropping the sides to make a long, thin rectangle will increase the sense of height. Cropping the top and bottom of a long horizontal shot will increase the sense of an endless horizon.

Cropping causes us to focus on the dramatic part of the image in Figure 7–18, a poster for the Cincinnati Ballet Company. The feet present a theme of repetition and variation and set up a wonderful visual rhythm.

Resizing

All the traditional *resizing* methods are becoming less important, as designers usually resize, crop, and experiment with the results on the computer. The important thing to understand is the concept of ratio. You must maintain the integrity of the photograph, without expanding or distorting the image to fit a space. Always maintain the original (or cropped) height-to-width ratio when rescaling a photograph. The software can help with that if you check the retain-proportion box or hold down the shift key when resizing.

Selecting

A designer may receive the photographs to work with or have the opportunity to order specific photos shot.

DIGITAL FOCUS
Resizing

When resizing a digital image it is important to pay attention to the resolution. *Resolution* refers to the fineness or sharpness of an image, based on the number of pixels per inch (ppi). Plan on 72 ppi for screen images and 300 dots per inch (dpi) for most print applications. When an image is resized, the resolution changes. As the image gets larger, the resolution decreases, because the same number of pixels are covering a larger area. To fill the space, the pixels get larger and coarser.

If you need to change the resolution or size of your digital image, open it in Photoshop and select Image > Image Size. Look at the resolution and document size. Check the constrain-proportions box to keep the horizontal and vertical dimensions proportionally true. Uncheck the resample-image box to make the resolution increase and decrease with changes in the file's physical size, as shown in **Figure 7–19**. Checking the box will let you maintain a resolution while changing the physical size, and vice versa. If you enlarge the image size significantly, however, it will not stay a clear image, because the increased pixels are *interpolated*, or generated by the program, and do not reflect actual data. Locking in a resolution while reducing size will produce crisp results.

↑
7–19 Adobe Product screenshots.

You may also elect to shoot them personally. It is a wise idea for anyone considering a career in graphic design to take a course in photography.

Choose photographs for your layout on three considerations: the quality of the print or digital file, the merit of the design, and the strength of the communication.

Photo retouching programs make it easier to correct problems with print quality. It is helpful to understand what good reproduction qualities in a photograph are in order to recognize and retain them. Watch for good contrast between darks and lights, a full tonal range, sharp focus (where appropriate), and lack of scratches, dust spots, and other imperfections. The Digital Focus box above discusses the relationship between digital resolution and resizing.

Multipanel Design

Folders and brochures present a layout problem slightly different from that of magazines, newspapers, and books. A brochure is actually more a three-dimensional construction than a two-dimensional layout. Contrasting size and visual rhythm to achieve harmonious proportions remains important.

The additional element of the fold complicates matters. Brochures may fold and unfold into unusual shapes (**Figure 7–20**). They may unfold several times and at each successive unfolding present a new facet of the design. Use this opportunity to tell a story. Each panel can give additional information, with the front panel acting as a teaser. Never give your punch line on the front panel. Lead up to it. A successful front panel will lure the reader inside. The succeeding panels will build interest and develop a theme. The panels in **Figure 7–21** gradually unfold to reveal the message "Imagine." If the brochure is a self-mailer, the address and stamp are placed directly on the back.

Other special decisions go into a multipanel design: the size of the piece, the number of folds and their

→
7–20 *Brochure construction calls for a design unified across multiple panels.*

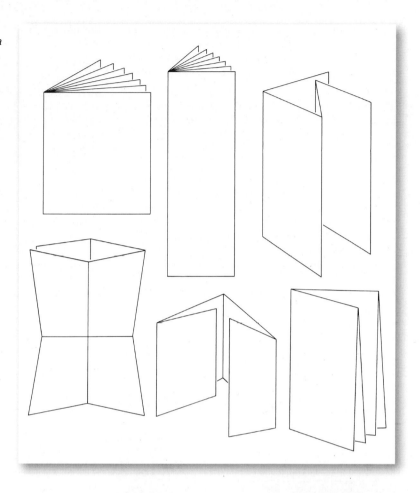

↑
7–21 Anita Syverson *created this multipanel design for Cummings Advertising, making creative use of stock photography.*

direction, and the flexibility of the paper. Usually, when preparing a comprehensive, the designer will try to use a paper similar to the one on which the brochure will finally be printed. Then the client can hold and unfold the design.

The brochure or flyer will often be part of a unified publication series. Then you must sustain the visual and intellectual theme of the entire series.

Layout Styles

During the discussion of design history presented in Chapter 2, you learned that the European-influenced modern style was exported to the United States during the 1940s. Characterized by sans serif typography and the belief in a universally shared aesthetic, the modern style saw order as the spirit of a modern, rational, technological civilization. The development of the grid system seen in the work of Swiss designers Josef Müller-Brockmann, Emil Ruder, and others fit into this perception of design as a wedding of science and aesthetics in a rational world.

Design in the 1960s became more eclectic and inclusive. The 1970s saw a questioning of the rational Swiss Design approach that led to the development of New Wave or postmodern graphic design. The designs of the International Typographic Style and modernism were seen as too reductive. A new interest in complex, layered forms and meaning developed. April Greiman's work shows the exuberance of this inclusive, eclectic style, which celebrates complexity and diversity while Greiman's work retains a strong sense of underlying structure (see **Figure 7–22**). As postmodernism has grown, art and design history has become a great visual resource for inspiration, a resource in which all styles are potentially meaningful. Art nouveau, art deco, pop art, Swiss modernism, and personal intuition may all be combined to generate the postmodern design.

←
7–22 April Greiman. *Poster. Objects in Space, AIGA Orange County. Four-color offset, fluorescent process, 24 x 36", 1999.* Courtesy of the artist and Made in Space, Inc.

April Greiman (b. 1948) created her first electronic designs on the Macintosh in 1984. She experimented with overlapping images and graphical elements, bitmapped fonts, and digital collage in spatial relationship, combining her respect for modernism and Swiss graphics (see Chapter 2) with new possibilities made conceivable by computer technology. In 2002, she formed a new design consultancy in Los Angeles called April Greiman Made in Space.

Her designs span print graphics, Web and motion, and architectural applications. The work demonstrates her philosophy that the pixel is the "DNA," the "architecture" of the computer. She is fascinated with revealing the structure of that architecture, when appropriate, by making reference to it in her design projects.

Born in metropolitan New York, Greiman studied graphic design at the Kansas City Art Institute and also in Basel, Switzerland. In 1976 she moved to Los Angeles and in a few years became the director of the Visual Communications Program at the California Institute of the Arts. There she began to work with computer graphics and video, combining her interest in Swiss graphics with the multilayering made possible with computers and digital data. Her work in print, Web, and architectural elements has made her one of the most influential figures in contemporary design.

↑
7–23 Cyan, Sophie Alex, Wilhelm Ebentreich, Detlef Fiedler, Daniela Haufe, and Siegfried Jablonsky. Stiftung Bauhaus Dessau, May–June 1995. *1995. Offset lithograph, printed in color, 33 x 23⅜" (83.8 x 59.4 cm).* The Museum of Modern Art, New York. Gift of the designers. Photograph © 2001 The Museum of Modern Art, New York/Art Resource, NY.

Katherine McCoy is another important figure in education and postmodern design who articulates and defines the nature of the multiple layers of communication possible in the contemporary visual design (Figure 2-28). She writes about design criticism and consults in graphic design, marketing, and interior design for cultural, educational, and corporate clients. McCoy's Web site at www.highgrounddesign.com contains an excellent discussion of contemporary issues.

Technological innovations contribute greatly to the changing face of design. The IBM PC and Apple Macintosh dominated the widespread use of computers in design that began in the 1980s. The computer brought a great deal of flexibility and made easy shifts of type size, shape, and style accessible to designers. **Figure 7–23** shows this flexibility and rich visual texturing of typography by a contemporary design group from the former East Germany that gained access to computer technology after the fall of the Berlin Wall in 1989. Much of their work is created for German cultural institutions. Graphics are now generated and prepared for prepress with software that encourages complexity and reflects our society's complex structure and informational mix. Electronic mail, facsimile transmissions, and low-volume desktop publishing decentralize information processing. The Internet is a great experiment in democracy, because information can be disseminated and accessed on personal computers beyond anything previously possible.

CONCLUSION

Layout is a balancing act that creates unity among the diverse elements on a page. An underlying grid can unite the many pages of a large publication. When

combining copy, illustration, and photography, unity can also be established by finding similar shapes, angles, values, and typestyles. Like a musical composition, a layout needs pacing, rhythm, and theme. This problem-solving approach stems from an understanding of visual language developed by 20th-century modernism.

Variety or contrast is important too. Many kinds of contrast—in visual texture, value, shape, typestyle, and size—can create a focal point or visual path in a layout. A combination of contrasting historical styles is currently used to provide a rich, visually complex design. Multiple layers of communication created

with this approach are a feature of postmodern style. Whatever the historical style, it is more than merely an affectation. Movements in art and design reflect the structure and values of society and help disseminate those values. Both modernism and postmodernism have been informed and enriched by an understanding of how visual information is processed and meaning is derived. This understanding is fundamental to all forms of graphic design.

Finally, whatever the style, your layout should strive to do justice to the intentions of the copywriter, the photographer, the illustrator, the client, and yourself.

EXERCISES

1. Use the sample grids shown in **Figures 7–24a–b** to design several rhythmic layouts. If you choose to use collage or pasteup, use old magazines and cut out photographs, cropping where necessary and adding some version of comped type blocks. If you use a computer, refer to the accompanying Web site to access photos and sample layout grids also on the accompanying Web site.

2. Select several magazines or annual reports and figure out their grid structure. Can you find one with an interesting complexity and nuance? Look for stylistic influences. Bring one publication in for class discussion of strengths and weaknesses.

3. Save samples of brochure designs that appeal to you and study them for future inspiration. Look for interesting multipanel samples that unfold the

message in sequential steps. Plan to keep a file of such samples throughout your career. Share what you've found with others in the class.

PROJECT

Two-Page Layout

In consultation with your instructor, choose a short story, myth, or fable. Select a visual and conceptual theme appropriate to your story. Incorporate original imagery and create a two-page layout with a grid structure. After doing several roughs by experimenting with at least two different grids, choose the most successful. Prepare a final polished version using any method you prefer. **Figure 7–25** *uses shaped type and an original illustration to create a visual path layout with a good figure/ground relationship. "Nymph"* (**Figure 7–26**) *is a well-integrated grid layout with an excellent airbrush illustration that makes a strong use of figure/*

←
7–24a, b *An underlying grid of squares (shown in a) can be applied to a cover design (shown in b) creating a subtle cohesion.*

Graphic Design Basics

AMY ARNTSON

ground relationships inspired by Milton Glaser. Research the designers in this and previous chapters on the Internet. Use their work as inspiration for your designs.

GOALS AND OBJECTIVES

Learn to choose an appropriate grid and fit layout elements into it.

Practice cropping and resizing photographs without distortion and practice integrating them with typography. Use all the information studied so far on balance, rhythm, figure/ground relationships, unity, and contrast to create a dynamic, integrated multipage layout.

CRITIQUE

Be prepared to present your work in class and to discuss the following questions: What is your grid structure? Why did you choose it? What decisions did you make related to it?

Describe your choice of typestyle, point size, line length, leading, and format. Did you make any variations in letterspacing?

How does the eye move through your layout?

Select your favorite design from the class and be prepared to talk about why it works.

←
7–25 Natalie Krug. *"Heart" is a path layout integrated with a watercolor illustration that addresses the multiple meanings of the word* heart.

←
7–26 Ming Ya Su. *"Nymph." A grid layout in which both illustration and layout show a sensitivity to figure/ground relationships.*

Visit the accompanying Web site for research links. Studio techniques in vector graphics include shaping type, gradient effects, and managing grids.

THE DYNAMICS OF COLOR

→

TERMINOLOGY
(See glossary for definitions.)

light waves
additive primary colors
subtractive primary colors
process colors
hue
value
tints
shades
intensity
color schemes
complementary
split complementary
analogous
monochromatic
color theory
simultaneous contrast
pixels
RGB
CMYK
HSL
gamuts
tint screen
fake colors
moiré
halftone
duotone
tritone
local color
arbitrary color

KEY POINTS

Color for the designer and color for the fine artist are similar at the creative stage, because a fundamental knowledge of color theory is vital to both designer and fine artist. Also, in preparing art on the computer for the Web, for multimedia, or for the printing process, the designer needs to be familiar with how color is influenced by its intended publication venue. A great deal of new terminology and concepts will be introduced, but first we'll brush up on color as a creative, pigment-based, and artistic communication (**Figure 8–1**). Then we will consider color from the computer and printing perspectives.

DESIGNING WITH COLOR

Every student who has completed an elementary course in art has heard that color is a property of light. Many people do not fully understand those words, however, until years after their art degree is completed. A young painter several years past her BFA tells a story of looking around her living room for a composition to paint. "I considered the objects in the room and the space they occupied; the corners of the ceiling and the negative spaces in the staircase. I looked at the carpet and saw the standard 'landlord green.' And then I looked at the carpet again and realized that my mind was processing 'landlord green,' but my eyes were actually looking at black geometric shapes swimming beside a shining pastel/fluorescent color of fresh spring leaves. The sun was shining in the window of my dark living room and transforming my carpet. Color is a property of light, I thought. Oh!"

Color has been accurately described as both "the way an object absorbs or reflects light" and "the kind of light that strikes an object" (**Figure 8–2**). The artist's carpet would have appeared to have a different color had it had a deep shag texture or a slick, shiny surface. It would have appeared

↑
8–2 *Color is a function of absorption and radiation of light waves.*

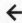 **8–1 E. McKnight Kauffer**. Reigate, *1916. 24.4 x 20" (62 x 50.8 cm). London's Transport Museum. This well-known painter and designer used complementary colors to create this striking poster for Britain's public transport system.*

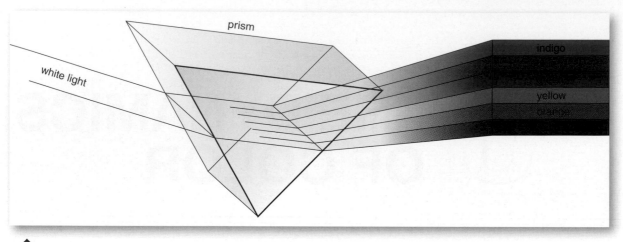

↑
8–3 *Light waves of many colors join to make white light.*

a different color under an incandescent or fluorescent light, bright natural sunlight, or light overcast by cloud cover. Even the angle from which it was viewed would have had an effect.

Isaac Newton first passed a beam of white light through a prism and saw it divide into several colors. The colors of the light-wave spectrum are red, orange, yellow, green, blue, and indigo (**Figure 8–3**). In physics, mixing the colors of the light wave together produces pure white light. It is such *light waves*, bouncing off or being absorbed by the objects around us, that give the objects color.

The three primary colors in white light are red, green, and blue (RGB). They are called *additive primary colors* because together they can produce white light. The eye contains three different types of color receptors, each sensitive to one of the primary colors of the light spectrum. This seems to suggest an active connection between our physiological makeup and the world in which we live. A powerful concept.

The artist and designer should understand that color depends on light. *Color is not an unchanging, absolute property of the object. It is dynamic and affected by its environment.* We'll learn more later about RGB as it applies to computer monitors, photography, and the Web.

Why wait until Chapter 8 to study color? Because it is so powerful, it can overwhelm choices about shape, figure ground, eye direction, and more. If you have chosen to begin working with color earlier in the

course, remember to integrate all the other design considerations and not let color become a crutch for an otherwise weak solution.

The Color Wheel

For the artist and print designer, mixing pigments will never produce white. Black is the sum of all pigment colors. Several color wheels have been developed to help us understand the effects of combining pigments.

The traditional pigment-based color wheel, developed by Herbert Ives, begins with the *subtractive primary colors* red, yellow, and blue. Mixing these hues produces secondary colors. Mixing the secondary colored pigments with the primaries produces a tertiary color. The term *subtractive* means that a pigment absorbs, or "subtracts," a segment of white light in order to reflect back its particular hue. The visual effect produced by combining such pigments is actually the sum of their subtractions. For the artist and print designer, that can mean a less brilliant result than is produced by a single pigment.

The Munsell color wheel is based on five key hues: red, yellow, blue, green, and purple. Mixing these primaries forms secondaries. Although these two classification systems differ, the basic look of the resulting colors is similar. The color wheel is only a workable system, not an absolute. **Figures 8–4a, b** show the Ives and the Munsell color wheels. The cyan, magenta, yellow, and black (CMYK) *process colors* used in offset printing are also a pigment-based subtractive gamut that we'll discuss later in this chapter.

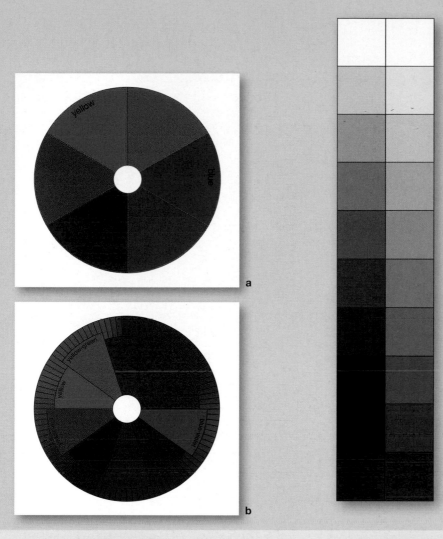

a

b

↑
8–4
a *The traditional pigment-based color wheel, developed by Herbert Ives, shows the three primary colors red, yellow, and blue with their secondary colors.*
b *The Munsell color wheel is based on five key hues with secondaries formed by mixing these primaries.*

↑
8–5 *Changes in value within a single hue create a wide range of "colors." The row on the right shows a high intensity, highly saturated blue, while the left side is a low intensity blue. Both have a wide range of value effects.*

Properties of Color

Every color has three properties: hue, value, and intensity. *Hue* is the name by which we identify a color. The color wheel is set up according to hue.

Value is the degree of lightness or darkness in a hue. It is easiest to understand value when looking at a black-and-white image. The darkest value will be close to black, and the lightest close to white, with a range of grays in between. Value also plays an important role in all color images. Every hue has its own value range (**Figure 8–5**). Yellow, for example, is normally lighter than purple. Its normal value in the middle of a yellow value scale will be lighter than purple. In a value scale, the color values lighter than normal value are called *tints*; those darker than normal

↑ ↖
8–6 *Different values of a single or similar hue can create a highly varied effect.*

↑ ↗
8–7 *These two complementary hues are used at varying intensities.*

↑ ↙
8–8 Tim Girvin, *art director, designer;* **Anton Kimball,** *illustrator;* **Mary Radosevich,** *production. Bright Blocks is a package design by Tom Girvin Design, Inc. It uses highly saturated color to target its young audience. The colorful design was credited with increasing sales dramatically.* Courtesy of the artist.

value are called *shades*. When working with pigments, the addition of white lightens a value, whereas the addition of black darkens it. **Figure 8–6** shows a design created using a variety of values of green.

The third property of color is *intensity*, or saturation. It is a measure of a color's purity and brightness. In pigments there are two ways of reducing the intensity of a color: Mix it with a gray of the same value, or mix it with its complement (the color opposite on the color wheel). Low-intensity colors have been toned down and are often referred to as tones. Colors not grayed are at their

most vivid at full intensity, as shown in the array of high- and low-saturation colors in **Figure 8–7**. **Figure 8–8** shows high-intensity colors applied to children's toys.

Color Schemes

Color combinations are grouped into categories called *color schemes*. Colors opposite one another on the color wheel are called *complements*. Art that combines these colors is said to be using a complementary color scheme. Complements heighten and accent one another and are often used to produce a bold, exciting effect. A *split complementary* scheme includes one hue and the hue

↑
8–9 *Complementary, analogous, and monochromatic color schemes.*

↑
8–10 John Mattos. Fidel of Dreams. *Illustrator document. This analogous color scheme is made dynamic by strong values and shapes.* Courtesy of the artist.

(on the color wheel) on either side of its direct complement. Colors next to one another on the color wheel are called *analogous*. An analogous color scheme is generally considered soothing and restful. A *monochromatic* color scheme is composed of one hue in several values. These color schemes are shown in **Figure 8–9**.

In color there are no real absolutes. That is why this information is often called *color theory*. It is unusual, but quite possible, to produce a tense, dramatic effect using analogous colors or a soothing, harmonious effect using complementary colors. Remember, these

principles are not rules but useful guidelines. An artist or a designer may choose to violate them for effect. **Figure 8–10** shows a dramatic use of an analogous color scheme made dynamic by the use of strong value contrast and shapes.

THE RELATIVITY OF COLOR

Our perception of color is influenced by many considerations. For example, the way each color looks to us is strongly affected by what surrounds it. This phenomenon is known as *simultaneous contrast*. We automatically compare colors that sit side by side.

When complements (such as red and green) are placed side by side, they seem to become more intense. They complement one another. A gray placed beside a color appears to have a tinge of that color's complement in it because our eye automatically searches for it. Therefore a neutral gray beside a red will appear to be a greenish gray; the same neutral gray beside a green will appear to have a reddish cast.

Simultaneous contrast also affects value. A gray placed against a black ground will appear to have a lighter value than the same gray placed against a white ground. The same hue will look very different on various background colors. **Figure 8–11** shows many of these effects.

One designer first experienced this effect when she was a child visiting her aunt for dinner. Butter in her own home was a yellow stick brought home from the store. On the aunt's farm it came straight from the cows, after a little churning. This fresh butter did not have yellow food coloring added to it. When her aunt placed it on the table on a yellow plate, the niece would not eat it.

It looked white and could not be the real thing. Who would eat white butter? The aunt, however, knew about simultaneous contrast, although not by that name. She whisked the butter plate away and returned with the same butter, this time on a white plate. The young girl was delighted with the "new" butter. This time, compared with the white plate it sat on, the fresh butter looked yellow.

Simultaneous contrast means that color is relative to the colors surrounding it. This fact was first discovered in the 19th century when a French chemist named Michel-Eugène Chevreul, also a merchant who dyed fabric, was disturbed by apparent inconsistencies in his bolts of cloth. He discovered that his dye remained consistent, but the viewing conditions did not. Bolts of the same color appeared to be different colors, depending on the color of the fiber samples around them. He went on to research and document color properties. In the 20th century, Josef Albers made a further intensive study of color. Albers experimented with simultaneous contrast and contributed greatly to our understanding

8–11 *Colors look very different on various backgrounds. The background color changes the visual effect of the center shape in these examples.*

8–12 **Josef Albers**. Josef Albers, Homage to the Square. 1969. Oil on Masonite, 24 in. x 24 in. (60.96 cm x 60.96 cm) San Francisco Museum of Modern Art/Gift of Mrs. Anni Albers and the Josef Albers Foundation/ © 2010 The Josef and Anni Albers Foundation / Artists Rights Society (ARS), New York

Josef Albers (1888–1976) was born in Germany and taught at the Bauhaus from 1923 to 1933, when he left for America. While at the Bauhaus, Albers ran part of the preliminary course and taught a 3-D workshop "materials class." The autonomy of the student was important in this workshop, which emphasized discovery and invention. In the United States, he taught at Black Mountain College and Yale University.

Albers married Anni Albers (1899–1994), a German-born fiber artist, who was a student at the Bauhaus. In 1933 both were asked to teach at Black Mountain College, an innovative school in North Carolina. Josef Albers taught there for the next 16 years, and it was at Black Mountain that he began his color studies. Anni taught weaving there and created her own significant body of work. From 1950 to 1958 Albers served as head of the design department at Yale University.

Albers began his *Homage to the Square* series in 1949 and worked on it for the next 25 years. Figure 8–12 shows a painting that is the result of this series. He carefully recorded the technical details of each piece, fascinated with the optical effects created through color contrasts. The entire series has only one shape, a square. In the series it is placed in various locations, at varying sizes, with a concentration on what happens as color changes are introduced. As a painter, a theoretician, and a teacher, Albers was an important influence on generations of young artists and designers.

of that effect. **Figure 8–12** by Albers shows his devotion to investigating the effects of color and shape.

THE PSYCHOLOGY OF COLOR

Relativity also holds true in the psychology of color. Colors have the power to evoke specific emotional responses in the viewer—some personal and some more universal. In general, for example, warm colors stimulate people, whereas cool colors relax them. Interior designers pay close attention to this relationship when they consider the color schemes for locations such as a bedroom, a dentist's waiting room, or the newsroom of a daily paper. Imagine sitting in a dentist's chair, staring at a bright red wall.

Red and yellow and their variations are referred to as warm colors, perhaps because we associate them with fire and the sun. Blue and green are considered cool colors. They also happen to be the colors of sky, water, and forests. The difference in the wavelengths of these colors may also account for our reactions to them.

Associations

Personal memories play a part in color perception as well. If your mother usually wore a particular shade of blue, and you loved your mother (and she loved you), that shade of blue has good associations for you. It seems a warm, friendly color, although to other eyes it may look cool.

Along with personal associations, we have cultural associations with color. They often appear in the English language in the United States as "black anger," "yellow-bellied coward," "feeling blue," and "seeing red." On her wedding day, a bride in Western culture wears white, the color of purity. Black is a funeral color and the color of mourning. These are not absolute associations; they change from culture to culture. For example, people in India wear white to a funeral. For a wedding, they favor yellow. These cultural differences continue to blend together and change with our increasing sense of a global community.

We can describe our culture's general color associations. It is by no means a description to be memorized and taken as gospel. Color psychology is complex, affected by many considerations, but if you can combine this information with a light hand and a sensitive eye, it may prove useful.

RED

Red is a dramatic, highly visible hue. It is associated with sexuality and aggression, with passion and violence. It is also an official hue found in most national colors. Red is often the favored color of a sports car or a sports team. A dignified, conservative executive, however, is unlikely to choose red for a primary car or a corporate logo unless its intensity is toned down or its value darkened toward black.

BLUE

In its darker values, blue is associated with authority. Our executive may favor a navy blue car, suit, and logo. A middle-value blue is generally associated with cleanliness and honesty and has a cooling, soothing effect. It is used as a background color in package design because of its quiet, positive associations. Even at full intensity, blue retains a calm quality, as seen in

BOOK of LORE

AMERICAN PLAYERS THEATRE

25 YEARS OF HISTORY

As in Human, Mother & Forces of

WE ATTRIBUTED IT TO *human* NATURE. Totally understandable. Our editor came down pretty hard on the idea of interviewing a bat for this book. ‹ "You're a classical theatre, not a zoo!" she cried. ‹ On the side of Mother Nature, we encountered resistance from the handlers of La Bella Bat Frieda. An interview in such a charged milieu was not advisable to their client. ‹ A compromise was reached. ‹ Make it crystal clear the bat was just one of many nuances to the richness of experience out here. ‹ For her part, Frieda released a statement saying how proud she would be "to speak for the Mother of all forces in this natural world. She who converges with power and beauty upon this small hilltop each summer." ‹ We finally caught up with the winged diva in early October, hanging backstage with an entourage. She was friendly. In a noblesse oblige sort of way. Yet she lost no time expressing dismay at the manner in which this *Book of Lore* had come together.

←↑

8–13a *American Players Theatre publication cover created by the* **Planet Propaganda** *design firm. A highly saturated blue gives this design a dynamic impact.*

←↓

8–13b *American Players Theatre publication interior pages created by the* **Planet Propaganda** *design firm. A variety of color treatments enrich this design.*

the cover for an American Players Theatre publication (**Figure 8–13a**). **Figure 8–13b** shows the interior pages using a variety of tints and full intensity hues for a soft but vibrant effect.

YELLOW

Yellow is often used in food packaging because it is associated with warmth, good health, and optimism. There still are reminders in the English language that yellow also has been associated with cowardliness and weakness. That does not appear to be the case currently, however. Even cultural associations are subject to change.

GREEN

Green is associated with the environment, cleanliness, and naturalness. Soothing and cooling, it is consequently a favored color among manufacturers of such products as menthol cigarettes and noncola beverages. These products benefit from a visual association with a healthy environment.

Selecting Color

When choosing a color, consider the psychology of the audience. A game or toy intended to appeal to children should have colors different from one intended to reach adults considering retirement plans. Our color preferences change as we grow older. In general, youth prefers a more intense color that signals urgency and excitement. The subtle color preferences of age are more often associated with restraint and dignity. Color trends also change regularly in areas such as fashion and home décor.

The institution you are designing for should also affect the selection of color. Banks tend to prefer the darker values and the blues and grays associated with authority and stability. A physical fitness club would probably want more vibrant and intense colors. A restaurant may choose complementary colors that are toned down to an attractive and intimate level.

Personal color preference is not the only, or even the primary, consideration for a designer. Choice of color should reflect five psychological factors:

1. Cultural associations with color
2. The profile of the audience and its color preferences
3. The character and personality of the organization represented
4. The designer's personal relationship with color
5. An awareness of current color trends

VISUAL PERCEPTION

Whenever we create or view an image, we bring a load of personal experiences and cultural background that help us make sense of that image. We structure the image as we create it on the screen or on paper. We also structure it in our brain and eye in the process of viewing it. The image depends on the artist *and* the viewer.

Realism in art and design is not an absolute. It is an interaction between the artwork and the mind and eye of the viewer, as we can see in Georges Seurat's

a

b

CHAPTER 8 The Dynamics of Color

8–14a, b
a Georges Seurat., French, 1859-1891, A Sunday on La Grande Jatte - 1884,1884-86, Oil on canvas, 81¾ x 121¼ in. (207.5 x 308.1 cm), Helen Birch Bartlett Memorial Collection, 1926.224, Reproduction, The Art Institute of Chicago
b Detail.

A Sunday on La Grande Jatte—1884 (**Figure 8–14**), where abstract color dots appear as people in a park. Seurat painted series of dots, but the result is that we see a summer day. An artist and designer works not simply with the elements of line, shape, and color. Basic principles of design and visual perception are a vital part of this interaction. The principle of similarity grouping occurs when we recognize similarities in shape, size, color, texture, and so on. This similarity helps visually bind a composition together, as in the texture of Seurat's dots.

In the process of recognizing similarity, the eye and brain also identify elements that are different. Again, in Seurat's painting, the color makes an important difference that allows us to "read" the painting. A dynamic interplay of similarity and difference makes for an active, successful design.

UNDERSTANDING ELECTRONIC COLOR

Color on a computer monitor is created in a manner much like a pointillist painting by Georges Seurat (Figure 8–14). In the painting, our eyes optically blend individual paint spots to create an illusion of softly blended colors. Computer images are composed of individual dots called *pixels*. The pixel is a rectangle of light on the computer screen that can be set to different colors. The more pixels, the better the resolution and clarity of the image. The resolution is determined by the hardware (**Figure 8–15**).

When designers work with a 24-bit system, each pixel is represented by 24 bits of color information: 8 for red, 8 for green, and 8 for blue. There are 256 possible values for each of these three colors. These differing values of red, green, and blue can be combined to produce more than 16.7 million colors.

Color Models

Designers study color theory in order to use it effectively. Color theory remains the same whether it is applied to a traditional design or an electronic one. But when using electronic color, it can be helpful to study its practical differences. **Figure 8–16** shows some of the

8–15 This enlargement shows the pixel structure of a digital image.

8–16 Hue and the properties of value and saturation are shown in various wheels and swatches.

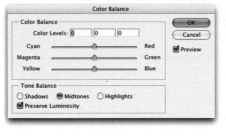

many ways to view and create color wheels and value studies on screen. We must understand the various ways color is created in order to see the final design printed and looking the way we intended. The previous section of this chapter discussed creating color using pigment-based subtractive primaries. You need to be familiar with three different color models when using computer graphics.

RGB

Unlike a pointillist painting, an image on the computer monitor is displayed in the additive primaries *RGB* (red, green, blue). It is a backlit image made by adding light. An image on the monitor may display colors in RGB that cannot be duplicated in the reflective copy of CMYK printing. Be prepared if the image on a printout does not match the image on the computer screen. The images are displayed in different color gamuts, or models (discussed shortly). Calibrating the monitor will help. Onscreen design is produced and viewed in RGB and is discussed further in a later chapter. **Figure 8–17** shows how RGB overlaps to form the CMY process color gamut. *K* stands for the black ink that is added for density.

CMYK

All of this electronic color is quite different from mixing and blending paint or colored pencils. When

the monitor's colors are transferred to paper or the file is ripped for offset reproduction, it is printed in the subtractive model of CMYK. The *CMYK* model is the basis for four-color process printing composed of cyan, magenta, yellow, and black inks. Remember, the *K* stands for black, which is added to give density to the final print. For additional information on CMYK, see "Process Color Separations" later in this chapter. **Figure 8–18** shows the overlapping CMY of transparent printing inks producing a variety of colors.

HSL

Hue, saturation, and lightness (HSL) are terms familiar to us from the world of color theory and a discussion of the properties of color. Photoshop allows the user to manipulate colors using this model and other models by moving pop-up menu sliders. The intensity of a color diminishes when its saturation slider is moved (**Figure 8–19a**). The lightness control varies a color from white to black (this corresponds to value in pigment-based color models). This can be a satisfying color model to use, because it is the most intuitive and closest to the way mixed pigment color is used in painting and drawing. You can switch to CMYK to prepare the prepress file.

Another Color Wheel

The RGB/CMY color model positions the two sets of primaries equidistant from one another. Each secondary color is between two primary colors; each color on the wheel is between two colors that are used to create it; and each color is directly opposite its complement.

→

8–20 *The outer shape represents the colors the eye can see. The black triangle represents the colors that can be shown on the monitor. The dotted line represents colors that can be printed on coated paper.*

This is a helpful model to study in order to understand what is happening on the computer monitor.

Red and blue make magenta. In order to decrease magenta in an image, the red and blue must be decreased. Whatever is done to a color, it has the opposite effect on that color's complement. In other words, decreasing red will increase cyan (**Figure 8–19b**).

Various computer programs that allow designers to do color correction have pop-up menus allowing this kind of manipulation. Photoshop is an effective color correction software in common usage by designers, although there are other dedicated color management programs. Its sliders allow the user to manipulate color quickly and see the resulting effects. It also allows the user to work from numbered percentages in order to specify colors that will match a CMYK print. And, finally, it allows the user to switch between color models, specifying that an image be created in RGB, CMYK, spot color, black-and-white, or duotone modes.

Color Gamuts

The visible color range of a color model is called a *gamut*. As **Figure 8–20** shows, the eye can see more colors than can be created in either the RGB or CMYK color models. The gamut of RGB, however, is larger than that of CMYK. This means that if a design is created with the RGB mode, some of its colors probably cannot be printed using CMYK process colors. Photoshop will show an alert symbol (a triangle with an exclamation mark inside it) in the picker palette if your

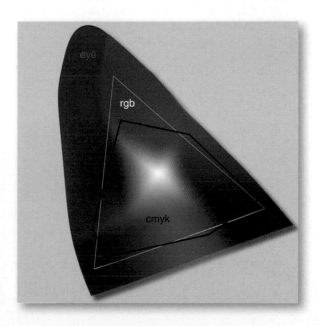

color is not printable. This allows you to substitute a printable color before sending the file for reproduction.

COLOR IN PRINTING

In addition to applying the psychology of color theory to design work, you must stay within restrictions imposed by the technology of mass reproduction. Designs must be created within the limitation of the budget, equipment, expertise, and time available for a particular project. *The designer's use of color must be not only creative and appropriate but also practical and printable.*

Tint Screens

In mixed pigments, adding a different pigment-based hue creates color changes. White is altered to gray by the addition of black; red is altered to a light pink by the addition of white; and mixing blue and yellow creates green.

Additive color on the RGB computer monitor is created though varying intensities of light, as just discussed. When the file is sent to press, in order to create a tint or a light value of a hue, the printer cuts back on the density of the ink through varying *tint screens*. Screens are available in gradients from 10 percent to 90 percent. There is a similarity between the tint screens of printing inks and the application of transparent watercolor. In both cases, white is made by allowing the white of the paper to show through, and applying less pigment or ink makes lighter values.

In appearance, the value scale of printer's screens is similar to a value scale mixed by an artist combining pigments. However, if you look at the printer's scale under a magnifying glass, the screened dots will show up. All commercial printing is a form of optical illusion achieved not by sleight of hand, but by dot screens. The same black ink is applied to paper for a 90 percent gray or a 10 percent gray, but the dot screen fools the eye into believing it is different. Where there are larger

dots, the ink looks blacker. Solid ink is not screened but printed at 100 percent.

There is an analogy here with the computer screen. The image onscreen is composed of dots, or pixels, of varying colors. The image the printer creates is also composed of dots, this time of solid colors of ink. The monitor uses varying intensities of light to create (additive) color, and the printer uses varying densities of ink (subtractive pigment) (**Figures 8–21a, b**).

Figure 8–22 shows 10 percent to 100 percent tint screens of the three process colors: yellow, magenta, and cyan. Try looking at them with a magnifier. Changing the hue or making an ink appear darker is done by combining screened percentages of different colors. To change a cyan to purple, for example, a tint screen of magenta could be laid over it. The new color effects generated by using overlapping screens of process colors are referred to as *fake colors* (**Figure 8–23**). **Figure 8–24** shows the overlapping of two spot colors using the Pantone© color formula guide electronically within software programs.

→↖
8–22 *Changing tint values with screens. Material furnished by Hammermill Papers Group for plates 4 and 5.*

→↗
8–23 *Tint screen percentages of the four process colors were combined to create this illustration.*

→↓
8–24 *Overlapping two screened "spot" colors can produce a wide variety of color effects when you can't afford four-color reproduction.*

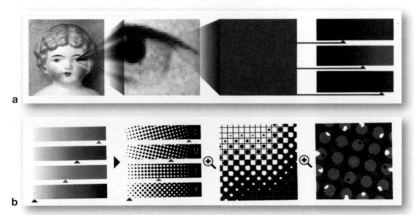

←
8–21a, b *This illustration documents the process of converting an original image into pixels, converting from RGB to CMYK halftones, and finally to the four-color printed piece.* Courtesy of Apple Computer.

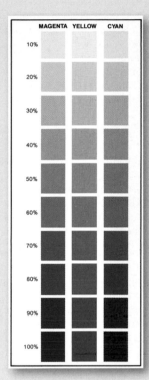

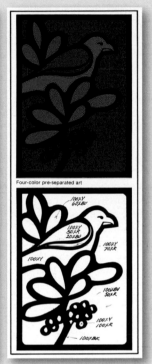

Four-color pre-separated art

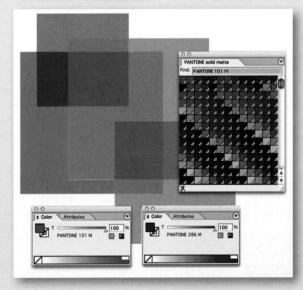

When overlapping screened percentages of color or halftone screens of photographic images, you may encounter a moiré effect. A *moiré* pattern occurs when two sets of parallel lines or screens are crossed. It looks like a set of window screens stacked together, creating odd patterns. Watch for this problem and avoid it by changing the angle of your screens or by not overlapping different halftone screens.

It is important to visualize screened color combinations correctly before sending them to the printer. The "comp" may have been generated on the computer and shown onscreen, or it may be output as a proof print to show the client and the printer. The goal is to arrive at a printed piece that matches expectations.

Spot Color or Process Color?

If you are using one to three spot colors, several numbered guides are available to assist you. The most complete, the Pantone© matching system, consists of a full line of color specification books coordinated by numbers. These formula guides, first developed in 1963, enable you to specify a color number that the printer can match by using a reference guide. This is much more scientific than specifying that a logo be printed in "a bright cool red." Each ink color has its own number.

Choose the ink color from the guide and enter it on your computer (as shown in Figure 8–24), or tell the printer its number. The printer then prepares the ink you have specified. To get the desired blue for a two-color design, you might specify a spot color of Pantone© 313 with a 20 percent screen of black. Various reference books show screened percentages of these ink colors. They also show what happens when you combine two different ink colors in screened percentages. Using spot colors is usually less expensive than using full process colors.

Process Color Separations

The offset reproduction of a full range of color, rather than just two or three colors, is done with CMYK process color. The three primary colors in process printing are yellow, magenta, and cyan, as we have discovered. The addition of black as a fourth color gives depth and solidity to the image. These four printer's inks produce the visual effect of full color (**Figure 8–25**).

Once the designer has given the printer a full-color illustration or photograph to reproduce, either traditionally or electronically transferred, the printer separates out the process colors. Artwork is separated into three color exposures from which the final prints are made. A black separation is also made. When the press is inked with each of these four colors, and the color is laid down onto the paper, an illusion of full color results. The varying densities of halftone dots overlap and lie beside one another, mixing optically. It is a truly effective illusion.

As with spot color tint screens, the mixing happens not within the pigment, but within the eye of the viewer. Unlike the even dot coverage of tint screens, a process color separation is made of dots of varying densities that correspond to the color density in the original image. This variation is why such a complex range of colors can be produced from only four process colors. Examine the full-color images in this book with a loupe or magnifier if one is available.

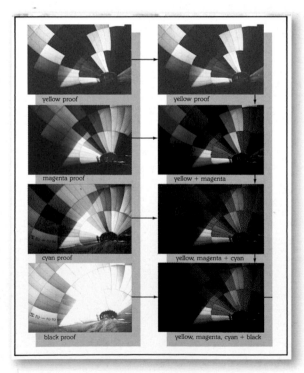

←
8–25 *Yellow, magenta, cyan, and black inks and their combinations.*

Cutting Costs

Each additional ink used in a design means the offset printer must do additional work ripping files and inking the press. The more ink colors you use, the more printing the design will cost. Combining screened percentages of inks will enable you to get the most out of each color and can decrease the cost of the job.

Another way to get more color into a job without increasing the cost is by printing on colored paper. Excellent reference books (many free from paper companies) deal with using colored inks on colored papers. The color of the paper will show through, subtly altering the look of the ink. White ink is seldom used in the printing industry, because opaque white is difficult to achieve. A study of the way tint screens, ink, and paper interact will help achieve the desired effect at a minimum cost.

Halftones, Duotones, and Tritones

Photographic prints used for *halftones* should have an extended tonal range with good contrast. If your negative has good detail, it can be converted to a good halftone. Although a poor negative or print with loss of detail can be improved, it cannot be converted into a high-quality halftone.

Duotones and tritones are commonly used techniques for printing black-and-white photography by using spot colors. Although these halftones are limited in color, there are many options to consider (**Figure 8–26**). Electronic manipulation can selectively enhance the tonal range, and different line screens can be employed from coarse to very fine. A halftone can be printed over a solid color or over a screened color to create a fake duotone effect. Generating two halftone negatives from the same image creates a *duotone*. By printing these negatives in various colors, you can achieve various effects. Duotone effects depend as much on how you use the two colors as on what colors you specify. For example, a black-and-violet duotone can be run with

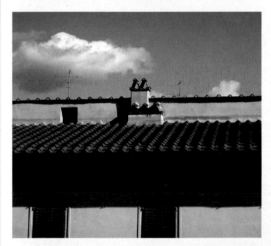
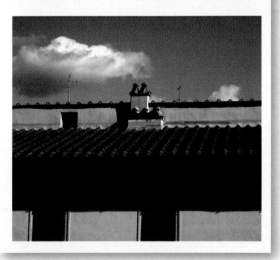

8–26 *A monotone, duotone, and tritone are shown here.*

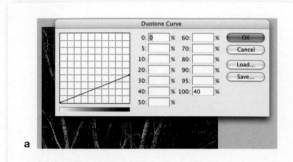

↑
8–27

a *Photoshop pop-up menu showing a duotone curve on one of the colors that will be used to create a duotone. This curve controls the distribution of color throughout the darks and lights of the image.* Adobe Product screenshot.

b *Photoshop pop-up menu showing a tritone combination of inks.* Adobe Product screenshot.

the black dominant or the violet dominant. The density range of each plate can be extended or compressed, producing shadow detail in one color while accenting the highlights in the other color. The *tritone* uses three colors for still more creative options. Black combined with two colors yields a new effect, as does printing with a warm black instead of a true black. A tritone can also be created during printing by using varnishes as a third color (**Figures 8–27a, b**).

Whereas designers used to depend on samples and their instincts to specify these techniques, now it is possible to simulate them quite accurately on the computer. The effects of varnishes and various paper surfaces on ink color, however, are still difficult to visualize before printing.

Technology is changing fast in the design and printing industry, but many principles stay the same. A good design sense and a working knowledge of color theory, coupled with a basic foundation in computer graphics, will see you through.

PROCESS COLOR SEPARATION SUMMARY

The digital image can be previewed on a color monitor. This display uses RGB colors, but the final image is converted and printed with subtractive primary colors (cyan, magenta, yellow, or CMY), with the addition of black (K).

Translating the three RGB values into four CMYK values results in variations caused by switching from an additive (RGB) system to a subtractive (CMYK) system. This entire translation process can be done on a personal computer as well as on higher-end systems.

The final step is to turn the CMYK values (which are continuous-tone separations) into four halftone films. The halftones are translated into film for making printing plates. In the halftone film, various sizes of halftone dots simulate color shades. In a digital press environment, the film step is skipped. Files are sent directly from computer to press.

EXERCISES

1. *Find printed samples of monochromatic, analogous, and complementary color schemes. Search for samples of color used in graphic design, advertising, or packaging that convey a particular mood and reach a particular audience.*

2. *Find an example of a two-color design that uses tint screens to achieve a multicolor effect. Make notes and discuss them with your instructor.*

3. *Find a duotone or tritone and use a magnifying lens to compare it with a traditional process color photograph. Then compare these halftone effects with the tint screen you analyzed.*

4. Using a program such as Photoshop, practice converting from RGB to CMYK to HSL and manipulating the colors by using slider controls (see Figure 8–27).

Experiments

Create your own shapes, or use the one shown on the Web site and try these effects:

Use colors you dislike to see if you can achieve a desirable effect with them.

Try for discordant color effects.

Choose a mood before choosing a color palette.

Analyze the preferred color choices of your favorite fine art painter and use that color palette.

PROJECT

Word and Image Poster

Prepare two full-color posters that combine the image of a famous person, place, or thing with a related word. The word related to each image can be a name or an association the image brings to mind. Pay close attention to integrating the typography with the image through various gestalt unit-forming techniques and color choices (Figure 8–28).

Choose a complementary, split complementary, monochromatic, or analogous color scheme and create two color versions of the poster. Use tint, tone, and shade to give your color schemes different personalities. Be creative with color choices. Local color designs try to keep realistic color (the sky is blue), but there are other choices. The use of arbitrary color frees you to assign whatever color seems desirable. The sky may become yellow to enhance the purple backlit tree trunks (as in Figure 8–1), or a man's hair may become dark blue in an analogous color scheme of cool hues.

GOALS AND OBJECTIVES

Experiment using color to express a mood appropriate to an image.

Practice integrating word and image from the standpoint of design, concept, and content.

Control color and learn more about it by using different models and creating variants of tint, tone, and shade.

Learn more about how to create and use electronic color.

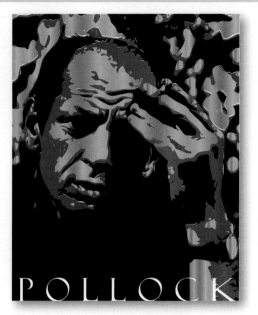

↑
8–28 Jorel Tingesdahl. Artist Portrait Series. *2004. Digital inkjet on paper. 11 x 8½".* Integrated Photoshop and Illustrator techniques were used to create this digital portrait for a student portfolio. This photo-based artwork should not be used commercially, but is appropriate for a student portfolio.

CRITIQUE

Your instructor may choose to have you display your work in print or do the initial critique on the monitor.

Present your work to the class. Discuss the following attributes of your final solution:

Why did you choose this particular subject?

What is the color scheme and why is it appropriate to the subject?

Did you use local or arbitrary color? Why?

How is the typography integrated with the image?

Discuss the process followed to produce this image, and discuss any problems you encountered.

Ask the class and the instructor how your work could be improved. Based on the discussion, make any changes that seem wise.

Visit the accompanying Web site for research links. Studio techniques in raster graphics include copy and paste, selections, filters, and more.

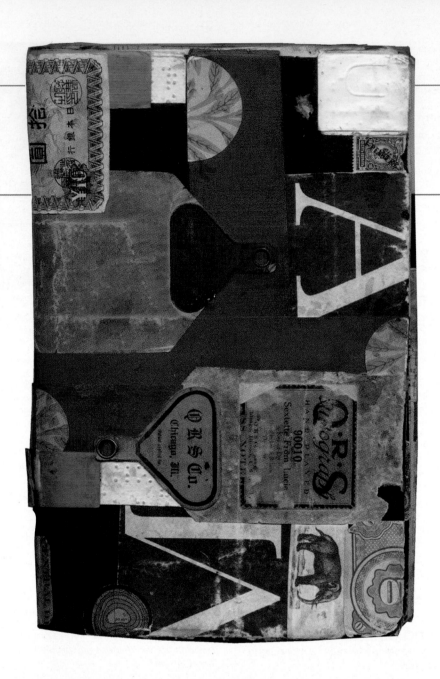

ILLUSTRATION AND PHOTOGRAPHY IN DESIGN

→

TERMINOLOGY
(See glossary for definitions.)

illustration
advertising illustration
editorial illustration
recording and book illustration
magazine and newspaper illustration
fashion illustration
in-house illustration
retail illustration
technical illustration
clip art
picture plane space
trompe l'oeil
photojournalism
product photography
corporate photography
photo illustration

KEY POINTS

Graphic designers work with illustrators and photographers. Often designers also create illustration and photography themselves. This chapter describes the various types of illustration and photography that appear in print and on the Web. It also discusses methods for creating and critiquing images.

Often the graphic designer is called on to create or acquire illustration and photography. The boundaries between design, illustration, and photography are less rigid than in the past, especially as electronic media make photographic manipulation and electronic painting tools available to a broad range of professionals. Every graphic designer needs to be familiar with the basics of image generation and manipulation. It is a rewarding and enjoyable part of the field and can lead to a career concentration in this area.

THE DESIGNER-ILLUSTRATOR

Illustration is a specialized area of art that uses images, usually representational or expressionist, to make a visual statement. Illustration is artwork created for commercial reproduction, possibly in print form, as animation, as motion graphics for various venues, or for Web delivery. Many drawings and paintings done as illustrations look and function as fine art and are exhibited and collected as such. Many painters have worked as illustrators at some point in their careers, and vice versa. The 20th-century painter Edward Hopper earned his living as an illustrator for the first half of his career; Pablo Picasso and William Blake illustrated books.

Some designers never actually do an illustration themselves; instead, they purchase freelance illustrations. Many illustrators are freelance artists who maintain their own studios and work for a variety of clients. **Figure 9–1** shows a sketchbook cover by the stylistically distinctive freelance illustrator David McLimans. The interior pages are full of his creative explorations (**Figure 9-2**).

Some studios have illustrators who do nothing but illustration, working with designers who are in charge of typography, photography, layout, and art direction. But *often the field has a need for illustrators who design and designers who illustrate.*

Some people feel that editorial illustration is the highest and most artistic form of design, as it exists in the cusp between fine art and design. Nevertheless, however much an illustration created for print reproduction may resemble a painting, the restrictions an illustrator works under are similar to those in other areas of graphic design. The

9–1 David McLimans. *Sketchbook cover.*
2003. Collage with found papers, 6¾ x 10¼".
Courtesy of the artist.

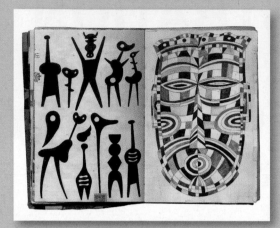

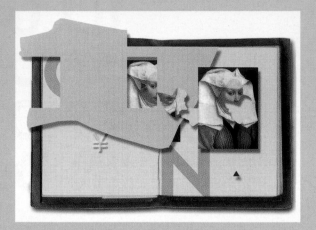

↑
9–2 David McLimans. *Sketchbook pages. 2003. Pen and ink. 13" x 10".* Courtesy of the artist.

↑
9–3 Roy Behrens. At a Loss for Words. *Digital montage print on paper. 2004. 5 x 7.5".* Courtesy of the artist.

illustrator works with the guidance of an art director, must be concerned about how the work will be reproduced, has to meet a deadline, and is responsible for satisfying a client and achieving a defined purpose.

WHY ILLUSTRATION?

Illustration may be chosen instead of straight photography for several reasons. It can show something about the subject that cannot be photographed, such as detailed information about how photosynthesis works. Also, by enhancing details, illustration can demonstrate certain particulars more clearly than a photograph. For example, it can enlarge tiny engine parts that are difficult to see or photograph. Illustration can also eliminate misleading or unnecessary details that confuse an image, thereby forcing the eye to focus on important characteristics. Also, an illustrator may be allowed where a photographer and camera are prohibited, as in a courtroom. Also, illustration is an effective way to present highly emotional, narrative, or fantasy-based material.

Although photography is capable of creating surreal and strongly emotive images, illustration is still more flexible. It is capable of turning out images of pure fantasy, by both electronic and hand techniques. **Figure 9–3** by Professor Roy Behrens is a combination of hand-cut and electronically pasted collage effects.

Many examples of both contemporary and historical illustration appear throughout this book. Illustration

has a variety of looks, depending on the medium, the style of the illustrator, and the purpose of the illustration. The artwork can be drawn, painted, constructed through mixed-media collage, or computer generated. It can be three-dimensional or a combination of 2-D and 3-D imagery. The illustrator may use a revived art deco style, a new wave or postmodern look, a highly personalized style, or an informational, descriptive rendering technique. Professionals usually concentrate on a consistent personal style. The multimedia fine art in **Figure 9–4** by Romare Bearden and the lithographic poster by Koloman Moser in **Figure 9–5** show powerful sources of inspiration that can be found in the history of both fine art and design.

→↑
9–4 Romare Bearden. Patchwork Quilt. *1970. Cut-and-pasted cloth and paper with synthetic paint on composition board, 35¾ x 47⅞" (90.9 x121.6 cm). The Museum of Modern Art, New York. Blanchette Rockefeller Fund.* The Museum of Modern Art/Licensed by SCALA / Art Resource, NY / Art © Romare Bearden Foundation/Licensed by VAGA, New York, NY

→↓
9–5 Koloman Moser. Frommes Kalender. *1903. Lithograph, printed in color, 37⅜ x 24⁹⁄₁₆" (94.9 x 62.4 cm). The Museum of Modern Art, New York. Given anonymously.* The Museum of Modern Art, New York/Art Resource, NY

If the field of illustration varies in medium and style, it also varies in intent. The purpose for an illustration may be to present a product, tell a story, clarify a concept, or demonstrate a service. The following section lists these varied purposes. For detailed information about contracts, trade practices, and pricing, consult the *Graphic Artists Guild Handbook: Pricing and Ethical Guidelines*. It is a valuable reference updated yearly with information for illustrators as well as designers.

ADVERTISING AND EDITORIAL ILLUSTRATION

Advertising and editorial illustration are two important divisions in the field with quite different focuses. *Advertising illustration* is intended to sell a product or a service—almost anything that can be offered to a consumer. **Figure 9–6** is a poster design that encourages the public to use the London subway system, called the Tube, to visit interesting places such as the Tate Gallery. The paint mimics a subway map that Londoners are familiar with.

In advertising illustration, commonplace objects must be shown with style and are often enhanced with dramatic highlights and textures. A creative concept can lead to delightful artwork that goes beyond product presentations, as in **Figure 9–7**. In the field of advertising illustration, illustrators work with art directors, account executives, and copywriters. Their work may need to please many people of various opinions. The best prices for illustration are paid in the advertising field.

In *editorial illustration*, the artist may concentrate on communicating emotion or opinion through an expressive treatment of line, shape, and placement. The field of editorial illustration can offer the freedom to experiment with media and to obscure details in favor of mood. Most important, editorial illustration can convey a concept or story by using a purely visual language as shown in **Figure 9–8**, making a statement concerning the United Nations' lack of effectiveness. The following sections discuss various uses for editorial and advertising illustration.

Recording and Book Illustration

Illustrators are used extensively to make creative packaging for *recording* and *book illustration*. Many record covers have become collector's items, and several books have been published on these covers. CD and DVD covers are also a creative avenue for illustrators. Although smaller in format than record covers, they provide an opportunity to integrate type and image and to express conceptual content.

Book jacket illustration is vital to the promotion and sale of a book. Some book publishers give the illustrator specific instructions, along with detailed notes from the art director. The illustrator may be asked to read a lengthy manuscript.

Artists who illustrate a book's interior add an important ingredient to the value of the book. Children's books, depending on the age of the target audience, often require illustration throughout. Payment for illustration varies from a flat fee for books in which the freelance illustrator contributes but is not the author to a royalty contract for books in which the illustrator is responsible for a major part of the impact and content. Children's book illustration is a rewarding field because unlike most adult books, children's books are commonly illustrated throughout. In books for young children, artwork must tell much of the story, with little reliance on the text. It is responsible for generating excitement, engaging nonreaders and advancing the plot. Some of the best current illustration appears in beautifully designed and illustrated children's books directed to a variety of ages. Arthur Rackham was one of the many excellent children's book illustrators from the turn of the 20th century (known as the Golden Age of Illustration) (**Figure 9–9**).

→ ↖
9–6 David Booth. *1987. 30 x 20". A photo illustration commissioned by the London Underground subway for traveling to the Tate Gallery.*

→ ↗
9–7 Professional illustrator **Matt Zumbo** *created these posters for Hoard's Dairyman's yearly Wisconsin cow-judging contest. The pencil sketch at the top right is Matt's 2006 poster concept inspired by the TV program* Desperate Housewives. *His process includes thumbnails, pencils, and color studies. His finished illustrations are done with a traditional underdrawing on illustration board, scanned, and then value and all color added with Photoshop tools. The delightful humor behind these poster concepts joins with Matt's amazing skill to create an unexpected and powerful result.* See accompanying website. Courtesy of the artist.

→ ↙
9–8 This "UNable" poster was created by Israeli designer **Yossi Lemel** *in 1995 as a response to the United Nations' lack of ability to solve the Bosnian conflict.* Image courtesy of The Advertising Archives

→ ↘
9–9 Arthur Rackham. *A children's book illustration from the period at the turn of the 20th century known as the golden age of illustration.*

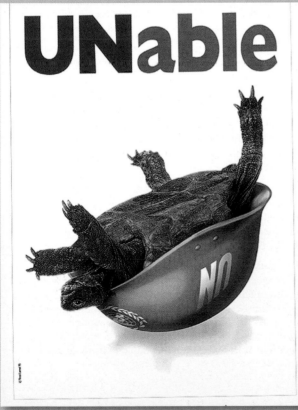

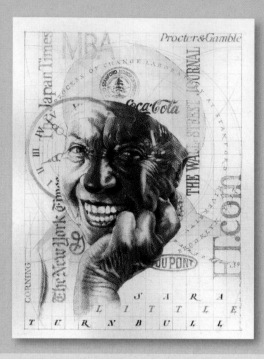

↑
9-10 Dugald Stermer. *Drawing of Sara Little Tumbill for @Issue magazine.*

↑
9–11 David McLimans. *Line-art illustration for the March 1991 issue of* The Progressive *magazine, accompanying an article on American political policy during the war in the Persian Gulf.* Courtesy of the artist.

Magazine and Newspaper Illustration

Magazines depend on illustration to set a tone and pique a reader's interest. A single image often must carry all the visual information for the accompanying story. The designer responsible for layout must integrate the illustration into the overall layout without detracting from the artwork. Ideally, treatment of the headline and text reinforces the art through repetition and careful placement. **Figure 9-10** by Dugald Stermer features hand-drawn imagery as well as hand-drawn typography.

Sometimes small spot illustrations are dropped into a page of text to enliven the visual presence. They are often black-and-white and executed in pen and ink. Newspapers often use black-and-white spot art in editorial sections. Many different kinds of illustration can be found as you search through the sections of a newspaper. Fashion, sports, editorial, product, and technical illustration of charts and graphs are all there.

Newspapers often use color only on the front pages of each section or for special feature articles. Newsprint does not reproduce details and nuances in tonal quality well, and the newspaper industry does not pay as well as some other fields of illustration, such as corporate work for annual reports.

The illustration in **Figure 9–11** by freelance illustrator David McLimans accompanies an article in *The Progressive* magazine. This publication and its contributors are concerned with political activism. Often payment is not the only reason people become artists and illustrators.

Artist and illustrator Sue Coe has done many illustrations concerning animal rights, the meatpacking industry, and much more. Her commentary on political events and social injustice is published in newspapers, magazines, and books; her prints and drawings are included in several major museum collections. She hopes her work will influence people to bring about change (**Figure 9–12**).

↑
9–12 *Pages from the book* Dead Meat, *created by fine artist, illustrator, and activist* **Sue Coe**. *Created for the client* Four Walls, Eight Windows *in 1995*. Sue Coe: Battery Cage. Copyright © 1990 Sue Coe. Courtesy Galerie St. Etienne, New York

↑
9–13 Margo Chase. *This logo/icon for hair care products signifies modern beauty.* Courtesy of the artist.

↑
9–14 *UCLA Extension summer 1991 catalog. Art director:* **Inju Sturgeon**, *UCLA Extension Marketing Department. Designer:* **Eiko Ishioka**. *A playful and highly skilled integration of 2-D and 3-D enlivens this in-house illustration.* Courtesy of the artist.

Fashion Illustration

Fashion illustration is a specialized area of advertising. A strictly literal drawing lacks the appeal of a drawing that presents the garment in a romantic, stylized manner. As a result, fashion illustration does not always simply convey information about the garment. It often attempts to persuade the viewer with the mood of the illustration. An important and interesting drape or texture of the garment or accessory, as well as the model's height, pose, and curves, is often emphasized for effect. Fashion photography shows a similar concern. A fashion illustrator draws from either a live model or a photograph of a model wearing clothes furnished by the client. The growth in the beauty and cosmetic areas, including related package illustration, has kept this field vibrant (**Figure 9–13**).

Illustration for In-House Projects

Educational institutions, government agencies, corporations and businesses, and not-for-profit entities hire illustrators to generate material targeted at internal audiences. The assignment often calls for editorial illustration—that is, the communication of a concept. Annual reports, corporate calendars, brochures, posters, Web sites, and an array of other materials are produced to communicate the nature of the institution to its employees and constituents. Depending on the company, in-house staff designers may be asked to provide illustrations as a part of their regular job. **Figure 9–14** is a highly creative piece done by an in-house department for UCLA. It uses a combination of photography and drawing to give it a 2-D/3-D appeal.

Greeting cards as well as medical and technical illustration are other markets that call for illustration, both freelance and in-house. The *Artist's and Graphic Designer's Market*, published by F+W Publications, lists more than 2,500 companies that hire freelance designers and illustrators.

Greeting Card and Retail Illustration

Greeting card and *retail illustration* involves retail products such as apparel, toys, greeting cards, calendars, and posters. The major greeting card companies publish cards created by staff artists, but they commission some outside work as well. Varieties of greeting cards include seasonal cards, special-occasion cards, and everyday cards. A new direction for growth is cards targeted at specific lifestyle audiences, such as working women and seniors. Illustration for cards and retail goods may be paid as flat fees or royalties.

Medical and Technical Illustration

Medical illustrators are specially trained artists who often have a master's degree in the field with a combined pre-med and art undergraduate degree. The accuracy of information as well as the clarity and effectiveness of presentation are vital in this field. The artist must be better than a camera in his or her ability to simplify, clarify, and select only what must be shown for complete communication. Illustrators should have knowledge of the human body and a background and interest in science and medicine.

Technical illustrators create highly accurate renderings of scientific or technological subjects, such as geological formations and chemical reactions as well as machinery and instruments. They often work closely with scientists or technicians in the field, and they produce art for a wide variety of publications, advertisements, and audiovisuals.

Animation and Motion Graphics

Expanding fields for illustration include Web graphics and various forms of motion graphics. These fields use illustration in the form of both scanned print-based artwork and artwork created electronically for online, CD-ROM, and film and video presentation.

Another expanding field that requires illustrators is 3-D imaging.

The computer has made an important impact in the field of illustration, especially for the designer-illustrator. The Web site shown in **Figure 9–15** exemplifies the flexibility of digital illustration. Visit this site to see the wide array of acclaimed designs created by the California-based but internationally recognized artist April Greiman.

STYLE AND MEDIUM

Illustrators use a wide variety of techniques, such as mixed-media collage, cut paper, pen and ink,

→
9–16a, b
a. **Matt Zumbo**, *illustrator, created this black-and-white graphite and colored pencil drawing on toned board.* Courtesy of the artist.

b Matt Zumbo *composited and colorized his original drawings on the computer to generate the final illustration. His use of a complementary color scheme enhances the dramatic quality.* Courtesy of the artist.

a

b

gouache and other painting media, sculptural construction, and computer generation. **Figures 9–16a, b** by Matt Zumbo, a Milwaukee-based illustrator who owns his own business, show a skillful integration of hand and electronic techniques. His choice of a complementary color scheme enhances the drama in the final piece.

Illustrator, Photoshop, and Painter get a lot of use, and professional computer systems come with their own specialized software programs. Programs such as Illustrator are vector graphics (object-oriented) programs that allow the creation of clean, precise, editable images. Painter is a raster program that gives a more intuitive feeling to the process of creating an image. However the artwork is originally created, computer graphics allows an ease of editing that cannot be ignored. When the client asks, "Can you make this change?" it is a lot easier to say yes when working with a digital image—even one that started with hand-drawn media, such as Figure 9–16.

Computer-generated and photographically based work will not completely replace hand-created illustration, however, because many people feel that hand-created images are appropriate when a warmer, more human touch is desired. Computer technology can always enhance, and aid the creation of, drawn and painted artwork. The artwork can be scanned, and then the final touches or revisions can be completed electronically. Computer technology is also helpful in archiving and transferring files. What is currently threatening illustrators is not computer-generated work but stock illustration that is readily and cheaply available electronically.

Whatever their artistic style, illustrators must be aware of all the technical information concerning color separations and printing methods. Die cuts, embossing techniques, and specialty inks may also play a part in the final product.

GETTING IDEAS

The illustrator goes through the same planning and visualizing procedures described in Chapter 1. The first step is getting to know the assignment. This research may call for reading a manuscript or understanding how a product functions.

Next comes the idea stage. Look at illustrations by other artists. Many annuals and periodicals show the most current illustrations. *Step-by-Step Graphics*

DIGITAL FOCUS
Gradients

Illustrators use electronic painting and drawing materials to create a wide range of subtly blended colors. Creating gradients enables you to enhance the blended color effects in your digital illustration. The gradient tool in raster and vector programs such as Photoshop and Illustrator can create multicolor linear and radial blends. You can find the existing gradients in the Swatches window or construct your own custom gradient. Open the Gradient window and click a color gradient swatch to observe the change. In Photoshop the window opens when the gradient swatch in the Properties bar is clicked. To make a custom gradient, click the color tab on the bottom slider in the Gradient window. Then pick a color from the Color window. If the color isn't exactly what you want, it can be adjusted in the Color window. Adjust the color as many times as you want, moving the Gradient slider tabs. Save your custom gradient by clicking New in the Gradient Editor or by dragging the color to the Swatches window. You can create a more advanced look by placing semitransparent gradients on top of each other. **Figure 9–17** shows the gradient tools in Illustrator; **Figure 9–18** shows the step-by-step process used by Chris Eichman to create a poster inspired by Alphonse Mucha.

←

9–17 *Photoshop and Illustrator tools can be used to create your own radial and linear gradients.*

↓

9–18 Chris Eichman *created these wine label stages in Illustrator in 2003. Inspired by the Art Deco artist Alphonse Mucha, he assembled a photo collage for reference. His pencil drawing is shown in the middle; the vector drawing stage is on the left. The final poster with gradients included is shown on the right. These stages are on the accompanying Web site.* Courtesy of the artist.

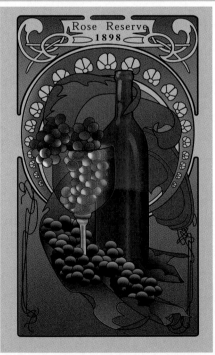

and *How* present ideas and techniques in the field of illustration. The *CA Illustration Annual* and many illustration sourcebooks such as the *Workbook* and the Graphic Artists Guild's *Directory of Illustration* are excellent sources to see the standards and styles in a particular field.

Classics from the history of illustration can also provide food for visual thought, as shown in Figure 9–18, which references Alphonse Mucha. Great artists such as Dürer, Seurat, and Magritte have provided inspiration for illustrators. Look through books of both fine art and simple descriptive photography for subjects related to your project.

Thumbnail sketches should explore the subject from every angle—high and low, as well as tightly cropped and at a distance. Imagine different kinds of spatial treatment: a Western perspective, isometric, surrealistic. Sketch these ideas, trying them in different media. Exploration is especially valuable to student illustrators who have not yet developed a particular style. As you progress from sketches to roughs, you may need additional reference materials. **Figure 9–19** shows a page from Barbara Nessim's 40th sketchbook. She is an internationally known artist, illustrator, and educator. Through the years, when searching for an idea for an illustration job, she will go to her many, many sketches for inspiration.

→
9–19 Barbara Nessim. Call Waiting. *1993. Gouache, Book #40. 20½ x14½". Part of the American Favorites series, output as Iris prints*. © Barbara Nessim. Courtesy of the artist.

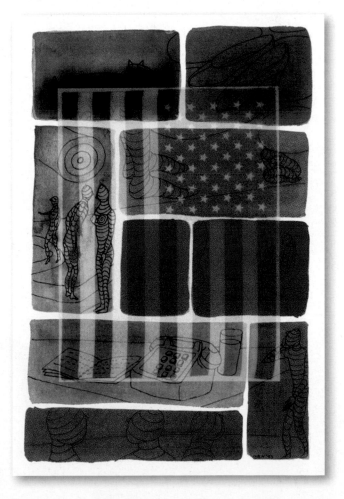

REFERENCE MATERIALS

Drawing from life means drawing from an actual object, landscape, or human model. Such work is most practical when using a still-life setup or a landscape. Models can get tired, and they can also get expensive. Drawing from life, however, may give illustrations immediacy and a vitality that drawing from photographs cannot.

Drawing from a photograph is convenient for many reasons. The camera has already converted the subject into a two-dimensional language. Cropping is easily visualized by placing a few pieces of paper around the photo's edges. The subject never gets tired.

Reference materials can add authenticity to your work. The Internet is an excellent source of images. Once the source photos are legally obtained, adapt them to the particular situation. **Figure 9–20** is a portfolio piece that uses multiple photographic references. It is a good idea for all designers and illustrators to begin a clip file of their own with images of many different subjects. Old magazines are a great source. You may be able to organize magazines by categories instead of cutting out the photographs. *Life*, *People*, and *Newsweek* magazines would fit into a "people" category; *Smithsonian*, *National Geographic*, and *Audubon* would fit into a "nature" category.

When working with photographs, respect the photographer as an artist. Do not duplicate a photograph exactly unless it has been shot specifically for you or by you, or you have purchased the right to use it. A noncommercial student portfolio has more leniency than you will find in the professional world. Copyright infringement laws concerning the use of photographs have gotten increasingly tight in recent years. The source photograph must be substantially altered before it will be legal to reproduce it as personal artwork. *Clip*

art denotes copyright-free images that can be used as is or altered to suit your needs. Books and CDs of electronic and print-based clip art are available from many publishing sources, such as Dynamic Graphics and EyeWire. Dover is the best print source for wonderful old line-art engravings on every subject (**Figure 9–21**).

There can be disadvantages to working with clip art or relying too closely on photos. The preexisting image makes many decisions about composition, lighting, and size. The photograph can also provide only one kind of spatial representation. These limitations can be overcome by remembering to use the clip art or photos as a source, not as an answer. Reference sources need not be taken literally; they should be interpreted creatively.

CONTEMPORARY VISION

The invention of offset lithography brought an explosion of illustration in the late 1800s. Coming into the 20th century as a vital force, and aided by new advances in printing technology, illustration retained its ability to draw inspiration from the fine arts. Painters in the early 20th century followed an investigation begun by Cézanne, and their art reflected the relativity of space, time, point of view, and emotional coloring. Discoveries in science, psychology, and technology supported their depiction of reality as changeable. It could shift, alter, and be processed by the brain in a variety of ways. The artist could interact with reality and help shape it.

Much of the art of the 20th century deals with *picture plane space*—the construction of a flat pattern on the flat surface of the paper or canvas. There is less illusion to this work than in previous art; it does not attempt to deny the flat surface it exists on by emphasizing perspective. Constructivism and the de Stijl movement worked with picture plane space. Cubism presented reality from multiple points of view within the same plane. An object might be portrayed simultaneously from the top, the front, and the sides. The concept and handling of picture plane space is a strong influence in contemporary illustration. Designers and illustrators have always been aware of the flat surface because they have also worked with typography, which encourages flat patterning.

The fauves and the German expressionists in the early 20th century also emphasized the flat patterning of the surface, using bright, flat colors to create images that were personal and highly emotional. This expressive quality currently takes various forms in editorial illustration. The emotionally charged image in **Figure 9–22** by Alan E. Cober created for the now-closed *Dallas Times Herald* uses a visual pun to match the topic of tools of violence making up the face of violence. It becomes what it represents, integrating form and function.

← ↑
9–20 Steve **Hojnacki**. *This portfolio piece was created in Adobe Illustrator for a student portfolio by using the gradient function and a combination of photographic references.*

← ←
9–21 *Copyright-free clip art is available from a variety of sources for reference and reproduction, both in print and CD. Stock art can be purchased by individual image with controlled usage or by CD or book with all usage rights transferred to the purchaser.*

← ↓
9–22 Alan E. Cober. *Illustration for the* Dallas Times Herald. Courtesy of the artist.

An interest in other forms of spatial representation began to appear in the mid-20th century. Trompe l'oeil artists revived an interest in life-size images inside a space that looks only inches deep. A French term meaning "fool the eye," *trompe l'oeil* works extremely well as an illusion of spatial reality. Our culture will probably never lose its admiration for this sort of artistic reality.

There are more artists, designers, and illustrators now than ever before in history. We have the benefit of a mass communications network to keep us informed of what is happening currently in art and design. Designers and illustrators are combining many materials and styles, concepts, and technologies to produce a rich variety of images and techniques. This makes the 21st century a truly exciting time to be a designer and illustrator.

THE IMPACT OF PHOTOGRAPHY

Paul Delaroche, a 19th-century French painter commenting on the invention of photography, reportedly exclaimed, "From today painting is dead!" He was commenting on the invention of the daguerreotype and was an advocate of this new form of creating images. Although some artists feared this invention, others embraced the new medium as a tool and an opportunity. From the beginning of photography, illustrators have used photographs as aids. The art nouveau illustrator Alphonse Mucha carefully posed models amid studio props and photographed them as a reference for his poster designs (**Figures 9–23** and **9–24**). Such well-known 20th-century illustrators as Maxfield Parrish and Norman Rockwell also relied heavily on posing and photographing models as a visual reference for later paintings. Photographer Eadweard Muybridge is well known in the design community for his photographic series documenting the movement of people and animals. Muybridge mounted photographic silhouettes of a trotting horse on a glass disk, which was rotated and projected onto a screen through a device invented by the photographer and called a "zoopraxiscope." This was first demonstrated to the public in 1880, in what some consider the first moving picture. This may have served as inspiration for

↑
9–23 Alphonse Mucha. *Studio photograph of model.*

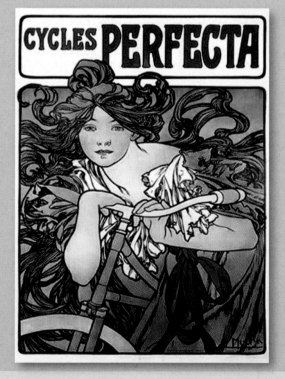

↑
9–24 Alphonse Mucha. *Art nouveau poster design based on the photographic reference shown in Figure 9-23.*

Thomas Edison's invention of the cine camera and perforated roll film. Muybridge's books remain a valuable resource for illustrators today (**Figure 9–25**).

THE DESIGNER-PHOTOGRAPHER

Often the designer is called on to create or locate, and then integrate, photography into a layout design. A working knowledge of how to evaluate photographs is useful.

Photography is a strong, expressive tool with which to prove a point, explore a problem, or sell a product. Many people believe that the camera does not lie. They believe that an illustrator can change things around and make people or situations out to be better than they really are, but such people fail to realize that the camera also represents a point of view. This suspension of disbelief makes the camera an effective tool for persuasion and communication. It is also this belief in the "photograph as document" that is changing with the digital image and the growth of photo illustration.

People want to know if they are looking at a manipulated image. The staff working on the cover for the February 1982 issue of *National Geographic* magazine had difficulty getting a photograph of Egyptian pyramids to fit the magazine's format. Because the image was stored digitally on a computer, it was a simple matter to move the Great Pyramid of Giza to fit the format. When that photo manipulation became public knowledge (it was widely reported), people's faith in photographic reality was badly shaken.

No photograph is truly candid. Its subject is selected, framed, and shot by an individual who is interacting with the environment. Moreover, a situation will change just because a camera is introduced. Another editing and selection process occurs when the contact prints are viewed. Darkroom and computer manipulation may influence the last stages. All of these processes place photography firmly in the camp of interpretive art. A photograph can tell the truth, but that truth is filtered through the eye and intent of the photographer. In the early 20th century, photomontage emerged as a

↑
9–25 Eadweard Muybridge. *Images from* Animal Locomotion, *one of the first photographic reference books.* *1887.*

precursor to the effects now possible with computer-mediated photography (**Figure 9–26**). John Heartfield's work continues to be an inspiration to editorial illustrators.

Designers use photographs and work with photographers throughout their careers. A photograph may be needed to document an event, illustrate a story, sell a product, or put across a point of view. In all cases, the photograph must be evaluated in terms of print quality, design quality, and ability to communicate. It is advisable to study and learn to appreciate good photos, through a class in darkroom work and/or in Photoshop. A photograph communicates in a particular and powerful way. We have a special relationship with photography, based on history, memory, and the photograph's similarity to the retinal image.

SPECIALTIES

Photojournalism

Photographs fall into two general categories: candid and staged. Most photojournalism is candid. It is not shot in a studio or with hired models. *Photojournalism* attempts to capture a news event on location with immediacy and honesty. When a *feature story* is run in a newspaper, whether in print or online, an art director or editor may ask for a photo essay that will illustrate a feature story with a single image or a sequence of images that give a sense of movement, establish a narrative, or set an emotional tone.

Staged photographs are often used in advertising and product photography. They are tightly directed and require elaborate studio lighting. Hired models can

DIGITAL FOCUS
Photography

The criteria for good design in a photograph are similar to good design in layout or illustration. A digital photograph can be accessed, manipulated, and transformed with incredible speed and efficiency. Digital cameras skip the analog stage entirely, although scanners ensure that any analog photo can also become digital. Multiple variations of a single image can be generated when the image is digital, and color editing and retouching can be easily accomplished. Mistakes are never fatal, because the original image is stored on disk (providing the disk and disk reader do not go out of date). Because so many variations are quickly possible, a critical eye for gestalt properties is important. Contemporary artist-educator Susan Ressler created the fine art image in **Figure 9–27** by digitizing original objects for a complex and rich series of manipulations. Her final piece suggests a conceptual similarity between veins in leaf and hand. The most important aspect of photography remains in the eye and mind (and perhaps heart) of the artist. The concept, the design, the element of communication, and excellence of the output determine the quality of a photographic image.

↑
9–27 Susan Ressler. *Electronic artist.* From Stone to Bone. *1991.* Courtesy of the artist.

make shooting time expensive. Product photographers are usually less concerned with truth telling than photojournalists and more concerned with presenting a product in the most favorable light.

Product Photography

Whenever the intent of photography is to promote or sell a product, it is called *product photography.* The product may be food, automobiles, furniture, clothing,

fine art, or a wide range of other items. Still-life photographs enhance the beauty and desirability of many products. Often this sort of product is prepared for the camera with special gels and coatings that intensify lighting effects.

Whether the assignment comes from an art director at an advertising agency or directly from the client, the product photographer is often told what to shoot within narrow specifications. The challenge in this form of photography is to help sell or present the product in a way that is personally and aesthetically satisfying.

Most photographers doing this kind of work are freelancers, and many work through an agent, or *rep*, who solicits work from clients. Major catalog houses and department stores have their own in-house photographic staff and facilities. Many regional advertisers also use an in-house photographic staff. However, national advertisers usually hire dependable freelancers whose previous work suits the project at hand.

When shooting a fashion layout for a catalog, newspaper, or direct-mail piece that calls for a model, the photographer works with an art director and with assistants who help with the details of clothing, makeup, props, and so on. All people at a shoot should show respect for one another's professional abilities.

Corporate Photography

Large corporations need a great deal of photography for annual reports, presentations, and other publications. The company's art director or designer often hires a photographer for an individual assignment and offers suggestions regarding the project.

A public relations (PR) executive also may become involved in the considerations. Sometimes a staff photographer does the photographic work. This photographer is typically a generalist working out of the PR department and shooting everything from candid news release photos to carefully composed and lighted architectural interiors.

Architectural photography calls for special skill in handling building interiors and exteriors. Lighting an interior so that the bright chandeliers as well as the details in dark corners of the room are all properly exposed and not distorted calls for considerable expertise (**Figure 9-28**) Photographing exteriors of tall buildings often requires special equipment that corrects for parallax.

Architectural photography is a specialty in itself, and those who specialize in it work for a variety of interior design firms, landscape designers, and corporate accounts.

Photo Illustration

Photography can illustrate a wide array of projects such as narrative story, a feature article on restaurant dining, or a CD cover. Photographic illustrations are some times closely art-directed by the designer. The necessary props and set may be provided, or the photographer may be asked to find or construct them.

This form of illustration leaves room for creative interpretation, but communication remains the primary objective. Digital photography and digital collage is the basis for the CD cover by California-based artist and illustrator Diane Fenster shown in **Figure 9–29**.

← **9-28 David Saylor.** (ASID). Interior and floor plan of the Cohen apartment, Milwaukee. Photo by Jim Threadgill. 1983.

→ **9–29 Diane Fenster**, illustrator, created this sensual photo illustration in Photoshop. Courtesy of the artist.

FINDING PHOTOGRAPHS AND PHOTOGRAPHERS

Stock photography agencies sell photographs to freelancers, advertising agencies, and in-house design departments. They have thousands of images on file that are constantly updated. Any type of photograph is available via transparency or CD-ROM, and agencies specialize in subjects such as architecture, current events, and the history of civilization.

The Bettmann Archive, Black Star Publishing Company, and Getty Images are three of hundreds of companies providing images and/or photographic services for use in editorial work, advertising, and television. *American Showcase* is a full-color reference book used by advertising agencies, PR firms, and others who want to hire freelance photographers and illustrators. Each portfolio page of photos is accompanied by the name and address of the artist who created them.

Photographers specialize in a variety of areas, each of which calls for unique expertise. As a designer, you'll want to know how to communicate and work with a photographer. As a photographer, you'll need to know your field and other related fields.

← 9–30 **Jackie Waylen** *constructed this portfolio piece as a student, combining clip art and old family photos in Photoshop.*

→
9–31 *Chris Eichman created a series based on his family photos and fabric scans.*

Know how to locate and select stock images when these are appropriate. The designer whose work is shown in **Figure 9–30** used a combination of family and clip art images as part of her original student portfolio. **Figure 9-31** uses family archival images combined in Photoshop with scanned textures.

PROJECT

Design a new cover for a CD you enjoy, incorporating photography and/or illustration. Find several images that are appropriate. You may research and obtain authorized copies, shoot the images yourself, locate copyright-free art, generate the imagery through your own drawings, or check the Web. Do not appropriate a professional photographer's or illustrator's work from magazines or other printed sources unless you plan on substantial manipulation. Choose or generate the images you will work with based on print quality, design quality, and visual information.

Combine the imagery with the title of the recording and the name of the artist. Prepare your piece to actual size. Always keep your treatment appropriate to the subject matter, and remember to use the gestalt unit-forming techniques to integrate word and image. You can choose to complete the CD package, including all typography.

GOALS AND OBJECTIVES

Practice working with thumbnails to develop a variety of creative solutions.

Practice creating and integrating imagery in a layout design, making type and image work together.

Strive to create an illustration that communicates visually, without dependence on words.

CRITIQUE

How do type and image in your design reinforce and echo each other? Are there repeated shapes?

How does this solution relate visually to the content of the music? Consider tempo, type choice, and symmetrical or asymmetrical treatment of type and image.

How is figure/ground treated? Discuss these factors in your own design and in one other.

Request and recommend changes to improve this design for your portfolio.

Visit the accompanying Web site for research links and project examples. Studio techniques in raster graphics include layering, masking, and importing.

WHAT IS ADVERTISING DESIGN?

→

TERMINOLOGY
(See glossary for definitions.)

advertising
retail advertising
national advertising
market research
storyboard
direct mail
point of purchase
corporate identity
graphics standard manual

KEY POINTS

This chapter discusses the differences and similarities between advertising design and graphic design. Various areas of advertising design are presented, including 2-D and 3-D print applications, television, and Internet and Web design. The importance of design structure to a successful ad campaign is discussed, as well as the importance of market research and working with a team in this field. **Figure 10–1** shows an early example of advertising design, created in 1914. This style, that incorporates a single word and image, is known as Plakatstil.

THE PURPOSE OF ADVERTISING

Advertising differs from purely informational graphic design in intent. It seeks primarily to persuade, and the presentation of information is usually secondary to that intent. The person who enters advertising design often is a multitasker who understands the marketing perspective and works with a copywriter. The copywriter is usually more involved in gathering information from the client or account executive, whereas the designer/art director remains more involved through the production stages. A successful designer in this field knows about local, regional, national, and/or international markets for the product. The field is highly competitive and fast paced and appeals to people interested in the psychology behind designs that sell.

The successful advertisement (1) attracts attention, (2) communicates a message, and (3) persuades an audience. Advertising can have many different looks. It may appear on television, in newspapers, in direct mail, in magazines, on billboards, on outdoor displays, online, and on point-of-purchase displays. Whatever the medium, it is characterized by an attempt to appeal to an audience, with the intent to boost sales, profits, and market share, or in the case of not-for-profit organizations, simply to persuade.

There certainly can be elements of information in an advertisement. The consumer may buy a product based on information supplied by advertisements. Future purchases are then based on firsthand assessment of the quality of the product. Equipment ads typically come with information about specific attributes that are important in the decision to purchase.

The ads most useful in informing consumers are probably regional ads announcing events such as plays, concerts, and meetings. Consumers may miss an opportunity to participate without an advertisement.

 10–1 Bernhard, Lucian (1883–1972) Bosch, 1914. Lithograph, printed in color, 17 ⅞ x 25 ¼". Gift of the Lauder Foundation. (236.1987) Location: The Museum of Modern Art, New York, NY, U.S.A. Photo Credit: Digital Image © The Museum of Modern Art/Licensed by SCALA / Art Resource, NY / © 2010 Artists Rights Society (ARS), New York / VG Bild-Kunst, Bonn

Those who explain the persuasive function of advertising maintain that advertisements exist primarily to change perception. Advertising hopes to convince the consumer that a product has certain desirable qualities or associations. Thus, soft drinks and blue jeans become associated with youth, zest, and popularity. Ads that promote them "sell" an attitude and a lifestyle, and buyers have youth and zest "rubbed off" on them, with little information provided about the product.

The clearest example of persuasive advertising can be found in national advertising, especially of long-standing, leading products. Consumers no longer need a lot of basic information on these products. What sells such products are the associations consumers have with them. Many of these associations are generated by advertising and have nothing obvious to do with the actual products.

To summarize this introduction, many advertisements have both persuasive and informative qualities. The closer an advertisement comes to pure information, the closer it comes to graphic design. The closer a graphic design such as a poster comes to not only announcing an event but also persuading ticket purchases, the closer it comes to pure advertising. **Figures 10–2** and **10–3** are newspaper ads that are part of an integrated campaign created for the Minnesota Zoo by Rapp Collins Communications, a well-known contemporary design firm in Minneapolis, Minnesota. Several examples of this wonderfully humorous and effective ad campaign are used throughout the chapter. An integrated advertising campaign crosses media boundaries, producing ads with a repeated visual and intellectual theme in various forms of print, Internet, and other media.

↑
10–2 *Advertisement created as part of the Bugs! ad campaign prepared for the Minnesota Zoo by Rapp Collins Communications. Creative director* **Bruce Edwards,** *art director* **Bruce Edwards,** *copywriter* **Chris Mihock.**

↑
10–3 *Advertisement created as part of the Bugs! ad campaign prepared for the Minnesota Zoo by Rapp Collins Communications. Creative director* **Bruce Edwards,** *art director* **Bruce Edwards,** *copywriter* **Chris Mihock.**

TYPES OF ADVERTISING

Retail and national advertising are two major categories of advertising. Each can be divided into several major areas, including newspaper, direct mail, and the Internet.

Retail advertising is so named because a retail establishment often sponsors it. It tends to be informational, especially when announcing special discounts or availability. It often attempts to get people to go to sponsoring stores to buy items they have seen advertised nationally. Studies show that retail advertising encourages price competition.

National advertising is advertising run by manufacturers with a nationwide distribution network for their product. It tends to be persuasive. It began when manufacturers wanted to differentiate their brands from similar or identical brands, and when there was a national delivery system for advertisements. **Figure 10–4** shows the step-by-step animation of a national TV presentation of the trademark designed by Paul Rand as part of the Westinghouse corporate identity system.

Television

A large percentage of total advertising dollars is still spent on television commercials, although the Internet is making a serious inroad. The content of national television advertising is strongly persuasive. Commercials may take the form of a network advertisement shown on national shows; a spot advertisement prepared nationally and shipped to local areas; or a local advertisement prepared and shown locally, as in the ad for the Minnesota Zoo shown in **Figure 10–5**.

↑
10–4 *TV storyboard of an animated logo designed for Westinghouse Electric Corporation by* **Paul Rand**. *1961.*

↑
10–5 *Storyboard of a TV advertisement created by Rapp Collins Communications for the Minnesota Zoo. Creative director* **Bruce Edwards**, *art director* **Bruce Edwards**, *copywriter* **Chris Mihock**.

Market research is important in all advertising, especially the heavily persuasive kind. It is a study of consumer groups and business competition used to define a projected market. Market researchers survey the area where a product or service will be offered and use the results to determine the cost of doing business, assess the competition, estimate potential sales, and so on. The two primary marketing considerations in television advertising are program attentiveness and viewer volume.

Program attentiveness is how strongly viewers concentrate on a show. Maximum attention ensures maximum recall. Unlike an ad on the Internet or in print media such as newspapers and direct mail, a television ad occurs within a specific time and cannot usually be "reread."

The second marketing consideration in TV advertising is the number of people viewing programs. Certain hours are considered peak viewing periods. These prime-time slots cost prime dollars. Because so much money is at stake, a great deal of research goes into ad effectiveness.

Usually a television advertisement is initially prepared in the form of a *storyboard*. When prepared two-dimensionally, it consists of two frames per scene: one carrying a visual depiction of the scene, the other carrying words to be spoken by an announcer or a cast. The storyboard depicts only key scenes.

The visual is often prepared so it will carry the message even if the TV volume is muted, as shown in **Figure 10–6**. The product name is often superimposed over the scene at the end of the ad. The audio is often written to also carry the message alone, in case the viewer is temporarily out of the room or unable to see the screen.

Newspapers

Newspaper advertising carries both regional and national ads. National advertising often arrives as a file ready for insertion. The creative work has been done at the company's ad agency. However, regional display advertising often requires designing by the newspaper's staff of artists and copywriters. Most newspapers now have a Web presence and hire designers to create and maintain their Web sites.

ADVANTAGES AND DISADVANTAGES

Specific challenges face the designer in newspaper advertising. First, the designer must often include diverse art elements and typefaces in a single ad. A logo and other elements relating to a national campaign must often be incorporated into an ad for a local sale. Often multiple companies share the cost of an advertisement if their logos appear in the ad. This diversity of elements can make creating a well-designed, attractive advertisement a challenge. Second, the designer must create within the limitations of cheap, absorbent newsprint and hurried printing to meet daily, sometimes hourly, deadlines.

Single-item ads for large institutional clients such as banks may use a full page with room for white space. These ads allow more leeway for design. No matter how many elements the advertisement contains, whether it is national or local, whether it is reproduced on newsprint or expensive glossy paper, good design always aids communication. Given some creativity, it also attracts attention and helps persuade the audience. Figures 10-2 and 10-3 are creative examples of such advertisements.

↑

10–6 *Jimmy John's Gourmet Sandwiches has long been known for Subs So Fast You'll Freak™. But the age of globalization, not to mention Jimmy's penchant for hyperbole, called for a new, bigger tagline: World's Greatest Sandwich Delivery. Stills from this 30 second commercial courtesy Planet Proganda Studio.*

There are advantages to newspaper advertising. You can find out how many people are looking at ads through subscription and newsstand sales. Advertisers can anticipate the number of people their ads will reach. Moreover, the circulation is localized. It is therefore easy for a retail outlet to reach the people most likely to be interested in and able to travel to a nearby sale. Finally, the copy can be changed daily (if it's a daily paper), and the updated ad will still reach its audience without great expense.

THE AUDIENCE

The readership for a mainstream newspaper is diverse. Newspaper advertising can be targeted to a limited extent, however, by considering the type of reader attracted to a certain type of paper. The readership of the *Wall Street Journal*, for example, differs from that of the *New York Post*.

Advertising rates are based on the size of the ad, the circulation of the paper, and the position of the ad within the paper. The sports, society, home, and financial sections are areas where advertisements allied to special subjects are likely to be seen by the desired group of readers. Advertisers pay extra dollars to ensure that the appropriate audience sees their ad. Other positions within the paper that are worth extra money are the outside pages, the top of a column, and next to reading material.

Direct Mail

Direct-mail advertising comes in many forms. It is an exciting and growing area of advertising that has boomed partly because of the credit card business and partly because of today's busy lifestyles. Forms of *direct mail* include letters, flyers, folders and brochures of various dimensions and formats, catalogs,

↑
10–7 *Cover for an annual report designed for Westinghouse Electric Corporation by* **Paul Rand** *in 1971.* Courtesy of Mrs. Marion Rand.

↑
10–8 *Salvation Army digital annual report. Created and produced by* **Click Here, Inc.,** *digital division of the* **Richards Group** *(Dallas, TX) ad agency.* Courtesy of The Salvation Army

and booklets. A single mailing may consist of several pieces, such as an outside envelope, a letter, a brochure, and a business reply card. It may be part of a campaign of related pieces that are mailed out over a period of weeks.

Direct mail accounts for most third-class mail and a considerable amount of first-class mail. Increasingly, the Internet is an important way for advertisers to target specific audiences with tailored messages. Direct mail is advertising in which the advertiser also acts as publisher. The advertiser produces a publication (rather than renting space in someone else's), selects the mailing list, and sends the publication directly to the prospects through the mail. A highly targeted form of direct mail includes printed communication to investors such as annual reports. These can be high-quality, high-dollar publications that carefully present an integrated corporate identity. **Figure 10–7** shows the Westinghouse Electric annual report cover from 1971, using the logo created by Paul Rand. Notice the similarity between Rand's print cover design for Westinghouse in Figure 10–7 and his TV storyboard in Figure 10–4.

Online delivery of sales material is a fast-growing market, as corporations increasingly find it appropriate to communicate with their audience directly via the Internet. This medium calls for an integration of the corporate identity program into the pages of Web sites and other forms of advertising. **Figure 10–8** shows an online annual report for The Salvation Army.

ADVANTAGES AND DISADVANTAGES

The advantages of direct mail are substantial. First, the advertiser can use a mailing list that has been compiled to reach a specialized audience. Businesses can either buy a list or develop their own. The primary sources of names are mailing-list brokers. They are in the business of building and maintaining lists of individuals likely to have an interest in a given topic. Lists are usually rented for onetime use, because they go out of date quickly and must be constantly updated. Second, direct mail does not have to compete for attention with other ads on a newspaper page or on television. Third, it is flexible in format. This feature makes direct mail an enjoyable challenge to the designer. The size, paper, ink color, and folding characteristics are all additional variables to be designed. A piece that folds is a three-dimensional problem. It must succeed visually from a variety of positions. The design develops from front to back, building interest and encouraging the reader to continue.

↑
10–9 *This online advertisement was created by the* **Cutwater** *ad agency, San Francisco, California, for Ray-Ban.* © Cutwater

One disadvantage of direct mail is that people can be hostile to it. If the audience throws away the envelope or catalog without even opening it, communication has failed.

Internet forms of advertising include Web sites for catalogs, e-mail messages alerting customers to sales opportunities, and banner ads that may feature movement and sound and increasingly elaborate "movies."

Other Forms of Advertising

ONLINE ADVERTISING

Online advertising uses the Internet and a system of interlinked documents contained on the Internet called the World Wide Web for the purpose of delivering marketing messages to attract customers. **Figure 10–9** is a delightful online ad created for Ray Ban sunglasses. Examples of online advertising include ads on search engine results pages, banner ads, social network advertising, Web page ads, online classified advertising, advertising networks, and e-mail marketing.

One major benefit of online advertising is the immediate publishing of information and content that is not limited by geography or time. And the emerging area of interactive advertising presents fresh challenges for designers.

Most online advertising has a cost directly related to usage or interaction of a customer with an ad. Thus, another benefit to the advertiser is the efficient use of the investment.

The three most common ways in which online advertising is purchased are CPM, CPC, and CPA.

CPM (Cost per Mille)—"Per mille" means per thousand impressions, or loads of an advertisement.

CPC (Cost per Click)—Advertisers pay each time a user clicks on their listing and is redirected to their Web site.

CPA (Cost per Action)—The advertiser pays only for the number of users who complete a transaction, such as a purchase or signup.

It is wise to keep in mind that the use of online advertising has implications on the privacy and anonymity of users.

MAGAZINES

Magazines also offer a forum for advertising. A wide variety of magazines are published. There are

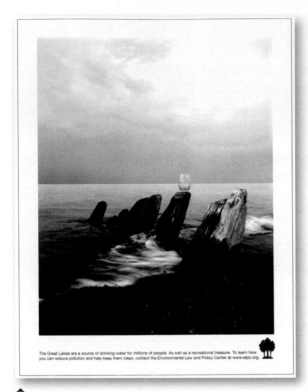
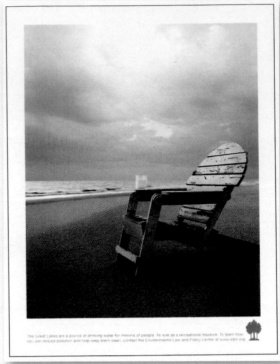

↑
10–10a, b *These magazine ads were created by the* **Downtown Partners Chicago**, *ad agency for the Environmental Law and Policy Center. To learn how you can help keep the lakes clean, contact www.elpc.org.*

general-interest magazines, such as *Newsweek* and *Life*, and specialty or "class" magazines, such as computer, religious, sports, and health publications. There are trade and professional magazines, such as *Print*, *Communication Arts*, and *ARTnews*, as well as professional publications for doctors, engineers, and so on. With magazines it is possible to target a specific interest group. If advertisers have a product to promote, they may choose magazine advertising because many magazines have a national circulation. However some national magazines have regional versions, targeting different parts of the country. **Figures 10–10a** and **b** are part of an advertisement series created for the Environmental Law and Policy Center concerning the need to reduce pollution in the Great Lakes. The copy reads, "The Great Lakes are a source of drinking water for millions of people. As well as a recreational treasure. To learn how you can reduce pollution and help keep them clean, contact the Environmental Law and Policy Center at www.elpc.org."

BILLBOARDS

The billboard shown in **Figures 10–11a, b, c** is part of the highly successful Minnesota Zoo campaign. When designing for billboards, remember that the message will be seen from a moving vehicle at a distance of at least 100 feet (30 m). The visual and the copy must be kept simple, but it is surprising how many billboards violate this principle. Type for billboards should be more than 3 inches (8 cm) high at 100 feet (30 m) and more than 12 inches (30 cm) high at 400 feet (120 m). A message of more than seven words is difficult to read. A single image is easiest to grasp. It should have a strong intellectual and visual

→
10–11a–c *Billboard ads created by Rapp Collins Communications as part of the Bugs! campaign for the Minnesota Zoo. Creative director* **Bruce Edwards**, *art director* **Bruce Edwards**, *copywriter* **Chris Mihock**.

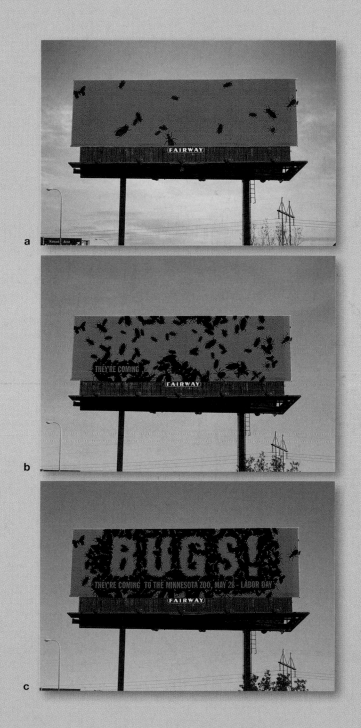

a

b

c

DIGITAL FOCUS
Online Design

The Internet is growing in importance as a form of advertising. Modern businesses are searching for ways to cut overhead costs and target new market segments as well as improve communication and profit margins. Web site design and Internet marketing strategies provide powerful applications that enable a company to achieve those goals. A design that reflects the corporate identity and unites a site from page to page is a vital part of this interactive advertising medium.

unity. The problems presented by transit advertising and outdoor advertising in general are similar to those for billboards. Because the audience is always in motion, the form of the appeal must be bold and simple, eliminating details.

POINT OF PURCHASE

Point-of-purchase ads and package design are other important forms of advertising. Both are primarily three-dimensional and should present a look consistent with the other promotional materials established for a product. **Figure 10–12**, designed by Paul Rand, shows the integration of his Westinghouse *W* into package

↑
10–12 *Light bulb packaging designed by* **Paul Rand** *for Westinghouse Electric Corporation in 1968.* Courtesy of Mrs. Marion Rand.

design. The term *point of purchase* describes the display that is present along with the product in stores. Studies have shown that people frequently make purchases on impulse. More than one-third of purchases in department stores and almost two-thirds of purchases in supermarkets are influenced by the display of the product, and its package design. The display in stores, especially supermarkets, consequently plays an important part in advertising products. Package design can be considered a form of point-of-purchase advertising and is an interesting area to investigate.

Personal Promotion

A special form of advertising that brings out the most creative and delightful work samples is personal promotion. This is the campaign an individual creates to advertise freelance services or to promote a small design firm. It can take many different forms, but the goal is to design a creative sample that shows the best of concept development, illustration, and design skills. It must reach and appeal to the appropriate audience. **Figure 10–13** shows one piece from a direct-mail print campaign designed by photographer Nora Scarlett. Photographic postcards numbering 1–10 were sent to her mailing list.

CORPORATE IDENTITY

Companies have used trademarks to identify themselves since the early Renaissance, as discussed in Chapter 5. This practice grew and flourished with the Industrial Revolution and culminated in the 1950s with complete visual identification systems. Names associated with this golden age of corporate identity include Paul Rand, Saul Bass, and Lester Beall.

Many large companies and institutions now have a master corporate identity plan that coordinates all their designs. This plan begins with the trademark and applies it to the layout of business cards, letterhead, advertisements, product identification, packaging, and Web presence. Even the company uniforms and vehicles form part of this identity program. In **figures 10–14a and b,** the Eyeware Gallery logo (see Fig 5-18) is applied to signage and billboards. *Corporate identity* is a specialized branch of advertising and design that creates a unified

→↑
10–13 *Personal promotional campaign designed by contemporary photographer* **Nora Scarlett** *for direct-mail delivery.* Courtesy of the artist.

→↓
10–14a, b *Eyewear logo (Fig 5-18) designed by the Memphis Design firm Tactical Magic is applied to signage and billboards.*

Nora Scarlett 212 741 2620

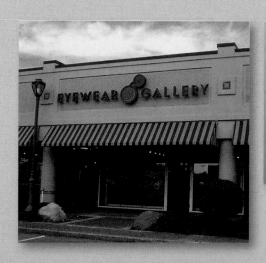

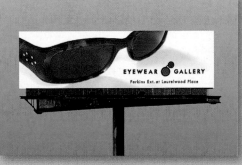

image of a corporation through a systematic application of constant design elements. Every aspect of typography and imagery and their application must be considered part of an integrated presentation.

This integrated presentation shows the corporation to the public in a positive and memorable light. It not only communicates an image, but also attempts to persuade the public that the corporation, and hence its products, are superior. A *graphics standard manual*, distributed to company personnel, details the appropriate use and placement of the trademark and related materials. This identity program must be flexible enough to be adapted to future needs.

WORKING WITH OTHERS

Advertising takes teamwork. The designer must communicate closely with copywriters, photographers, illustrators, clients, and market researchers. Either the visual or the verbal element may be the departure point for developing a message. An integration of form and content, of design and communication is at the heart of good advertising.

The team works together to establish key information. Who is the audience? What is the nature of the product? Where will the ad appear? What is the purpose of the ad? What is the budget? Once these questions are answered, the designer can begin to translate this information into visual form.

A successful ad attracts attention, communicates through its unified arrangement of elements, and persuades through the interaction of strong and appropriate copy and layout.

EXERCISES

1. *Find some persuasive ads in a magazine. How do they catch the attention of their intended audience? What associations with the product do the ads stimulate? How?*

2. *Find a product ad that targets different audiences by appearing in two different magazines in a different format. Try looking at "African American" and "senior" and "youth" magazines for a similar product.*

3. *Turn off the sound on a TV set and watch commercials. Does the visual convey a complete message? Now try listening without viewing commercials.*

4. *Scan your local newspaper. Which advertisements attract your attention? How do position and design affect their success?*

5. *Examine the illustrations in this chapter and identify Gestalt properties and the relationship between form and function.*

PROJECT

Choose one of the following assignments:

Magazine Advertisements

Design two magazine advertisements in an 8½ x 11" (20 x 28-cm) format for a nonprofit public service organization. Your task is to warn two different readerships of a hazard you are concerned about. Consider alcohol and drug abuse, smoking, and environmental and social problems. The primary audience for one ad is 18- to 24-year-olds; the primary audience for the other ad is up to you. Identify the magazines in which each ad will appear. Figures 10-10a and b are a good example.

Research issues that may be targeted and discuss them in class.

Prepare one of the ads for black-and-white reproduction, including an image, a headline, and a few lines of body copy. Prepare the other ad for full-color reproduction. In your thumbnails, try various approaches, including a path layout, a grid layout, and a simple dominant image. For each ad write an accompanying explanation of your subject, your message, and how the message relates to the visual design choices you made. **Figure 10–15** *is a student solution for a similar project.*

Personal Promotion

Prepare a personal promotional campaign. Create a logo for yourself as an independent designer-illustrator, apply it to a business card and letterhead, and prepare a brochure for your promotional mailing. The research stage of this assignment primarily involves looking at other personal promotional campaigns. Set your standards high. Try to top the professionals.

Write an explanation of your message and how it relates to the visual design choices you made. What is your market? How are you addressing it?

GOALS AND OBJECTIVES

Experiment with researching an issue and targeting (or appealing to) a particular audience.

Practice both communicating a message and persuading an audience.

CRITIQUE

Present your solutions, discussing each topic, your relationship to it, and the research you conducted. How do your choices of type, image, and layout relate to the topic and the audience? Be as specific as possible.

Visit the accompanying Web site for research links. Studio links include advanced layering, channels, and masking.

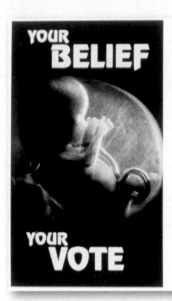
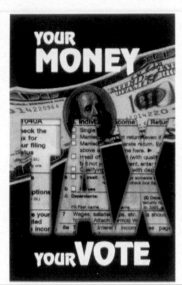
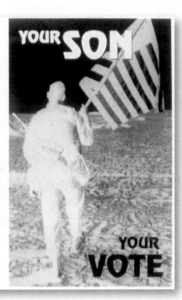

↑
10–15 Terri Breese. *Integrated ad campaign created to encourage voter participation.*

11

PRODUCTION FOR PRINT AND ONLINE GRAPHICS

→

TERMINOLOGY
(See glossary for definitions.)

Part I

hidden line elimination
tweening
depth cueing
analog
pixel
bitmap
bit plane
resolution
object-oriented graphics
bitmapped graphics
vector graphics
Cartesian coordinates
raster graphics hardware
hardware
CPU
software
bit
byte
memory
RAM
ROM
Part II
postscript
inkjet printer
laser printer
imagesetter
prepress production
camera ready
stripper
offset printing
line art

continuous tone
registration
nonregistered color
commercial register
hairline register
dot gain
LPI
RIP
trapping
chokes
bleeds
printer font
screen font
dpi
link
lossless compression
lossy compression
Part III
HTML
URL
protocol
domain name
pathname
file format
GIF
PNG
QuickTime
JPEG
dithering
indexed color
adaptive palette
hyperlink
tables
frames

KEY POINTS

This chapter will introduce the structure of digital data and its application to print and online graphics. Part I begins with an historical overview, leading to an examination of how computers work. **Figure 11–1** shows the pixels that make up a raster image. Part II covers the nuts and bolts of print reproduction, while Part III discusses file preparation for online graphics. Computers are at the core of contemporary design and production. The design field is constantly expanding, as new avenues for print and nonprint evolve with developing technology. The computer is our active, creative partner that joins with hand and eye, reshaping our perception of ourselves and the world in which we live. *Exciting as this electronic tool is, the greatest tool of all remains a flexible, curious, open mind.*

PART I

A DESIGNER'S TOOL

There are many computer applications in design. These include CAD/CAM (computer-aided design and manufacturing) systems through which a designer can generate three-dimensional models of a new automobile without touching anything but the computer. Print applications travel as digital files from the designer's desktop to final reproduction. The Internet knits us together with an exchange of visual information and data sharing as never before. Readily available multimedia and animation programs, such as Premiere, Flash, and After Effects, allow the designer to generate animation, interactive environments, and presentation graphics in a desktop environment. Flash is increasingly available for cell phones.

HISTORY OF COMPUTER GRAPHICS

New ways of thinking and doing are born in response to a new medium. Our tools have always had an important role in shaping our society. Consider the importance to civilization of the invention of the wheel and of the gradual development of hand tools. Our tools of visual communication have also contributed to building our world. *From cave drawings to today's varied personal computers, we learn, grow, and build the world around us with communication tools as much as with physical ones.*

 11–1 Chris Eichman *created this illustration to show the relationship between hand and computer drawn artwork.*

DIGITAL FOCUS
Desktop Revolution

The development of desktop computer graphics has been a vital part of the computer revolution for the field of graphic design. Just as the invention of the printing press and movable type in the 15th century made the printed word accessible to a newly emerging middle class, desktop computers took computer graphics beyond the domain of the scientific and technological elite.

Apple Computer introduced the first Macintosh in 1984. The screen presented a black-and-white visual display at a resolution of 72 ppi (pixels per inch). The opportunity to integrate text and graphics was limited. In 1985 Aldus introduced Page-Maker software for the Macintosh, and desktop publishing began. Adobe Systems developed the PostScript programming language, which enabled printers to output a combination of text and images on a page, and Apple introduced a laser printer that used PostScript fonts. Technological developments continue at a rapid pace, giving individual designers increasing control over their product in a desktop environment, whether that product is print, Web, or multimedia design.

↑
11–2 *Ivan Sutherland using the Sketchpad, a program for interactive computer graphics. 1963 photo of the artist dates from work at MIT in the 1960s.* Courtesy of MIT Museum

The Moving Dot

Computers began as number crunchers in the 1940s around World War II. They functioned as powerful adding machines, performing millions of calculations at a speed never before imagined. The development of computer graphics at the Massachusetts Institute of Technology (MIT) eventually affected everyone in the field of art and design. The first animation was a moving dot on the visual display terminal, rather like the old computer game, Pong.

In 1953 the display of a moving dot had application in the defense industry. It could accurately show the track of an enemy bomber. This visual display's invention was funded by and created for defense, but innovations in computer graphics were quickly adapted in a wide variety of fields such as, but not limited to, medicine, architecture, geology, communications, art, and design.

Realism in Computer Graphics

In the 1960s Ivan Sutherland (b. 1938) invented a device he called Sketchpad, which could draw lines in

response to a marker pointed at the screen. This was the first light pen and interactive display. This display could use *hidden line elimination* to depict a three-dimensional (3-D) object in space. The lines in back of an object were hidden from view, making for a more realistic model. The object's background lines were omitted, remembered, and recalled as the object on the screen rotated. **Figure 11–2** shows Sutherland using his new invention at the Massachusetts Institute of Technology.

Animation

An important development in the early days of computer animation was the invention of *tweening*. Tweening allows the animator to omit several stages of the animation and to concentrate on creating key steps. The computer draws the in-between stages. During the 1970s, 3-D animation with *depth cueing* began to display the information in the background lighter than the images in the front to enhance the realism of the animations.

Professor Charles Csuri (b. 1922) at the College of the Arts at Ohio State University was a pioneer in early computer graphics and animation. His innovative work began in the early 1960s.

In 1967 his experimentation led to animated drawings, including one of a hummingbird in flight. Csuri produced more than 14,000 frames, which exploded

↑

11–3 David Em. Transjovian Pipeline. 1979.

the bird, scattered it about, and reconstructed it. These frames were output to 16-mm film. The Museum of Modern Art purchased the film in 1968 for the permanent collection as representative of the first computer-animated artworks. Csuri is sometimes referred to as an Old Master in a new medium.

Painting and Drawing

Many artists experimented with and contributed to computer graphics during the 1980s. David Em (b. 1953) began during this period to create his illusionary three-dimensional imagery, which he thought of as paintings. He was a pioneer in his conviction that computers and art were natural allies. Em started as a painter but in 1974 began to experiment with electronic manipulations of TV images. His introduction to the Jet Propulsion Laboratory (JPL) and the research work of pioneer Jim Blinn led to Em's mature computer art style. **Figure 11–3** shows his use of the innovations in computer graphics, including depth cueing and texture mapping.

Joan Truckenbrod (b. 1945) is a professor in the Art and Technology Department at The School of the Art Institute of Chicago. Her work is exhibited

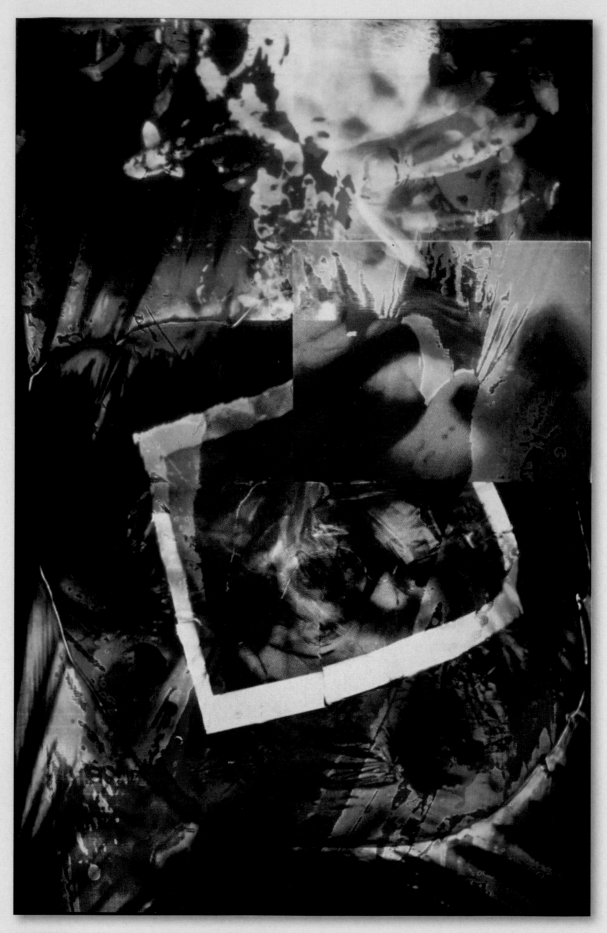

internationally. She began working with computer graphics and paint systems in the early 1980s. Her digital art included experiments with image transfer to fabrics, and her explorations with available paint system technologies have continued to the present day (**Figure 11–4**). Several other names are important in the aesthetic development of this tool in the last decades of the 20th century. Many of them are shown throughout this text and on the accompanying Web site.

Layered Communication

Academic institutions began to incorporate computer graphics into design education programs in the 1980s. Cranbrook Academy of Art in Michigan was an important and influential leader in this movement. Graphic designer Katherine McCoy (b. 1945) and her husband, product designer Michael McCoy (b. 1944),

co-chaired the design department from 1971 to 1995. During that time, experimentation with computer graphics led McCoy and her colleagues to develop a highly complex layered graphic style based on a concept of hierarchical information. The relationship between the designer and audience was recognized as a two-way communication, allowing for various readings of the postmodern design work. This anti-linear exploration of form and visual communication was different from modernism's precise rules. These designs deliberately revealed the layered structure of the composition, as seen in **Figure 11–5**, where type and image overlap and interweave to create a rich visual texture.

The computer made possible this visual and conceptual layering that is the hallmark of postmodernism in graphic design. By the last decade of the 20th century, graphic designers were encouraged to move away from

←

11–4 Joan Truckenbrod. Thresh-olding. *2002. Limited Edition Giclee Print*. Courtesy of Joan Truckenbrod

→

11–5 Katherine McCoy. Cranbrook recruiting poster. *1989*. Courtesy, Katherine McCoy. *Images of student projects are layered with typography and a diagram related to design theory.*

the formal and structural approach of modernism and to work more intuitively. Postmodern typography could be used to explore multiple meanings rather than only to clarify a fixed message.

The mid-20th century saw the development of groundbreaking technology in the field of computer graphics. In the 1970s creative artistic exploration expanded the applications for this technology. The 1980s gave designers and artists access to high-end computer systems as well as early desktop computers. In the 1990s we experienced rapid development of desktop applications and resulting stylistic innovations. In the opening of the 21st century, we continue to find new applications for electronic data.

ANALOG AND DIGITAL DATA

How does this technology work? Many users are unaware of the structure of the hardware they are manipulating. What is it that sets computers apart? Their unique structure deals in digital information.

The *analog* world is full of continuous-tone photographs, long-playing records (remember?), and clocks with smoothly moving hands. We ourselves live in an analog world, with time flowing smoothly past, as day fades to night, as we grow up and gradually age.

The digital world, however, is full of discrete units of information, such as the music on CDs and the data on digital clocks. Each digitized piece of music and unit of time is a discrete entity that can be accessed and manipulated. When a black-and-white continuous-tone photograph is examined under a magnifier, all that can be seen are continuously changing gray values. When a digitized photograph is examined up close on a monitor, what can be seen are individual picture elements, or *pixels*, which give the illusion of continuous gray or color tones (**Figure 11–6**). Each of those pixels can be manipulated—adjusting value, hue, and luminosity—thus giving the designer, photographer, or photo retoucher tremendous control over the image.

↑
11–6 *Enlarging a raster image on a monitor will reveal its pixel structure.*

↑
11–7 *All computer graphics are created by on and off commands, represented here as black and white and 1 and 0.*

Analog to Digital Conversions

In a scanner or a digital camera, analog-to-digital converters (ADC) change analog voltage signals to digital RGB values. In a flatbed scanner, for example, a page is placed facedown on the scanner, and a scan head moves along the page, illuminating it. The light reflected from the page strikes a series of mirrors, which redirect the light to a lens. This lens focuses the beam of light into a prism that splits the beam into red, green, and blue components. The red, green, and blue light beams strike rows of photosensitive CCD (charge-coupled device) cells, where they are converted into an analog voltage level. Finally, the analog-to-digital converter changes these voltage levels to digital information, storing the RGB levels for all the individual pixels in the image that appears on the screen.

The Screen Image

Raster graphics create the video display. A raster beam shot from electron guns illuminates the display line by line. As it moves across the screen, the raster beam's brightness and color are determined by instructions from the computer hardware.

A digital image is composed of pixels, each of which can be individually accessed and manipulated. Each pixel represents a location in memory that consists of a *bitmap* that has an on or off command stored several *bit planes* (layers) deep. All of computer graphics comes down to on and off commands (**Figure 11–7**).

The *resolution* of the screen controls the sharpness and clarity of the image. You may have noticed jagged edges on some computer displays or printed graphics. Because each spot on the visual display is a pixel corresponding to a spot in memory, the number of individual pixels in the file determines the resolution of the image (**Figures 11–8** and **11–9**). The screen, the file, and the printer may all have different resolutions. For print graphics, a high-resolution file and output are mandatory. For online viewing, however, a lower resolution is adequate.

↑
11–8 *These on and off commands represent an X.*

↑
11–9 *This bitmap shows the on-and- off commands represented on the monitor as pixels forming a simple X.*

11–10 *Vector graphics consist of lines drawn between coordinate points.*

11–11 *The selection points in this vector graphic are easily manipulated to rescale or reshape the object.*

Object-Oriented and Bitmapped Graphics

There are two kinds of image files in computer graphics: vector (*object-oriented*) graphics and raster (*bitmapped*) graphics. Illustrator, for example, is an example of a *vector graphics* program. Images are created by lines drawn between coordinate points rather than being composed of pixels (**Figure 11–10**). These images can be selected and moved separately from other objects. Vector graphics programs create images with clean, sharp edges.

René Descartes (1596–1650) was a 17th-century French philosopher, mathematician, and physicist whose most remembered philosophical words were, "I think, therefore I am" (I am thinking, this proves I exist). Descartes created the *Cartesian coordinate* system that vector graphics is based on. In this coordinate system, *x* and *y* represent a two-dimensional graphic, and *x*, *y*, and *z* represent three dimensions. It is amazing to realize that computers use information developed that long ago. Objects created in vector graphics, such as the Illustrator image in **Figure 11–11**, are easily selected and manipulated through pushing, pulling, adding, and deleting mathematical points with no loss of data.

Bitmapped programs use *raster graphics* to create images. This means that each pixel is individually manipulated in terms of color and size to create a "map" of an image. Accessing the individual bits in each pixel does this. Photoshop is a bitmapped graphics programs. This type of program seems to have an intuitive feel, operating much like painting or drawing materials. However, bitmapped images lose data when enlarged in size, unlike vector graphics, which retain their clarity as they are scaled up or down.

Page layout programs accept both forms of graphics. Such programs are usually where type, illustrations, and photographs are compiled for commercial printing. For example, Adobe InDesign works with outline vector graphics fonts to give sharp, clear, resizable typography, and pixel-based images can also be placed in the file.

Hardware and Software

Hardware components are the physical objects that make up a computer graphics system. The monitor we view images on is also known as a visual display terminal (*VDT*). The central processing unit (*CPU*), the main part of the system, is the portion of a computer system that carries out the instructions of a computer program. The hard drive, along with CD, DVD, and various portable drives, gives access to personal

↑↑
11–12 *A bit of information (top) is organized into groups called a byte (middle). A group of bytes make up a "word (bottom)."*

↑
11–13 *When each pixel has two bits, as shown on the left, four numerical possibilities exist per location. If there are three stacked bitplanes, then eight possibilities exist for each bit, providing eight color variations per pixel.*

file storage. The computer case houses the hard drive as well as the other internal components: CPU, motherboard, power supply, internal drives, RAM, video/ sound cards, etc.

Software programs are sets of instructions that tell the computer system what to do. Software is intangible, having no physical or "touchable" components. The term is also used to describe application software such as graphics programs.

Memory

All of a computer's ability to store, recall, and display images is based on the simple notion of *on* or *off*. A single piece of information equivalent to the choice of *on* or *off* is called a *bit*. It can represent a black or a white pixel. Hence the term *bitmapped graphics*. A group of bits can handle grays and even complex colors (**Figure 11–12**). Eight bits are called a *byte* and can store 256 different grays or colors per pixel. Three bytes (24 bits) make it possible to render 16.7 million colors. Full-color effects are achieved when eight or more bits represent each pixel within an image. A full-color image will take up more memory than a gray-scale image, because it uses more bits of information. Bitmaps are stacked several bit planes (layers) deep to

achieve the number of on and off options necessary to achieve full color. **Figure 11–13** shows two stacked bit planes creating four possible numerical combinations per pixel. As shown, three stacked bit planes give eight possible combinations per location. If there are eight stacked bit planes in the bitmap, each pixel is one byte and can have 256 possible combinations, providing a full-color effect.

RAM and ROM

A computer has two kinds of *memory*. An integrated circuit chip on the computer's motherboard has a permanent memory called *ROM* (read-only memory). It holds the computer's essential operating instructions. The other kind of memory, called *RAM* (random-access memory), is used to actively create your files. When you launch an application or open a document, it is loaded into RAM and stored there while you work. Enough RAM is needed to hold the software you are using and the data you generate. RAM needs are constantly escalating. If your computer has limited RAM, buy and install as much as you can to meet your needs. Personal computers currently will easily hold 16 gigabytes (GB) of RAM. RAM chips also vary in speed (measured in nanoseconds [ns]). Be sure to buy the RAM chips specified for your computer.

Most RAM chips are installed onto memory module boards. They are fairly easy to plug in and can be added to your system to increase its memory capacity. Each system has a particular configuration of inline memory module boards. Make sure RAM chips will fit and are compatible with your particular board when adding to your computer's memory.

Storage Devices

Where do you store the large files you have created? Hard drive space is always too small, and the need for more gigabytes increases every year. If you're planning to work on animation and multimedia, an external terabyte storage device can be useful to store and back up work. Designers resort to a wide array of external portable storage devices to send their files to the prepress service bureau or to archive data. Obviously, whatever device you choose, the vendors you deal with must be able to support it. Electronic file transfer via e-mail is a valuable timesaving method for sending graphics files to a client or reproduction house. A physical CD or an online FTP document can be used to send large files.

INPUT/OUTPUT DEVICES

Data In

Many peripheral devices are capable of capturing data for a computer. Scanners come in many varieties, from flatbed to transparency to drum scanners. The higher the resolution a scanner can produce, the better the scan data will be. Excellent quality is now available for much less cost than in previous years.

Digital cameras are another form of input. A digital camera captures a continuous-tone analog image and converts it to digital data, saving it to a hard drive as bits and bytes. Digital video is now commonly available at the consumer level, complete with simple editing programs. High-end digital video cameras are used in the field by news organizations. A transceiver allows images to be transmitted anywhere in the world. A transceiver is a device that contains both a transmitter and a receiver that share circuitry or a single housing. A tremendous variety of input devices are available, and careful research will help determine which will meet your particular needs and budget.

Data Out

As a student or a job seeker you will want both a print and an online version of your artwork for a design portfolio. The image on the screen should be output to print, and you may also plan to place it on a Web site or to download to a digital CD portfolio for viewing. Perhaps you plan to create a portfolio of analog media

paintings or drawings. A digital capture will allow you to show this work in multiple venues.

A variety of printing technologies are available, and each creates a slightly different kind of image. A basic description follows.

A PostScript-equipped printer that can read EPS (encapsulated PostScript) files is an important piece of equipment for a professional design studio that uses various software to create type and image files. *PostScript* is a device-independent format that means the file will print out at whatever dpi (dots per inch) the printer is capable of delivering. PostScript is well known for its use as a page description language in the electronic area.

An *inkjet printer* sprays ink drops onto paper, where they form characters or shapes. Archival ink sets are available for several product lines, producing a high-quality, long-lasting image. Inkjets are cost-effective and suitable for most color proofing and student portfolio prints.

A *laser printer* is a common type of computer printer that produces high-quality text and graphics on plain paper. The image is produced by the direct scanning of a laser beam across the printer's photoreceptor. A laser printer prints quickly with relatively inexpensive dry ink, or toner. As with most electronic devices, the cost of laser printers has fallen markedly over the years.

An *imagesetter* is a high-resolution device found at service bureaus and commercial print shops. It uses lasers to expose an image onto film in preparation for offset reproduction. This dry, chemical-free process can produce positive or negative film separations direct from a computer. The high resolutions (up to 3,000 dpi) of the imagesetter combined with the quality of film provide high-quality printing for photographs and halftones. A *platesetter* is a machine that receives a raster image from a raster image processor and, in turn, creates a lithographic plate suitable for use on an offset press, thus skipping the imagesetter step.

Fine Art

Digital imagery is also created for fine art purposes. **Figures 11–14a, b,** and **c** show an innovative mixture of digital and hand done input and output for a series created by Wisconsin artist and art educator Coleen Deck.

→

11–14a–c Coleen Deck. Signs of the Times. *2010. Nine 8 x 8" birch panels constitute a mixed-media series of computer-aided wood engraving, acrylic, pencil, and charcoal. This contemporary statement is about the relationship between personal identity and the mass-produced signs/rules that surround us. The figure/ground form supports the message.* Courtesy of the artist.

PART II

PRODUCTION FOR PRINT
The Process

The first step in preparing art for the offset commercial printer is the job of the graphic designer. The designer is responsible for decisions about the placement of elements, the location of color, the choice of imagery, and the typographic treatment. Once the design is approved, the job is sometimes turned over to a prepress artist who prepares the design for printing. Many entry-level jobs for designers are in *prepress production*, although many designers who generate their own electronic designs also prepare their own files for press.

Preparing art for the printing process has changed a lot in recent years. Currently this preparation is done primarily with electronic techniques. An understanding of the terminology involved will provide a strong foundation for the new designer. It is possible to better understand the currently process when we begin with a historical knowledge of prepress production. Much of the terminology from the traditional hand techniques has carried over to the current electronic techniques.

An Historic Process

Before computers, the traditional pasteup artist prepared a black-and-white version of the design that was *camera ready*. All the components of the design were assembled in black and white and pasted into position, and colors were specified before sending the job to a process camera to have film shot and plates burned. If any artwork was to be reproduced in full (process) color, it was sent separately to be color separated by a camera. All black-and-white photographs were also sent to be screened into halftones.

A process camera produced negatives of all text and image materials. These negatives were prepared for plate making by a technician called a *stripper*. He or she would cut, trim, and tape the negatives into position on a carrier sheet. The plate would then be exposed and put on the printing press, and the final printed copies of the original layout would be produced on specified paper in specified colors.

In the current digital prepress version, files done by the designer or at a high-quality professional bureau are sent to the commercial printer. There the final composite file can be created. Files go through a RIP (raster image processor) for color separation, then are laser etched onto plates, or just sent straight to the digital press. The RIP is the process of turning vector information into a high-resolution raster image. The RIP takes the digital information about fonts and graphics and translates it into an image composed of individual dots that the imaging device can output. The inking process on the offset press remains essentially the same as it was before digital file creation. Spot or process color inks are put on the press rollers, and the color is printed onto paper. The diagram in **Figure 11–15a** shows this process.

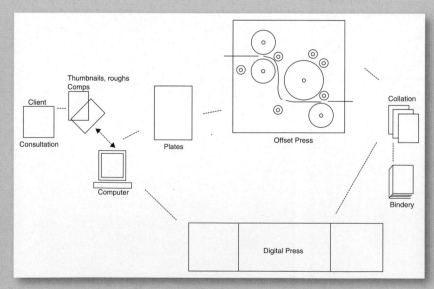

11–15a *From concept to printed piece.*

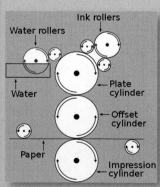

11–15b *The offset press functions as shown here.*

The prepress and printing process requires high standards and good communication from everyone involved. Often the printer can answer a designer's questions about the equipment a job will be run on, which will influence preparation of the artwork. This section of the chapter discusses the preparation of artwork for the offset press, the most common method of reproduction.

Terminology

To the printer, the terms *art* and *copy* refer to all material to be reproduced. The copy is the typeset material; the art is everything else. All photographs, illustrations, and diagrams are called art. In general, they fall into two classifications: line art and continuous-tone images.

OFFSET REPRODUCTION

The most commonly used printing process, *offset printing*, involves three production steps: prepress (just discussed), the press run, and bindery. During the press run, the inked image is transferred (or "offset") from a plate to a rubber blanket, then to the printing surface. The offset technique is based on the repulsion of oil and water. The image to be printed obtains ink from ink rollers, while the nonprinting area attracts a water-based film, keeping it ink-free (**Figure 11–15b**).

LINE ART

Line art consists of a black-and-white image with no variation in grays except those created by optical mixing. In the previous prepress process, any line art could be pasted up directly onto a board and it was ready to be photographed for reproduction. Anything not line art was handled separately, because it needed to be converted at the printer's or via electronic prepress into line-art dots called screens or halftones. The printing press would reproduce only line art. **Figure 11–16a** shows line-art, grayscale, and spot color images with an enlarged dot screen pattern beneath.

Typography, India ink drawings, one-color vector diagrams, high-contrast black-and-white photography, bitmap images, and line-art scans are all forms of art and copy that contain only black-and-white data with no shades of gray. These are printed as one-color designs, as shown in the three illustrations in **Figure 11–16b**).

CONTINUOUS-TONE ART

Art that produces a graduated or blended variety of values is called *continuous-tone* art. It includes photographs, art, and illustration done with pencil, paint, or any other method that produces a variety of values. When transferring such art to computer, the image is scanned or photographed digitally to reproduce a range of values.

The electronic prepress artist sends a file with line art or continuous-tone art in place and ink color specified. The final offset color printing on a nondigital press is created by making a separate negative and plate for

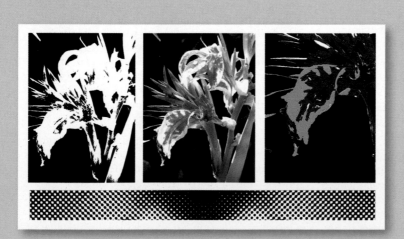
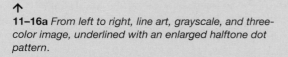

↑
11–16a *From left to right, line art, grayscale, and three-color image, underlined with an enlarged halftone dot pattern.*

↑
11–16b *Line art reversed. Gray-scale art with Photoshop special effects. Line art with a tint screen.*

each necessary color. The different inks are printed on the paper by the press in succession. Direct digital imaging can skip the negative and plate stages and go directly to press.

Reversals and tint screens are line-art variations that can add interest to one- or two-color art (also called spot color). This topic is discussed in Chapter 8. Such variations should be planned at the design stage. Figure 11-16b shows three ways to enrich a one-color design.

Registration marks, shown at the top and bottom of **Figure 11-17**, indicate how the layers of color should overprint. The crop marks are indicated at the edges of the image.

There are three types of color register: nonregistered, commercial register, and hairline register. *Nonregistered colors* do not abut. *Commercial register* (sometimes called *lap register*) means that slight variations in placement of color, of about one row of screen dots, are not important. *Hairline register* is a term for extremely tight registration, where the tolerance is not greater than half a row of dots. When preparing an electronic file, *trapping* becomes an important consideration to ensure successful tight registration of colors that lie side by side. Otherwise, a thin outline of white or dark can surround inked shapes. Some software programs, such as InDesign, do automatic trapping, inserting *chokes* and *bleeds* to slightly reduce or enlarge the overlap of inked outlines. In most cases the printer or prepress service bureau will trap the file if your software program has not.

Quality Issues

Careful consideration of dot gain, LPI (lines per inch), and paper quality is necessary to ensure quality output.

Dot gain occurs when halftone dots print larger than intended. It causes a printed piece to look very dark and full of high contrast. When examined under a magnifier, the halftone dots appear to be bleeding into the white spaces. An absorbent paper can cause dot gain, as can problems with the press itself.

LPI refers to the screen frequency of the actual printed piece. Again, your printing company is a good source of information about the recommended LPI for your job. The higher the LPI, the finer the printed image, because the rows of halftone dots are closer together and are very small. However, the higher the LPI, the greater the tendency toward a clogging of halftone dots, or dot gain. Coated paper

↑
11–17 *Accurate registration and crop marks are vital for a file going to offset reproduction.*

will handle higher screen frequencies than uncoated paper or newsprint:

133–175 LPI for coated paper stock

85–133 LPI for uncoated paper stock

60–80 LPI for newsprint

DIGITAL PREPRESS

The design and production stages are highly integrated now. Designs are previewed on the computer screen (or in a proof stage), changes are suggested by the client, adjustments are made by the designer, and the final design is sent to the production people as electronic files. Color correction, photo retouching, and color separations can be done on a desktop system before sending the files to a service bureau or printer for high-resolution output to print proof or to press. Once the design is in digital form, there are vast possibilities for archiving and reutilization.

All of this may sound simple, but it is actually quite complex. There are many ways to corrupt a digital file. Clear communication between the designer, the prepress technician, and the printing technician is a must.

The RIP

Once the publication file is assembled, the designer or prepress technician needs to verify that the file is ready for *RIP* (raster image processing). A typical computer

monitor has a resolution of 72 dpi; a typical laser printer has a resolution of several hundred dpi. The imagesetter that will send a file to film has a resolution of 2,400 dpi or higher. The pages may print fine on a designer's laser or inkjet printer but fail to print on an imagesetter, because it calculates pixels by a different method. It is a safe bet that if the pages do not print on a laser printer, they will not print on an imagesetter. How do you ensure that those pages are ready to RIP? Such considerations are especially important when using imported elements and multiple programs.

SOME DOS AND DON'TS

- It is important to keep an electronic file clean and neat. If you do not need something in a file, delete it. Do not cover it with a white rectangle or leave it on a hidden layer.

- Avoid putting files into files and then putting these files into yet more files. This process is referred to as *nesting*, and it can snarl the RIP by requiring many unnecessary steps in electronic memory (**Figure 11–18**).

- When using multiple programs, it is best to assemble all the elements in your final output program.

- Finish any manipulation of those elements in the original file before importing. Rotate and resize an image in Photoshop, for example, before sending it to a page layout program.

- Avoid scaling graphics up or down by large amounts. The data may distort when reduced, or you can end up with a large but relatively low-resolution image.

- Always scan or create an image at approximately the size it will be in the final publication. If it is necessary to drastically reduce the size of an image, plan to also use the software program to reduce the resolution (dpi). If you are planning to enlarge the image, watch what happens to the resolution. It will decrease as the image size increases.

Fonts

Fonts are composed of a *printer font* and a *screen font*. The printer (PostScript) fonts are outline font specifications developed by Adobe Systems for professional digital typesetting and allow typography to output cleanly to print. The screen font is a cruder version that shows up on the monitor. Screen fonts display a font onscreen at 72 dpi. The RIP needs to find and use exactly the font used to create the document. The font cannot be some other vendor's version of Helvetica. It has to be the exact one used in your publication for the line breaks to work out correctly. Send all printer and screen fonts along with your document or as a PDF file. This file is used for representing documents in a manner independent of the application software, hardware, and operating system Otherwise, plan to convert vector files such as Illustrator to "outline" (**Figure 11–19**). If

↑
11–18 *Avoid* nesting *electronic files as shown. Instead, import each element directly into the page layout program.*

↑
11–19 *Convert vector files to Outline or rasterize fonts before sending them to print.*

you rasterize (convert to raster graphics) typographic files in Photoshop, they will not print as sharply as a vector graphics file.

Digital Image

In the precomputer days of offset reproduction, the designer sent a continuous-tone photograph or transparency along with the pasteup or mechanical and specified where the image should be inserted and resized. The printer then created a halftone negative at the correct LPI for the press and the paper choice. The primary tool for creating a halftone today is the computer. The designer needs to be familiar with terms such as *LPI* and *dpi* and understand their relationship to ensure good results.

The higher the resolution an image has, the more *dpi* (dots per inch) it has. The term *dpi* refers to how many dots fit within each inch to recreate the image. More dpi produces more data and potentially a finer reproduction of the image or typography. A 72-dpi, or *low-res*, scan, though suitable for online use, will show jagged edges of pixilation when printed. Most consumer-level digital cameras can now shoot a file that converts to 300-dpi print quality at 8 × 10 in. And it keeps getting better.

LPI and dpi

When a continuous-tone, chemically processed photograph is scanned, it is converted into dots on an electronic file. The more dots, the higher the resolution, or dpi.

There is a relationship between the resolution of an image and the lines per inch of the final printed piece. For a good-quality printed piece, pay attention to this relationship.

Do you know the optimum LPI of your printed piece? If not, ask the printer and look at the LPI list in this chapter. LPI will vary depending on the paper used for printing. LPI is sometimes called screen frequency or screen ruling. For halftones, a final dpi resolution of 1.5 or 2 times the LPI usually works well. The formula is LPI × 1.5 = dpi scanning resolution. Remember that resizing the image can change the dpi, so plan accordingly.

SUGGESTIONS

■ Using a retouching program to sharpen an image will produce a cleaner-looking file. A blurry scan may not be improved with higher resolution, but it will look better when software-sharpening filters, such as Photoshop's unsharp mask filter, are applied.

■ When scanning, crop away the white borders. They create data that adds to the file size. If any cropping is desirable, do it in the scanning stage.

■ A line-art image will not need to be screened when it is scanned. When creating a line-art scan, use very high resolution and use sharpening. Image resolution does not need to be higher than the output resolution, but if the file is going to an imagesetter for a RIP, try for at least 800 dpi on a line-art scan.

■ Every time photographic material is duplicated in a compressed JPEG file format, image degeneration, or loss of information, occurs. Do not resave JPEG files.

File Links

To insert scans or other graphics files into a layout program, the computer must find those files. To find a file, the computer searches along a path established when the graphic was imported into the layout program. This path is known as a *link*.

There are several reasons why this link may not be found. If the graphic was renamed or moved to another folder, the link could be broken. All graphics files should be sent to the printer along with the job if the job has various software graphics assembled in a page layout program. These files should be in the same folder that uses the graphics.

File Formats for Print

The way an image is stored determines which programs can open, read, and edit that image. If an image is not stored in the proper format, it will not appear as an option to open or import into another program.

Photoshop's PSD and Illustrator's AI are standard formats that will import into easily into page layout programs.

TIFF (tagged image file format) is a widely used bitmapped file format. It is appropriate for scanned images and digital photos. Almost every program that works with bitmaps can use the TIFF format; it is used for exchanging documents between different applications and computer platforms.

EPS (encapsulated PostScript) is an object-oriented file format that is excellent for storing graphics of any kind. Most illustration and page layout programs support this type of PostScript file. EPS is a refined form of PostScript that will allow an object-oriented or bitmapped program to open the file for editing. Files should be converted to TIFF or EPS before placing in a page layout program.

PICT is a Mac object-oriented file format. It handles bitmap and vector images well.

DOC is a file extension for word-processing documents, most commonly for Microsoft Word.

Understanding the basic concept of file links and file formats clears up a lot of questions about why an image may not appear correctly onscreen when imported into another program. At a more advanced level, you will learn more about this topic.

Compression

Sometimes a file is simply too large for a storage device. In that case, data can be compressed to shrink the number of bytes needed for storage. Two methods are used to compress bitmapped data: *lossless compression* and *lossy compression*. Lossless methods give less compression but preserve the original image. Lossy methods give high compression but lose information in the original file. For example, JPEG is a lossy compression method that throws away some high-frequency variations in color. RLE (run-length encoding) is a lossless method that depends on batch-processing adjacent pixels with identical values.

Preparing Electronic Files for a Service Bureau

There is a great deal to know about preparing artwork for reproduction. The better a designer understands the tools and procedures of offset reproduction, the better his or her designs will reproduce in print. All digital files prepared for offset reproduction must be clean and accurate.

ACHIEVING ACCURATE FILES

- Assemble the file in a page layout program. It is easier to RIP files from a layout program than from an image manipulation program.

- Bring all images from Illustrator, Freehand, and Photoshop into the final document as EPS files.

- Select the automatic trapping option in the layout program, and ask the service bureau to check your trapping.

- All files must be CMYK if prepared for full-color output.

- When using Photoshop, check the color picker menu for an alert symbol. If the triangle has an exclamation point in it, the selected screen color will not print accurately in printer's inks.

- Include all original scans, fonts, and vector graphics links or files in the documents sent to the printer.

- Be sure all documents are linked. Check the links menu in your layout program. If files are missing, locate and include them. Software such as InDesign and FlightCheck has an option that will check your document for missing items and collect the necessary files.

- Supply all fonts used in your document or convert them to outline or rasterize them.

PART III

PRODUCTION FOR THE WEB

There are many design similarities between print and Web. They benefit equally from the application of the graphic design basics discussed in this text. But there are a number of differences between production for print and production for the Web. This section discusses these similarities and differences and introduces the basic structure of designing and creating files for the Web.

Internet Origins

The Internet (or "the Net") is a medium with few geographic boundaries. It connects millions of computers globally and is used for a variety of applications, including e-mail. The World Wide Web (or simply "the Web") is contained on the Internet and is a method of accessing and sharing information by using browsers. It is the largest and most popular subnetwork on the Internet.

In 1969 the first network connection between two computers (ARPANET) was successful and the Internet was launched. This research, sponsored by the U.S. government, was an attempt to increase technological advancements. In 1990, Tim Berners-Lee developed the backbone of the World Wide Web, hypertext transfer protocol (HTTP). Computer scientists using this early relatively limited version of *HTML* (hypertext markup language) created the first Web sites. These sites were linear, text based, and unhampered by fine distinctions in typography because users set their font viewing preferences on their own computers. However, the Web quickly became a powerful and exciting tool for designers. See the accompanying Web site for more information.

In the 21st century, the Web and multimedia increasingly take us beyond text and still images. As we know, human perception is a blend of sensory input from sight, hearing, touch, taste, and smell—all shaped by memory.

THE GLOBAL VILLAGE

The World Wide Web allows ease of international communication, as our communication and design

↑
11–20a, b *An excellent Web site to visit for both the design of the site and the design of the artwork it showcases by* **David McLimans***.* David McLimans.

issues become a shared worldwide experience. The new media are vitally linked to the actualization of Canadian media theorist Marshall McLuhan's concept of a global village. These media are also linked to the establishment and redefinition of cultural and personal identity.

The telephone, the microscope, and the telescope are examples of earlier technologies that extended the range of our senses. Now we can see inside storms and along chains of molecules. From book to photograph to computer disk, our means of storing and retrieving information has grown. New-media technologies rely strongly on visual communication, requiring users to be visually literate. Designers must be knowledgeable about both the production and the consumption of images. Because media technologies are constantly evolving, we need to be prepared to renew our knowledge base constantly throughout our careers.

SIMILARITIES AND DIFFERENCES

The Web-based medium is very different from print, because it is nonlinear and interactive. DVDs can also be burned with nonlinear, interactive information, using programs such as Adobe Director (formerly Macromedia Director), a multimedia application authoring platform. The Web, however, is the still most powerful of the interactive media presentation modes.

When you type an address into a Web browser such as Internet Explorer or Safari, your computer sends a request over the Internet for a specific URL address. The file at that address is then downloaded over the

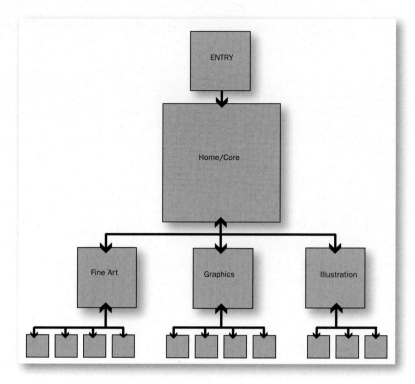

11–21 *A suggested student flowchart for a portfolio site.*

Internet to your computer. Finally, the browser displays the file. The *URL* (Uniform Resource Locator) is the address entered to access a particular Web site. This URL consists of three parts:

- Protocol—http://

- Domain name—www.server.com

- Pathname—folder/filename.ext

The *protocol* is the communications language the URL uses. The *domain name* is the server where the desired file is located. The *pathname* is a particular file at a site. For example, http://www.davidmclimans.com/ takes you to a site for a portfolio (**Figure 11–20a**), and http://www.davidmclimans.com/1.htm takes you to a particular page at that site (**Figure 11–20b**).

There are many similarities and differences between print-based and Web-based design. Let's begin by examining the similarities and then look at the differences.

Common Methodology

- Begin any publication by defining the message and the audience.

- Familiarize yourself with the competition.

- Research and analyze the available resources.

- Organize the content. In Web design that means developing a flow chart or site map for content. **Figure 11–21** shows a typical flow chart for a portfolio site.

- Design the visuals, developing a look and feel tied by a common visual and conceptual theme.

- Produce the Web site or print piece.

Design Similarities

A book or magazine presents information in a sequence of pages, as does a Web site. All pages should be tied together with a similar visual treatment, such as a uniform grid, a consistent choice of font, and alignment of typography. Consistency in placement and visual treatment of items such as page numbers or navigation bars and buttons is important. In addition, a successful publication, whether online or in print, typically uses a visual and conceptual theme to unite the pages.

The 20th century produced wonderful examples of print-based graphic design. The gestalt unit-forming

principles of visual perception form a basis for design of Web graphics as well as print media. Repetition and variation, rhythm, continuation, and figure/ground treatment are fundamental to the design of any publication. Although various cultures have devised unique design solutions using these visual components, all cultures deal with these visual foundations.

Production Similarities

A bottom-line production similarity between print publication and online publication is that when a Web site is mounted online or a print piece is sent to press, all elements must be prepared correctly in order to function properly.

Design Differences

A book or magazine presents linear information. The pages follow each other sequentially from front to back, and the structure of the information flow is one-directional. Information on the Web is nonlinear and interactive.

Because the structure of Web site information flow tends to be complex, it should be diagrammed before the site is created. It is possible to get stuck out on a limb on a Web site, with no links back into the

information flow, causing a viewer to end the session. A successful flow leaves the viewer only a click or two from the home page.

Time, motion, and sound are important components of Web design. All design communicates a message, but it may not have the desired effect if the designer lacks conceptual or production skills.

Production Differences

In terms of production, online publication differs from print publication in many ways. The dpi of image scans, availability of fonts, appropriateness of file formats and sizes, and color gamuts of RGB versus CMYK must all be learned anew for their application to Web graphics. Consider the ephemeral quality of the online environment, with the variable characteristics of its users and their equipment, versus the concrete reality of the printed page. This is an important difference. Download time is also a crucial issue in Web design that does not exist in print graphics. What's more, in Web graphics, naming conventions must be understood and carefully followed. *The Web is a picky medium, and it is vital to understand its rules in order to reach an audience with the intended message.*

WHAT ARE THE RULES?
Naming Your Files

Filenames use different conventions and restrictions, depending on the operating system (Windows, Mac OS X, UNIX, and more). Because the server computer mounting your site may run an operating system different from yours, name your files so that they can be used on a variety of servers. Keep filenames simple, brief, and descriptive, followed by a three- or four-character extension. Do not use spaces or other special symbols; use only lowercase letters and numbers. For example, a Web page would have a .HTML extension. Name your first page index.html and your image and GIF animation assets with recognizable names of no more than eight characters, followed by the extension .JPEG or .GIF. The chart in **Figure 11–22** shows standard file extensions that signify different file formats. This is an important topic, because if the file name won't work, the Web site won't work either. Web designer Chris Eichman comments, "I bang my head against a wall so many times because of these rules. I can't get an image to load because of a capital letter or a typo, or space, or forgotten extension. These rules are such a pain!"

Keep all files related to your site in one folder, with sections grouped together by either subfolders or naming conventions. Don't scatter your links and high-res images in a variety of folders.

11–22 *Web site directories follow strict naming conventions.*

File Formats

A *file format* tells a computer what kind of file it is dealing with. It is a particular way that information is encoded for storage. The *GIF* (Graphics Interchange Format) file format supports storage of both still images and simple animations. It is a lossless file format, which means that it compresses graphics without eliminating detail and is designed for 8-bit (256 colors or fewer) graphics. *PNG* (Portable Network Graphics), designed for transferring images on the Internet, is a lossless bit-mapped image format. Not all browsers support PNGs (for example, Internet Explorer has problems with it), but one of their advantages is 256 levels of transparency. The *QuickTime* format, developed by Apple, can act as a container for many different types of multimedia such as digital video, animation, and music.

The *JPEG* (Joint Photographic Experts Group) is designed to store still photographic images. JPEG is best used for gradations or photographic images for the Internet. It produces compressed file formats, producing graphics with reduced file sizes. It is a lossy file format, which removes data from an image when it compresses a file. Designed for displaying 24-bit true color, it can describe a photographic-like image with a small file and a fast download.

The Portable Document Format (PDF) is used to send 2-D images that are independent of the software, hardware, and operating system.

Resolution

Prepare final Web files at 72 dpi. Keep in mind, though, that the best results often come from scanning or otherwise preparing initial images at a higher resolution and reducing the file later. Keep an unflattened high-resolution version of your image files, so you can go back and make all necessary changes on the original.

Print graphics at a resolution of 72 dpi look terrible. However, Web graphics are displayed on monitors. Most monitors display images at a resolution of about 72 pixels per inch (ppi). The bigger the monitor is, the more pixels it can display onscreen, but a larger monitor simply displays a larger image, not necessarily a higher-resolution image.

File Size

File size, measured in bytes, is the amount of disk space required to store a file. The larger the images, and the more complex and numerous the elements added to a page, the longer that page will take to view in the browser window.

Keep graphics as small and concise as possible to avoid long download times and frustrated users. Once a graphic is used, it is downloaded and can be reused without wasted time. These graphics are cached in memory, eliminating the need to download them again. Flat, solid areas of color reduce a file's

 11-23a, b *How to change Macintosh and Windows screen size and resolution.*

size considerably. Top-to-bottom gradations create a smaller file size than right-to-left gradations.

Monitor Size

For the most conservative size, guaranteed to reach all users, keep important elements of text and graphics of your Web page within a 920 × 600-pixel area, using the remaining area for background color or design. Many computers use a screen size of more than 1024 x 768 pixels. To get an approximate idea of how your file will look on various monitor resolutions, on the Macintosh go to *System Preferences* found under the Finder's Apple. Choose *Displays* to experiment with different screen resolutions and size, as shown in **Figure 11-23a.** In a Windows 7 platform, as shown in **Figure 11-23b,** right click on the desktop, select [screen resolution]. Select the resolution you wish to use. Click on [OK] then choose [keep changes]. Repeat these steps to select another resolution.

If your monitor is 800 × 600 and you change its default display to 1024 × 768, you'll have more pixels, but they'll be smaller. A Web file you create to completely fill your 1024 × 768 screen will be too large to view on someone else's 800 × 600 screen.

Color

Current versions of Photoshop let you save your file for the Web and present a pop-up window of choices to specify the format and color table. **Figure 11-24** also shows JPEG options.

Convert all files for Web to RGB mode. To make a smaller file, changing an image from RGB to *indexed color* mode reduces an image's color usage from RGB's 16.8 million colors. You can choose from a number of standard color palettes to save computing memory and file storage and to speed up data transfers. These include the 216 Web-safe colors, the 256-color Mac and Windows system palettes, or custom palettes.

When using indexed color mode, real-life images are represented with better fidelity to the original by using *adaptive palettes*. Both are accessible from Photoshop's Image > Mode > Indexed color command menu. If the graphic contains both photographic imagery and some flat color elements filled with Web-safe colors, choose an adaptive palette. It is made up of colors most appropriate for the particular image. *Dithering* is most noticeable in solid flat-color areas. Dithering scatters different colored pixels in an image to make it appear as though there are intermediate colors in images with a limited color palette.

WEB COMPONENTS

Pages and Sites

A Web site is composed of separate, linked pages. The site must be mounted on a server if it is to be viewed anywhere but from a disk.

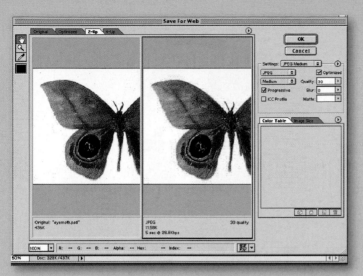

↑
11–24 *The Photoshop Save For Web option.*

↑
11–25 *Graphic buttons that can be used as links are often created in Photoshop, then placed in Dreamweaver.*

Links

A link (also known as a *hyperlink*) is an active part of a document (**Figure 11–25**). Clicking a link can take you to another part of the same Web page, to other Web pages on your hard disk, or to a location on a remote computer. Every link contains the Web address for the page that the link refers to. This Web address is called the page's URL.

Tables and Frames

Tables allow you to precisely align online layout elements into columns and rows. They also keep data from jumping around when a window is resized. Think of tables as similar to the underlying grid that provides structure to a print publication design.

Frames are very different from tables, although they look similar. A frame splits a Web page into sections.

Typically one stationary frame on the left side has links that call varying content into the frame on the right side. Each frame is actually a separate Web page. Frames are excellent devices for controlling the presentation and flow of information.

Animation and Sound

GIF files can be used to create small animations. Freeware and shareware products are available for download to allow creating and optimizing GIF animations. See **Figure 11–26**. Flash is the top program on the Web for generating sophisticated motion that downloads quickly, as well as for designing interactive sites. Interactivity means that something happens in response to a viewer action. For example, clicking an image or button can cause a sound file or animation to run. There are many forms of interactivity on Web sites. The simplest one is a button link to another page.

Web Software

All Web sites are created with HTML (hypertext markup language). Designers do not necessarily need to know this language, but a little background is advisable. Many software packages write the HTML for you invisibly. For example, Dreamweaver is an excellent professional design and production tool for the Web from Macromedia, although several other programs on the market also do a good job.

Web Publishing

A great variety of online services for Web publishing are available. Google Sites and many others offers a free Web site. Like commercial television, free sites run advertisements to turn a profit, so be prepared to have ads running along with your pages. These services offer the beginner excellent practice in troubleshooting and mounting a site.

↑
11–26 *A GIF animation with its several stages is ready to be inserted in a Web site.*

SUMMARY

Characteristics of Good Web Site Design

■ *Appealing opening or home page that attracts viewers*

■ *Clearly marked navigational devices*

■ *All elements (links and assets) functional*

■ *Integrated design that visually unites the pages*

■ *Good use of design basics throughout*

■ *Acceptable download time*

■ *Communication of an appropriate message to an identified audience*

The Web combines modernist and postmodernist values. It reflects both modernism's emphasis on rational organization and postmodernism's emphasis on eclecticism and layering.

Discussion Questions

1. How is the computer a tool like any other throughout history? How does it present ways of seeing and shaping reality that makes it significantly different from tools of the past?

2. What are the constants we bring to the use of new technology?

3. What is truly new about the new media that cannot be duplicated by any other media?

PROJECTS

Web Site Review

Choose a Web site to evaluate. Use the terms found throughout the chapter to identify elements. Refer to the list "Characteristics of Good Web Site Design" to help you in your evaluation. Refer to the "Critique" section for additional ideas.

Web Page Design

Refer to the methodology discussed earlier in this chapter to plan and design a small Web site of about six pages. These will be prepared as print pages. For your site's topic, research and prepare a short presentation on an artist or designer mentioned in this text. Gather and prepare several images for your topic. Prepare a sample flow chart to show the instructor. Then construct the pages in Photoshop, writing a brief amount of copy to include. Be sure to design button icons intended to act as links between pages. Print these pages for presentation and critique, or show them online. During the class critique, discuss their intended navigational structure and overall design theme.

CRITIQUE

The critique of a print-based or Web-based design should center on issues specific to the design medium. The critique should also consider the larger issues of medium and message and cultural impact.

- Consider the overall complexity of the site. How many elements such as JPEG files, GIF files, animations, and links are there?

- How complete is the research on the site's topic?

- How successfully is the visual and conceptual theme communicated?

- Is there a clear logic to the navigational structure?

- Are the files error free?

- How well does each image fit your viewing screen? Try accessing it using a different monitor resolution and a different browser platform.

IN CONCLUSION

This chapter presented an introduction to the historical development and basic structure of computer graphics. Year by year, the technical data concerning production of print and online graphics will change, but the fundamentals of design will stay relevant. Education is a lifelong process—especially now, as changes continue to challenge our understanding of the world and how we function in it.

Visit the accompanying Web site for research links.

Abstraction A simplification of existing shapes.

Adaptive Palette When using indexed colors in a digital palette, real life images are represented with better fidelity by using adaptive palettes in which the colors are selected directly from the original image by picking the most frequent colors.

Additive Primary Colors Red, blue, and green, which combine to produce white light.

Advertising The activity of attracting public attention to a product or business. Advertising appears in paid announcements in print, broadcast, or electronic media. It seeks primarily to persuade, and the presentation of information is usually secondary to that intent.

Advertising Illustration Images created for the purpose of selling a product or a service.

Age of Information A term applied to the period when movement of information became faster than physical movement, during the late 20th century.

Alternating Rhythm A regular variation on a repeated visual theme.

Ambiguous Open to more than one interpretation; having a double meaning.

Analog Signal that may be varied continuously. Computers cannot process this kind of signal, so their information must be converted to digital. Analog refers to everything in the real, noncomputerized world.

Analogous Colors Colors next to one another on the color wheel

Arbitrary Color Whatever color seems artistically desirable to artwork, rather than photo-real colors.

Art Deco The predominant decorative art style of the 1920s and 1930s, characterized by precise and boldly delineated geometric shapes and strong colors. Although it developed at the same time as the Bauhaus, art deco emphasized the figurative image with decorative appeal.

Art Nouveau A style of decorative art, architecture, and design prominent in western Europe and the U.S. from about 1890 until World War I and characterized by intricate linear designs and flowing curves based on natural forms.

Arts and Crafts Movement A movement that originated in England around the middle of the 19th century and spread to continental Europe and the United States. It rejected the heavy ornamentation of the Victorian style in favor of good craftsmanship and clean design.

Ascender Section of a lowercase letter that extends above the x-height.

Asymmetrical Layout See definitions for *Asymmetry* and *Layout*.

Asymmetry Distribution of shapes of different visual weights over a picture plane to create an overall impression of balance.

Baseline The line that typography sits on.

Bauhaus A school of design in Germany from 1919–1933 whose faculty encouraged the use of techniques and materials from industrial sources. The Bauhaus school affected graphic design with its emphasis on the elements and principles of design. *Form follows function* is a phrase that describes the Bauhaus interest in how the form of an object (its dimensional appearance) should be descriptive of how the object is used.

Bit Abbreviation of Binary Digit. The most basic unit of digital information. A bit can be expressed in only one of two states, 0 or 1, meaning on or off, yes or no. This is actually the only information that a computer can process. Eight bits are required to store one alphabet character.

Bitmap Text character or image comprised of dots. A bitmap is the set of bits representing the position of items forming an image on the display screen.

Bitmapped Graphics Image comprised of dots (pixels), as distinct from an object-oriented graphic. Characterized by jagged edges. Also known as a raster image.

Bit Plane A single bitmap is a bit plane and is only one bit deep, storing a zero or one in each pixel location to represent black or white.

Bleed Part of an image that extends beyond the edge of a page and is trimmed off.

Bracketing Thick- and thin-stroke serifs that seem to merge into the main strokes.

Byte Unit of information made up of eight bits. Bytes are commonly used to represent alphanumeric characters or the integers from 0 to 255.

Camera Ready Artwork that has been assembled and prepared for reproduction on a process camera.

Cartesian Coordinates Numerically represent a two-dimensional area. The horizontal axis is the X axis, while the vertical axis is the Y axis.

Choke Method of altering the thickness of a letter or solid shape, used in trapping to ensure proper registration of colors.

Clip Art Libraries of copyright-free images available in print or electronic form that can be used as is or altered to suit your needs.

Closure When the eye completes (closes) a line or curve in order to form a familiar shape.

CMYK Process colors of cyan, magenta, yellow, and black inks used in four-color printing.

Color Schemes Categories of color combinations based on position on the color wheel. (See *Analogous*, *Complementary*, *Monochromatic*.)

Color Theory Color is produced when light strikes an object and reflects back in your eyes. This element of art has three properties:
Hue is the name of a color (e.g., red, yellow, blue).
Intensity is the purity and strength of a color (e.g., bright red or dull red).
Value is the lightness or darkness of a color.

Color theory is a set of principles used to create harmonious color combinations.

Combination Mark Trademark that combines a symbol and logo.

Commercial Register Also called lap register. Slight variations in placement of color, of about one row of screen dots.

Complementary Colors opposite one another on the color wheel

Comprehensives The fourth step in the design process. It is the highly finished layout for presentation.

Computer Graphics Branch of computer science that deals with creating and modifying pictorial data.

Concrete Poetry Poetry in which both typography and layout add to the overall meaning.

Constructivism An art style or movement in which assorted mechanical objects are combined into abstract mobile structural forms. The movement originated in Russia in the 1920s and has influenced many aspects of modern architecture and design.

Continuation When the eye is carried smoothly into a line or curve that links adjoining objects.

Continuous Tone Illustration that contains continuous shades between the lightest and darkest tones without being broken up by the dots of a halftone screen or a digital file.

Corporate Identity Elements of design by which an organization establishes a consistent identity through various forms of printed materials and promotions.

Corporate Photography Photography created for a variety of corporate publications including annual reports.

Counter The white shapes inside a letter.

CPU Central processing unit, the main part of a computer system; is the portion of a system that carries out the instructions of a computer program.

Cropping Eliminating part of the vertical or horizontal dimension of a photograph to focus attention on the remaining portion. Cropping is also used to fit a photograph into an available space by altering its proportions.

Cubism An early 20th-century style and movement in art, esp. painting, in which perspective with a single viewpoint was abandoned and use was made of simple geometric shapes, interlocking planes, and collage. Cubism emphasized the flat surface of the canvas.

Dada An artistic and literary movement from the post–World War I period that produced anti-art based on the irrational, the absurd, the nihilistic, and the nonsensical.

De Stijl A 20th-century Dutch art movement founded in 1917 by Theo van Doesburg (1883–1931) and Piet Mondrian. The movement favored an abstract, economical style. It was influential on the Bauhaus and constructivist movements.

Depth Cueing Depth cueing is used by the computer to render 3-D effects such as haze and distance. It can generate the visual effect that objects farther away from the viewer get less clear with increasing distance.

Descender The part of a lowercase letter that falls below the body of the letter.

Design Studio A studio with designers, production artists, account service representatives, and often illustrators and photographers who work on design projects for clients, mainly advertising agencies and large and small companies or institutions.

Direct Mail Advertising in which the advertiser acts as the publisher. Forms of direct mail include letters, flyers, folders and brochures of various dimensions and formats, catalogs, and booklets.

Dithering Technique used to add extra pixels to an image to smooth it, or to reduce the number of colors or grays in an image by replacing them with average values. It smooths the jagged effects of pixellation.

Domain Name A series of alphanumeric strings separated by periods, such as www.server .com, that is an address of a computer network connection and that identifies the owner of the address.

Dot Gain Aberration that can occur in a printed image, caused by the tendency of halftone dots to grow in size. This can lead to inaccurate and coarsely printed results.

DPI Dots per inch. This refers to the number of dots (resolution) a device is capable of producing

Duotone Two-color halftone reproduction made from one-color, continuous tone artwork.

Editorial Illustration An illustration communicating emotion or opinion through an expressive treatment of line, shape, and placement.

Egyptian A slab-serif type category.

Environmental Design A large general category that includes the design of buildings, landscapes, and interiors. Environmental design develops physical environments.

Expressionism A style that appeared around 1905. The expressionist movement aspired to show subjective emotions and responses rather than objective reality.

Fake Colors New color effects generated by using overlapping screens of process colors.

Fashion Illustration A specialized area of advertising for presenting fashion, often in a stylized manner. Fashion illustration does not always simply convey information about garments; it often attempts to persuade the viewer with the mood of the illustration.

Fauvism Led by Henri Matisse and similar in look to expressionism, with its open disregard of the forms of nature, this style of art favored wildly expressive, subjective, and nonlocal colors.

Figure/Ground Relationship between the figure and the background of an image. The eye and mind separate an object (figure) from its surroundings (ground).

File Format A type of format for encoding the information in a data file. Some common image file formats include TIFF, JPG, and BMP.

Flush Left Format for typography that gives an aligned left edge.

Flush Right Format for typography that gives an aligned right edge.

Focal Point The point of entry into a design; the first area that attracts attention and encourages the viewer to look further.

Font Complete set of type of one size and one variation of a typeface.

Frames On the Web, frames give a method of displaying more than one page mat a time within the same window. Frames are the separate viewable areas

Futurism Artistic movement established around 1909 by the Italian poet Emilio Marinetti. It rejected traditional forms so as to celebrate and incorporate into art the energy and dynamism of modern technology.

Gamuts The visible color range of a color model.

Gestalt Unified configuration having properties that cannot be derived from simple addition of its parts.

GIF Graphics Interchange Format. A file format used for transferring graphics files between different computer systems via the internet. It creates very small data files.

Golden Section A mathematical proportion in which the ratio between a small section and a larger section is equal to the ratio between the larger section and smaller sections put together. Shapes defined by the golden ratio have long been considered aesthetically pleasing in Western cultures. The ratio is about 8:13.

Graphic Design The design of things people see and read.

Graphics Standard Manual A master corporate identity plan.

Grid Layout An arrangement of horizontal and vertical lines that produce a network of squares and rectangles giving underlying structure to elements in page layout.

Hairline Register Extremely tight registration, where the tolerance is not greater than half a row of dots.

Halftone Reproduction of continuous-tone art, such as a photograph, through a screen that converts it into dots of various sizes.

Hardware Physical components of a computer graphics system, including all mechanical, magnetic, and electronic parts.

Hidden Line Elimination In computer graphics, leaving out the part of an object that is partially hidden by another object.

Hot Type In printing and typography, a 19th century method for injecting hot molten metal into a mold. The cast metal type is then used to press ink onto paper.

HSL Hue, saturation, and lightness. A color model.

HTML hypertext markup language. A page description language used to format documents on the Web.

Hue The name by which we identify a color. Hue is one of the three properties of color.

Hyperlink A Web link to other documents that is embedded within the original document. Clicking on the link will take users to another Web site or ,document.

Icon In the study of semiotics, an icon is a sign that bears a direct relationship to the object described, such as realistic ,drawings and photographs.

Illustration a specialized area of art that uses images, usually representational or expressionist, to make an applied, visual statement, usually accompanying text.

Imagesetter A high-resolution device found at service bureaus and commercial print shops. It uses lasers to expose an image onto film in preparation for offset reproduction. This dry, chemical-free process can produce positive or negative film separations direct from a computer. The high resolutions (up to 3,000 dpi) of the imagesetter combined with the quality of film provide high-quality printing for photographs and halftones.

Index In Semiotics, a sign that bears a direct relationship to the object it represents without simply showing the object. For example, a shadow or a footprint of an animal.

Indexed Color An image mode of a maximum of 256 colors that can reduce the file size of RGB images for use in Web pages.

Industrial Age A period characterized by a population evenly divided between agricultural and manufacturing industries.

Industrial Design The design and development of three-dimensional functional objects.

Industrial Revolution A period of rapid industrial growth, when machines and large-scale production replaced hand tools. It began in the mid- to late 1700s in England and spread to other countries in the 1800s. This period lasted in the United States and Europe through most of the 1800s, as nations shifted from an agricultural to a manufacturing base.

In-House Design Graphic design services can be provided by in-house staff that work solely for the institution that employs them.

In-House Illustration Illustrators may work for a single company, such as a book publisher, or greeting card company.

Inkjet Printer A printer that sprays ink drops onto paper, where they form characters or shapes and a high-quality, long-lasting image.

Intellectual Unity An idea-generated and word-dominated method of unifying a publication.

Intensity Saturation or brightness of a color. It is a measure of a color's purity and brightness. Intensity is decreased by the addition of a gray or a complement.

Interactivity The dialogue between a user and a website or between a computer and a user that allows the user to influence content.

International Typographic Style An influential modernist style that began in Europe and the United States in the 1920s and 1930s and lasted several decades. It was characterized chiefly by unadorned geometric forms in architecture and the grid system in graphic design.

Interpolation A computer process used to add or delete approximate pixel data when resizing an image.

Italics The slanted version of a Roman type design originally derived from cursive handwriting.

JPEG Joint Photographic Experts Group. A lossy data compression file format that creates small compressed files by discarding part of the data before compressing. The reconstructed file usually looks quite good on photographic images.

Justified All lines of type are the same length, so that the left and right edges of the column of type are straight.

Kinesthetic Projection A sensory experience stimulated by bodily movements and projected onto the images we view.

Laser Printer A common type of computer printer that produces high-quality text and graphics on plain paper. The image is produced by the direct scanning of a laser beam across the printer's photoreceptor. A laser printer prints quickly with relatively inexpensive dry ink, or toner.

Layout Design Page design for a piece to be printed or published electronically.

Leading Amount of vertical spacing between lines of type. The historical origin of the term goes back to hot-metal typesetting, when a thin strip of lead was inserted as a spacer between lines of metal type.

Letterspacing The amount of space between letters of a word.

Light Waves The part of the electromagnetic spectrum that contains visible mlight. The colors, from longest wavelength to shortest, are red, orange, yellow, green, blue, indigo, and violet.

Line Art Black and white copy with no variations in value. Suitable for reproduction without a halftone screen.

Line Length The length of a typeset line, traditionally measured in picas and points, but now measured in inches as well.

Link A pointer in an HTML document that takes the user to another location by clicking on it.

Local Color Retains the photo-realistic color of objects.

Logo Trademark of unique type or lettering that spells out the name of a company or product.

Lossless Compression A method of compression in which no data is discarded.

Lossy Compression A method of compression that gives high compression but loses information in the original file.

LPI Lines per inch. Printing term referring to the resolution of an image.

Market Research A study of consumer groups and business competition used to define a projected market.

Memory The recall of digital data on a computer. Usually referring to RAM or ROM.

Modern Type category that has great variation between thick and thin strokes and thin, un-bracketed serifs.

Modernism Modern art refers to an approach to art in which it was no longer important to literally represent a subject. The invention of photography had made this function of art less important. Instead, artists started experimenting with new ways of seeing, often moving toward abstraction.

Moiré An unwanted pattern caused by the overlapping of multiple halftones or tint screens in incorrect positioning.

Monochromatic Use of a single hue in varying values.

National Advertising Advertising run by manufacturers with a nationwide distribution network for their product. It tends to be persuasive.

New Typography A term that came to identify the new, Bauhaus-inspired approaches to graphic design. Its chief German proponent, Jan Tschichold, designed typefaces that emphasized clarity.

Nonobjective Abstractions that have no recognizable realistic shapes.

Nonregistered Color Colors do not abut.

Object-Oriented Graphics Graphics applications that allow the selection and manipulation of individual portions of an illustration or design. This is a characteristic of a vector graphic file and is the opposite of bitmapped graphics.

Offset Printing A printing technique where the inked image is transferred from a plate to a rubber blanket, then to the printing surface.

Old Style Type category characterized by mild contrast between thicks and thins, and by bracketed serifs.

Orphan A short line that appears at the bottom of a column or page, or a single word or word part that appears on a line by itself at the end of a paragraph.

Path Layout The harmonious arrangement of elements that assume no underlying grid structure.

Pathname The name of a file or folder listed with all parent folders. This is the full name that the computer uses for a folder or a file.

Photo Illustration Photography that illustrates an accompanying story.

Photojournalism Candid photography that captures a news event on location.

Photomontage The technique of making a picture by assembling pieces of photographs. This is often done in combination with other nonphotographic collage materials.

Pica Typographic measurement of 1/16 inch (0.4 cm).

Pictogram A symbol used to cross language barriers for international signage. It is representational rather than abstract.

Picture Plane Space Flat surface of a two-dimensional design, possessing height and width, but no depth.

Pixels Individual picture element. It is the smallest element of a computer image that can be separately addressed.

Plakatstil A flat-color pictorial design style that maintains a balance between 2-D design structure and imagery. It emerged in Germany early in the 20th century.

PNG Portable Network Graphics, a bitmapped image format that employs lossless data compression designed for transferring images on the Internet.

Point Typographic measurement of 1/72 inch, or 1/12 pica.

Point of Purchase A display that is present along with a product in stores.

Postmodernism Of or relating to art, architecture, or literature that reacts against earlier modernist principles. This is sometimes achieved by reintroducing traditional or classical elements of style or by carrying modernist styles or practices to extremes.

Postscript Page-description language used to describe how a page is built up of copy, lines, images, and so on, for output to laser printers and high-resolution imagesetters. It is a device-independent format that means the file will print out at whatever dpi (dots per inch) the printer is capable of delivering.

Prepress Production The reproduction processes that occur between design and printing.

Printer Font High-resolution bitmaps or font outline masters used for the actual laying down of the characters on the printed page, as opposed to displaying on the screen.

Process Colors Cyan, magenta, yellow, and black (CMYK); the colors used in offset printing

Product Photography The intent to promote or sell a product using photography.

Progressive Rhythm When a repeated element changes in a regular fashion in layout design.

Proportion The relationship in size of one component of a work of art to another. The size relationship of parts to a whole and to one another.

Protocol A set of rules that hardware and software must observe in order to communicate with one another.

Proximity Visually grouping by similarity in spatial location.

QuickTime Format, developed by Apple, that can act as a container for many different types of multimedia such as digital video, animation, and music.

Radial Symmetry Equal proportion around a central point like spokes radiating out from the center of a wheel.

RAM Random-Access Memory.

Raster Graphics Computer graphics comprised of bitmaps that create a grid of individual picture elements (pixels).

Realism The representation in art of objects in nature without idealization or presentation in abstract form.

Registration Fitting two or more printing images on the same paper in exact alignment.

Research The first step in preparing a design solution; determining the parameters of the problem.

Resizing Changing the size of an image with an understanding of cropping and the retaining of correct proportions. resolution

Resolution The fineness or sharpness of an image, based on the number of pixels per inch (ppi).

Retail Advertising Advertising sponsored by a retail establishment such as a clothing or motorcycle store.

Retail Illustration Illustration involving retail products such as apparel, toys, greeting cards, calendars, and posters.

Reversible Figure and ground can be focused on equally when positive and negative elements attract our attention equally. What was initially background becomes foreground. Because we cannot simultaneously perceive both images as figure, we keep switching between them.

RGB Red, green, and blue are the primary colors of the additive color model used on the Web.

RIP Raster Image Processing. Converting data into a form that can be output by a high-resolution imagesetter for use in commercial printing.

ROM Read-Only Memory. ROM resides in a chip on the motherboard. This memory can be read from, but cannot be written to.

Roman The standard characters of a font in which the characters are upright and not boldface.

Roughs The third step in the design process; Layout plans that come after preliminary thumbnails and are usually executed in half or full size.

Sans Serif Letterforms without serifs. See *Serif*.

Screen Font Low-resolution bitmaps of type characters that show the positioning and size of characters on a computer screen.

Semiotics The study of signs and symbols, what they mean and how they are used.

Serif A short line that projects off the main stroke of a letter at the bottom or the top.

Shade Darker value of a hue, created by adding black.

Shape An area created by an enclosing boundary that defines the outer edges. The boundary can be a line, a color, or a value change. Shape describes a two-dimensional artwork.

Similarity Visual grouping of images with similar shape, size, or color.

Simultaneous Contrast Colors, side by side, interact with one another, changing our perception of color accordingly.

Software Sets of instructions that tell the computer system what to do. Software is also used to describe application software such as graphics programs.

Split Complementary A color scheme based on one hue and the hues on either side of its complement on the color wheel.

Stable The unambiguous relationship of an object to background.

Storyboard A series of sketches showing each shot of a scene or film in order.

Stress The distribution of weight through the thinnest part of a letterform.

Stripper The offset technician who cuts, trims and tapes negatives into position on a carrier sheet.

Stylization The act of stylizing; causing to conform to a particular style.

Subtractive primary colors Red, yellow, and blue—the colors left after a pigment absorbs, or "subtracts," a segment of white light in order to reflect back its particular hue.

Suprematism An art movement focused on fundamental geometric forms (in particular the square and circle) which formed in Russia in 1915–1916.

Surrealism A literary and artistic movement was based on revealing the unconscious mind in dream images, the irrational, and the fantastic by juxtaposing incongruous subject matter. The art of producing incongruous imagery by unusual juxtapositions and combinations.

Swiss Design See *International Typographic Style.*

Symbol Type of trademark to identify a company or product. It is abstract or pictorial but does not include letterforms.

Symmetrical Layout See definitions for *Symmetry* and *Layout.*

Symmetry Formal placement of design elements to create a mirror image on either side. A less common form of symmetrical balance also creates the mirror image vertically.

Tables Boxes made up of rows and columns in which data, such as images and text, can be organized for placement on a Web page.

Technical Illustration The creation of scientific or technological objects to illustrate a subject.

Text Type Book-size type, set in paragraphs, as opposed to headlines; any type that is less than 14 points in size.

Thumbnails The second step in the design process; idea sketches that provide visual evidence of the thinking, searching, and sorting process that leads to final solutions.

Tints Light value of a hue, created by adding white.

Tint Screen Flat, unmodulated light value made of evenly dispersed dots, usually achieved by stripping a piece of halftone film into the area on the negative that the artist has masked out.

Trademark Any unique name or symbol used by a corporation or manufacturer to identify a product and to distinguish it from other products.

Transitional Category of type that blends old style and modern, with emphasis on thick and thin contrast and gracefully bracketed serifs.

Trapping Slight overlap of two colors to eliminate gaps that can occur due to normal registration problems during printing.

Tritone An image that is printed using three colors. Typically, a black-and-white image is enhanced using the addition of two additional colors.

Trompe L'Oeil French for "fool the eye." A two-dimensional representation that is so naturalistic that it looks actual or real (three-dimensional).

Tweening An interpolation technique by which an animation program generates extra frames between the keyframes that the user has created.

Type Categories Typefaces grouped into categories such as Old Style, Transitional, Modern, Egyptian, and Sans Serif.

Type Family Complete range of sizes and variations of a typeface.

Type Size Height (not the width) of a type character usually measured in points. There are 72 points in an inch.

Typeface Style of lettering. Each family of typefaces may contain variations on that typeface, like "italic." typography

URL Uniform Resource Locator. This is the address of a resource on the Internet. World Wide Web URLs begin with "http://".

Value The degree of lightness or darkness in a hue.

Vector Graphics Type of computer graphics in which graphic data is represented by lines drawn from coordinate point to coordinate point.

Visual Design Theme A visual content that unites the pages of a layout.

Visual Direction When the eye is directed in a particular direction across a composition.

Visual Perception A dynamic exchange between the eye and the brain's interpretation of visual data.

Visual Rhythm The repetition of shapes, values, color, and textures to set up a visual or intellectual pattern.

Visual Texture Visual creation of an implied tactile texture.

Visual Unity The placement of design elements to achieve a harmonious whole.

Visual Weight Lightness or heaviness of a visual image.

Web and Multimedia Design The design of interactive, often motion-based graphics.

Widow Short line at the end of a paragraph that falls at the top or bottom of a column page, or a single word on a line by itself at the end of a paragraph.

Word Spacing The varying space between words, often adjusted to create a justified line of copy.

X-Height The height of the body of a lowercase letter such as *x* or *a*. It does not include the ascender or descender. The x-height varies in typefaces even though the point size is identical.

BIBLIOGRAPHY

See the Webliography Links on the Accompanying Web Site.

CHAPTER 1
Applying the Art of Design

Albers, Josef, *Interaction of Color*. New Haven, Conn.: Yale University Press, 1972.

Aynsley, Jeremy. *A Century of Graphic Design*. Hauppauge, N.Y.: Barron's, 2001.

Baumgartner, Victor, *Graphic Games*. Englewood Cliffs, N.J.: Prentice-Hall, 1983.

Behrens, Roy, *Design in the Visual Arts*. Englewood Cliffs, N.J.: Prentice-Hall, 1984.

Bevlin, Marjorie, *Design Through Discovery*. New York: Holt, Rinehart and Winston, 1985.

Buchanan, Margolin, *Discovering Design*. University of Chicago Press, 1995.

Gomez, Edward, *New Design: Tokyo*. Gloucester, Mass.: Rockport Publishers, 1999.

Itten, Johannes, *The Art of Color*. New York: Van Nostrand Reinhold, 1974.

Kepes, Gyorgy, *Language of Vision*. Chicago: Paul Theobald, 1969.

McKim, Robert H., *Experiences in Visual Thinking*. Monterey, Calif.: Brooks, Cole, 1980.

Rand, Paul, *Design Form and Chaos*. New Haven and London: Yale University Press, 1993.

Supon Design Group, *International Women in Design*. New York: Madison Square Press, Distributed by Van Nostrand Reinhart, 1993.

CHAPTER 2
Graphic Design History

Aynsley, Jeremy, *A Century of Graphic Design*. Hauppauge, N.Y.: Barrons, 2001

Bayer, Herbert, et al., eds., *Bauhaus 1919–1928*. New York: Museum of Modern Art, 1938.

Berryman, Gregg, *Notes on Graphic Design and Visual Communication*. Los Altos, Calif.: William Kaufmann, 1990.

Cirker, Hayward, and Blanche Cirker, *Golden Age of the Poster*. New York: Dover, 1971.

Craig, James, *Graphic Design Career Guide*. New York: Watson-Guptill Publications, 1983.

Friedman, Mildred, and Joseph Giovannini, eds., *Graphic Design in America: A Visual Language History*. New York: Harry Abrams, 1989.

Garner, Philippe, *Sixties Design*. Taschen, 1996.

Glaser, Milton, *Milton Glaser*: Graphic Design. Woodstock, N.Y.: The Overlook Press, Walker Art Center, 1983.

Green, Oliver, *Underground Art*. London, England: Studio Vista, 1990.

Greiman, April, *Hybrid Imagery: The Fusion of Technology and Graphic Design*. New York: Watson Guptil, 1990.

Heller, Steven, and Elinor Pettit, *Graphic Design Timeline*. New York: Allworth Press, 2000.

Hoch, Hannah, et al., *The Photomontages of Hannah Höch*. Minneapolis, Minn.: Walker Art Center, 1997.

Hoffman, Armin, *Graphic Design Manual*. New York: Van Nostrand Reinhold, 1965.

Hurlburt, Allen, Layout: *The Design of the Printed Page*. New York: Watson-Guptill Publications, 1977.

Jackson, Lesley, *The New Look and Design in the Fifties*. New York: Thames and Hudson, 1991.

Meggs, Philip, *A History of Graphic Design*. New York: Van Nostrand Reinhold, 1998.

Motherwell, Robert, *Dada Painters and Poets*. New York: Wittenborn, Schultz, 1951.

Müller-Brockmann, Josef, *The Graphic Artist and His Design Problems*. New York: Hastings House, 1961.

Müller-Brockmann, Josef, *A History of Visual Communication*. New York: Hastings House, 1971.

Nelson, Roy Paul, *Publication Design*. Dubuque, Iowa: William C. Brown, 1991.

Pesch and Weisbeck, *Technostyle*. Zurich: Olms, 1995.

Rand, Paul, *A Designer's Art*. New Haven, Conn.: Yale University Press, 1985.

Rand, Paul, *Thoughts on Design*. New York: Van Nostrand Reinhold, 1971.

Scheidig, Walter, *Crafts of the Weimar Bauhaus 1919–1924*. New York: Reinhold Publishing, 1967.

Schwartz, Lillian, *The Computer Artist's Handbook, Concepts, Techniques and Applications*. New York: W.W. Norton & Co., 1992.

Snyder, Peckolick, *Herb Lubalin*. New York: American Showcase, 1985.

Varnedoe, Gapnik, *High & Low: Modern Art and Popular Culture*. New York: Museum of Modern Art, 1991.

Velthoven, Willem, and Jorinde Seijdel, *Multimedia Graphics, The Best of Global Hyperdesign*. Chronicle Books, 1997.

Wheeler, Daniel, *Art Since Mid-Century, 1945 to the Present*. New York: Vendome Press, 1991.

Wrede, Stuart, *The Modern Poster*. New York: The Museum of Modern Art, 1988.

CHAPTERS 3–5
Perception

Arnheim, Rudolf, *Art and Visual Perception*. Berkeley, Calif.: University of California Press, 1974.

Behrens, Roy, False Colors: *Art, Design and Modern Camouflage*. Dysart, Iowa: Bobolink Books, 2002.

Bloomer, Carolyn M., *Principles of Visual Perception*. New York: Van Nostrand Reinhold, 1976.

Fishel Catharine & Bill Gardner, *logolounge3*, Rockport Publishers, 2008

Gombrich, E. H., *Art and Illusion: A Study in the Psychology of Pictorial Representation*. New York: Pantheon Books, 1960.

Gombrich, E. H., Julian Hochberg, and Max Black, *Art, Perception, and Reality*. Baltimore: Johns Hopkins University Press, 1972.

Goodman, Nelson, *Languages of Art*. Indianapolis: Bobbs-Merrill, 1968.

Graphis Letterhead: *An International Compilation of Letterhead Design*. Zurich, Switzerland: Graphis Press, 1996.

Graphis Logo: *An International Compilation of Logos*. Zurich, Switzerland: Graphis Press, 1996.

Graphis Logo Design 7. Graphis Press, 2009

Gregory, R. L., *Eye and Brain*. New York: McGraw-Hill, 1966.

Gregory, R. L., *The Intelligent Eye*. New York: McGraw-Hill, 1970.

Lauer, David, & Stephen Pentak, *Design Basics, 7th* edition. Wadsworth Publishing, 2007.

Letterhead and Logo Design: Creating the Corporate Image. Rockport, Mass.: Rockport Publishers, Distributed by North Light Books, 1996.

Macnab, Maggie, *Decoding Design: Understanding and Using Symbols in Visual Communication* (F+W Media, 2008)

Meggs, Philip and Rob Carter, *Typographic Specimens and the Great Typefaces*. New York: Van Nostrand Reinhold, 1993.

Pedersen, Martin, Graphis Letterhead 7, 2009, Graphis Press

Steuer, Sharon, *The Illustrator Wow! Book*. Berkeley, Calif.: Peachpit Press, 1995.

Wilde, Judith, Visual Literacy, Watson Guptill.

Zakia, Richard, *Perception and Photography*. Rochester, N.Y.: Light Impressions Corporation, 1979.

CHAPTERS 6–7
Text Type

Blackwell, Lewis, and David Carson, *The End of Print: The Grafik Design of David Carson*. San Francisco: Chronicle Books, 2000.

Carter, Rob, et al., *Typographic Design: Form and Communication*. New York: Van Nostrand Reinhold, 1985.

Craig, James, *Designing with Type*. New York: Watson-Guptill Publications, 1992.

Dair, Carl, *Design with Type*. Toronto: University of Toronto Press, 1982.

Dürer, Albrecht, *On the Just Shaping of Letters*. Mineola, N.Y.: Dover, 1965.

Evans, Poppy, and Sherin, Aaris, *Forms, Folds and Sizes: All the Details Graphic Designers Need to Know but Can Never Find*. Rockport Publishers, 2009

Graphis Book Design II. Zurich, Switzerland: Graphis Press, 1995.

Graphis Brochures, *An International Compilation of Brochure Design*. Zurich, Switzerland: Graphis Press, 1996.

Graphis Brochures 6, Graphis Press, 2009

Hiebert, *Graphic Design Sources*, 1998, Yale University Press.

McLean, Ruari, *Jan Tschichold: Typographer*. Boston: David R. Godine, 1975.

Massin, *Letter and Image*. New York: Van Nostrand Reinhold, 1970.

Ruder, Emil, *Typography*. New York: Hastings House, 1981.

Samara Timothy, *Making and Breaking the Grid*, Rockport Publishing, 2002

Tschichold, Jan, *Asymmetric Typography*. New York: Van Nostrand Reinhold, 1980.

Weber, Max, *The Layout Look Book*, Collins Design, 2007.

CHAPTERS 8–10
Color, Illustration, Advertising

Cabarga, Leslie, *Dynamic Black & White Illustration*. Glenbrook, Conn.: Art Direction Book Co, 1997.

Cassandre, A. M., *A. M. Cassandre*. St. Gall, Switzerland: Zollikoffer & Company, 1948.

Delamare, Francois, and Bernard Guineau. *Colors: The Story of Dyes and Pigments*. New York: Abrams, 2000.

Douglas, Torin, *The Complete Guide to Advertising*. New York: Chartwell Books, Inc., 1984.

Dover Pictorial Archives. Mineola, N.Y.: Dover

Glaser, Milton, *Art is Work*, The Overlook Press, Woodstock and New York, 2000

Glaser, Milton & Ilic, Mirko, *The Design Of Dissent*, Rockport Publishing, 2006

Gomez-Palacio and Vit, *Women of Design*, HOW books, 2008.

Graphis Advertising: *The International Annual of Advertising*. Zurich, Switzerland: Graphis Press, 1996.

Graphis Poster Design: *The International Annual of Poster Art*. Zurich, Switzerland: Graphis Press, 1996.

Haller, Lynn, *Fresh Ideas in Promotion*. Cincinnati, Ohio: North Light Books, 1994.

Heller, Steven, and Marshall Arisman, *The Education of an Illustrator*. New York: Allworth Press, 2000

Hurley, Gerald D., and Angus McDougall, *Visual Impact in Print*. Chicago: Visual Impact, Inc., 1971.

Itten, Johannes, *The Art of Color*. New York: Van Nostrand Reinhold, 1974.

New York: Van Nostrand Reinhold, 1994.

Koehler, Nancy, Vietnam, *The Battle Comes Home: Photos by Gordon Baer*. Dobbs Ferry, N.Y.: Morgan & Morgan, 1984.

Leland, Karyn, *Licensing Art & Design*. Cincinnati, Ohio: North Light Books, 1990.

Nyman, Mattias, *Four Colors/One Image*. Berkeley, Calif.: Peachpit Press, 1993.

Pitz, Henry, *200 Years of American Illustration*. New York: Random House, 1977.

Steuer, Sharon, *The Illustrator's CS Wow! Book*. Berkeley, Calif.: Peachpit Press, 2010

Vaizey, Marina, *The Artist as Photographer*. New York: Holt, Rinehart and Winston, 1982.

Whelan, Richard, *Double Take*. New York: Clarkson N. Potter, 1981.

Wilson, Stephen, *Using Computers to Create Art*. Englewood Cliffs, N.J.: Prentice-Hall, 1986.

Zelanski, Paul, and Mary Pat Fisher. *Color*. Englewood Cliffs, N.J.: Prentice Hall, 1989.

Ziegler, Kathleen, *Digitaline Digital Design and Advertising*. Southhampton, Pa.:

CHAPTER 11
Production, Web Design

Adobe Photoshop S5 Classroom in a Book, 2010, Adobe Creative Team.

Adobe Dreamweaver CS5 Classroom in a Book, 2010 Adobe Creative Team.

Adobe InDesign CS5 Classroom in a Book, 2010 by Adobe Creative Team.

Bennett, James Gordon, *Design Fundamentals for New Media*. Clifton Park, N.Y.: Thomson Delmar Learning, 2005.

Blatner, David, and Steve Roth, *Real World Scanning and Halftones*. Berkeley, Calif.: Peachpit Press, 1993.

Chartier, Lee, and Scott Mason, *Creating Great Designs on a Limited Budget*. Cincinnati, OH: North Light Books, 1995.

Dennis, Ervin, Olusegun Odesina, and Daniel Wilson, *Lithographic Technology in Transition*. Thomson Delmar Learning, 1997.

Evans, Poppy, *The Graphic Designer's Source Book . . . An Indispensable Treasury of Suppliers*. Cincinnati, Ohio: North Light Books, 1996.

Gordon, Bob and Maggie Gordon. *The Complete Guide to Digital Graphic Design*. New York: Watson-Guptill, 2002.

Graphic Artists Guild Handbook: *Pricing and Ethical Guidelines*. 12th edition. New York: Graphic Artists Guild. 2010

Pocket Pal, 20th edition. New York: International Paper Company, 2007.

Ziegler, Kathleen, Nick Greco, and Tamye Riggs, *MotionGraphics Film and TV*. New York: Watson-Guptill, 2002.

Ziegler, Kathleen, Nick Greco, and Tamye Riggs, *MotionGraphics Web*. New York: Watson-Guptill, 2002.

Periodicals and Annuals

AIGA Graphic Design, USA. New York: Watson-Guptill Publications, annual, 1980–present.

Artists' Market: Where and How to Sell Your Artwork. Cincinnati, Ohio: Writers Digest Books.

Artnews. New York.

Ballast. Roy Behrens, ed., Dysart, Iowa: Boblink Books.

Communication Arts. Palo Alto, Calif.: Coyne & Blanchard, Inc.

Graphic Artists' Guild, *Handbook of Pricing & Ethical Guidelines*. Cincinnati, Ohio: Writers Digest Books.

Graphis. Zurich, Switzerland: Walter Herdig.

How. New York: RC Publications.

Print. Washington, D.C.: RC Publications.

Print Casebooks. Washington, D.C.: RC Publications, six annual volumes, 1975–present.

Step-by-Step Graphics. Peoria, Ill.: Dynamic Graphics Educational Foundation (DGEF).

Women in the Arts. Washington, D.C.: National Museum of Women in the Arts.

A

Abstract art
 design and, 60
 movements, 27–30
 shape and, 51
Adaptive palettes, 208
Additive primary colors, 132
 printing and, 144
Adobe Director, 204
Adobe Illustrator. *See* Illustrator
Adobe InDesign. *See* InDesign
Adobe Photoshop. *See* Photoshop
Adobe Systems, 188
Advertising, 172–185
 anti-advertising campaign, 35
 billboard advertising, 180–182
 careers in, 14–16
 constructivism and, 27
 *corporate identity advertising,
 182–184*
 direct mail advertising, 177–179
 illustration and, 154–158
 and Industrial Revolution, 19
 *information elements in,
 173–174*
 magazine advertising, 179–180
 market research and, 176
 national advertising, 175
 newspaper advertising, 176–177
 online advertising, 179
 personal promotion, 182
 *point-of-purchase advertising,
 182*
 purpose of, 173–174
 retail advertising, 175
 single-item ads, 176–177
 staged photographs in, 166–167

 teamwork in, 184
 television advertising, 175–176
 types of, 175–182
 working in, 60–61
AEG designs (Behrens), 24
Agents for product
 photographers, 168
Age of Information, 5, 90–91
Agha, M. F., 32
AI files, printing, 202
AIGA. *See* American Institute of
 Graphic Arts (AIGA)
Albers, Anni, 29, 137
Albers, Josef, 29
 Homage to the Square, 136–137
 profile of, 137
 *and simultaneous contrast,
 136–137*
Alcoa trademark (Bass), 76
Aldus' PageMaker software, 188
Alex, Sophie, 127
Alphabets, 89–90
Alternating rhythm, 116
Ambiguous figure/ground
 relationship, 44–46
American design, 31–36
 postmodernism, 35
American Institute of Graphic
 Arts (AIGA), 32
 researching on Web site, 9
 type solutions in archives, 101
American Players Theater
 publication (Planet
 Propaganda), 138–139
American Showcase, 170
Analog data, 192–196
Analogous color schemes, 135
Analog-to-digital converters, 193

Animal Locomotion images
 (Muybridge), 164–165
Animation
 computer graphics and, 188–189
 illustration for, 158
 for Internet publishing, 210
Ansel, Ruth, 32
Apollinaire, Guillaume, 26
Apple Computer, 188. *See also*
 Macintosh
*April Greiman Made in
 Space,* 127
Architectural photography, 168
Arcimboldo, Giuseppe, 74
Armored Train in Action
 (Severini), 24–25
Arnheim, Rudolf, 24
Arntson, A. E., 11, 13, 79
ARPANET, 203
Art deco, 30
 revival of, 35
Art for printing, 199
Art Institute of Chicago, 191
Artist Portrait Series (Tingesdahl),
 149
*Artist's and Graphic Designer's
 Market,* 157
ARTnews magazine, 180
Art nouveau, 20
 revival of, 35
Art nouveau poster (Mucha), 164
Arts and crafts movement, 22
Arts magazine, 180
Ascender of letter, 54
"As in the Middle Ages . . . so in
 the Third Reich" (Heartfield),
 74–75
Aspen Design Summit, 32

Associations with color, 137–139

Asymmetry
 and balance, 65–66
 layout, asymmetrical, 112
 type, asymmetrical, 104

At a Loss for Words (Behrens), 152

A3 Design, 76

Audience magazine drawing (Glaser), 63

Audio for Internet publishing, 210

Audubon magazine, 163

Avant Garde, 32

Avant Garde design (Lubalin), 100, 118–119

B

Background colors, 136

Balance, 58–71
 asymmetry and, 65–66
 color and, 69
 contrast and, 66
 dynamic tension and, 64
 isolation and, 68
 layout and, 111–112
 location and, 67
 predictability and, 64
 shape and, 69
 size and, 67
 spatial depth and, 67
 structure and, 69
 subject matter and, 68
 symmetry and, 65
 texture and, 68
 value and, 68–69

Balla, Giacomo, 24

Baltimore Sun, 2–3

Baseline of letter, 54

Baskerville, John, 93, 95

Baskerville typeface, 54, 92, 93–94
 x-height of, 101

Bass, Saul, 76, 182

Bauhaus, 7, 24, 27, 28–29
 Lissitzky, El and, 28
 new typography, 30
 sans serifs, use of, 93, 95–97

Bauhaus Magazine cover (Bayer), 58

Bayer, Herbert, 29, 58
 Universal typeface, 95

Beall, Lester, 31–32, 183

Bearden, Romare, 152

Beardsley, Aubrey, 21

Behrens, Peter, 24, 28–29

Behrens, Roy, 152

Ben Sidran's *Concert for Garcia Lorca*, CD package for, 13

Berlin Dada movement, 74

Berners-Lee, Tim, 203

Bernhard, Lucian
 Lithograph, 172–173
 Osram ZAO, 24–25

Bernhardt, Sarah, 20

Bettmann Archive, 170

Bill, Max, 67

Billboard advertising, 180–182

Bitmapped graphics, 194
 black-and-white data in, 199

Bitmaps, 193

Bit planes, 193

Bits of information, 195

Bittman, Dan, 123

Black in figure/ground relationships, 46

Black Mountain College, 137

Black Star Publishing Company, 170

Blake, William, 151

Bleeds, inserting, 200

Blinn, Jim, 189

Blue. *See also* RGB colors
 associations with, 137–139

Bodoni, Giambattista, 92, 95

Bodoni typefaces, 52–53, 92, 94–95

Book illustrations, 154–155

Book of Kells, 88–89

Booth, David, 154–155

Bosche (Bernhard), 172–173

Bottom of page, shapes at, 62

Bracketing, 93

Bradley, Will, 64

Brandt, Marianne, 7

Breese, Terri, 185

Breton, André, 30

Brigham Young University, 14

Bright Blocks package design, 134

Broadway typeface, 106

Brochures, multipanel design for, 124–126

Brodovitch, Alexey, 68

Brown, Michael David, 66

Bugs! ad campaign (Edwards & Mihock), 43, 174–175, 180–181

Bust Portrayal of Nakamura Nakazo II as Matsuomaru (Kunimasa), 50

Bytes, 195
 for Internet files, 207

BYU Magazine spread (Patrick, Johnson & Rees), 108

C

CAD/CAM tools, 187

CA Illustration Annual, 161

Cala, Ronald J., II, 5

Calagraphic Design, 5

Calibrating monitors, 142

California Conservation Corps symbol (Vanderbyl), 83

"Calligrammes" (Apollinaire), 26

Call Waiting (Nessim), 161

Camera ready design, 198

Careers in design, 14–16

Carl Solway Gallery, 18–19

Cartesian coordinate system, 194

Caslon, William, 91, 92, 95

Caslon typeface, 93, 95

Cassandre, A. M., 30
 poster for optician, 59

Cattle brands, 81

CDs
 for computer storage, 196
 cover photography, 168

Centered type, 104

Central processing unit (CPU), 194

Century typeface, 95

Cézanne, Paul, 163

Challenge of graphic design, 16–17

Chase, Margo
 hair care products logo, 157
 John Fogarty's Eye of the Zombie *album cover, 65*
 Virgin Records logo, 69

Chaucer typeface, 91–92

Chéret, Jules, 20

Chevreul, Michel-Eugène, 136

Children's books, illustration for, 154–155

Chokes, inserting, 200

Chwast, Seymour, 32

Cincinnati Ballet Company poster (Bittman, Hirschfeld & Hennegan Company), 123

Clarendon typeface, 95

Class magazines, advertising in, 180

Click Here, Inc., 178

Clip-art, 163

Closure and gestalt, 78–79

CMP (Cost per Mille), 179

CMYK colors, 132. *See also* Color separations
 color separations, 146
 explanation of, 142–143
 gamuts, 143–144
 Photoshop sliders controlling, 142

Coats of arms, 81

Cober, Alan, 162–163

Coe, Sue, 156–157

Color models, 141–144. *See also* CMYK colors; RGB colors

Color process work, 20

Colors, 130–149. *See also* Hue; RGB colors; Saturation; Value of color
 balance and, 69
 cost-cutting for printing, 147
 designing with, 131–135
 duotones, 147–148
 fake colors, 144–145
 gamuts, 143–144
 halftones, 147–148
 for Internet publishing, 208
 light waves and, 131–132
 in printing, 144–148
 properties of, 133–134
 psychology of, 137–139
 relativity of, 135–137
 selecting colors, 139
 tritones, 147–148
 visual perception of, 139–141

Color schemes, 134–135

Color separations, 146
 RIP (raster image processor) for, 198
 summary of, 148

Color theory, 135

Color wheel, 132

Combination marks, 85

Commercial registered colors, 200

Communication Arts magazine, 180

Communications at turn of 20th century, 22

Complementary colors, 134–135
 RGB/CMYK color model and, 143

Comprehensives, 13

Compressing files, 203

Computer graphics, 36–37. *See also* Vector graphics
 analog data and, 192–196
 animation and, 188–189
 bitmapped graphics, 194
 bitmaps, 193
 development of, 188
 digital data, 192–196
 drawing, history of, 189, 191
 file links for, 202
 fine art, creation of, 196
 future of, 36, 38
 hardware for, 194–195
 history of, 187–192
 input/output devices, 196
 interactivity and, 36
 layered communication, 191–192
 memory requirements, 195
 moving dot technology, 188
 object-oriented graphics, 194
 painting, history of, 189, 191
 printing technologies, 196
 RAM (random-access memory), 195–196
 raster graphics, 52
 realism in, 188

Computer graphics, *continued*
 resolution of screen, 193
 RIP (raster image processing),
 200–201
 ROM (read-only memory),
 195–196
 screen images, 193
 software for, 194–195
 storage devices, 196
 vector graphics, 52
Computers. *See also* Computer
 graphics; Monitors
 electronic colors, 141–144
 history of, 187–192
 postmodernism and, 35
 typestyles and, 48
Concrete poetry, 26
Condé Nast, Cipe Pineles at,
 32–33
Confection Kehl, Marque: PKZ
 (Holwein), 21
Constructivism, 27–28, 29
 picture plane space and, 163
Continuation
 and gestalt, 77–78
 grid, continuation on, 121
Continuous-tone art, 199–200
Contrast
 balance and, 66–67
 grids and, 119
 simultaneous contrast, 135–136
Convex shapes in figure/ground
 relationships, 46
Cook, Roger, 83
Cook and Shanosky
 Associates, 83
Cooper, Muriel, 35
Copperplate engraving, 92
Copy
 correcting, 107
 for printing, 199

Copyrights
 clip-art, copyright-free, 162–163
 infringement issues, 163
Copywriters, 173
Corporations
 identity advertising, 183
 photography for, 168
Counters of shapes, 52
CPA (Cost per Action), 179
CPC (Cost per Clic), 179
Cranbrook recruiting poster
 (McCoy), 191
Cropping
 photographs, 122–123
 printing, crop marks for, 200
 white borders, 202
Cross symbol, 82
Csuri, Charles, 36, 188–189
Cubism, 22–23
 picture plane space and, 163
Cultural color associations, 137
Cummings Advertising brochure
 (Syverson), 125
Cutwater ad agency, 179
Cut with the Dada Kitchen Knife
 (Höch), 26
Cyan, 127

D

Dadaism, 24, 26, 29
 Heartfield, John and, 74
Dallas Times Herald illustration
 (Cober), 162–163
Death in the Afternoon from
 Creativity Illustrated
 (Brown), 66
Deck, Coleen, 196–197
Delaroche, Paul, 164
Depth cueing, 188
Der Dada cover, 26
Descartes, René, 194

Descender of letter, 55
Designer-illustrators, 151–152
Designer-photographers, 165–166
Design studios, careers with, 14
Desktop publishing, 188
De Stijl, 24, 28, 29, 60
 grids, use of, 120
 picture plane space and, 163
Deutsche Werkbund, 24, 28–29
Diagonal lines, 63
Didot, François-Ambroise, 95
Didot, typefaces, 92
Digital cameras
 analog-to-digital converters
 in, 193
 as input devices, 196
Digital data, 192–196
Digital photography, 167
Digital prepress, 200–203
Digital typography, 106
Digital video cameras, 196
Direct mail advertising, 177–179
 online delivery of, 178
Directory of Illustration, 161
DiSpigna, Tony, 95
Ditto Corporation trademark,
 84–85
DOC files, printing, 203
Does It Make Sense? Publication
 (Greiman), 34–35
Domain name for URL, 205
Dooley, Dennis, 116
Dorner, Tiffany, 109
Dot gain and printing, 200
Dover, 163
Downtown Partners Chicago, 180
Dpi (dots per inch), 201, 202
 for Internet files, 207
Dreams, 22
Dreamweaver, 209, 210

Duchamp, Marcel, 26
Duotones, 147–148
Dürer, Albrecht, 48, 112
Dynamic Graphics, 163
Dynamic tension, 61–62
　balance and, 64

E

Ebentreich, Wilhelm, 127
Ecology book cover (Fenster),
　96–97
Editorial content theme, 119
Editorial illustration, 154–158
Edwards, Bruce, 43, 174–175,
　180–181
Egensteiner, Don, 61
Egyptians, 92–93
　writing, 89–90
Egyptian typefaces, 95
Ehrenfels, Christian von, 23
Eichman, Chris
　on filenames, 206
　illustration, 186–187
　photo series, 171
　Rayovac logo concepts, 85
　Web site design, 118–119
　wine label stages, 160
Einstein, Albert, 22
Electronic file transfer, 196
Em, David, 189
Engravings, ideas from, 163
Environmental design, 8
Environmental Law and Policy
　Center ads (Downtown
　Partners Chicago), 179–180
EPS files, 196
　printing, 202
Ernst, Max, 30–31
Eros magazine logo (Lubalin),
　32–33
Erté, 30

Escher, M C., 80–81
Ewen, Stuart, 35
Existentialism, 22
Expected size, 113–115
Expressionism, 23, 29
　picture plane space and, 163
Eye and Brain (Gregory), 38
Eyebeam Creative, 84–85
EyeWire, 163

F

Fact, 32
Fake colors, 144–145
The False Mirror (Magritte), 31
Family Circle logo (Lubalin &
　Peckolick), 78
Family of Robot: Grandfather
　(Paik), 18–19
Fashion illustration, 157
Fauvism, 23
　picture plane space and, 163
Fear of Flying brochure
　(Koppel), 111
Feature stories, 166–167
Feitler, Bea, 32
Fenster, Diane, 168–169
　Ecology book cover, 96–97
　"Look, Listen, Think, Feel,"
　　16–17
　profile of, 170
Fidel of Dreams (Mattos), 135
Fiedler, Detlef, 127
Fields of design, 7–9
The Fifer (Manet), 35
Figurative movements, 30–31
Figure/ground relationships,
　40–41, 42–48
　categories in, 44
　conditions for, 46–47
　gestalt and, 79–81
　letterforms and, 48

File formats
　for Internet, 207
　for printing, 202–203
Filenames for Internet, 206
Filters for sharpness, 202
Fine Print page design (Walker &
　Garvey), 65
First International Dada Fair, 74
Flag symbol, 82
Flash for animation, 210
Flush left type, 103
Flush right type, 104
Focal point in layout, 122
Fonts, 54. *See also* Typography
　defined, 97
　in InDesign, 194
　for printing, 201–202
　reversed fonts, 99
Form and substance issue, 35–36
Format design of type, 103–104
Form of shapes, 50–52
Fortune magazine ad
　(Egensteiner), 61
Four-color offset printing, 142
Frames for Internet publishing,
　209–210
Frankfurt Institute of Psychology,
　23–24
Freehand, 106
Freelance careers, 16
Freud, Sigmund, 22, 30
Friedman, Julius, 60,
　110–111, 120
Frommes Kalender (Moser),
　152–153
From Stone to Bone (Ressler),
　167
Frutiger, Adrian, 95
FTP documents, 196
Futura typeface, 93
Futurism, 22–23, 24

G

Gamuts, 143–144

Garamond, Claude, 91

Garamond Book typeface, 91, 94

Garamond typeface, 52–53

Geometric shapes, 52

German expressionism. *See* Expressionism

Gestalt, 23, 72–87
 closure and, 78–79
 continuation and, 77–78
 figure/ground and, 79–81
 principles of, 74–81
 proximity and, 76–77
 similarity and, 76
 simplicity and, 41–42
 symbols and, 82–83
 trademarks and, 81–85

Getty Images, 170

GIF files, 206
 for animations, 210
 for Internet, 207

Gigabytes (GB), 195

Gill, Eric, 95

Gill Sans typeface, 95

Girvin, Tim, 47, 65
 Bright Blocks package design, 134

Glaser, Milton, 32
 Audience magazine drawing, 63
 Portrait of Nijinsky & Diaghilev, 62

Global village, 203–204

Golden type, 91–92

Gone Fishing: Ocean Life by the Numbers (McLimans), 72–73

"Good Things Come in Small Packages" (Roehr), 114–115

Google Sites, 210

Gradients in illustration, 160

Graphic Artists Guild, 161
 Handbook: Pricing and Ethical Guidelines, 154

Graphic design. *See also* Computer graphics
 defined, 4–9
 history of, 18–39
 as problem solving, 3
 process of, 9–16

Graphic Havoc, 38

Graphics standard manual, 183

Grayscale images, 199

Great Beginnings (Scher), 28, 103

Greek alphabet, 89–90

Green. *See also* RGB colors
 associations with, 139

Greeting card illustration, 158

Gregory, R. L., 38

Greiman, April, 34–35, 69
 Does It Make Sense? Publication, 34–35
 Made in Space Web site illustration, 127, 158
 Miracle Manor retreat site, 36
 Objects in Space poster, 126
 profile of, 127

Grids
 choosing a grid, 121
 construction of, 121
 continuation, invisible line of, 121
 cover design and, 128
 history of, 119–121
 layout in, 119–121
 ornamental grid design, 120
 photography on a grid, 122
 themes and, 119
 visual weight and, 119

Griffo, Francesco, 92

Gropius, Walter, 24, 28–29

Grosz, Georges, 74

Gutenberg, printing press by, 19

The Gutenberg Galaxy: The Making of Typographic Man (McLuhan), 204

Guyon, Craig, 120

H

Haas typefaces, 95–97

Hairline registered colors, 200

Hairline serifs, 98

Hakala, Mary, 116

Halftone dot pattern, 199

Halftones, 147–148
 screens, 144–146

"Halloween Haunts" (Hart), 154

Hammermill Papers Group, 144–145

Hard drive for computers, 194–195

Hardware for computer graphics, 194–195

Harmonious proportion, 112–113

Harper's Bazaar, 21, 32

Haufe, Daniela, 127

Hausmann, Raoul, 74

Health Plus logo (Macnab), 81

"Heart" (Krug), 129

Heartfield, John, 26–27
 "As in the Middle Ages..so in the Third Reich," 74–75
 The Meaning of Geneva, 166

Helfand, Jessica, 37

Helvetica, 52–53, 93, 96–97
 popularity of, 106
 type family, 97
 x-height of, 101

The Hennegan Company, 123

Hidden line elimination, 188

High-intensity colors, 134

Hirschfeld, Corson, 123

History
 of computer graphics, 187–192
 of graphic design, 18–39
 grids in, 119–121
 of Internet, 203
 of posters, 20
 symbols, historically important,
 82
History of Graphic Design
 (Meggs), 36
Hitler, Adolf, 24
Hoard's Dairyman's posters
 (Zumbo), 154–155
Höch, Hannah, 26–27
Hoffman, Andy, 44–45
Hofmann, Armin, 30
Hojnacki, Steve, 162–163
"Hollywood and Highland"
 signage (Sussman), 8
Holwein, Ludwig, 21
Homage to the Square (Albers),
 136–137
Hopper, Edward, 151
Horizontal lines, 63
Hot type technology, 97
How magazine, 14, 159
HSL colors. *See* Hue; Saturation;
 Value of color
HTML (hypertext markup
 language), 203
 extensions, using, 206
HTTP (hypertext transfer
 protocol), 203
Hue, 133
 complementary hues, 134
 Photoshop sliders for,
 142–143
 properties of, 141
Hughes, Pat, 78–79
Humane Society logo (Hoffman),
 44–45

Hummingbird (Csuri), 188–189
Hyphenation problems, 106

I

IBM (Rand), 32–33
IBM PC, 127
Icons, 83
Illinois Institute of Technology,
 31
Illustration, 152–154
 advertising and, 154–158
 for animation, 158
 clip-art, 162–163
 designer-illustrators, 151–152
 editorial illustration, 154–158
 fashion illustration, 157
 gradients in, 160
 greeting card illustration, 158
 ideas for, 159–162
 for in-house projects, 157
 magazine illustration, 156
 media for, 158–159
 medical illustration, 158
 for motion graphics, 158
 newspaper illustration, 156
 picture plane space, 163
 reference materials for, 163
 retail illustration, 158
 styles for, 158–159
 technical illustration, 158
Illustrator, 106
 gradients, working with, 160
 grid-based layout with, 121
 illustration and, 158
 vector graphics for, 52
Imagesetters, 196
InDesign, 106
 grid-based layout with, 121
 trapping with, 200
 vector graphics for, 52

vector graphics in, 194
Index, defined, 83
Indexed color modes, 208
India ink drawings, 199
Industrial design, 7
Industrial Revolution, 19–20
 typefaces and, 90
In-house design careers, 14–15
In-house projects, illustration for,
 157
Inkjet printers, 196
Institute of Design (Moholy-
 Nagy), 31
Intellectual unity, 59–60
 in advertising agency, 61
Intensity of color, 134
Interactive Financial Learning
 Systems symbol (Arnston), 79
International Design Conference
 in Aspen (IDCA), 32
International Exhibition of
 Modern Decorative Art, Turin,
 1902, 20
International Typographic Style,
 30, 103, 113, 127
Internet, 8. *See also* Computer
 graphics
 adaptive palettes for, 208
 advertising on, 179
 careers in design, 16
 designing for, 182, 205–206
 file formats for, 207
 filenames for, 206–207
 file size for, 207–208
 frames for Web pages, 209–210
 as global village, 203–204
 history of, 203
 links to documents, 209
 methodology for, 205
 monitor size and publishing
 on, 208

Internet, *continued*
postmodernism and, 35
print medium distinguished,
204–208
production for, 203
researching on, 9
resolution requirements, 207
sound for, 210
student flowchart for portfolio
site, 205
tables, alignment with,
209–210
Web pages, 208
Internet Explorer, 204
Interpretation, 42
The Interpretation of Dreams
(Freud), 22, 30
Ishioka, Eiko, 157
Isolation and balance, 68
@*Issue* magazine, 156
Italics, 92
Ives, Herbert, 132–133

J

J. I. Case Company corporate
logo, 183
Jablonsky, Siegfried, 127
Jacobs, Russ, 87
Jadowski, George, 77
Japanese Society for the Rights
of Authors, Composers, and
Publishers silkscreen
(Yokoo), 35
Japanese symbolic picture, 44–45
Jenson, Nicolas, 91
Jet Propulsion Laboratory
(JPL), 189
Jimmy John's Gourmet
Sandwiches commercial, 177
John Fogarty's *Eye of the Zombie*
album cover (Chase), 65

Johnson, Emily, 108
Jones, Danny C., 77
Joyce, James, 30
JPEG files, 206
for Internet, 207
resaving, 202
Justified text, 102
format design and, 103
word spacing and, 103

K

Kafka, Franz, 100
Kafka, Kurt, 24
Kahn, Emil, 24–25
Kandinsky, Wassily, 27
Kantscheff, Stefan, 77
Staaliches Operettentheater
symbol, 78
Kauffer, E. McKnight, 24
Reigate, 130–131
Kelmscott Press, 21, 91–92
Kerning, 102
K.G. Brucke catalog (Kirchner),
23
Kinesthetic projection, 61
Kinstgewerbe-museum poster
(Müller-Brockman), 60
Kirchner, Ernst, 223
Kliese, Becky, 70
Köhler, Wolfgang, 24
Kokoschka, Oskar, 23
Kontra-Komposition mit
Dissonanzen XVI (van
Doesburg), 29
Koppel, Terry, 111
Koppel & Scher, 93
Kowai, Cal, 18–19
Krug, Natalie, 129
Kruger, Barbara, 35
Kunimasa, Utagawa, 50

L

Lair, John, 110–111
Lap registered colors, 200
Laser printers, 196
resolution of, 201
Layered communication,
191–192
Layout
balance and, 111–112
effective size and, 113–115
focal point in, 122
grid layout, 119–121
multipanel design, 124–126
path layout, 121–122
photography in, 122–127
proportion and, 112–115
size and, 112–115
visual rhythm and, 115–119
Leading, 100–102
grids and, 121
line length and, 101
type size and, 100–101
typestyles and, 101–102
Le Corbusier, 112
Left side of page, 63–64
Lemel, Yossi, 154–155
Lepape, George, 30
Les Valeurs Personnelles
(Magritte), 114–115
Letterforms. *See also* Typefaces
and figure/ground relationships,
48
grouping, 49–50
manipulating, 70
shapes, 51–52
Letterspacing, 102–103
rhythm and, 116
Lichtenstein, Roy, 161
Licht und Schatten (Light and
Shadow) (Preetorius), 44–45

Life magazine, 21, 163
 advertising in, 180
Light waves and color, 131–132
Line art, 199
Line length
 grids and, 121
 leading and, 101
Links
 creating, 202
 to Web pages, 208
Linotype machine, 90
Lionni, Leo, 32
Liset Tattoo (Zumbo), 66
Lissitzky, El, 29, 61
 USSR Russische Ausstellung, 28
 *Victory Over the Sun lithograph,
 96–97*
Location and balance, 67
Logos, 83–85
 advertising and, 183
 vector graphics for, 85
London *Times*, 90
"Look, Listen, Think, Feel"
 (Fenster), 17–18
Lossless compression, 203
Lossy compression, 203
Louisville Ballet poster (Friedman
 & Lair), 110–111
Low-intensity colors, 134
LPI (lines per inch), 200, 202
Lubalin, Herb
 *Avant Garde design, 100,
 118–119*
 Eros magazine logo, 32–33
 Family Circle logo, 78
 Mother design, 79
 Photo, 68
 *Reader's Digest trademark,
 84–85*

U&lc magazine cover, 118–119
Lubalin Graph typeface, 52–53,
 94–95

M

Macintosh, 127, 188
 monitor size, 208
Macintosh, Charles Rennie, 20, 21
Macnab, Maggie, 81
Macromedia Director, 204
Maddoux Way Arabians logo, 81
Made in Space Web site
 illustration (Greiman),
 127, 158
Magazines
 advertising in, 179–180
 illustration for, 156
 as reference materials, 163
The Magic Mountain layout
 design (Scher), 93
Magleby, McRay, 14–15
Magritte, René, 30–31, 161
 The False Mirror (Magritte), 31
 *Les Valeurs Personnelles,
 114–115*
Malevich, Kasimir, 27
Manet, Éduoard, 35
Manutius, Aldus, 92
Marinetti, Emilio, 24
Market research, 176
Mark of the maker, 61
Massachusetts Institute of
 Technology (MIT), 35,
 188, 206
Matisse, Henri, 23
Matter, Herbert, 67
Mattos, John, 2–3
 Fidel of Dreams, 135
Mayakovsky, Vladimir, 28
McCord, Walter, 120

McCoy, Katherine, 34–35
 Cranbrook recruiting poster, 191
McCoy, Michael, 191
McLimans, David, 43
 *Gone Fishing: Ocean Life by the
 Numbers, 72–73*
 *The Progressive magazine illus-
 tration, 156*
 *Sketchbook cover collage,
 150–151*
 Sketchbook pages, 152
McLuhan, Marshall, 32
 profile of, 204
The McLuhan Program in Culture
 and Technology, 204
McWilliams, Donna, 104
The Meaning of Geneva
 (Heartfield), 166
The Mechanical Bride
 (McLuhan), 204
Media for illustration, 158–159
Medical illustration, 158
Medici tombs (Michelangelo), 35
Meggs, Philip, 36
Memory requirements for
 computer graphics, 195
Mergenthaler, Ottmar, 90
The Metamorphosis layout
 (Scher), 100
Michelangelo, 35
Mihock, Chris, 174–175,
 180–181
Minnesota Zoo Bugs! ad
 campaign (Edwards &
 Mihock), 174–175, 180–181
Modern typefaces, 92, 95
Moholy-Nagy, László, 29, 31
Moiré pattern, 146
Mondrian, Piet, 28
 grids, use of, 120

Monitors, 194
 calibrating monitors, 142
 Internet publishing, size for, 208
Monochromatic color
 schemes, 135
Morris, William, 21–22, 24,
 91–92
 classic typefaces, revival of,
 92–93
 The Wood Beyond the World
 page, 92
Moser, Koloman, 152–153
Motion graphics, illustration
 for, 158
Motion pictures and futurism, 24
"Movement" word illustration
 (Kliese), 70
Mucha, Alphonse, 20, 160, 161
 Art nouveau poster, 164
 studio photograph of model, 164
Müller-Brockmann, Josef, 30,
 60
 grids, use of, 121, 126
Multimedia design, 8
Multipanel design, 124–126
Munsell color wheel, 132–133
Museum of Modern Art, 37
Muybridge, Eadweard, 164–165

N

Naming files for Internet, 206
Napoleon, 95
Narnia Zoo mark (Jacobs), 87
National advertising, 175
National Geographic magazine
 illustration ideas from, 163
 photography, use of, 165
Nazi Germany, 74–75
Negerkunst, Prähistoriche
 Felsbilder Südafrikas (Bill), 67
Neo-expressionism, 23

Nessim, Barbara, 161
Nesting electronic files, 201
Newspapers
 advertising in, 176–177
 audience for advertising, 177
 illustrations for, 156
 photojournalism, 166–167
Newsweek magazine
 advertising in, 180
 ideas from, 163
Newton, Isaac, 132
New Typography, 30, 103
New Wave design, 35, 126
New York Art Directors Club, 32
Nietzsche, Friedrich, 23
Nihilism, 23
Nihon Buyo (Tanaka), 51
Nonobjective shapes, 51
Nonregistered colors, 200
"Nympth" (Su), 129

O

Object-oriented graphics, 194
Objects in Space poster
 (Greiman), 126
Offset commercial printers,
 198–200
Ohio State University College of
 the Arts, 188–189
Old style typography, 91
1 + 1 Design symbol (Hughes &
 Quinn), 78–79
"On Gestalt Qualities"
 (Ehrenfels), 23
On the Just Shaping of Letters
 (Dürer), 48
On the Spiritual in Art
 (Kandinsky), 27
Optician, poster for
 (Cassandre), 59
Organic shapes, 52

Ormrod, Frank, 115
Orphans, 106
Osram ZAO (Bernhard), 24–25
Out-of-gamut colors, 143–144

P

Package design, 7–8
Packaging advertising, 183
Page from Portfolio
 (Brodovitch), 68
PageMaker software, 188
Paik, Nam June, 18–19
Painters as illustrators, 151
Palais de Glace poster
 (Chéret), 20
Pantone© colors,
 for process colors, 146
 for spot colors, 146
Paper
 colored paper, printing on, 147
 quality and printing, 200
Papyrus, 90
Parrish, Maxfield, 21, 164
Parthenon, 112
Patchwork Quilt (Bearden),
 152–153
Pathname for URL, 205
Paths
 layout in, 121–122
 type on a path, 106
Patrick, Bruce, 108
PDF files
 for fonts, 201
 for Internet, 207
Peckolick, Alan, 78
Pen-and-ink thumbnails, 11
People magazine, 163
Perception of color, 139–141
Personal color associations, 137
Personal promotion
 advertising, 182

Phoenician alphabet, 89–90
Photography. *See also* Photoshop
 black-and-white data in, 199
 corporate photography, 168
 cropping photographs, 122–123
 designer-photographers,
 165–166
 digital photography, 167
 impact of, 164–165
 in layout, 122–127
 in multipanel design, 124–126
 photojournalism, 166–167
 product photography, 167–168
 resizing photographs, 123–124
 retouching photographs, 124
 selecting photographs, 124
 stock photography agencies, 170
Photojournalism, 166–167
Photomontage, 26, 165–166
Photoshop
 adaptive palettes, 208
 as bitmapped graphics program,
 194
 color correction software, 143
 for digital prepress, 201
 duotone curve menu, 148
 gradients, working with, 160
 hue, saturation and lightness
 sliders, 142
 illustration and, 158
 out-of-gamut colors, 143–144
 raster graphics for, 52
 resizing images in, 124
 Save for Web option, 209
 tritone curve menu, 148
 unsharp mask filter, 202
 working with, 166
Phototypography, 90–91
Picas, 98
 grids and, 121
 rule for, 99

Picasso, Pablo, 151
PICT files, printing, 203
Pictograms, 83
Picture plane space, 163
Pineles, Cipe, 32–33
Pixels, 141, 192. *See also* Raster
 graphics
 bits in, 195
 structure of image, 141
Plakastil, 24
Planet Propaganda, 138–139
 Ben Sidran's Concert for Garcia
 Lorca, CD package for, 13
 Jimmy John's Gourmet
 Sandwiches commercial,
 177
 Web site, 4
 Wisconsin Film Festival ad sam-
 pler, 8–9
Platesetters, 196
PmFAQtory, 10
PNG files for Internet, 207
Poetry and Dadaism, 26
Point size, 98
 charts, 99
 grids and, 121
 x-height and, 102
Pong computer game, 188
Pontresina Engadin (Matter), 67
Portrait (Mattos), 2–3
Portrait of Nijinsky & Diaghilev
 (Glaser), 62
Positive/negative space, 42
Postmodernism, 35, 126
 Japanese postmodernism, 35
PostScript language, 188
 printing with, 196
Practice of design, 8
Predictability and balance, 64
Preetorius, Emile, 44–45
Presentation of design, 14

Primary colors, 132. *See also* RGB
 colors
Printing
 black-and-white data, 199
 camera ready design, 198
 colors in, 144–148
 compressing files for, 203
 computer graphics technologies,
 196
 continuous-tone art, 199–200
 cost-cutting for printing
 colors, 147
 cropping for, 200
 digital prepress, 198, 200–203
 dos and don'ts of digital
 prepress, 201
 dot gain, 200
 file formats for, 202–203
 file links for, 202
 fonts for, 201–202
 four-color offset printing, 142
 history of process, 198–199
 Internet medium distinguished,
 204–208
 line art, 199
 LPI (lines per inch) and,
 200, 202
 offset printing, 198–200
 production for, 198–200
 registration marks, 200
 service bureau, preparing files
 for, 203
 spot color variations, 200
 suggestions for, 202
 terminology of, 199–200
 tint screens, 144–145
Printing companies, careers
 in, 16
Printing presses, 90
Print magazine, 180
Problems in design, 3

Process colors, 132–133. *See also* Color separations

Pantone© matching system, 146

Process of design, 9–16

Product design, 7

Production, readiness for, 14

Product photography, 167–168

The Progressive magazine illustration (McLimans), 156

Progressive rhythm, 116–119

Proofreader's marks, 107

Proofreading, 107

Propaganda work, 28

Proportion and layout, 112–115

Protocol for URL, 205

Proximity and gestalt, 76–77

PSD files, printing, 202

Psychology of colors, 137–139

Public relations (PR) and corporate photography, 168

Punch line in multipanel design, 124

Push Pin Studios, 32, 62

Q

QuickTime files, 207

Quinn, Steve, 78–79

R

Rackham, Arthur, 154–155

Radial symmetry, 65

RAM (random-access memory), 195–196

Rand, Paul, 82, 183

annual report for Westinghouse Electric Corporation, 178

IBM, 31–32

light bulb packaging for Westinghouse Electric Corporation, 182

profile of, 176

Trademark, the American Broadcasting Corporation, 52

TV storyboard for Westinghouse Electric Corporation, 175

Rapp Collins Communications' Bugs! ad campaign, 43, 174–175, 180–181

Raster graphics, 52

bitmapped programs using, 194

enlarging raster images, 192

for logos, 85

platesetters for, 196

Ray, Man, 26, 30–31

Ray-Ban online advertisement (Cutwater ad agency), 179

Rayographs, 26

Rayovac logo concepts (Eichman), 85

Readability and line length, 98

Reader's Digest trademark (Lubalin), 84–85

Realism, 41

color and, 139–140

Recording, illustration for, 154–155

Red. *See also* RGB colors

associations with, 137

Rees, John, 108

Reference materials for illustration, 163

Regent's Park (Ormrod), 115

Registration marks, 200

Reigate (Kauffer), 130–131

Relativity of colors, 135–137

Renaissance art, grids in, 120

Repetition of shapes, 50

Research and design, 9

Resolution

of digital image, 124

dpi (dots per inch) and, 201, 202

for imagesetters, 196

for Internet files, 207

of laser printers, 201

of screen, 193

Responsibility and design, 17

Ressler, Susan, 167

Retail advertising, 175

Retail illustration, 158

Reversed fonts, 99

Reversible figure/ground relationship, 44

RGB colors, 132. *See also* Color separations

explanation of, 142

gamuts, 143–144

for Internet publishing, 208

Photoshop sliders controlling, 142

Rhythm

in typography, 116–119

visual rhythm, 115–119

Richards Group, 178

Right side of page, 63–64

RIP (raster image processing), 198, 200–201

RLE (run-length encoding), 203

Rockwell, Norman, 164

Rodchenko, Aleksandr, 27–28

Roehr, Karen, 114–115

Roman alphabet, 90

Roman types, 92

Rose Boudoir chair (Macintosh), 20

Roughs, 11–13

Rubin's vase, 46

Ruder, Emil, 113, 126

photo placements on grid, 122

Ruffins, Reynold, 32

Rushkin, John, 21–22

Russian Revolution, 27

S

Safari, 204

Saint Louis arch, 61

Salome illustration (Beardsley), 21

Salvation Army digital annual report (Click Here, Inc.), 178

Sans serifs, 52, 92–93, 95–97
and leading, 101
leading and, 102
popularity of, 93
style of, 98

Sara Little Tumbill drawing (Stermer), 156

Saturation, 134
Photoshop sliders for, 142–143
properties of, 141

Saylor, David, 168

Scaling for digital prepress, 201

Scanners
analog-to-digital converters in, 193
as input devices, 196

Scarlett, Nora, 182–183

Scher, Paula, 28
The Magic Mountain layout design, 93
The Metamorphosis layout, 100
profile of, 103

School of Applied Arts and Crafts, 28

Schwitters, Kurt, 28

Second Story, Inc., 104

Selection points in vector graphics, 194

Semiotics, 42–43, 83

Serifs, 52, 90
hairline serifs, 98
and leading, 101
leading and, 102
for old style typography, 91
popularity of, 93
square slab serif type, 95

Service bureau, preparing files for, 203

Seurat, Georges, 161
A Sunday on La Grande Jatte, 139–141

Severini, Gino, 24–25

Sexuality, 22

Shades of color, 133–134

Shanosky, Don, 83

Shapes, 49–56
balance and, 69
form of shapes, 50–52
grouping shapes, 49–50
letterform shapes, 51–52
nonobjective shapes, 51
repetition of shapes, 50
terminology of, 52–54
visual rhythm and, 115
volume and, 49

Sidran, Brian, 13

Signage advertising, 183

Signs of the Times (Deck), d196–197

Similarity and gestalt, 76

Simultaneous contrast, 135–136

Size. *See also* Type size
balance and, 67
expected size, 113–115
layout and, 112–115
photographs, resizing, 123–124

Sketchbook cover collage (McLimans), 150–151

Sketchpad, 188

Smithsonian magazine, 163

Software
CAD/CAM tools, 187
for computer graphics, 194–195
instruction, 16
Web software, 210

Sorel, Ed, 32

Sound for Internet publishing, 210

Southern California Institute of Architecture Summer Programs poster (Greiman), 69

Spacing. *See* Letterspacing; Word spacing

Spatial depth and balance, 67

Spell-checking, 107

Split complementary schemes, 134–135

Spot colors
overlapping, 144–146
Pantone© matching system, 146
printing variations of, 200

Square slab serif type, 95

Staaliches Operettentheater symbol (Kanscheff), 78

Stable figure/ground relationship, 44

Starkey Chemical Process Co. trademark, 84–85

Statue of Liberty, 83

Stempel Foundry, 97

Step-by-Step Graphics, 159

Stermer, Dugald, 116–117, 156

Stiftung Bauhaus Dessau, May-June 1995, 127

Stock photography agencies, 170

Stone lithography color prints, 20

Storrm, Michelle, 70

Storyboards for TV ads, 175–176

Stress on letter, 54

Strippers, 198

Structure and balance, 69

Sturgeon, Inju, 157

Styles
for illustration, 158–159
shape and, 50
of typefaces, 98–100, 104–106

Stylus, 90

Su, Ming Ya, 129

Subject matter and balance, 68

Subtractive primary colors, 132

Success magazine cover (Parrish), 21

Sun and Moon (Escher), 80–81

A Sunday on La Grande Jatte (Seurat), 139–141

Sundwall, Joe, 95

Suprematism, 24

Surrealism, 30–31

Sussman, Deborah, 8

Sutherland, Ivan, 188

Swastika symbol, 82

Swiss Design, 30, 126

Symbols, 42
 gestalt and, 82–83
 historically important symbols, 82

Symmetry
 and balance, 65
 and layout, 112

Syverson, Anita, 125

T

Tables for Internet publishing, 209–210

Tactical Magic, 79, 182–183

Tanaka, Ikko, 51

Tapestry "Angeli Laudantes" (Morris), 22

TCP/IP, 206

Teapot (Threadgill), 49

Technical illustration, 158

Technology. *See also* Computer graphics; Internet
 design and, 127
 illustration and, 159
 new technologies, 36–38
 postmodernism and, 35
 printing and, 148

Television
 advertising, 175–176

McCluhan, Marshall on, 32

Text. *See* Typography

Texture
 balance and, 68
 figure/ground relationships and, 46

Themes and grids, 119

Theory of design, 8

Thieme, Candy, 10, 134

Third-class mail advertising, 178

Threadgill, James, 49

Threadgill, Linda, 49

Three-color images, 199

Thresholding (Truckenbrod), 190–191

Thumbnails, 10–11, 161

Tiffany, Louis, 21

TIFF files, printing, 202

Tim Girvin Design, Inc., 134

Tingesdahl, Jorel, 149

Tints, 133–134
 printing, tint screens for, 144–145

Top of page, shapes at, 62

Toulouse-Lautrec, Henri de, 20

Trade card, 19th century, 20

Trademark, the American Broadcasting Corporation (Rand), 52

Trademarks. *See also* Logos; Symbols
 advertising and, 183
 combination marks, 85
 gestalt and, 81–85
 long term design, 82

Transitional typefaces, 92, 93–95

Transjovian Pipeline (Em), 189

Trapping, 200

Tree of Life Window (Wright), 65

Tritones, 147–148

Trompe l'oeil, 164

Tropon (van de Velde), 27

Troy typeface, 91–92

Truckenbrod, Joan, 190–191

Tschichold, Jan, 30

Tweening, 188

12Twelve Design brochure (Hakala & Dooley), 116

20th century
 abstract movements, 27–30
 American design, 31–36
 figurative movements, 30–31
 modernism, 24–27
 postmodernism, 35
 turn of the century, design at, 22–24

Typefaces, 54. *See also* Fonts; Type families
 alphabets, 89–90
 combining, 98–100
 format design, 103–104
 historic type families, 93–97
 leading and, 101–102
 line lengths, 98
 measuring type size, 98
 miscellaneous faces, 97
 modern typefaces, 95
 path, type on a, 106
 point size, 94–95
 rhythm and, 116
 selecting, 98
 shapes an, 52
 sizes, 98
 style and, 98–100, 104–106
 summary of design, 106
 technology and, 90–91
 text type, 98
 transitional typeface, 93–95

Type families, 97–106
 historic type families, 93–97

Type size
 grids and, 121
 leading and, 100–101
 of letter, 54
Typography, 98. *See also*
 Typefaces
 black-and-white data in, 199
 categories of design, 91–97
 correcting copy, 107
 orphans, 106
 rhythm in, 116–119
 structure and, 69
 summary of design, 106–107
 transitional typefaces, 92
 value contrast in, 68–69
 vector graphics for, 52
 widows, 106
Tzara, Tristan, 26

U
UCLA Extension summer 1991
 catalog (Sturgeon & Ishioka),
 157
U&lc magazine cover (Lubalin),
 118–119
"UNable" poster (Lemel), 154–155
*Understanding Media: The
 Extensions of Man*
 (McLuhan), 204
Unity
 intellectual unity, 59–60
 visual unity, 59–60
Universal typeface, 95
University of Utah, 14
Univers typeface, 93, 95
 popularity of, 106
Univers typestyle, 54
"Untitled" (Kruger), 35
URL address, 204–205
U.S. Department of Defense, 206
 and computer graphics, 36

U.S. Department of
 Transportation pictograms
 (Cook and Shanosky
 Associates), 83
U.S. Energy Extension Service
 symbol (Jadowski & Jones), 77
USSR Russische Ausstellung
 (Lissitzky), 28

V
Valley Winery logo (A3 Design),
 76
Value, 5–7. *See also* Value of color
 balance and, 68–69
Value of color, 133
 Photoshop sliders for, 142–143
 properties of, 141
 simultaneous contrast and, 136
Vanderbyl, Michael, 77
 *California Conservation Corps
 symbol*, 83
Van de Velde, Henry, 27, 28
Van Doesburg, Theo, 28–29, 60
 grids, use of, 120
 vertical composition and, 63
Vector graphics, 52
 lines in, 194
 for logos, 85
 as object-oriented graphics, 194
Vehicles, signage for, 183
Vertical lines, 63
Vertical stress and leading,
 101, 102
Victor Bicycles poster
 (Bradley), 64
Victory Over the Sun lithograph
 (Lissitzky), 96–97
Villarreal, Miguel, 70
Virgin Records logo (Chase), 69
Virtual reality, 38
Visible Language Workshop, 35
Visual design theme, 119

Visual direction, 66–67
Visual display terminal
 (VDT), 194
Visual dynamics, 61–62
Visual perception, 41
 of colors, 139–141
Visual rhythm and layout, 115–119
Visual texture, 68
Visual unity, 59–60
Visual vocabulary, 9
Visual weight, 66–67
 grids and, 119
Vogue magazine, 30
Volume and shape, 49
Voter participation ad campaign
 (Breese), 185

W
Walker, Scott, 65
Wave of Peace poster (Magleby), 15
Waylen, Jackie, 170
Weber, Jeremy, 70
Web sites. *See* Internet
Wertheimer, Max, 23–24
Westinghouse Electric
 Corporation. *See* Rand, Paul
Whole/parts in gestalt theory, 73
Widows, 106
Wilde, Oscar, 21
Wirth, Melissa, 70
Wisconsin Film Festival ad,
 8–9
The Wood Beyond the World page
 (Morris), 92
Wood display type, 106
Word spacing, 102–103
 rhythm and, 116
Workbook, 159
World War I, futurism and, 24
World War II and computers,
 188

World Wildlife Fund logo
(Eyebeam Creative), 84–85
Wright, Frank Lloyd, 65
Writing, development of, 89–91

X
X-height
and leading, 101
of letter, 54
and point size, 102

Y
Yellow, associations with, 139
Yokoo, Tadanori, 34–35

Z
Zeisler, Richard S., 24–25
Zoopraxiscope, 164
Zumbo, Matt
black-an d white illustration, 159
colorized drawings by, 159

Frog Bucket logo, 15
Hoard's Dairyman's posters,
154–155
Seurat-inspired, 31
symmetry example, 66